TO A VIOLENT GRAVE

Books by Jeffrey Potter

MEN, MONEY & MAGIC
DISASTER BY OIL

TO A VIOLENT GRAVE

An Oral Biography of

JACKSON POLLOCK

by Jeffrey Potter

G. P. PUTNAM'S SONS NEW YORK

G. P. PUTNAM'S SONS
Publishers Since 1838
200 Madison Avenue
New York, NY 10016

LIBRARY OF CONGRESS CATALOGING IN PUBLICATION DATA

Main entry under title:

To a violent grave.

Includes index.
1. Pollock, Jackson, 1912–1956. 2. Painters—
United States, Biography. I. Pollock, Jackson,
1912–1956 II. Potter, Jeffrey.

ND237.P73T58 1985 709'.2'4 (B) 85-590
ISBN 0-399-12910-3

PRINTED IN THE UNITED STATES OF AMERICA

1 2 3 4 5 6 7 8 9 10

IN MEMORY OF LEE KRASNER

"I cannot exaggerate Lee's importance to Jackson."
—*Clement Greenberg*

"A great artist, she was totally authentic.
Her belief in Pollock never faltered."
—*Terrence Netter, S.J.*

"These were heroic people.
I can't imagine his eminence without Lee."
—*Ronald Stein*

ACKNOWLEDGMENTS

My indebtedness to Elizabeth Feinberg Pollock, first wife of Charles Pollock (Jackson's eldest brother), is large. Her faith in this work has been constant, and she has offered a broad and vibrant recall of Jackson's early New York years. Also, she has granted access to her papers filed under restriction with the American Art Archives, furnished photographs, and prepared a meticulous index. Saying that she has "the tongue of a snake," she asks that the following be put on the record: "In 1965, when Charles directed O'Connor to me [Francis V. O'Connor, co-editor of the Pollock catalogue raisonné], I refused to give an interview and so wrote to Charles. He responded that 'Your memory is so much better than mine,' and in 1973, once more approached by O'Connor, I again refused. In 1982, Charles, both by letter and telephone from Paris, informed me that he had referred you [the author] to me. Over the long, long years, despite only an occasional encounter, there has been maintained a friendly and trusting relationship between members of the Pollock clan and myself. I do not want to hurt them by ripping away their fantasy of a brotherly Jackson; I do not want to be hurt myself by having them assume that I have ruthlessly publicized a reality. I am convinced, however, that most of them want the truth to come out, and that Charles should assume responsibility for having so determinedly insisted that you and O'Connor seek me out."

While all Pollock family members have been cooperative, Charles and his wife Sylvia (Wolf) in Paris, and Frank and his wife Marie (Levitt) in San Francisco, provided many hours of enlightening interviews. Among the more than one hundred and fifty people interviewed in person and at length, B. H. Friedman, author of *Jackson Pollock: Energy Made Visible*, has been all—and more—that one biographer could ask of another.

Among Jackson's early friends, I am particularly indebted to the sculptor Reuben Kadish, who has given unlimited time and thought to this work. Stanley William Hayter, at whose Atelier 17 Jackson liked to work with Kadish after hours, has been most helpful with his intelligent recollections.

A major figure in Jackson's career, the critic Clement Greenberg, has been as generous in consenting to repeated interviews as he has been candid. The painter Fritz Bultman shared his highly informed insights without reservation, as did Robert Motherwell, whose wife, Renate Ponsold, generously supplied her photographs. The psychoanalyst Violet deLaszlo, M.D., even more than Jackson's other therapists, contributed to a clinical understanding of the artist with her informed insights during three long, probing interviews.

For the East Hampton years, Alfonso Ossorio and Ted Dragon have been not only extremely helpful but patience itself, while Nicholas Carone and Patsy Southgate have been ideal interviewees. Their efforts have meant a great deal. Interviews with Carol Braider have been enlightening, and her elucidation of the clinical nature of alcoholism, as well as that of Sally Christiansen, R.N., M.S., has been helpful.

My apologies to those who granted interviews but do not appear in this work due to length limitations, and my thanks to Harry Jackson for his copyright material.

The final form of the work—once a memoir, then the equivalent of a two-volume biography—is due to the sound judgment of Ellis E. Amburn, editorial director of G. P. Putnam's Sons. The contribution made by the inspired editing and reassurance of Putnam's Fred Chase has been outstanding. Denise Auclair's creative suggestions and uniquely intelligent typing are also deeply appreciated.

In the vast bibliography consulted, the superb *Jackson Pollock Catalogue Raisonné,* edited by Francis V. O'Connor and Eugene V. Thaw, has been of great help. So, too, has B. H. Friedman's *Jackson Pollock: Energy Made Visible.*

Finally, I am indebted to my wife, the painter Priscilla Bowden, for her patience and encouragement. Her efforts have been endearing.

Jeffrey Potter
East Hampton, NY
January 1985

AUTHOR'S NOTE

Jackson Pollock and I shared some personality equivalents. We saw ourselves as outsiders: He was so much one I kept notes on our meetings in the hope of using him as hero of a novel to be called *The Outsider*. By the time the project was abandoned, the taking of notes had become a habit. They have been used as the basis of his statements herein, and while they are not always direct quotes—his words could be too unprintable and his utterances too halting for that—their meaning and feeling are his.

Our conversations dealt not with art but country matters, machines, women, money worries, occasionally mysticism and often, toward the end, death. On this he thought me an expert because of my World War II service with the Royal Indian Army in Burma.

Jackson's curiosity and empathy for the concerns of others made him a loyal friend, but in his loneliness and later despair he could seem almost a professional orphan. He referred occasionally to what he called "my analysis," and much has been written about the relationship of psychoanalysis to his work. However, Jackson was never in analysis. His psychotherapy, it is clear now, consisted of supportive, informed listening.

In 1978, Jackson's widow, Lee Krasner, asked me to do a study of the feasibility of establishing their property on Accabonac Creek in Springs as a regional art archives center. Lee named it successively the Accabonac, Pollock/Krasner and finally the Krasner/Pollock Foundation. Under whatever label it has yet to be, I like to think that the acreage will be made a memorial to them both. Although Jackson was at times far from happy in the house and his studio did not work well for Lee when she tried using it after he died, seldom can a man have had greater love for the landscape around him, or a woman greater commitment to a man and his work.

AUGUST 11, 1956: FIREPLACE ROAD, EAST HAMPTON

FIRST NEIGHBOR *[mechanic]:* Funny, the way on a damp night you can hear cars coming down Fireplace Road. You can hear a car when it leaves East Hampton village and heads our way, but I never heard *him* coming. Anyway, little after ten o'clock this horn starts blowing and it blew too long some way.

SECOND NEIGHBOR *[bulldozer operator]:* It was a heavy night and we sat home with friends, with the windows all open. I heard a hell of a thump like something hitting the earth, and at that very instant a horn started blowing. It kept blowing for I don't know how long.

THIRD NEIGHBOR *[welder]:* We were playing pinochle and about nine-thirty, ten o'clock this horn began to blow, blow, and blow, and it didn't stop. Cars were going up and down the road—we could see them from the front room—but that horn just kept blowing. And it was too steady like.

FOURTH NEIGHBOR *[truck driver]:* Even to this day I can hear cars coming clear from Two Holes to Water, downgrade all the way. It's almost to the point where I can identify them. When I heard this car barrel-assing down the road, I said, "That fool isn't going to make the curve."

PART ONE

CHAPTER ONE
THE WEST

When his work wasn't going well, Jackson Pollock liked watching my earth movers and marine contracting rigs. He was good about keeping out of the way, even out of sight, but eventually the frustration he projected would make me join him. We used to lean against a fence or my pickup and look down at the sand and dirt we were scuffing; mine was worked into little mounds, his into designs.

Jackson would break his usual silences with questions to hold me until his mood lifted. Then he would scrape away the designs, tell me to cheer up, and get on with his day. My day would now be one of sudden fatigue, and a job gone sour.

The only aspect of self he talked about during our seven-year East Hampton friendship had to do with his problems. He spoke rarely of childhood and never of his father, Roy Pollock; I can recall but one mention of Stella, his mother; of his four siblings, all older brothers, the only occasional reference was to the closest in age and companionship, Sande. Such lack of information about his background fueled the rumors that he had been adopted or was illegitimate.

Actually, it was Jackson's father, Roy Pollock, who was adopted—at the age of twenty. Roy Pollock was born LeRoy McCoy on February 25, 1877, at Tingley, Iowa; his name is given as Lee Roy on a family document, though he usually signed himself L. R. Pollock. His mother died before he was a year old and his father by the time he was five. Roy was reared on a neighboring farm by a childless couple, James and Elizabeth Lewis Pollock. Two other boys raised with him never were adopted: One, who kept the name McCoy and may have been a half brother, became a Presbyterian minister; the other, referred to by Jackson as "Uncle" Frank Pollock, was older than Roy and never knew who his parents were.

Roy's heritage was Scotch-Irish, Stella's predominantly Scottish. Both backgrounds were sternly Presbyterian and agricultural, but in Stella's there were also weavers, and at twelve she wove floor coverings for her parents' entire house. The eldest of seven children, she was born Stella May McClure a couple of years earlier than Roy in Tingley, where her father ran a lumberyard. She and Roy were in their thirties at the time of Jackson's birth; of it Roy said that instead of a girl at last, he now had five boys and none bearing his name.

Their first child—the only one not to be born at Cody, Wyoming—was Charles Cecil, born in Denver in 1902. Then came Marvin Jay in 1904; Frank Leslie in 1907; Sanford LeRoy in 1909; and finally Paul Jackson on January 28, 1912, and not on a ranch but in Cody itself. Charles became a painter and calligraphy teacher; Marvin, who called himself Jay, chose rotogravure work; Frank became a commercial rose grower; Sanford (Sande) did painting and silk screening; and Paul Jackson, later known as Jackson or Jack, from his teens hoped to be "some kind of artist." The boys bore a closer resemblance to Stella than to Roy; and at a bare 5' 10" Jackson was the tallest.

Jackson's birth, as is often the case with those destined to make an impression on the world, was unusual.

ALMA BROWN POLLOCK (Jay's wife): There was a lot of trauma about that birth and the doctor forbade Mother Pollock to have another: Jackson was strangled by the cord. Stella told me he was "black as a stove," a little phrase that has gotten around. Mother Pollock would never in the world tell me anything like that if it weren't true. But there was no indication that this was an abnormal baby, or that insufficient oxygen might explain later emotional and physical problems.

Before a year passed, Jackson's family made the first of what would be eight moves in fourteen years. This one was to San Diego for a brief stay followed by their removal to a farm of about thirty acres near Phoenix. Four years later, farm and stock were auctioned and the family moved to fruit and nut acreage at Chico, California. By 1922 the Pollocks had moved to northern California timber country and bought a two-story hotel at Lassen with mountain acreage and a barn across the road. That effort failed a little more than a year later, and the property was exchanged for twenty acres at Orland in the Sacramento Valley, a final farming effort. Next, Stella and the younger boys moved near Phoenix, where she worked as a housekeeper. Then came Riverside, California, where Jackson went to high school. In 1926 the last family home was established in Los Angeles.

While some of these moves were the result of Roy's business failures,

there was also Stella's determination to find suitable schools for their boys.

CHARLES POLLOCK: Mother was the strength of the family—the dominant force and strong minded. I always felt she was warm toward us, though our people don't show emotions. I wouldn't say she had humor, but there was plenty of pride. She was just, though she may have learned things which led her to be more sympathetic toward Jack.

ELIZABETH FEINBERG POLLOCK (Charles's first wife): Stella was incapable of finding fault with her children. Were you her child, she would cook for you; wash your clothes, your socks, your smelly things; sew for you; clean for you; make your clothes; all this, but never would she ask you to pick up a sock or make a bed. Stella would praise you for everything you did and see in you *only* the best. She would never ask you to consider her, only to let her serve you. Yet she was incapable of grabbing a child and hugging or kissing it; she had to *serve* that child! The Pollock boys needed that warm physical action, though.

This practically uneducated, non-bookish, farm-reared Iowa woman from Tingley, a mere crossroads, knew only the hard labor of farming, hand laundering, cooking and sewing; yet she possessed those kinds of ideologies we assume are garnered only by sophisticated intelligence. From girlhood she mistrusted all organized religion, all governmental authority, all racist apologies among other mores that fetter the credulous.

And then with her sons, while "respectable" parents were indoctrinating sons with contempt for sissy careers—writing, painting, etc.—Stella welcomed even the most childish demonstration of an aesthetic inclination as promise of an artistic future. Many times she told me how hopeful she had been when one of the small boys gathered colored snippets of her sewing, or collected illustrations from magazines. And to work simply for moneyed success puzzled her.

SYLVIA WOLF POLLOCK (Charles's second wife, thirty-four years his junior): Stella didn't bat an eyelash, though Charles and I were on our way to Estes Park, Colorado to get married. I got the notion that she said to herself, "This is the girl Charles has chosen to marry, and Charles is my son." So she was graceful and pleasant and didn't discuss his first wife in front of me. She was too refined ever to have said something like, "Aren't you a bit young to be involved with my son?"

Besides Charles, Jay and Frank are the other surviving Pollock brothers. Charles admires Jay as "a strong stick and a rotogravure craftsman,"

and Sylvia points out that Jay is more relaxed than the others. Jay's life has been dedicated to his wife, Alma Brown, a lifelong invalid.

ALMA POLLOCK: Mother Pollock was very neat; you never saw her in a bathrobe—very conventional.

JAY POLLOCK: She even made our suits for a long time, but it's strange the way she dressed us. It made us look like little girls.

ELIZABETH POLLOCK: She dressed for the day early, every hair in place, tightly corseted and shoes highly polished. Her clothes, of her own design and manufacture, were immaculate; she never wore an apron, yet at evening her dress was still spotless. I wonder if she was not a kind of natural Thoreau, an earth mother whose life was caring for her children, giving and forgiving.

FRANK POLLOCK: My mother never seemed to worry about the next day, whether we'd make it. My god! She'd drive a team and spring wagon to town for supplies, buying hundred-pound sacks of flour. She knew one flour from another, where it came from, which was good and which wasn't. She made all the bread and pies, and she made all the shirts we ever wore and her own clothes too.

 She didn't only do housework and cook. She did everything on the farm but work in the fields; I never saw her beyond the corral. At that time if you worked your woman in the fields it would be something strange. But she milked cows and when Dad went off with the produce she milked more than normally. She had enough work to do without the milking, of course, and now I think about it the fact that she milked is kind of shocking. But she did it not under duress; she did it lovingly, and she liked animals.

MARIE LEVITT POLLOCK (Frank's wife): I used to say in irony to Frank, "Of course, a Pollock can do no wrong." And I must say I never did hear a word of criticism from Stella about any of her boys. I don't think that would hold for her husband, though.

 Roy Pollock was a hard-working husband and provider: dishwasher, sheep rancher, farmer, concrete mason at the time of Jackson's birth, gravel plant operator, pavement contractor, surveyor assistant.

FRANK POLLOCK: He had blue eyes, leathery type skin from being in the outdoors all his life, dark hair, and he was about 5′ 7″. He was a no-nonsense man, stern, but just. He didn't have any trouble with us kids. We were well behaved, had our own chores, and there was no dissatisfac-

tion within the house. He never talked about his parents and wasn't very vocal, but he said what he had to say and we understood it. He had a small library and he'd read aloud for Charles and Jay from Robert Louis Stevenson and Mark Twain. He was very informal. I don't think he had a suit of clothes, not that he couldn't have; it's just that he wouldn't wear it. He knew mathematics better than any of his sons ever did.

My dad was handy, a very good craftsman. If he built a farm gate, it had to be square, planks parallel, bolts spaced right, and all the hardware just so. And fences had to have four strands of barbed wire always parallel, the posts absolutely equidistant, and all of it was done by eye. He was a hard worker and stuck to his job, always trying to improve his livestock and he was very proud of winning prizes with his produce at state fairs. But sometimes Mother would say to us boys, "Stay out of Dad's way; he's got the blues." I think he suffered depression from time to time. And I'm sure he drank more than he should have at Cody, but once we left I can never remember him being permitted to take a drink. He never came home with liquor on his breath; Mother had him pretty well throttled.

ELIZABETH POLLOCK: Stella, the motivating force, told me how exasperating Roy was when they had to go someplace. She would wait in the wagon after making him go and change his clothes like a little boy; or when the boys were going out too and she had them cleaned up, his clothes would be soiled from the barn all over again—just another little boy to take care of.

I don't think Roy could talk about anything important even to Stella. He became a nonentity—simply was not considered, didn't count. This was a failed man, but Stella never complained; the Pollocks are incapable of criticizing each other.

FRANK POLLOCK: My dad was proud of his livestock operation. He liked what he was doing—his boys were giving him a hand—and he loved animals. I would say animals liked him; he was very kind to them.

JAY POLLOCK: When we'd get in disagreements, he would say, "Put the boxing gloves on and fight it out." We didn't want to fight, but we did. I think it helped me, for I became a good athlete for my size. I even used to box with my father, really rough it up in my terms. Then we lost the gloves, or something happened to them, and we'd box with open hands. I was a pretty tough little guy—I think.

FRANK POLLOCK: As to my dad's temper, once he accused us—Sande, Jack and me—of letting the few sheep we had into the barn where the hay was. We had nothing to do with letting them in, but he knocked out the staves of a broken barrel and selected one. Then he

lined the three of us up and gave us a good licking. Of course, we went to Mother, screaming and crying. She wouldn't tolerate abuse of her children, and to my knowledge she really gave it to him. That didn't help the relationship for the next few days.

CHARLES POLLOCK: My father was a very sensitive man, sensitive to human relations. In a country which could hardly tolerate the sight of blacks, Orientals, or Latins, my parents had warm relations with all of them, especially the Mexicans and Japanese. They were ethical and moral but not church-minded. I never saw a Bible at home.

FRANK POLLOCK: My dad wouldn't permit our being baptized, though I remember a head of Christ on the wall at Phoenix. I assume Mother wished to have us baptized, since we were. I don't know why he was so opposed, unless it was because of his foster mother; he may have rebelled against that religious fanatic. My dad wasn't the kind of man to mislead his boys, to have them think he knew all the answers. So when my mother asked him if there was a god, his reply was that he didn't know. Another thing he was against was circumcision; none of us were circumcised.

JAY POLLOCK: I remember having to go to church a few times in Cody, probably when *she,* Dad's foster mother, stayed with us. That religious fanatic turned us against church-going: You couldn't do a damned thing; on Sundays you couldn't play baseball, for Christ's sake!

I think growing up in the West has something to do with our attitudes toward life: living on a farm—a ranch, we called it. Charles and I were a pair; Frank and Sande were close at one time, but then Sande and Jack were.

FRANK POLLOCK: Those two kids were the closest I've ever seen: They played together, ate together, slept together. But the taking care of the other was by Sande of Jack; it was never the other way around. Jack never could take care of himself. And Sande was assertive, came from Mother all right.

JAY POLLOCK: The better part of the older boys' education came from associating with and listening to stories of characters like Rattlesnake Bill and Mossy Bill, living in the wide open spaces. There time didn't mean very much and your spiritual life came direct and without words. It was where you could see and feel human nature as a whole.

The adobe house on the twenty-acre farm near Phoenix didn't have enough bedrooms for seven people, so for months the older boys slept out in the open.

CHARLES POLLOCK: In the growing season we took produce in the wagon to the big market at Phoenix and if we were lucky the stuff got sold. But when there was a glut on the market it didn't, and I remember my father going to restaurants trying to peddle the stuff. He couldn't do it easily; it was humiliating for him.

FRANK POLLOCK: Our house was dominated by Mother's kitchen and, my god, we certainly had plenty of food! I don't remember conversations of any kind at table, just "Pass the whatever." My dad felt obligated to feed and water the stock before he ate, morning and night.

We each had a job except for Jackson, who was too young—and Mother's baby. He never had to milk a cow and do chores and I'm not sure he ever rode a horse. As a child he wasn't a cut-up, but I suspect my dad didn't think he would amount to much. Not even Mother thought Jack would be a painter; my god, it's ridiculous! He wasn't a craftsman in any sense of the word.

My dad and mother didn't favor any of us that we were aware of, but I remember her saying of Jack, "He's my baby. There are no more babies, this is it. Jack's my baby." And really, he wasn't influenced by his father; he was influenced by his mother. She was certainly very fond of Jack.

ELIZABETH POLLOCK: Stella saw all her sons as potential geniuses, wanted them to be artists of some kind. She saw in Charles proclivities toward art because when she sewed he would handle the materials; or he might become a musician because he put his ear next to the sewing machine to listen to its vibrations. But Jackson was the one she adored; she never saw him as any kind of cripple and in later years she was always longing for him. I was infuriated by her adoration of him.

JAY POLLOCK: A relationship was found to take care of and help Jack: Sande. I think he had this responsibility because he was closest to him.

FRANK POLLOCK: Charles, he thought he was going to be a great painter. And he was an artist from the very beginning, his drawing very able. At twelve or thirteen he would ride away for formal instruction once a week, and he was always drawing. My dad thought he ought to be on the farm more, but Mother would say, "He's entitled to it."

CHARLES POLLOCK: It began, my interest in the visual—certainly in calligraphy—by discovering at age seven an abandoned schoolhouse near us in Cody. The floor was covered with foolscap sheets of Palmer writing exercises and I found the pattern beautiful.

I'd never been in an art museum or gallery and we had no art books at home—we had a few magazines, such as *Country Gentleman* and *Ladies' Home Journal.* I see my mother communicating a sense of quality, craftsmanship. I believe Jack got his sensitivity from his father and his sense of *matière* from his mother.

JAY POLLOCK: Our artistic side, Charles says, came from her. I don't see any evidence of that, aside from the fact she was a good seamstress and made quilts, that sort of thing.

JASON McCOY (Sande's son): I think saying any artistic heritage came from Stella is bullshit. It doesn't make sense, and for a source you look to the oldest brother, Charles. His interest was more intense in what was happening in the West—socially, politically and with the Mexican realists.

FRANK POLLOCK: Mother took care of Sande when he was kicked by one of the horses. For days he couldn't walk and it was a month or two before he didn't have to use the sluice as a kind of crutch coming into the kitchen door. And when I cut my elbow with a broken bottle—it was a bloody mess—I never saw a doctor, either. She dressed it and all, but there's a scar. Later, when Jack lost a fingertip—he put his finger on a stump to show a friend where to strike his ax, and the boy did exactly as he was told—whole nail and things gone, she took care of him and *he* never saw a doctor.

Slaughtering was a distasteful business. In Phoenix Mother would wring a chicken's neck or tie the bird to a clothesline by the feet, then grab the head and cut the neck. I made a frightful job of chopping a chicken's head off—awful. Hogs my father killed by rifle shot, the only killing he did.

Mother loved driving her team and wagon, but something must have frightened the horses in Phoenix, still a country town, and they took off. It seems to me she was thrown out, the wagon turned over and she got bruised—nothing more than that. There was immediate help from the street and she drove the team home.

JAY POLLOCK: Something happened to the horses—shaft fell down maybe—and we were left stranded but finally got back. I was there and Jack was there but pretty young.

After Jackson was a resident of East Hampton, he told an Amagansett friend, Roger Wilcox, of a runaway when he was five years old, though to Jay the story doesn't ring true.

ROGER WILCOX: He told me he was going into town with his mother taking produce in a wagon. A bull was running across a field near the road and frightened the horse. The horse ran and the wagon upset. He said he was crying and a man on horseback chased the bull away, then came over and picked Jackson up. He said, "What's the matter with you, crying when your mother may be hurt and you're lying there!" He slapped him very hard; Jackson said he was terrified. The man helped put the wagon upright and so forth. They didn't go on into town but back home.

The Phoenix farm provided a living, but Charles was aware of parental arguments and Frank of such friction it was to mean the end of their life there.

FRANK POLLOCK: Mother was instrumental in carting us off to California; she thought the schools would be better for her boys coming along now to high school age. You see, she was a purposeful woman, my mother: "It's either this or you can go down the road." She had a lot of power, her own and that of the love of her boys. She told us to get all the education we could. "They can't take that away from you," she said. Sande told me that he didn't learn much in school and Jack didn't learn anything.

JAY POLLOCK: I didn't finish grammar school or ninth grade; I wanted to get out in the world. My father wasn't so strong about getting an education, but it bothered my mother. Even so, we seemed to take off whenever we wanted.

CHARLES POLLOCK: I quit because I was bored and not sure I was doing well. Jay and I boarded with "Uncle" Frank, who had a second-hand store at Chico, for two years, but with all that moving around I was fed up. I borrowed some money and went to Otis Art Institute while working at the *Los Angeles Times* there in 1922.

The farm was auctioned off with the stock in 1917, after Roy had spent four years building it up.

FRANK POLLOCK: I think of my dad's life being ended when he left Arizona. He was a beaten man in Chico, California. What I consider happened to him and his relationship with his family is that he ended up on a twenty-acre ranch with almonds, prunes, peaches and apricots, but he was not a fruit-growing person. He was a husbandman and that's very different. He lost his contact with the animals he loved, and he lost the closeness of his family.

He was forty-three years old then and really over his head for a while. In that strange new life my dad had to learn how to prune trees, harvest

fruit, how to treat the harvest. And times were not good then; there was a terrible depression after the First War and no market for crops. I don't know how many mortgages he piled up, but two weren't enough. And it turned out there was a strip of black alkali through the middle of the Chico place, which was a significant loss and maybe why he gave up and moved to Lassen, northern California.

They took over a hotel there in 1923—two stories and a bar. Mother would run the kitchen for the few people who might pass through, maybe take a bedroom. They were grasping at straws, really. My mother put her foot down about hard liquor being served, although bootleggers were everywhere. There was just soda pop and a few cowboys dancing to an accordion. And when Dad's foster mother came from Arkansas to visit, my mother said, "We got to get that word BAR off the front window and door."

The friction between Mother and my dad—their life was never the same after he was uprooted from his holding in Arizona. Charles said he didn't have any business sense, but I'm not in a position to confirm that. I do know that his holdings diminished in trades and selling outs.

CHARLES POLLOCK: He was looking for opportunity—a disappointed man. They moved so many times.

FRANK POLLOCK: The hotel was less and less of a way to make a living, and ultimately my dad disappeared. I shouldn't use the word "disappear"; he had to make a living, so he got a job on a state survey team, later a federal one. . . . Well, he left but always sent the money; Mother always got the checks and she ran the whole shebang.

The hotel was traded for another twenty-acre farm, this one at Orland down in the Sacramento Valley. My dad was never on that farm, being out on a survey team for eighteen months during which we never saw him. It was the last farm we had, and though only ten, I was the oldest hand on that place. When it went, we moved back near Phoenix, where my mother worked as housekeeper for a widower who had cows. My dad was still away, and although I milked the cows all right, instead of going to high school I used to shoot pool. My mother didn't know, but one day Sande came running and said the truant officer was looking for me. I said to Sande, "I quit school." He said, "Me, too." So we went home and confessed to Mother. There was talk of a job up on the rim above the Roosevelt Dam where my dad was with a survey gang, and we had a terrible time getting our old Studebaker that had been part of a land swap up there. Like everything else, it was diminished; we were down to nothing, you see.

Jackson was a sixth grader at Munroe Elementary School in Phoenix when he and Sande explored the nearby areas of desert and small settle-

ments. Stella moved what was left of the family to Riverside in 1925, and soon the youngest boys were in high school there. Charles moved to New York a year later to study under Thomas Hart Benton, a leader of the Regionalist School who would later say of his Paris exposure that "It took me ten years to get rid of that modernist dirt."

Stella was delighted that Frank was elected president of his sophomore class and won a national school paper contest, but another activity Frank kept to himself.

FRANK POLLOCK: It was when I was about fourteen in Arizona that I started drinking "white mule," called that for its kick. My friends and I would drive out into the desert at night to a tent where they bottled the stuff for a buck and within an hour I'd be deadly sick. It didn't stop me though, and in Riverside I bought jugs of wine by the gallon to drink by myself.

One night there a classmate came pounding on the door and said that Jack was down in such and such a place and making a bit of a noise— he'd been drinking. I went with him to this little dark bar with stools, and Jack had had a few, all right. Where he got them I don't know but it wasn't there—wasn't permitted for such a young kid. As to what he'd been drinking, it could have been beer.

Jack was sort of trying to give me the brush-off, but with a big smile hollering "Get out of my way, doing no harm." He was pretty damned young. We'd had drinks together in California with a friend of my dad, but my dad didn't know. And when Jay was visiting for a day or two with a Chevrolet coupe, we—Jackson and I—took off with him for Los Angeles, drinking. Well, Jay was a man then and we were just kids; I don't think we ever got there.

You know, Sande drank, I drank, Charles drank, we all drank. Mother had to know some of the time, but she didn't seem to have much influence on us, even if she had throttled my dad.

The behavioral problems Jackson began having in school were serious enough for Roy to write him on December 11, 1927, offering advice and apologies for not being able to do more, as well as communicating his own sense of failure.

FRANK POLLOCK: Jack was having a hard time staying in school and wouldn't confide what was in his mind. I don't know—here were his brothers being active, seemingly accomplishing something, yet one just isn't doing anything—didn't even have a girl. I sometimes wonder if the marriage hadn't broken up if . . . but we didn't seem to mind my dad being away. Mother was never upset; you have to give credit to her.

ELIZABETH POLLOCK: Jackson caused her grief by being in trou-

ble at school, but she wouldn't criticize him and always found a rationale to explain it. She not only gave her boys all, she said in effect you can do anything you want with me—*use* me. She had no discipline over Jackson and he—he had contempt for her, this strong-willed woman, and he took advantage of her. He was suckering her, and there is no prettier word for that.

Among other problems at Riverside High School, Jackson got into a dispute about ROTC that gave him and the school an excuse for a parting of the ways. In the spring of 1928 there was the final family move: to Los Angeles, so that Jackson could attend Manual Arts High School there. He enrolled in the fall and used, for reasons no one is clear about, the name Hugo.

ALMA POLLOCK: Jack was a very good-looking boy then, but as a kid sister of his friend Don, I wasn't impressed. He had very little to say, just an uncommunicative person and sort of in the background. But Phil Goldstein—Philip Guston—talked a lot and made a much better impression. I remember that Jack was explosive; you never knew exactly what he might do. Mother was a little dubious about Don going out at night with them because of that; I think they must have drunk a bit or she wouldn't have been so nervous about Don—that, and once in a while Jack would break loose.

Alma's brother, Don Brown, was in Manual Arts with Jackson, as was Manuel Jerair Tolegian, who would become an even closer friend.

MANUEL TOLEGIAN: As an Armenian, I come from a pretty strict Christian background, but, as you know, his mother tolerated smoking and drinking—smoking particularly—when he was about thirteen; there was nothing like that in our house. She was pretty strong but left us alone; and I thought that was great.

At school he was a rebel, couldn't conform. He would come with long hair and surveyor's boots, which was very unusual. It scared off the girls, not that he cared; he did see one for a while, Bertha Pacifico, but it didn't amount to much. He made a big effort trying to draw in class, trying to be conventional, you know, but just couldn't make the grade. Not everybody was nice to Jackson, but he had a special charm. I always thought in his own mind he was sort of an orphan.

We were his close friends, Philip Guston and two brothers by the name of Lehman who were interested in sculpting. The Manual Arts School had 4,500 students and no one had time for us except Schwanny—Frederick John de St. Vrain Schwankovsky. He was a rebel, too, the first one there to have nude models. It was he who got us all started in

abstract art—an outstanding teacher. Schwanny was a founder of the Laguna Arts Colony, where his wife taught music, and he would take students there. He was interested in yoga also, and would get Krishnamurti to talk to students on Saturdays. Jackson was fascinated by this, but for some of us the whole thing was knocked to smithereens. We were there once in Laguna, fifty-five miles from L.A., and on leaving Krishnamurti told us that before we got to the city limits he'd be at the Embassy Hotel. Well, we drove back much faster than we had come but he wasn't there!

Jackson's inevitable confrontation with authority at Manual Arts took the form of a couple of manifestos called the *Journal of Liberty,* written and circulated with other reform-minded students. The first attacked the faculty, the second the school athletes, some of whom cut Jackson's hair.

MANUEL TOLEGIAN: We had formed a group to have the things printed, and we distributed it to all the classrooms at five-thirty or so in the morning. A janitor noticed one of us running with something, but they didn't catch me or the other guys. The guy they caught was Pollock. The following day three or four men came into Schwanny's class and there we were all sitting, not saying a word. They put the finger on Pollock for bearing the revolutionary paper, and he was expelled. This guy took the blame for all of us! I wanted to graduate, so he was a lifelong friend after that. And Schwanny, you could say, was a lifelong influence on us with his mysticism and yoga, but I didn't go in for extremes and reading *The Dial* and metaphysical works like Pollock was then trying to.

Philip Guston, who was a member of the manifesto group, kept telling his friend Reuben Kadish that he had to meet Jackson.

REUBEN KADISH: We organized a demonstration at my high school against the ROTC and the Marines being in Nicaragua, and the papers carried headlines about a Communist conspiracy and I was kicked out. Jackson called me and we had a long conversation. Then I met Phil Guston. "Wait'll you meet Jack," he said. "That's the guy, that's the guy!" But Jackson and I didn't meet until he came home from his first winter in New York.

Schwanny managed to have Jackson reinstated in Manual by explaining that his student had no intention of graduating but a strong interest in art and that he, Schwanny, would keep an eye on him. But in that fall of 1929, Jackson got into trouble at school again. He wrote Charles and Frank that he and the head of the physical education department had

come to blows and that they thought he was "a rotten rebel from Russia." And in January 1930, he wrote Charles that he wanted to be "an artist of some kind." For the spring term Schwanny managed to have him admitted again, though only for courses in clay modeling and drawing on a part-time basis. This time Jackson kept out of trouble; in the interim, Stella had talked to the principal.

Charles came home that summer and took Jackson to see the new mural by José Clemente Orozco at Pomona College in Claremont, among other expeditions. It was Charles who first attracted Sande and Jackson to art, partly by sending them magazines from Los Angeles, and Philip Guston with Schwanny confirmed it. In addition, to their encouragement, Charles paved the way for his brothers' careers: Jay was helped to join the *Los Angeles Times* rotogravure department, Sande its plate-making department, and Frank followed Charles to New York, where he got a night job at the Columbia Law Library under the brother of Rita Benton, Thomas Hart Benton's wife.

CHARLES POLLOCK: Our father was an influence on all of us but less on Jack. Jay is a rotogravure etcher, in Frank there is a fierce desire to do well and Sande, an aspiring painter who had to go to work to support his family as well as Jackson for a while and later our mother in part, was a craftsman in his silk screening. Not only that, some of his paintings are as good as any of ours. And Jack, even though he drank and could behave badly, had dignity.

SYLVIA POLLOCK: The Pollock brothers were brought up to love and respect their father. They were all serious and sensitive, with a singleness of purpose and a fierce desire to do things well. They were high-minded, what I would call refined, and to get high-minded farmboys out of that time is pretty special. I see it as an outgrowth of Puritanism; they're Stoics, and the place they were from cannot explain it.

I've never not been struck by these brothers and the way they walk, the way they talk, by the way they are determined. There is nothing ordinary about them; in fact I'm sure there's never been a family like them. But Jackson, the driven one and the troubled one, was the more talented one.

NEW YORK: THE STRANGER

Jackson's trip to New York with Frank and Charles in September of 1930 was made in the 1924 Buick touring car Frank and Charles had bought in New York for ninety dollars and driven out to California.

CHARLES POLLOCK: It was me and Frank who urged Jack to return with us to New York. Since I was studying at the Art Students League with Benton, it was assumed that Jack would do the same. On the way east I suggested he use the name Jackson instead of Paul.

Charles himself had been accepted as a student "on faith, without samples of my work" and on the recommendation of friends at the Otis Art Institute. Frank was certain the Bentons would welcome his brother Jackson.

FRANK POLLOCK: When I landed in the fall of 1928, I didn't have enough money to pay for the cab. I ran upstairs to the Bentons' apartment on Eighth Avenue, where Charles lived a couple of floors down, and I borrowed the money from them although they were about as poor as Charles. Rita took care of the Pollocks, see; she really loved us all.

CHARLES POLLOCK: I was almost a member of the family and took over the job of babysitting for their year-and-a-half son, T.P. Tom Benton was a genial, very dynamic person and Rita had been a student of Tom's; he had just begun teaching at the Art Students League, and I was one of his first students. Rita was a tremendously warm Italian woman.

FRANK POLLOCK: Rita thought Charles was going to go beyond Benton. That was in representational art, of course; I never heard of abstract art in those days.

CHARLES POLLOCK: The flair that Jack generated struck Rita very forcibly because of her Italian temperament. He was a handsome young man, flattered by their attention, and I know they saw a hell of a lot more promise in Jack than in me.

SYLVIA POLLOCK: Jackson as a brother has been more handicap than help to Charles and I think Charles ought to be jealous. Being known as Pollock's oldest brother is part of Charles's life as man and painter, but I am touched by his pride in always saying, "Yes, that's my brother Jack."

ELIZABETH POLLOCK: Charles adored Jackson; he always had a protective, loving attitude toward him. The fact that he was ten years old when Jackson was born and took care of him physically has influenced his attitude toward him. Charles is incapable of jealousy. I have a feeling that long after we're dead, Charles is the one who's going to be seen as the great artist of his time.

Nor are Frank and Jay envious, Frank because to him the family has lived normally, without fame; Jay because he's not impressed with Jackson's work. He once received a postcard of one of Jackson's abstractions.

JAY POLLOCK: I forget the name of it. You couldn't tell which end is which. If you're not used to this kind of painting, you begin to wonder what the hell it is.

ELIZABETH POLLOCK: Jackson was very handsome, a headful of hair and the only tall Pollock. He had beautiful teeth, almost like a movie actor, and a full smile in those days—and he was charming, ingratiatingly delightful. He was so happy to have been rescued from his misery out west; there he was seen as a delinquent, a born troublemaker. But now everybody was falling all over him, and going to homes of important people like the Bentons made him very happy. He never struck me as sexually attractive, though; he was cold.

All four brothers acted toward Jackson as if he had been a disabled child—one leg shorter than the other, or a withered arm, or an impediment in his speech. All of them recognized that there was a flaw in him of some kind and that he needed protection.

CHARLES POLLOCK: Jack first shared 42 Union Square with me, the top floor Benton vacated when he moved to 8th Street. Jack took

New York in his stride, but he was impressed by the museums and galleries with so many European artists being shown; it was part of his education.

At the Art Students League, Jackson took classes with Benton in painting and composition five nights a week, as well as a class in drawing from the figure. There was a relaxed atmosphere at the League, although Benton (who gave criticism twice a week) demanded work, and tuition was $12.50 a month. Jackson, now nineteen, still had enough of the kid left in him for a lot of posturing. He wasn't always taken seriously either at the League or at Greenwich House, a tuition-free charitable organization where he attended classes occasionally.

CHARLES POLLOCK: The Benton class was of ten or twelve students and was not a painting class with color discussion, but concerned with questions of line and space. Tom worked by criticism, pointing out things in your drawings and giving examples and analyses of Renaissance work. For Jack he was a force in the nature of things he had to oppose, but Jack got a hell of a lot more than that from Tom—such elements as relationship and structure of things, which he later took over and transferred into his own idiom.

Jack's draftsmanship didn't have the flair some students had in drawing from the figure—you don't think of that early self-portrait of his in terms of draftsmanship—but painterly, yes. And in the analyses Jack made, it wasn't the single line but a group of lines that was important.

MANUEL TOLEGIAN: Charles had said, "You got to go to New York to paint," and when I arrived a couple of months after Pollock I slept on their floor. Then I got to be monitor for Benton's class; he was a drinker, and Pollock took him as a role model, macho and all. We all drank a bit, but Pollock couldn't take alcohol. Benton was tolerant about Pollock's effort to draw—all the teachers were tolerant, friendly, at the League except for John Sloan—and he felt sorry for him. Pollock tried but he just could not do realistic forms, couldn't cut the mustard.

CHARLES POLLOCK: Benton was a four-square drinker, but he was never out cold, contentious or violent. He was highly intelligent, well read in certain areas and wrote highly competent prose articles in the early twenties. He had studied in Paris at the Académie Julian for several years.

ELIZABETH POLLOCK: Jackson was given all the advantages associated with the Bentons, and for the first few months seemed an accommodating and charming young man. Women were attracted to him and all he had to do was to be responsive, but he was inarticulate.

I think one of the most harmful things that happened to him was being taken up by the Bentons. Because they needed babysitters, he was brought in and shared their social life as if he had earned it, this callow youth who had done nothing but rebel against his background. But I was always ill at ease with Benton because he was such a cold person—a very small man and feisty like a bulldog. He was what I call "juiced," the kind of person who sips at something all day long; it made him gruff.

GEORGE MCNEIL: Jackson was very macho from the beginning, drinking being the big thing. Behavior at the League could be pretty far out; you could be drunk in the lunchroom, loud, all kinds of things; and there were Saturday night bouts at 125th Street in Harlem. I remember the folds in his face and the way he *felt* big—strong and tough. He came on like a big guy, and his walk seemed a kind of shuffle—a wobbling walk, not direct.

Yet he was shy, hated crowds, would go to the rooms with no one in them at shows and didn't like openings. He wasn't a joiner and he wasn't interested in politics. There was always emptiness about Jackson, like living in an abyss; you could feel it in the way he talked, in the way he looked. It was as if he came from nowhere and felt from nowhere.

REGGIE WILSON: It was startling in those days to see a fresh youngster at the League in high-laced boots. He had a habit of rolling his eyes away from you, and he'd give you a quick look sometimes as if to see whether he'd punch you in the nose or not.

HERMAN CHERRY: It is my feeling that without Joe Meert—Benton called him his most promising student—and his wife Margaret, with whom I shared an apartment, Jackson's life would have been shortened. Many times late at night I would hear Jackson bellowing beneath my window like a wounded beast for them to take him in. When he was desperate, torn by his conflicts and too drunk to be of any use, he would head for the Meerts' for succor.

JOSEPH MEERT: Jack could be pretty wild and because I was a good friend, he would come to me when he was upset. "Help me, Joe," he'd call from the sidewalk, "Joe, let me in—help me."

CHARLES POLLOCK: At first in New York I wasn't aware that Jack was drinking, but at a party of young people, and several times after that, he was rather drunk. As an older brother, I did my best to take care of him. If he had not been a painter, in one way or another Jack would have thrown his life away.

• • •

It was through Benton that Charles started teaching art at the City and Country School in Greenwich Village that winter. One of the first progressive schools, it was run by Caroline Pratt. She and her friend Helen Marot, who was involved in psychology, were close to the Bentons. Charles's duties were not onerous, and the two women took an interest in Jackson, particularly Helen. According to Tolegian, Jackson was employed as part-time janitor at the school for fifteen dollars per week. His League tuition was paid by working in the cafeteria.

MANUEL TOLEGIAN: Although we were still kids in a way, Pollock and I were pretty good workers around the League and for the Bentons whenever they needed cleaning work. We carried down garbage cans from the cafeteria every day, mopped floors, cleaned tables, washed dishes. Some artists made fun of us for lending ourselves to such work when we were supposed to be studying art. One of them was another Armenian, Arshile Gorky, a great big guy and pretty nice-looking, mustache and airs. But all he did at the League was sit in the cafeteria lunchroom and entertain the women.

The Bentons felt sorry for Jackson—he was really trying very earnestly to get there and whatever he had to do, he'd do it. He didn't fool around in class, but the alcohol made it kind of miserable; how can you see things and paint properly with that going on? Benton tried his damnedest to work with Pollock, and he was very happy that Pollock was babysitting because Benton worked at home and could personally instruct him. I remember Benton making corrections on Pollock's works. It may have been one of those that years afterward when Benton was looking at a new book of Pollock illustrations made him suddenly shout, "I did that! That's not Pollock's work."

You'd think they would have been worried about having a guy so undependable around all the time. Of course, the real violence came a little later, and Mrs. Benton always kind of mothered him. Pollock behaved himself around Benton, had great respect for him. But he was very scared of color, really was, and Benton himself had no color sense.

GEORGE MCNEIL: I studied with Jan Matulka at the League for a couple of years and Benton was a dirty name. It's absolutely astounding that Pollock ever came to anything out of that; I don't think anyone else well known did. Everything that was negative—American small-mindedness—was there, yet the art positives were coming from Internationalism. It was a very backward tendency. With Pollock I had the feeling that the bad influences negated each other—like Surrealism, and Mexican painting also. Yet, like a devil's brew, all the bad influences worked out well.

But he fit in well with Benton and his nationalistic beliefs, with others always being either Communists or pansies. There was a rhythm, a flow, between them from the beginning to the end of their lives. It was a physical, gestural rhythm; teacher and student were *bonded,* you might say.

I liked Benton. He was a tough, small, scrappy guy and he came from tough people. He was more tough really than macho, which is a difference between him and Pollock. But when I heard Benton speak of Paris—"There are no artists there—none at all"—I thought, what is this man saying? Picasso is there, Matisse, Braque, all the great figures! After that I couldn't talk to him.

PHILIP PAVIA: Jackson had a high opinion of himself, but he got that from Benton. *There* was a macho bastard! Benton called curators homosexuals, you know; they were all scared of him. And Jackson used to act like him; he really thought we were a bunch of Jews and wops and all that. Here's Benton's babysitter become the same guy! We used to laugh.

Jackson was dead serious, though, drawing Leonardo da Vinci. I'd say, "You and all that wop culture!" I was with Picasso, thought he was the greatest, but Jackson didn't like Picasso then too much. I'd say, "You and your wop Leonardo—why don't you leave him alone?" Benton and all those Leonardo poses—poor Jackson was all wrapped up in wop culture then.

When Stuart Davis was teaching at the League, Arshile Gorky would come to see him. When you went in that lunchroom and Gorky was there, he took over the scene. He had color, was the brightest guy, and Jackson was quiet around him. Gorky had an influence on all of us without teaching us, though he did teach. He was the interest around the League, not Jackson—that Gorky, he was the best. I tell you, he *impressed* Jackson!

EDITH SYMONDS: Tom was very impressed by Pollock, whom I remember as being very thin and very threadbare. He was not just another boy but terribly intense—and terribly poor. Benton got his friends Caroline Pratt and Helen Marot, who had a floor-through apartment on West 11th Street, to show some of Pollock's work there for someone big in the arts to see. Pollock was *so* hoping for promotion, and it was a sunny day with good light, but all the paintings he brought out looked exactly like Bentons.

MERVIN JULES: Benton trained us to develop sketches into paintings, scaling them up from the ones he had, and he would put transparent paper over to indicate flat areas. He also had maquettes which he

used to light and paint tonally to get the effect he wanted for teaching. He emphasized that you have to learn the relationship between the bump and the hollow, then you have the whole thing.

His drinking was never evident in class, but he would blast the women, using vulgar language, so that they would dwindle away by the end of the month. Then to keep Benton on as our teacher we'd have to browbeat new ones into joining the class—sometimes people we knew wouldn't last more than a week with this treatment. He and I broke up over his portrayal of the Negroes in the mural he did for the Whitney. There was a basic antihumanist approach that was reflected in all his people. But he gave the Regionalist School, with people like Grant Wood and John Steuart Curry, voice.

EDITH SYMONDS: Benton didn't think women should be painters; he would look at the work of a dear friend with whom I painted and tell her to go down and draw a skeleton. I felt he put on this hard-boiled, rough-fellow manner the way an artist puts on a cape so he'd seem a hillbilly. In class his "bumps and hollows" were good training and I did learn, as when he'd analyze classical reproductions. And I learned about frescoes and egg tempera, but he never said my work was any good. He'd say, "That's okay. Now do this next time." He didn't give a damn about people.

WHITNEY DARROW, JR.: Pollock and other Benton students would make models out of plasticine, squares and cubes, with focused light to bring out the angles—very helpful. Pollock would make clay models, too, paint them black and white, for Benton to analyze, swirling things with interesting curves and forces.

REGGIE WILSON: Benton would come in once or twice a week and was rigorous about drawing the figure—draw, draw, draw—*his* way. Charles was very good at this, but when I came in with a summer's work from back in Ohio, with forty or fifty watercolors, he said, "Well, these are pretty good, but they're not what I would have suggested you should be doing, so there is nothing I can say about them."

Tom was the kind of teacher who wasn't very interested in you unless you did things exactly the way he thought they should be done. This was fairly easy for Jack, because he was very impressed by Benton and they had a closer personal relationship. But I felt color was the dynamic element and Jack didn't have this; he didn't care about it and this was Benton's influence.

Monday nights were hillbilly music playing nights at the Bentons' and because Jackson couldn't learn the harmonica, Tolegian taught him the Jew's harp.

PETER BUSA: I was getting worried in class because Benton never gave my work criticism. I asked Jackson, who said there wasn't any until after a month. I told him I'd been there for six weeks already. He said, "You wait. When he comes through that door, he'll be right over to you." And Benton did, only calling me Tony—I guess I looked Italian—"Hey, Tony, you play the harmonica?" I said no and he just walked away. He was only interested in the guys playing at his home, and I never did get criticism.

CHARLES POLLOCK: Jack would get pretty agitated. He broke up a violin because he couldn't play it; I suppose he got into it because of Benton's music nights. And he would get in a rage with his work—hack at it, tear it up. I tried to salvage some and thought I had, but it has all disappeared.

As to what he thought of my work when he was with Elizabeth and me, I have no idea. They were constipated things of trucks and machinery; later I was doing typical social realism. Jack and I didn't talk about our work, and I would have been the most likely member of the family. But what is there to say? You've done it, there it is—what else?

June meant the end of Jackson's first try at life in New York, a fairly successful one. In addition to having joined the world of the Bentons, he had been exposed to mural work at the New School for Social Research. Both Orozco and Benton had commissions there, the latter's being the ten-panel *America Today* recently sold by the school and restored. Jackson not only posed as a hillbilly harmonica player for the mural; he and Tolegian helped to install it, along with the one Benton did for the Whitney Museum (later he would watch Diego Rivera work on his controversial Rockefeller Center mural, which was destroyed as Communist propaganda). Near the end of the month, Jackson and Tolegian hitchhiked across the country, urged by Benton to sketch as they traveled.

MANUEL TOLEGIAN: We only had a few dollars, having planned on doing jobs along the way. But this was the Depression; nobody could give us rides so we took freights, hoboing it, and slept under railroad cars on sidings. At Indianapolis we misjudged the speed of a freight and almost got killed. We started running for it and Pollock was yelling at me to run faster. I yelled I couldn't, just couldn't grab the step. I'll be damned if he didn't do it, just one finger holding on. Beyond Indiana— Ohio, I think—we met again. I was trying to hitch a ride out in the sticks when all of a sudden a car comes by and stops. Here's Pollock sitting in it with this guy. I got in and the fellow said, "You see this gat here?" He pulls it out and scares the hell out of us. Then he says, "I want you kids to know this is a stolen car but everything's going to be all right."

• • •

The trip took Jackson three weeks, and he found Jay working as a laborer on a road construction gang under Roy at Big Pines. The landscape was all that Benton said it was, and so were the jails although Jackson's version of how many nights he spent in them varied.

MARIE POLLOCK: I liked Jack so much I gave him my knapsack and a bag of Bull Durham for the trip; he used to keep a bag in his back pocket. Jack was very attractive, with a beautiful smile and three dimples. He got by without having to really work—no nose to the grindstone for him—because he charmed everyone.

The major event of his California visit was finally meeting Reuben Kadish, who remembers Stella's dinner table laden with mason jars of sprouting grain.

REUBEN KADISH: Everybody ate this stuff. Jack's mother, who would go along with any kooky ideas the kids had, was damn important to him. When the father—he was away a lot—would come home on Saturdays the two of them might retire to the bedroom, disappear for two or three hours, and we'd chortle about it.
 Jack had a way of making magic out of things: When he saw something interesting, it was created strictly for him as an artist. There was a big boulder in the river not far from their Morningside Drive house in L.A., and it took on a lot of importance; the shape appealed to him. It was a job getting it out of the river and up the bank, but we got it into the car finally. Then we took it to their backyard and it sat there. He was entranced by it, and each time he came back he thought he would do something with it.

ARLOIE CONAWAY MCCOY: They—Phil Guston, Reuben Kadish and Tolegian—made a sort of studio out back. There were pencil sketches on the walls and beautiful copies of old masters. They would turn the works upside down to discuss composition; they were so *serious* and intense about art. It was thrilling.

MANUEL TOLEGIAN: We were interested in sculpture too, and Pollock would bring stones and things to my backyard. He was limited, but it was a genuine interest. Also, it was a way of testing himself.
 I learned about Pollock's relationship with his father that summer, and it was the most unfatherly one I ever experienced. We were cutting wood—sawing logs, not cutting timber like lumberjacks—on a mountainside at Santa Ynez, California, not far from where his father was working on a road job. He was a quiet, one-word, one-sentence man—a

frightened man and a stranger to his family. I would say he was a depressed person. He wasn't a drinker then that I know of, but I'd heard that when Pollock was only ten or eleven years old he took him up to one of the work camps. There, on Saturday nights, the men got a kick out of feeding this little guy whiskey and watching him dance. The thing that amazes me most is a father letting it happen.

That summer was the first time Pollock was going to kill me. Sawing wood by hand is hard work, and each night we'd take the long two-man saw down the 7,000-foot mountain to sharpen it. This one day I guess he thought I hadn't been pulling it right; it was in the car between us as I drove down the mountain. With no warning, Pollock grabbed the saw and pushed it hard against my throat. If I hadn't steered into the side of the mountain, we'd have been 2,000 feet off the other side. And dead.

I thought of those Saturday nights when Pollock was so young and drinking for the men in work camps. Then it dawned on me that maybe this man was not right—that this man had mental damage.

Before leaving for New York in October, Jackson wrote Charles that neither he nor Tolegian had done much drawing, although Sande did some interesting watercolors, and that their father "thinks I'm just a bum—while Mother still holds the old love."

MARIE POLLOCK: Jack was Stella's pet. The sun rose and set with him.

For the winter of 1931–32, Jackson registered at the Art Students League for Benton's course in mural work and became class monitor. Benton gave Jackson further Renaissance exposure and arranged a partial tuition grant for him. Although Jackson gave his address as 49 East 10th Street, he moved with Charles from Union Square to 47 Horatio Street and they took meals with Elizabeth. According to Reuben Kadish, who came to New York in the fall of 1931, dealers in painting materials often carried Jackson on credit.

REUBEN KADISH: They had confidence that sooner or later his work would make it; this guy Pollock had a lot on the ball. He got from Benton the sense of the artists' community and his joining it was professionalism. We used to go once a week to galleries and museums; at the Frick Library we'd look at reproductions and at the Metropolitan we'd go down into the department of drawings. Jackson was dedicated to the big time, so to speak; he wasn't going to be a small person in that community.

REGGIE WILSON: He was not a pesky person in the early years but reticent—very quiet and shy. But his shyness wasn't a problem in being a

monitor, the function of which was just being there and seeing that things were taken care of. I always thought that Jack was talented, but I felt he was limited by the direction he was going with Benton. That analysis of rather Baroque painters of the Italian school extended in a strange kind of way into Jack's early work.

WHITNEY DARROW: Jackson was a good monitor, composing models to facilitate the El Greco techniques of using "the hollows and the bumps." This required him occasionally to touch a model to arrange the tactile quality. When he wasn't drinking, he was sweet, gentle and kind. When he was, he was terrible—belligerent and hostile.

MARIE POLLOCK: One evening we brought a friend to Charles's studio, where Jack lived, and made the mistake of bringing a bottle too. Jack drank too much and started being abusive to her—rough with her physically. I tried to intervene and Jack turned on me, picking up a hatchet. I remember his very words: "You're a nice girl, Marie, and I like you. I would hate to have to chop your head off." There was a painting of Charles's on the wall, one he had sold to someone who was good enough to lend it for a show. It wasn't Charles's anymore, but Jack swung at it with the hatchet and slashed it.

Although Charles has no memory of this episode, Frank recalls that he and Jackson shared a room and double bed for a while when Frank was peeling potatoes at a restaurant by day and working in the library stacks at night.

FRANK POLLOCK: When I came home at night, I'd rap on our door and this girl would get out of bed and have to dress. Then she would walk to get the subway home and I would take over her space in our bed.

MARIE POLLOCK: She was beautiful—doesn't wish her name associated with Jack—and probably fell in love with him. It was the first affair for both of them; she told me that when later we reestablished our friendship.

MANUEL TOLEGIAN: Pollock and I saw each other every day at the League, had lunch always, but I worried about him all the time and the kind of trouble he'd get into. That story about his standing over my bed with a knife ready to kill me isn't true, though. Like a lot of stories about Pollock, it was made up.

HERMAN CHERRY: Jackson was still very much under the influence of Benton, to whom I was drawn by reading his article on Tintoretto. We all made copies of that master in class, along with El Greco and Rubens, but actually Jackson's were not very well done. Benton thought him only one of his more talented people, but Jackson worshiped him. Later when he was famous—his face got so tortured, unlike Charles's which is benign—he gave a sense of being enormous, but he wasn't. His hands were huge though, always were, and one night he thought I made a disparaging remark about Benton. I did not and told him so, but he got violent and wanted to punch me in the nose. He absolutely adored Benton!

Not many of Jackson's works of this period have survived and concise dating is almost impossible, although his brother Sande, who was the most familiar with these early efforts, placed the Bentonesque works and the Renaissance studies between 1930 and 1933 for the most part. Among these would be a couple of studies in the form of lunettes for a mural at Greenwich House. They are done in oil on brown wrapping paper in a flowing, elliptical motif. No juvenilia—work prior to his arrival in New York—has been positively identified as authentic.

REUBEN KADISH: It's a good thing some of the early things that Phil Guston and Jack did were destroyed. They were drawings under Schwanny's influence, like some Hare Krishna illustrations—not the kind of thing one regards as serious art.

WHITNEY DARROW: Jackson in the Benton days seemed so young and uneducated. But he tried terribly hard "to be with culture"—painting, writing, art trends and so on—and to be an "Artist" was much romanticized. He was not, certainly, an academic; I felt he was rather juvenile, uninformed and emotional rather than intellectual—entirely emotional.

That summer of 1932 brought a second trip west, this one in a tired Packard 6 touring car Marie had bought for not much more than the cost of the oil alone that it consumed. Frank did the driving for his companions: Marie, Jackson, Whitney Darrow, Jr. and J. Palmer Schoppe, another League student who would later teach art in Los Angeles. Jackson went for free, the others dividing expenses.

FRANK POLLOCK: Four guys and a gal—quite an experience crossing the country that way. I hadn't been seeing much of Jack, he being downtown and I uptown, and I never saw his work. He and Charles used the same studio, but Jack's work was always turned to the wall.

WHITNEY DARROW: There was terrific enthusiasm in the way Jackson talked about getting out from under the closed-in greenery of the east

and all that implied. But on the actual trip he was very quiet and, as I recall, there was no drinking. He brought along this chalk box full of watercolor sticks and when short of water he'd use spit. They were like Chinese ink sticks, rectangular, and when wet would print on a pad. He'd do desert scenes and the prairies using earth colors, and he loved playing his harmonica, raising coyotes and all. We went up through Canada, then down to the Grand Canyon, down to California, up into the Rockies, and by the time we arrived at his family's we were worn with traveling.

These were simple people, and as an easterner out of Princeton, I felt ill at ease. His mother was a solid woman with a very kind face; the power was with her. The father, hard-working and weathered, was a drinker, I gather. Table contact was on a simple level: taxes, food and smoking.

MARIE POLLOCK: In my family everyone talked at once. It was bedlam. But at this table everyone *ate*. There was no conversation at all and I couldn't understand it. About the only things said was a "please pass the potatoes" and compliments for the mother.

At the Chouinard Art Institute in Los Angeles, Jackson and Whitney saw the murals by David Algiero Siqueiros which were unusual for being on exterior walls and done in part with Duco, a paint that Jackson himself was to use often. There does not seem to have been much contact with Roy, whom Jackson would never see again.

WHITNEY DARROW: I bought a Model A Ford coupe for the trip back; it cost one hundred and fifty dollars and Jackson and I just made it home with another ten dollars to get it towed away. He and I spelled each other driving by way of New Orleans, eating meagerly—cans of beans, quarts of milk and so on in the car and by the roadside. We practically never went to a restaurant and we didn't stop often. On the way Jackson did all that Benton smokestack-and-"tote-that-bale" kind of thing. This was the West and he was good out there; we even tried chewing tobacco, but driving it blew back in the window. It was in the spirit of Americanism, but in the desert we came into a town at night with an American Legion dance. There were innuendos that we better look out; bums like us were not welcome. In the desert we used sleeping bags and we'd watch the sun come up the way it does out there; that was the kind of thing Jackson loved.

He talked like a profound but mock philosopher and we got on well, in spite of the repressed violence in him. He was very tactile, always using his hands, and he would grab you to make it physical. Because our backgrounds were so different, our real tie was the Benton class. Actually, Jackson's Benton things are very muddy, no real color at all. Yet what he enjoyed most out west was the color!

• • •

Jackson began his third New York winter in a building at 46 Carmine Street that Elizabeth had found for Charles as a studio.

ELIZABETH POLLOCK: It was close to my apartment on Bleecker Street, and it was so ancient the toilet was over an open sewer. Charles and I were too broke to have the electricity turned on, but Jackson ate with us. He feared me terribly and was shifty-eyed—I had the tongue of a snake. Although highly courteous, all he had, I guess, was his good looks and his discontent.

ARLOIE MCCOY: Elizabeth was very critical of Jackson. I feel a little prickly about that. I mean, he was just a kid. She had done an awful lot for Charles and may have resented what he was doing for Jack. And when he began having a name that exceeded Charles's, that didn't help much either.

FRANK POLLOCK: I remember one time I bought Jack a corduroy jacket at Macy's for twelve dollars. Elizabeth criticized me for wasting money on Jack when I didn't have anything myself.

ARLOIE MCCOY: Coming into the Sande/Jack situation the way I did, I leaned over backwards so as not to interfere with their relationship. I knew how much Sande loved Jack and how important it was to him that Jack not destroy himself—in an artistic way aside from a physical way. Their relationship was very, very strong.

Benton left for Indiana in December of 1932 to do a mural commissioned by the state and Jackson became a member of the Art Students League. This permitted use of the graphic arts studio, where he made some lithographs on Saturdays; later he was assisted by the printmaker Theodore Wahl. Early in the following year, Jackson attended Robert Laurent's sculpture classes at Greenwich House. In addition, he took John Sloan's classes in life drawing, painting and composition at the League. He was not impressed by Sloan, although intrigued by his applying paint direct from the tube.

MANUEL TOLEGIAN: Sloan had to dominate you. He was a dandy—spats, silver-headed cane and diamond stickpin—quite a man and putting on an act. It was one that impressed us, but he was ineffective—knew he was just a substitute. Sloan insisted that the model should be on a high stool—Benton let it be anywhere we wanted—and when we didn't do it, Sloan insisted it be put back up there. He didn't last long—three or four months, maybe. He kind of went haywire in the end.

• • •

So great had Jackson's interest in sculpting become that both Charles and Frank wondered if he would turn out to be a sculptor rather than painter. It looked more like hammers for Jackson than brushes. Part of Jackson's excitement was due to working with the stone carver Aron Ben-Shmuel.

REUBEN KADISH: Ben-Shmuel worked in stone—athletes, boxers, things like that—and Jackson had a strong feeling about the work he did with him. It might have had to do also with his response to the person; Ben-Shmuel was dynamic, again for Jack a matter of personality. My feeling was that Jack really wanted to be a sculptor—he carved that little head in Pennsylvania which I cast in bronze and Arloie had—but the impact of Benton was too tremendous.

AXEL HORN: Jackson was a janitor at Greenwich House Annex on Jones Street for a while one winter, and I saw a couple of stones he worked on. They were fragmentary and indicated a tremendous struggle and resistance on the part of the material.

Jackson didn't finish his course with Sloan, but he did complete the Laurent semester. And he was drawn more than ever to the art community.

WHITNEY DARROW: At that time, Jackson was a neophyte. He wanted to be an "Artist," but he didn't seem to enjoy his painting much. And he didn't do that much, either. He was ambitious—either that or extremely neurotic—and unsatisfied, frustrated. Jackson wanted recognition as a *person,* and art was the way to do it. He was so intense about it, and in everything he did in spite of emotional insecurity and aberrations. I don't think he ever thought about any career but art.

MILTON RESNICK: The artists had a problem in the thirties. It was a period when they said, "How do you become a modern artist?" It was such a self-conscious thing; you felt phony. People were so half-baked, and there was a lot of shit around. But mostly they worked, and they had an important way about them: You felt they were their own men.

It's good to talk things out, but Jackson wasn't interested in talking. He could be a big pain in the ass, and the thinking he did was phony, like trying to get across some ideas about color or this and that. It was a ritual, that kind of talking, and people were stuffed with ideas they couldn't use. Jackson was like silent and rough—trying to figure you out—and he'd be saying things to challenge you. But the challenge wasn't on a level of understanding each other; it was more a kind of "You want to fight?"

The women didn't like the Waldorf Cafeteria and places where we talked—too boring for them. And they had a way of putting us down; they felt they had to be strong, you know. Besides, they were too political and would call you a fascist. I was called that because I didn't like Rivera's murals.

AXEL HORN:　　Jackson had a sense of right and wrong, but repartee with him was on a very elemental level. It was physical, like backslapping, punching, squeezing . . . that was conversation for him.

ELIZABETH POLLOCK:　　Ours was a culture of talking over big meals of spaghetti with young people deciding how to save the world and so forth, but never did I hear thoughtful comment from him. When we had people over who were his age, young apprentice painters, he would sit looking at them with dissatisfaction on his face. The only things he could laugh about were the ugly comments about people. Anything cruel or spiteful about another person, or hearing of someone's failure, gave him great pleasure. Jackson was a taker, not a giver, who rarely—the truth is I remember no incident at all—proffered a helping hand either in the flesh or in the spirit. He was filled with demons.

On March 6, 1933, Roy Pollock died of cancer, although his illness had been diagnosed as endocarditis. Stella was with him at the end, but the family members in New York were too poor to attend the funeral. Jackson did write his mother a letter of consolation with no mention of his own sense of loss. He supposed that there was no money but that Frank and Charles would be able to help her, and he was "still lazying" with no prospect of earnings from his work. But the mood of at least one painting in Charles's studio about this time speaks of Jackson's loss.

MARIE POLLOCK:　　There were paintings on the walls but nothing of Jack's. After a while, he went to the closet and brought out a painting. It portrayed a Mexican couple with a baby that had died and was in a coffin. You saw the backs of the mother and father looking at the baby in the coffin. It was quite primitive in style.

That spring Elizabeth obtained the top-floor apartment of 46 East 8th Street for thirty-five dollars a month. Jackson was given a room opening on the hall at the top of the stairs; this afforded Charles and Elizabeth, with whom he took his meals, some privacy. The following account is based on her restricted files at the Smithsonian's Archives of American Art:

> Uncertain if he could paint and rootless, he comes with his peculiar dissatisfied, selfish temperament to a young couple who are greatly

in love and both of them involved in their lives; Charles was painting every day, I doing my freelance work every day. We had our feet on the ground, knew where we were. Jackson was envious of Charles's confidence and determination. He was ravaged by a kind of jealously and envy, especially of the trust and deep affection between Charles and me, of our easy companionship, and of the fair terms to which most of our friends had come with their own lives—a self-acceptance he never would realize. He and I conducted ourselves as if we were armies under truce.

I would find him, when returning exhausted from multiple freelance jobs, late winter afternoons, comfortably ensconced beside the stove with his huge feet propped on another chair—never reading, just waiting to be fed and having emptied the last of the scuttle of coal. I would have to ask him to bring up more coal, as he never volunteered any kind of help. . . . I had utter contempt for this hulk of a lazy giant who . . . devoured more of our limited supplies than both of us put together. . . .

He was not working at his craft . . . He was not sketching but scribbling, though not vigorously or with concentration. He did nothing but lie on the bed in his room, and he wasn't reading—just lying there.

The room was a foul garbage pail and the smell was so offensive, I used to threaten to call the health department.

Jackson continued working with Ben-Shmuel for much of the summer and visited the Bentons at Martha's Vineyard as he had on an earlier occasion. Although no longer Benton's student, Jackson made himself useful and their personal relationship continued in the form of the musical nights until Benton moved to Kansas City in 1935. Elizabeth does credit Jackson with not drinking in the 8th Street apartment, but his alcohol consumption elsewhere appeared limited only by the expense.

REUBEN KADISH: He would drink for two or three days sometimes, once ending up on the Bowery. He was a horrendous mess when he came back and very sick, but he made a decision: The Bowery bum was not for him. If Jack was going to be a bum, it was going to be his own kind of bum.

MANUEL TOLEGIAN: The Italians on Bleecker Street were having a candle mass just when Pollock and I were doing the town, so we followed this group. It ended up at a church where they settled themselves but Pollock didn't. He went right up to the altar and knocked everything down: candles, lights, all those things. The cops came and I

had to go to the police station with him. They put him away but didn't keep him for more than a couple of hours.

One night we were in a stupor on a Hudson River dock and very mad at civilization. We started throwing change from our pockets into the river, but then Pollock threw himself in too—right off the dock! I had to pull him out—couldn't wait for help—because he was drowning.

WHITNEY DARROW: You know, he would start screaming and yelling in the street, and so on. I went to the Jefferson Market courthouse to appear for him, but it was settled out of court.

Jackson's income as part-time janitor at the City and Country School was occasionally augmented by selling ceramics with Rita Benton's help. The number of pieces he produced is in doubt, and the condition of some of those that have survived show kiln problems. The pieces do not carry a date and when signed say merely "Jackson" or "Jackson/Rita."

EDITH SYMONDS: On the mantel at Rita's dream house on the Vineyard—hideous with its overstuffed furniture—there used to be pieces Jackson had done. When he needed money he would do a piece and they would buy it from him. They used to give marvelous parties at which everyone got drunk and Tom would play the harmonica.

Rita had this enormous, Italian feeling for children, and being so motherly with that warmth she would have been moved by Jackson. But it was no more than that; in fact I've *never* heard of Rita having affairs.

CHARLES POLLOCK: I heard rumors about Jack and Rita, but I don't know if the implication was that they were lovers and I didn't pursue the matter. Jack was drawn to strong women, but this could be dismissed as fantasy. Rita was flirtatious—maybe dropped some casual remark—but I would be surprised were there an affair. And I do know Tom would have not taken such an affair with equanimity.

MANUEL TOLEGIAN: One day a couple of young women came up from Tennessee playing music—one a singer, the other a guitarist—and they were both very beautiful. They were talented, probably way ahead of their time as far as western music is concerned. They were doing what they call country music, not hillbilly. We took them all over, showed them New York. And really, these were beautiful young women, so I don't blame Pollock for falling head over heels for *both* of them. Then, quick as they came, they suddenly left town. This fellow, I think, went berserk; there was a basic change sometimes.

ELIZABETH POLLOCK: We took Jackson to a party at which there was a particularly bright, unmarried woman in her late thirties, a lovely person. Jackson sat in a corner for a long time, glowering at the laughing and dancing. He suddenly rose and crossed over to her, then roared, "You are one goddamned ugly bitch!" I cried with frustration.

Charles and I came home unexpectedly one summer afternoon and near the top floor we became aware of scuffling, a twisting of feet, as if forcibly propelled, and of a girl's frightened protest. Jackson was pushing a slightly built woman into his room and she was resisting. We stood transfixed at our door, for a fleeting instant confronted by a sight that was as puzzling as it was upsetting. Both were fully clothed and he pushed her, brutally shoving this girl ahead of him through his door, her face twisted with real fear as he slammed the door behind them.

We waited with our door closed behind us for him to bring the girl to our room for coffee or wine, but a few minutes later we heard him arguing with her. Shortly thereafter, we heard him muttering to the still protesting girl, pushing her along the hall and accompanying her down the stairs.

We had thought it unnatural for him not to bring women home, yet here he was hiding this girl as if she were some kind of leper. I burned with resentment at the humiliation to which he had subjected that young woman, but Charles's evasive eyes and tightened lips, which reminded me of his mother's way of expressing anger, silenced me. This was the only time I saw Jackson with a girl.

AXEL HORN: I had a very early Pollock portrait of a young girl he was friendly with. She was a sort of misfit—not very attractive or pretty. I left it in my old studio, not dreaming it would be worth something some day.

Charles bought a Model T Ford runabout for fifteen dollars that spring and took Jackson across the country. It was a year of drought and the Okie migration, and they sketched all the way to Los Angeles.

REUBEN KADISH: I had a car out there and carted Siqueiros around. Sande got acquainted with him that way and became the contact for Jack when Siqueiros became established in New York. But Jackson passed Siqueiros off. "The *real* man," he said, "is Orozco, and his *Prometheus* at Pomona is the thing to look at."

Siqueiros was very sharp and his idea was to build up "a syndicate of painters"—his very words. The first thing we did independent of him—Sande, Phil and myself, Sande being the helper—was a mural for a club which was a Communist Party fringe outfit, and we signed it "Syndicate of Painters." The papers wrote about us, saying we were "misguided individuals committing themselves to communism."

• • •

In the fall Sande drove to New York with Jackson in the Model T, which they were able to sell for thirty dollars, and found an apartment at 76 West Houston Street.

ARLOIE MCCOY: It was a *terrible* place—a pigsty in the city! Sande didn't want me to come, saying it wasn't fit for a woman, and it got so cold they had to burn some of their furniture. Sande adored Jackson and had a great deal of belief in him and his talent. Sande wanted to be a painter, having been drawn to art through Charles, and I had the same feeling about Jack he had: I loved him too.

PETER BUSA: As the smallest of them, Sande one night at a Palm Garden benefit for the League jumped up on Jackson's shoulders and started hitting people all over the room.

MANUEL TOLEGIAN: In my opinion Sande was a bad influence; he did a lot of damage to Pollock. Everything was fine until he came and started making all Pollock's decisions for him. That wasn't necessary; he should have let the man alone.

FRANK POLLOCK: An artist himself, Sande still helped Jack keep alive. He was very concerned about Jack and just wouldn't let him be destroyed—or destroy himself, as he ultimately did. Charles never did more for Jack than provide him with food, housing and some comfort, but Sande took physical care of him. He'd actually lead him down the street, get him home and stay with him to be sure he wouldn't go out again, all of that. But Sande was a crazy drinker; he could be dangerous. The story is that he threatened Mother with a knife.

ELIZABETH POLLOCK: I had deep affection for Sande because he was so thoughtful about his mother; she lived with Arloie and Sande later. He was the single one of the sons who gave Stella the affection she needed, but the one she adored, always longed for, was Jackson.

Sande was also hired as a janitor at the City and Country School, but the brothers did no more than survive. In December, Rita Benton persuaded the Ferargil Gallery, which handled Benton's work, to let the basement be used for the sale of works by young artists. Jackson was among them, showing ceramics he had decorated with the help of Benton, and also watercolors. Among these was one called *Cody, Wyoming*. It is a Bentonesque scene of Western town activity and marks the first recorded effort by Jackson at barter; he exchanged the watercolor for a suit of clothes. Jackson later showed at the Walker Gallery.

REGGIE WILSON: An eminent actress bought a watercolor of Jackson's at the Walker and this really set him up. At that period it could have been in his *Cotton Pickers* style. Anyway, her friends may have told her it was a pretty lousy work because two days later the actress returned it. It was Katharine Hepburn.

The new year, 1935, was to bring Jackson both reassurance and sustenance. In February, the Brooklyn Museum's show of watercolors, pastels and drawings included at least one of his oils, *Threshers* (c. 1933), sometimes also called *Departure*. The work shows not only Benton's influence but that of Albert Pinkham Ryder, and there is an Expressionist sky effect. Stretching a point, Jackson now listed the Ferargil as his gallery.

Toward the end of the month, using Ben-Shmuel's name, Jackson found himself a stonecutter for the City Emergency Relief Bureau. As Kadish remembers it, that project was partly federally funded and, he says, "They put him to work cleaning monuments." The pay, $1.75 an hour, was not bad, nor the work heavy, but something went wrong and Pollock was demoted to assistant with a pay cut to eighty-five cents an hour. In early summer he was cleaning the handsome bronze relief by Attilio Piccirilli on the firemen's memorial that graces Riverside Drive at 100th Street. Friends were amused by how hard he worked on the phallus of General Sheridan's horse in Christopher Park.

After the WPA Federal Art Project was inaugurated in 1935, Jackson joined the mural division in August at $23.86 a month. Sande joined the easel division later. One of the mural division's major assignments was for a group of murals for the hospital on Welfare Island, now known as Roosevelt Island. Although it is not certain that Jackson worked on them, it does seem likely that he worked on a mural for Grover Cleveland High School under Job Goodman, also a former Benton student, and that he transferred to the easel division during the winter of 1936. This would be his professional home off and on until the Project was closed down in 1943.

Charles moved to Washington, D.C. in the fall of 1935, so Jackson took over the 8th Street apartment and was joined by Sande. A folk singer, Becky Tarwater, came into Jackson's life shortly thereafter.

REUBEN KADISH: She was very pretty and very nice—a terrific gal. At one of Rita's parties she sang songs with an Elizabethan flavor indigenous to her culture, maybe the Smokies. It was very touching. Jack would be like a dodo, staring and hypnotized by her. But most of the time he would just get drunk. Then he'd sit in a corner and blubber. So one day, she packed her bags and left—that was it.

• • •

Arloie McCoy says that Jackson felt badly for a while, but even if his hurt was deep his excitement about the art community on the WPA Project helped him overcome it.

WHITNEY DARROW: Jackson wanted me to be on the WPA with him, to be an artist too. I'd tell him, "What the hell, I have no talent for art." And he'd say, "Don't be silly; do your cartoons for the Project." It was an unusual thought, doing my magazine cartoons for *that*. He meant not that I should stop commercial art, but that I should go on the Project. Instead of making twenty-four dollars per cartoon I'd be getting a weekly stipend from the WPA and then I'd be an "Artist." It was a crazy idea.

Another distraction for Jackson came in the form of exposure to Siqueiros in the spring of 1936.

REUBEN KADISH: The dynamism and fecundity of Siqueiros was absolutely fantastic! So the kinship between them was of personality rather than art.

Siqueiros's workshop was at Union Square, the center for frequent and noisy demonstrations. Banners, placards, murals and figures for floats were turned out and on many of them Jackson worked as general helper, as had Sande in Siqueiros's Los Angeles studio.

Siqueiros, who later was part of the Trotsky assassination attempt and carried a pistol, brought with him to New York a reputation for fireworks and gun play. When he and Jackson got into a brawl at a farewell party for Siqueiros a year later on his leaving to join the Spanish Loyalists, it was finally stopped by Sande's right to Jackson's jaw.

AXEL HORN: There was a lot of bantering and kidding around Siqueiros and his South Americans, but this night Jackson had a few drinks and was getting boisterous—the usual macho business. He may have lunged at Siqueiros, who misunderstood it and got frightened. Jackson's friendly gestures got very physical when he drank and it was hard to pull away sometimes. There was no animosity between them, but they ended up in a contest under the table. That pistol of Siqueiros's, maybe, was what set Jackson off.

Some of Jackson's studies and a few oils from this period demonstrate a Mexican influence, but what is more important was that the Siqueiros exposure began to free him in his approach to the canvas and use of space. Eventually it would lead to his seeing the entire canvas as an arena in which to create.

July of 1936 brought change to 8th Street: Arloie Conaway joined Sande and they were soon married.

ARLOIE MCCOY: Jackson was a good apartment sharer—always very sweet and very kind and helpful. But he was drinking and that caused us a lot of worry. I made a very strong point: I did not want to see him when he was drunk. Periodically, he would go out and then Sande would get worried and go looking for him. He would usually find him and when they came home, they'd come in the kitchen for coffee and talk while Sande calmed him down. I would go to our room because I didn't want to get involved; I knew he would be violent when he was drunk.

Usually the next day, Jack would be really depressed. If I caught a glimpse of him in his room, very often he'd just be sitting there with his head in his hands—it could be for a day. But gradually he'd get back to normal and we'd have a normal relationship. I was upset about it— Sande was too, so that we didn't want to have children while we were living in that situation; I thought it was too traumatic. One night Woody Guthrie was there: Sande played the harmonica, Bernard Steffan the dulcimer and Tolegian was *very* good. But Jack only played *at* the Jew's harp or harmonica.

Christmas was a little bleak, but about that time Jackson had a first meeting with the woman who nine years later would become his wife: Lee Krasner. The meeting seems to have been remembered better by Lee than Jackson. Four years later when she went to see him at 8th Street, as she has told John Gruen, it occurred to her that Pollock was the man who cut in when she was dancing and that he was "a lousy dancer."

MERVIN JULES: He got mean when he was drunk. We had to take him away occasionally in order to avoid confrontation—strangers or friends, it made no difference.

ELIZABETH POLLOCK: Jackson wrecked a sleazy nightclub, mauled a cop, spent the night in jail and had to be sprung the next day by the husband of a fellow worker on the *New York World*. He was British, elderly, undertaker-like dignified, and was able to impress the court so that only a severe admonishment was handed down. Jackson acted proud of the affair.

MILTON RESNICK: I'd heard talk about his being a wild Indian, that he gets drunk and stands in the middle of the street and acts like he wants cars to "run me over," things like that. But I found out that with the drinking there was a shrewdness and he could say things that normally he couldn't. He would open up, then act up, challenging

people. But I wasn't easy to challenge and told him, "I'm going to beat the hell out of you." He smiled and I said, "Now that's the way. When you smile, you win me over." After that he trusted me, but I never knew a person like him in the art world. There was no other person like that.

KARL FORTESS:　I was the kind of drunk who wanted to go to Coney Island if I got high, but he was the kind that wanted to beat up cops. Before the Cedar Tavern there was this corner place and Jackson pushed his fist through the glass door. It was not a pleasant thing.

MANUEL TOLEGIAN:　We used to stroll on 14th Street to get atmosphere, you know, and although I'd had a few drinks I never got like Pollock did. A fellow in a porkpie hat was walking two big dogs and Pollock, maybe showing off his macho, goes right up to him on this crowded street and knocks his hat off. You'd laugh, but here is this fellow holding back the two big dogs. I defended my friend, explained he was drunk and apologized for him. The man was very mad and said, "This is very bad behavior; he can hurt someone. I didn't sic the dogs on, but I'm calling the police." Pollock was mumbling things and I calmed him down, told him he was going to get the cops on him, for God's sake! The fellow did bring charges, but they weren't pressed. Several times, you know, I pulled Pollock out of jail.

The City and Country School head, Caroline Pratt, was made aware of Jack's drinking by Sande. Her friend Helen Marot, who had connections in the psychiatric world, persuaded the pioneering therapist in alcoholism, Dr. Ruth Fox, to treat Jackson. (Dr. Fox, a founder of the National Council on Alcoholism, later owned a Pollock called *Number 4, 1951,* presumably a gift and not compensation.)

ANN ALLEN:　Eventually my mother decided that psychotherapy was relatively ineffective, as by the time an alcoholic reached that stage there was a body chemistry derangement. She liked Mr. Pollock, I remember, and any links she had with him later were as a friend.

ELIZABETH POLLOCK:　Sande appointed himself wet nurse for Jackson; he stopped painting and did nothing but watch over him. I could almost say Sande babysat for Jackson in an effort to keep him from destroying himself and others.

ARLOIE MCCOY:　I don't think Sande regretted helping Jackson, but I think he would have begun to paint again. Sande was one of those who are interested and supportive but do not achieve themselves.

REUBEN KADISH: Sande had this thing about taking care of Jack all down the line. There wasn't anything you could do to encourage Sande to act professionally, and there wasn't anything you could do to stop Jack expressing his professional activity.

ALMA POLLOCK: Arloie had a saintly nature; not many wives would have put up with that kind of devotion. She was a young bride, too, but Jack came first, always came first. He would not have survived without all the self-sacrifice in taking care of him. It was strange to me that Jack got so many people devoted to him because he seemed to give so little—the tyranny of the weak.

A friend of Marie Pollock, Ruth Stone, who had been a student at Manual Arts with Jackson, wrote Marie of her reception by what she calls Marie's "beloved brother-in-law":

> When I arrived, Jackson was fast asleep on the couch. Upon being awakened, he stared at me vaguely—mumbled—shook his head—almost fell asleep again—made a great effort and rambled on somewhat in this order:
> "Sure, sure, I remember you, Ruthie! Sure, Manual Arts—hate reminiscences—old school days, let's talk about school days—remember those pamphlets I distributed? Yes—you were on the streetcar and I was waiting on the corner—that's right. Oh, when you get back to L.A., look up my mother, will you? Go to see her—I'm very sentimental about my mother—never write to her—but you see her, will you? Promise! You won't forget? You mean it? All right—all *right*! You go see my mother . . . mother . . ."
> And he was asleep. Romantic, what?

A work of Jackson's, probably *Cotton Pickers,* was in the Municipal Art Committee's exhibition at its temporary gallery on 53rd Street in February of 1937. This event brightened an otherwise dark winter. After six months in the care of Dr. Fox, Jackson was still not able to control his drinking, and on a visit to the Bentons at the Vineyard he drank some gin bought as a present for them. The result was his chasing a girl on a bicycle not his, and finding himself under arrest for disorderly conduct. He was detained in an outhouse with a locked chain around it, a cell not being available, and Benton paid the ten-dollar fine.

The impact of powerful personality still had a strong effect on Jackson, a new example being that of John Graham.

PETER BUSA: Graham was a great proselytizer of ideas and was more intellectual than most painters. He was very well read and stimu-

lated Jackson's interest in Picasso. Graham already knew the works of Freud and Jung. He became interested in Jackson as a young painter and he liked his later work—genuinely liked it.

Graham so approved of Jackson's work that he included him posthumously in the second edition of his *System and Dialectics of Art*. He also approved of Jackson's courage in coming to meet him without introduction.

NICHOLAS CARONE: Jackson told me, "I went to see Graham because I thought he knew something about art and I had to know him. I knocked on his door, told him I had read his article and that he *knew*. He looked at me a long time, then just said, 'Come in.'"

There wasn't much drinking in the summer of 1937 because there wasn't money for it, but Jackson did have a Model A Ford given him by Charles.

REGGIE WILSON: Jack was a startling driver—very fast and willing to accept any space that opened up, and incensed if his rights were infringed on. One morning a sedate limousine was hogging the road and Jack honked and honked. Finally he couldn't take it and went around the limousine on its right side, shouting at the chauffeur. You know, even sober this reticent man could rise to such anger it was frightening.

We were paying fifteen dollars a month that summer for an old Dutch farmhouse in Bucks Country at Revere, a few miles across the Delaware from Frenchtown where there was a family hotel run by a friend of Jack's and where we had meals sometimes. The house was big enough so friends would come on weekends—the Schardts, Sande and Arloie, some other couple. Jack had women who were friends—but girlfriends, that was just something not there; he was quite shy. There was a stone barn and the farm was beautiful, so everyone was doing landscapes from the porch and out in the fields. We criticized each other's work but were at that stage of development you don't turn things out easily, don't do twenty paintings in a couple of months.

As a lot of us were, he was very moved by the work of Ryder, and he had a thing about the moon. One night we'd had a couple of beers at that Frenchtown hotel and there was a bright moon. After we'd gone to our rooms we heard a great noise on the roof, so Bernie Schardt and I went out and saw Jackson up there. He was running back and forth along the ridge pole, waving his fists at the moon and shouting, "You goddam moon, you goddam moon!" We talked him down after a while, but we were really scared!

• • •

Jackson had at least one watercolor in the opening show of the Federal Art Project's gallery next door to the Art Students League in October 1937. In December he went to spend Christmas with the Bentons in Kansas City, which required a Project leave, granted in spite of Jackson's shaky attendance record. His trip included a visit to Charles and Elizabeth in Detroit, and as usual he was impressed by the "pretty swell country."

Jackson's drinking became more frequent in early 1938 and with that came more chaotic behavior.

MANUEL TOLEGIAN: Even though it was the Depression, I was getting five and six hundred dollars for work at the Ferargil Gallery. They called me during one of my shows because Pollock was knocking all the paintings off the walls. This was jealousy, let loose by booze.

As an idealist, I took over an old building on Vandam Street and refurbished it to rent space to artists reasonably. I was superintendent, stoked the coal and everything, and had the top floor. About two or three one morning I hear glass being broken—in *my* building! Jackson was across the street and he'd arranged stone in triangular piles like cannon balls. There were enough to break all the windows left, top to bottom. I went downstairs saying to myself, "The cops will do it to him, just as well I do it." So I beat the hell out of Jackson. He didn't bother me after that.

It was a troubled winter for Jackson, and during it he stopped being treated by Dr. Fox. In early May his request for a leave from the Project was turned down, making it impossible for him to go with Benton on a sketching trip. A few weeks later he was discharged for frequent absence.

ARLOIE MCCOY: Jackson was going through one of his violent stages. Sande was terribly worried and he was, himself.

In mid-June Jackson had himself admitted to Bloomingdale, now the Westchester Division of New York Hospital for treatment of acute alcoholism at the urging of Helen Marot and Dr. Fox. His therapist, Dr. Edward Allan, has since died.

DR. JAMES H. WALL: Jackson was rather anxious, as sensitive people often are, and suffering from depression. There was a lot of calming down to be done and building up of his self-esteem. He was an intelligent and cooperative patient and made real progress fairly soon.

It was obvious that here was a talented artist and during therapy he turned out several works in copper. Later, he gave me a lovely bowl

which is now my son's . . . My recollection is that, aside from genuinely liking him as a person, we felt good about our work with him as a patient. Such a case depends in the end, of course, on the patient wishing to be well and in helping himself toward it once our work is done. It took me a while to understand his later work, just as it took him a while to recognize his worth and to accept it. Now I can see a sweetness and strength in his work just as I did in him. It really is a lovely bowl and he really was a lovely person.

On Jackson's return in the fall he was greeted by a supportive letter from Rita Benton saying that Tom had had a productive summer after going on the wagon.

ARLOIE MCCOY: Jack tried to stay on the wagon, but first thing his friends offered him a drink. Of course, he took one and—boom! It's ironic the way our society fights everyone who tries not to drink.

Thanks to the influence of friends, the end of November brought Pollock reassignment to the FAP's easel division. His wages were reduced, perhaps as a sop to those resisting the forgiveness of past sins, but even that must have taken doing. Public criticism of the Project, in spite of the thousands of art works placed in public buildings nationwide, resulted in a Senate inquiry and cutback in funds in the new year.

January of 1939 was a month of crisis for Jackson. Helen Marot turned to a friend, Mrs. Cary Baynes, for a psychiatric referral on his behalf. A Bollingen Press editor, she had translated with her husband, the analyst Dr. H. G. Baynes, the early works of Dr. Carl Jung and was familiar with Jungian circles in New York. Mrs. Baynes recommended her friend, Joseph L. Henderson, M.D., who had been analyzed by Jung and was in his first year of practice.

In deference to patient confidentiality, Dr. Henderson has declined to discuss Jackson's case for publication. The comments below are by a professional source close to the case.

THE SOURCE: Pollock, a large, self-contained man, explained that he did not feel the way he looked; that he was in a diminished state of being as a result of his problems with alcohol. He thought of himself as less of a person than the brother [Sande] with whom he was living; he knew what everything was about while Pollock didn't. This brother, whom he seemed to regard as his keeper, saw to it that Pollock got to his appointments and home again without losing his way or going into a bar, and took care of the fees.

No attention was paid to the alcoholism, nor was there any back-

ground on the hospitalization or prior treatment; he was taken simply as he presented himself. However, at that time it may be that his drinking was necessary to keep afloat, if you'll pardon the expression. There was no discussion about his mother, but there was a hell of a mother problem. He was fighting this tremendous creative energy that had been put into him and he was supposed to live out, yet he kept falling back into it. He never spoke of his father either, so there was no family history. With all the things troubling him, his personal life in this critical period couldn't come out.

He had an aesthetic intelligence but not a philosophic intelligence. His authentic aesthetic allowed him to relate to that area but not much outside it. Basically uneducated, he took in a lot and his intuition was highly developed; with that degree of inner energy, his imagination was turning over ninety miles a minute. His take on people and situations had an authenticity similar to a story someone might tell, and he looked at life in that sort of way rather than in terms of trying to understand ideas.

Cary Baynes had wanted a therapist who would not be a strict Freudian or something like that, and the sessions were never on a psychoanalytic level; not even his friends were gone into. Pollock was not in a state to be able to answer questions as to his associations and that sort of thing; all that was discussed was his immediate situation with himself. This was not even counseling; it was just his coming to the sessions and later bringing in drawings which were discussed. He was working out his own philosophy of art and his listener would make a comment here and there about his creative process—an ear, essentially.

No formal diagnosis was made; he was not schizophrenic but tended close to it at times. Pollock was treated not as a sick individual but as an artist in the process of finding his career. The treatment, therefore, was vocational rather than therapeutic.

He was certainly a very introverted man and also something of a feeling type man—feeling was an important way in which he related both to himself and others. He let others do the thinking and reality testing and all of that; he was not interested. He was a survivor of the Depression, a very deprived era for young people and *very* threatening. It was his dedication to art that prevented Pollock going over the edge.

NEW YORK: BREAKING OUT

With Dr. Henderson on vacation for part of the summer of 1939, Jackson and the McCoys shared a ten-dollar-a-month house in Bucks County near the one Jackson had rented earlier. They still drove the Model A Ford, with which Jackson had had an accident at Frenchtown.

REUBEN KADISH: Jack didn't have to be drinking to drive like a madman. It was something about the excitement it gave, and one trip from New York to Bucks County—I thought we'd never make it.

Even that ten-dollar rent was a problem for Jackson and Sande, who felt that Jackson's drinking might be less in the country. The WPA was reorganized in July in deference to public criticism about "boondoggling" and Leftist influences. It was now called the Program, and those who had been on the rolls for eighteen months were dropped. This included Sande, though he managed to get in again in January of 1940.

MICHAEL LOEW: We had to borrow from each other often—in those days you could buy a meal with a quarter—and some of us paid back. Pollock would approach you on the street for money; I suppose drinking took most of his money, not that there was much. Inside us there was something burning all the time and it had to break out; if it didn't people turned nasty.

European artists, many of them Surrealists, began coming to the United States after the September 1939 outbreak of World War II. Jackson was exposed to Kandinsky's work and to the Museum of Modern Art's *Picasso: Forty Years of His Art*. He also saw the Julien Levy Gallery's

exhibition of work by the Chilean-born, Paris-based Roberto Matta Echaurren (who called Jackson a "closed man"). And then there was Gorky, who took pride in being influenced by others.

PETER BUSA: Jackson was always a little hostile about painters he didn't know well; maybe it was jealousy. Anyway, here was Gorky pulling out his things, one after another, and Jackson finally said, "Why don't you get a little shit in your work?" What he meant was that it was a little clean, but Gorky drew himself up. He was getting mad, so I had to put Jackson down. Strange, but when Pollock was influenced, it always came out looking like Pollock.

PHILIP PAVIA: Gorky was trying to get away from Picasso, but we were all victims of Picasso. Pollock liked Rouault once and that was because of Gorky; he was looking up to Gorky, and so was Stuart Davis. So Pollock was getting it all mixed up: Rouault, Picasso, Surrealists, but he kept his career going all the time. We thought he was just a career guy, he started on it so early.

NENE SCHARDT: Jack was devoted to art and so honest with himself, he had to make the break with Benton. That father/son relationship, though, made it traumatic for Benton. He never quite understood or accepted it.

Sande, in a letter to Charles, spoke of this as "outgrowing the Benton nonsense." But there was another kind of nonsense which Jackson did not outgrow in spite of strong lecturing by Charles.

ELIZABETH POLLOCK: Jackson never participated in his brothers' responsibility toward his mother's livelihood. Later in the Depression when she was living out west, the brothers were all together once and I asked if they'd sent her any money. They looked at me sheepishly. I said, "That's all right. The grass is green out there; she can go and graze." Out of sight out of mind, but if you nudged them they'd give anything— except for Jackson. Yet he remained in her heart as her most beloved, and she always sat with adoring eyes, regardless.

He used her for years and as his debt to her became greater—a debt she never presented, he despised her. He had a tremendous load of guilt where she was concerned. I understand he said after being in therapy that he'd never be a whole man until he murdered his mother, but I knew him too well not to recognize another of his manipulative ploys. I saw this Oedipal posturing as a cover-up for guilt in never having shared with his brothers the care of his aging mother. My belief is that his "hate" for his mother was his guilt for being both unwilling and, perhaps, unable in any way to merit or to respond to such smothering affection.

• • •

During the winter of 1939–40, Jackson managed both to stay on the Project and with Dr. Henderson. The drinking was not quite as chaotic, but communication remained difficult until Jackson began bringing in drawings which gave a reference point and were to some extent revealing about his inner feelings.

THE SOURCE: The therapeutic objective was now to promote rather than try to reform or save the ego. The alcoholism was felt to be a dead end because of what often happens with alcoholics in psychotherapy: We talk about how not to drink and then he goes out and drinks. . . . One element of alcoholism was probably present with Pollock: the alteration of personality, a Jekyll and Hyde effect. Any form of drug addiction is a kind of slow suicide attempt, though suicide is a little too strong a term. It is more that they can't allow themselves to be well and that may reach the point where it means actual suicide.

Pollock did not have a theory about his work, but he was compelled to paint the inner aspect of life, the primordial level of the unconscious. That would be the hardest thing in the world to do. It is as close to the archetype unconscious as it is possible to get without losing all external form. That became his achievement, that he did it so much better than anyone else.

Jackson was dropped from the Program in May on the basis of the eighteen-month regulation. To that loss was added the fact that Dr. Henderson planned to move West. Yet another loss was the death of Helen Marot, which produced a period of regression. Although Dr. Henderson never met her, they spoke several times about Jackson on the phone. On one of these occasions she asked him if he thought they were possibly dealing with a genius.

THE SOURCE: He was the one patient in this first year of practice whose separation from was regretted; it was felt that his therapy might have gotten on a better basis, and that Pollock could have learned more than he had. As to the drawings, which showed the influence of other artists, at the time they did not have any therapeutic value. They were talked about as spontaneous products of the collective unconscious and as the raw material for the art works he was planning to create. He seemed so limited by his problems one would not have supposed he could rise to such fame. But there were elements of greatness always there, and these were responded to. This would explain why the therapeutic approach was not more strictly psychiatric: you don't touch creative genius with scientific instruments.

• • •

During the summer of 1940 Jackson wrote Charles that he had been undergoing violent changes and didn't feel up to entering the art competitions available.

FRITZ BULTMAN: Here was a human being in anguish; there was always a plea for help in his behavior. Doubt could have been part of his depression, but he was a sick man emotionally who had psychotherapy throughout his life. It never grew him up in any way, as he used it as a crutch.

PETER BUSA: Jack had problems all over: problems with drinking, with adjusting, with women, with the therapeutic element. I had the feeling his problems propelled him, that that's what gave him the push.

ALMA POLLOCK: He wanted his life to be free to paint. In order to do that, others had to do everything else. And he didn't want to be helped; he wanted to be taken care of.

Jackson was taken back on the Program's easel division in early October, but within a week was dealing with a new problem: draft registration. By the time of his registration, the anxiety he was experiencing was by Dr. Henderson's referral: Violet Staub deLaszlo, M.D. She had been trained by Jung, with whom she maintained a friendly relationship.

DR. DELASZLO: The important thing for Jackson was the human relationship. My work with him was a continuation of the work he had done with Henderson, so there was no break in that sense. He came to our sessions knowing he was accepted and this was important in the therapeutic relationship. He had a great need for acceptance, but he couldn't voice this. He was in pain; it hurt him very much. His main problem was great doubt about himself—as a person and as an artist Jackson was a haunted person.

Although reluctant to do so because of its possible effect on the therapeutic relationship, Dr. deLaszlo wrote Jackson's draft board to help him obtain deferment. In June of 1941, he was found unfit for military service due to chronic alcoholism and was classified 4–F. Sande also obtained deferment later, on the basis of defense work. In July, Sande reported to Charles on Jackson's condition, particularly in regard to their mother and referring to one symptom as "depressive mania (Dad)."

CHARLES POLLOCK: I know nothing about the psychological difficulties Jack may have had with his mother. I'm sure he must have recog-

nized her strength, her skills, her composure, perhaps making her hard to reach for him. She was a nice old lady. I have no knowledge that my father had a "depressive mania" either, and I have no ideas about the cause of Jack's problems. Maybe it was the driving ambition to be an artist with doubt as to whether he had the stuff to carry it off.

As the year 1941 drew to a close, John Graham invited Jackson to appear in a show of French and American painters he was organizing at the McMillen Gallery. The Europeans—Picasso, Matisse, Braque, Modigliani, among others—were known outside the art world; the Americans, among them Stuart Davis, Walt Kuhn, Lee Krasner and Willem de Kooning, were not. Jackson was represented by the unsigned and undated *Birth,* its lyrical quality giving a hint of moving beyond Picasso.

Lee Krasner was surprised there could be an abstract artist good enough to be in that show whose work she didn't know. She visited his studio and was impressed particularly by *The Magic Mirror* (1941). She felt a live force in the Picasso influence and vitality and power with a potential beyond that master. She was certain that a major statement would be made by Pollock, and later found her own work irrelevant. To her he was the important thing.

Four years older than Jackson, Lee was born Lenore Krassner, in Brooklyn, the fifth of six children. Her Orthodox Jewish parents had emigrated from Odessa; the remote father had a fruit store and the mother was "loving but not demonstrative." Art studies were the primary element in Lee's education, and by the time she met Jackson she had worked as a waitress and fashion designer's model (for her form, not her face, as Peter Blake points out). Active in leftist causes, she was a member of the Artists Union and a vocal power in the American Abstract Artists Association. Her painting earned praise from Hans Hofmann, under whom she studied. He told her that her work was good enough to have been done by a man.

MICHAEL LOEW: Lee was an intense, serious person who didn't go for small talk or nonsense. Her work was semi-Surrealist and she was seeking the most advanced ideas in art. Mature and strong but by no means affectionate, she had a warmth about art and she could be a good friend if you went along with her ideas. We shared an apartment when she was with Igor Pantuhoff—a caricature of the White Russian, charming and suave—who used to do portraits on ocean liners. He was a real man of the world but wild, running around with women. I could hear them scrapping a lot.

FRITZ BULTMAN: Lee was a contentious but brilliant student and involved in Hofmann's and Piet Mondrian's concepts of the plastic. I

remember her surprise at Jackson's admiration of Morris Graves, the Surrealists and other non-plastic manifestations. As to the myth that Jackson also studied with Hofmann, when Hans was asked that he would give his great laugh and say, "He was never my student but the student of my student."

With Igor, Lee had a sparkle and gaiety she didn't with Jackson, and he paid great attention to her as an artist—more than Jackson did. But her relationship with Igor was very difficult; she was tormented by him, such as his saying in front of her, "I like being with an ugly woman because it makes me feel more handsome." And he had that Russian anti-Semitism, would say, "I am not anti-Semitic; I am anti-Jewish." Lee would take this because she knew it was part of an act of his. There was a large element of masochism in Lee, just as there was a large element of sadism. But the two sides balanced out—more or less.

Jackson had a child's intuition in common with Igor: three words and he knew the whole story. He was not a reader, though Lee tried to make him out to be one; like many Americans, he was capable of learning the verbal tradition of teaching and had a retentive memory. When something was said to him he was able to relate it, which I think is more important than an intellectual reading of books. He could talk only when half gone; you got a babble of silence mostly. He was extremely capable then of rather complex abstract thought, and of holding his own with someone who also was not a reader but highly intelligent, such as Hofmann.

Lee was quite excited about Jackson, having written in great big blue script on her wall as a way of anticipating their life together, a part of Rimbaud's *Season in Hell* about worshiping the beast and so forth, and Jackson was certainly an "infernal bridegroom." But he was very lonesome and warm underneath his not knowing how to make contact with people. The alcoholic macho thing was a mask; he needed a breakout from time to time. He and Lee complemented each other, but it was almost like an antagonism.

MAY TABAK: A guy in overalls would come in at Lee's and never say a word. I didn't know whether he was half-witted or deaf; he'd sit silently for maybe half an hour, then get up and leave. She never said hello or anything to him, so I didn't know who he was any more than why she didn't introduce him. Then I decided he was the local handyman and probably was making stretchers for her—maybe didn't speak English. It was Jackson.

MERCEDES MATTER: We hadn't seen Lee for weeks; she had disappeared saying she "really liked someone now." We had a lot of catching up to do, and I remember Lee having said Jackson should study with

Hofmann. When I saw his things I told her she was crazy: "He's already made his own world. He doesn't need to study with anyone."

Well, when Lee and I finally stopped catching up, there was absolute silence downstairs and Lee said she'd better go down and save the situation. But when she and Jackson left, Herbert, my husband, said, "What a wonderful fellow." I told him they didn't seem to have had much to say to each other. "Not at all. Jackson said this is a terrific time to be living and that gave us enough to think about." So they had a perfect communion—always.

CLEMENT GREENBERG: Lee was a master of self-centeredness, a prodigy of self-centeredness. She introduced me to Jackson on the street, saying in her uncouth way, "This guy is a great painter." He looked bourgeois in a gray felt hat—the only time I ever saw Jackson in a hat— and affable but silent, with a reluctant smile. It was a hard face, having to do with alcoholism and with his needing help—with his always being in danger because he felt helpless. And it had to do with living on the edge—not painting on the edge but living on the edge.

CHARLES POLLOCK: Lee and I never had much to say to each other and I had no real impression of her work. Lee had strength, which certainly Jack needed, and ways of opening up avenues for him. If he hadn't met her, he might have gotten tied up with a lethal woman.

ELIZABETH POLLOCK: Jackson was narcissistic, totally in love with Jackson; that's why he had to be mothered. Lee struck me as extremely capable and domineering; I knew immediately why Jackson was with her: He had found a "mummy."

Jackson's sessions with Dr. deLaszlo continued on a regular basis during the winter of 1943–44.

DR. DELASZLO: We worked on a one-to-one basis, sitting comfortably, not the rigid-couch-and-remote-therapist position. I was very careful with him, trying to avoid involvement. This was a man twelve years younger dealing with a woman then almost forty, and anything else would have been disturbing to the therapeutic relationship. Whenever there is dependence there is also hostility concentrated in the unconscious, but none of that came at me then.

At first his main preoccupation and sorrow was not being able to paint and paint as he wanted to. His creative difficulty stemmed from profound inner sources, including his rather schizoid isolation. That was a contributing factor to his drinking and thus it became a vicious circle. More, it meant severe pain. When drinking he would go to friends, he

told me, and be physically destructive—break furniture and so forth. It was after one of these episodes that he destroyed his canvases.

Diagnosis in psychiatry is still in its early stages. I prefer to speak of syndromes, meaning a group of symptoms, rather than of the illness. Various combinations are possible, such as depression and elation. He was not elated, except in a creative phase. A characteristic of the elated stage is a flight of ideas, highs such as with Cocteau. His elation, I can imagine, had expression in his work, for they manage to accomplish things one can't do normally. This well could be the case with Jackson's work; I got the impression that when his energies could not find the right outlet—could not be used in the way he wanted—this turned into destructiveness. But also he had the talent to make something of great value from them.

No Rorschach test was taken; it was just being introduced then. There was no mention of parents; perhaps I was remiss in not trying to elicit some from him. He was unaware of other people, and I think he relied on himself for what he felt. I had no way of finding out what he was reading, *if* he was reading; I never had the feeling he was a reader. There was despair, but no weeping in the sessions. He was intelligent and I would say he was intuitive, but I could never make out what the degree of awareness was because he was so covered. There was little humor in our sessions, but I can imagine it was there.

He couldn't express himself—what he had to say he expressed in his work—and he brought in no dreams for interpretation, nor was free association possible. The sessions were exhausting, I had to put so much of myself into them, but they were important for him because he was taken seriously. He had great power in his work and as a man on one hand; on the other there was utter helplessness.

His mother's projected visit to New York sent Jackson on a binge that ended in Bellevue Hospital. Lee and Sande worked on getting him in shape for Stella's welcoming dinner, to keep her from knowledge of the alcohol problem.

FRITZ BULTMAN: That mother was almost monolithic, and her visit reminded me of Franz Kline's reaction to his mother's visits: always a monumental drunk. This time Jackson was totally silent around his mother, a silence I still remember.

ELAINE DE KOONING: All three mothers—Jackson's, Franz Kline's and Bill's [de Kooning]—looked as though they could walk through a stone wall. These were domineering mothers and its effect on the sons was a rebelliousness, a kind of resistance, and their attitude toward women. Also, these were non-drinking mothers, straight-laced,

hard and with ramrod backs. I never heard Franz mention his father—
he died young or something—or Jackson speak of his; Bill's father sepa-
rated. Often the father is there statistically as "the drunken father," but
in a Pollock survey I'm sure it would be "Mom" there in every case.

MAY TABAK: I had lunch with them and his mother. Lee took out a
lipstick and Jackson said, "No makeup." Lee was taken aback because she
always used lipstick, maybe a little rouge. She said, "But everybody does,
Jackson, even your mother does!" He said she couldn't talk about his
mother that way, and Lee was frightened by his rage at this terrible insult
to his mother. His mother just sat there—Lee and she were very for-
mal—and finally Lee said to her, "*Please* tell him." So his mother said,
"When your father died, I wept so, my eyes got swollen and my face was
puffed. I thought it would be bad for you children to see me looking as if
I was crying all the time, so . . ." She told the story as if to show she had
made a sacrifice for the boys, only he had never even noticed.

During the winter Jackson's exposure to the work of Europeans
grew—Miró, Dali, Breton, Max Ernst, Léger, Matta, Mondrian—and so
did Lee's efforts to have him meet useful people. He felt threatened,
though, by Hofmann's air of authority and prominence, as well as by his
importance to Lee.

FRITZ BULTMAN: Jackson and Hans were very important to Lee
and she would switch back and forth. Hans had a marvelous way of being
deaf to Jackson's aggressive/defensive manner, but he was quite aware of
the hostility. Later when the Pollocks were in their worst financial straits,
he bought a couple of pictures.

On behalf of Lee, Mercedes and Herbert Matter brought Alexander
Calder to see Jackson's work, but Calder found it rather too "dense."
However, the Matters' next introduction, James Johnson Sweeney of the
Museum of Modern Art, bore fruit.

MERCEDES MATTER: Sweeney was not one to put himself out on
a limb, but Herbert said here was a young unknown that he just had to
look at. Sweeney's respect for Herbert's judgment was so great, he be-
came interested in Jackson.

One of Jackson's better oils this year was *The Moon-Woman* (1942), a
work quite removed from Benton and offering a suggestion of Jungian
archetypes with Picasso elements. It is an interesting contrast to *The
Moon-Woman Cuts the Circle* of c.1943.

DR. DELASZLO: How much he knew about Jungian theory is a big

question, but he may have known more than I thought. Henderson could have spoken with him more specifically about Jungian theory, and he is better at interpreting symbols than I. In the drawings Jackson brought in—about a dozen, given later to my son—there were very scattered symbols, and I would try to fish out various elements in spite of his long silences. He had an affinity for the moon, which I associated with the feminine element in his nature, and in these disparate drawings—little improvisations, or whatever you wish to call them—quite often a half moon would appear. Also, there would be a female figure vaguely reminiscent of a madonna.

There was a lingering suicidal element, as there tends to be with alcoholics, but in this period it was not excessive. In the only bigger work he brought in there are two rooms with barred windows—he had been taken to a police station—and within the upper right-hand corner there is something like a moon, dirty or darkened. In the center is someone hanging by a cord. I took it to be a hint of suicide, but I thought it was too delicate a subject to talk about.

Lee and Jackson signed a petition in May protesting Program cutbacks in the easel division, and that same month Sande began proceedings to have his name changed to McCoy, which he had been using to avoid showing that so many Pollocks were employed in the Program. During the summer Jackson worked under Lee doing window displays for the War Services Division of the Program, and that fall the McCoys moved to Deep River, Connecticut. There Sande had a defense job and later learned the silk screening craft from Bernard Steffan. Lee joined Jackson in the 8th Street apartment, and in December he made his first appearance at the Metropolitan Museum with *The Flame* (c. 1934–38) in the "Artists for Victory" show.

When his Program employment was terminated at the end of January 1943, Jackson had a try at the sheet metal trade, hand-painting neckties and decorating lipsticks. The only positive element in this bleak period was meeting other artists. Although Jackson refused to appear in the major "First Papers of Surrealism" exhibit, which was sponsored by French Relief Societies at the Whitelaw Reed Mansion, he and Lee joined Robert Motherwell, William Baziotes, Peter Busa and Jerome Kamrowski in sessions led by Matta exploring creative expression of the unconscious.

ROBERT MOTHERWELL: Matta rightly thought the Surrealists hadn't carried their theory of psychic automation as far as they could have. In Freudian terms it is roughly equivalent to free association, and if I put it that way Pollock dug it. To de Kooning or Hofmann, it wouldn't have meant anything; they were oriented toward the European hostility

to psychoanalytic thinking. When we went to visit de Kooning, he was sleepy and uninterested; maybe he forgot we were coming. Just Pollock and I went to Hofmann's studio, hung with works by Léger, Miró, Braque, etc. As I heard my voice I saw the absurdity of a twenty-year-old lecturing a sixty-year-old on the future of painting. Of course, it was the enormous enthusiasm Matta and I had in those days which carried us along.

We were drinking from a jug of wine when there was a phenomenon like changing gears in a car; Pollock's whole expression changed, literally in seconds, and his eyes became glazed—a real Jekyll and Hyde. Jackson and Hofmann both lived on the top floors of their buildings, so Hofmann, in his sixties, and I had to drag him down five or six flights, then along 8th Street to his building's foyer. We buzzed his apartment but no answer.

Hofmann tried to persuade him to give us the key so we could help him upstairs. Pollock would pull it out of his watch pocket and as we would go for it, he'd put it back in again with a kind of smile. Finally, he leaned farther toward Hofmann with the key and Hofmann tried to grab it. Pollock lurched back too suddenly and fell, hitting his head against a marble dado and was absolutely out. We looked at each other in horror and thinking maybe the guy was dead. What to do—get a doctor? We stood there confused; it was all so sudden and unexpected. One of us got the key—by then Hofmann was puffing—and I had never been through anything like this. I was getting more and more furious at this unconscious Pollock putting an older man through it all, but we dragged him up all the way to the top floor. We were trying to open the apartment door when Lee opened it; she'd been there all the time but wasn't answering. I was so enraged by that, we just dropped him. And to this day I have no idea what was going on in her mind.

Over the next couple of years we made so-called automatic forms with Baziotes and our wives, each taking a line and so on. I was the literary person in the group, and eventually we realized it was really sort of nonsense, not interesting. Only after fifteen years of exposure to the art world did it occur to me that Pollock showed the most interest because he was the most interested in getting to Peggy Guggenheim. She had opened her Art of This Century gallery and he was ambitious.

Nowadays his would be called a left-handed intelligence, an instinctive intelligence, but along with it was a demonic quality. Many people are uncritically attracted, almost sexually, to this kind of explosiveness. He was so involved with his uncontrollable neuroses and demons that I occasionally see him like Marlon Brando in scenes from *A Streetcar Named Desire*—only Brando was much more controlled than Pollock.

A member of the wealthy copper mining family, Peggy Guggenheim could afford to be a patron of the avant-garde. Among her advisors were

André Breton, Marcel Duchamp, Sir Herbert Read, and the pioneering director of MOMA, Alfred Barr, Jr. Peggy's collection was formed in Europe, where she knew and supported Surrealists among others. She eventually married Max Ernst, whom she brought to this country in 1941 with a refugee contingent, and had Frederick Kiesler design the interior of her Art of This Century gallery with flashing lights and curved walls; there was a prohibition against frames. The gallery was an instant public relations success. Among Peggy's assistants were Jimmy Ernst, Max's son by a previous marriage.

JIMMY ERNST: I was kind of afraid of Pollock—not very outgoing and very tense. He came to look Eleanora Lust's gallery over and Eleanora was so scared she got rid of him. I was in awe of his desperation; I never met a man like him. Max and Pollock were men possessed, but Pollock lacked the charm and wit of Max. There was a difference in background, each bringing the environment which formed them.

As for Peggy, she could be self-effacing but with clatter and noise. There was a dependence: she needed to love; Max, maybe, to be loved. But Jackson, I always felt, was a man looking into the rain, a hard-driving rain.

ROBERT MOTHERWELL: Peggy had planned an international show of collages by Ernst, Picasso and Braque, and she had already registered Pollock, myself and Baziotes as interesting young artists. The Surrealists were always interested in the young ones, believing there is a particular quality they have, such as Rimbaud and the early de Chirico.

Pollock and I were scared of collage yet wanted to be in such a beautiful show. We spent a long afternoon in his studio and made one or two collages. He had no particular feel for collage, but I remember being surprised at the violence of his attack on the material.

Shortly after the collage show in April of 1943, Peggy adopted Sir Herbert Read's idea of having a "spring salon" for young artists and appointed a jury consisting of herself, Barr, Sweeney, James Thrall Soby, Mondrian, Duchamp, and Howard Putzel.

JIMMY ERNST: Painters were asked to bring in three or four works for final selection by the jury members. Mondrian came in very early and looked at the paintings while Peggy and I rushed around arranging things. But then he came to the Pollocks—I can't remember what they were, but it was before the drip period—good paintings, interesting paintings. *Stenographic Figure* (c. 1942) was one.

Peggy stopped next to him and looked at the Pollock he was looking at. "Awful," she said. "Dreadful, isn't it?" and walked away. After a while she came back and he was still there. She said, "It's so disorganized. There's

no discipline and the color is muddy in places." Then she walked away again, but Mondrian went on looking. When she came back, she said, "You're still standing here? I think it's an awful work."

Mondrian, still looking, said, "I'm not so sure . . . I'm trying to understand what's happening here. I believe it's the most interesting work I've seen in America yet."

"You of all people, you? The way you paint, *you* like this work?"

"Well, merely because my work seems serene doesn't mean I can't admire other work."

Now, this is not against Peggy, but when Barr came in, she pulled him over to the Pollock and said, "Look what an exciting new thing we have here!"

DENISE HARE: Marcel Duchamp designed the poster for the show and didn't know Jackson well. He made fun of Jackson as a person—he had no judgment about people, just about art—and when the show closed, Jackson ripped the poster off the wall, tore it up and made it into a ball. He handed it to Marcel saying, "You know where this goes."

The exhibition brought Jackson recognition from important critics such as Robert Coates of *The New Yorker* and Clement Greenberg of *Partisan Review*. Then John Graham made it possible for Jackson to be hired by the Baroness Hilla Rebay, director of the Museum of Non-Objective Painting (later the Solomon R. Guggenheim Museum). Her patron was Solomon Guggenheim, Peggy's uncle, and her lover was Rudolf Bauer, whose work was much in evidence along with Kandinsky especially, and Chagall, Robert Delaunay, Jean Arp and Moholy-Nagy. Because of the Museum's emphasis on Bauer, Peggy called it a joke.

LELAND BELL: These people Pollock didn't love. He was a general workbody downstairs, mostly putting silver leaf on baguette frames. He'd say, "Arp—blah-h-h! I could do an Arp easy!" He'd make faces about Mondrian, whom I knew well because he loved jazz and I'm a jazz drummer; and Klee, particularly Klee, because he rarely did large work. "Monumentality," I'd say, "is a measure and has nothing to do with physical size. Rembrandt did things you can do on a letterhead." But those things to Pollock were "Blah-h-h!" As for the Baroness's Kandinskys, we agreed at least he's a painter . . . but her Bauer—really!

The de Niros, parents of the movie star Robert, told me they'd copy from exhibit catalogues, things like Kandinsky, and take them to the museum where Bob de Niro Senior was a guard. They said I could do what they were doing and I explained that as an abstract painter I wouldn't have to fake it; I'd take my own *real* work there.

I went with them and our work was laid out on a low bench. The

Baroness came along with Rudolf Bauer, who was perfect to play a Junker general: snow-white hair, mustache, four-in-hand tie with pearl stickpin, gray spats, wide linen shirt cuffs with gold links. They were ramrod stiff as they looked at each work, then said separately, "Cosmic." When they came to mine, which were only done the night before, they said, "*Nicht* cosmic, *nicht* cosmic." I was so mad others faked their stuff and mine was real, I walked out. But de Niro persuaded me to go to an opening at the Baroness's Carnegie Hall studio and told me not to say I was a painter but from out of town. So I did, all dressed up, and she hired me.

My first job was buying movie magazines and putting up with Bauer. My next job was to be at attention by the door clicking the counter when the Baroness would come in the morning with her entourage. Pollock was usually in the cellar, out of sight, but the Baroness had personal spies who would write down what staffers said to visitors asking questions about the collection. They didn't know about the flood where Pollock worked in the cellar, though.

There were exhibitions for young artists, one of whom entered an abstraction for the show. The Baroness added three big squares to it. He sued and won. Soon after Frank Lloyd Wright was there discussing a new building and you could see how the guy hated painting: He was knocking paintings with his cane. With *his* ego, you know he wasn't going to help painting any.

At this time, Jackson was worried because Peggy Guggenheim was going to bring Duchamp to see his work. I had been at his studio and was impressed by *The She-Wolf* and others of that period; there was a baroque force, grandiloquent handwriting you don't find in Klee or Gris. Anyway, Pollock was worried because Duchamp might say yes to Peggy Guggenheim and he'd get a show. "But," he says, "suppose it flops. Then the Baroness finds out I'm not non-objective, and I'll be fired!" Couple of weeks later, I sent some museum visitors to Mondrian's first one-man show; he made all this stuff we were showing look like shit. I was told by her I was disloyal to the museum and was fired.

ALFONSO OSSORIO: Jackson told me about that incident when he was working at the precursor of the Solomon Guggenheim Museum under the Baroness—it was all painted and hung with gray, Bach on the Muzak, and huge Bauers on the walls with hard-edge and mystical abstractions. Jackson took in a drawing to the old Kraut—well, this authoritarian German lady—and she said, "This and this is wrong, you see." Taking a ruler, she tore off piece after piece, so Jackson walked out and never went back.

• • •

However, Jackson was careful to write the Baroness how much he appreciated her criticism and for "the very pleasant period of employment." After his initial interview, Jackson had been almost obsequious by letter, and it brought a small check for painting materials. His three-month association with the Baroness really ended because Peggy Guggenheim offered him a show, which would mean a contract—he would be the only artist with a contract in Peggy's "stable." The Baroness later called his work "not even decoration—meaningless scribbles and scrawls."

Jackson's show, scheduled for November, had a catalogue introduction by Sweeney and would enlist Clement Greenberg as Pollock's foremost critical champion. Jackson's contract with the Art of This Century gallery was for a year with payment of $150 monthly; commission was one-third of sales, and if they didn't gross $2,700, the gallery would receive works in compensation.

JIMMY ERNST: Peggy was intrigued by Jackson as an artist and in spite of all the gossip, she had too many man/child things going to take him on that way. He was her discovery, even though Mondrian had to prod her. As in so many cases, she allowed herself to be prodded in the right direction. She was very proud of having helped Pollock, and she did. I don't know what would have happened to him at that time; nobody was going to take a chance on *that*. I don't see Sam Kootz, who opened a gallery soon after, doing it; he already had Motherwell.

Peggy worked very hard trying to sell him, but I think her hesitation to commit herself to buying more work when the contract ran out got in the way. That was part of her problem: money. She could be very generous, supporting people like Djuna Barnes, but she could be very tight when she had to lay money out for herself. There were petty things, like charging a quarter admission to the gallery; it didn't make up the deficit obviously, but it was that people *should* pay to come in. She said that Jackson always reminded her of a trapped animal who should have stayed in his burrow.

Peggy, who had taken a duplex apartment on East 61st Street with Kenneth McPherson, commissioned Jackson to do a mural for its large foyer. It was to be about eight feet by twenty feet and, at the suggestion of Marcel Duchamp, on canvas. It was to have been on view by the time of Jackson's November show, but works for the show itself were all he could handle. Jackson spent much time looking at the great expanse of canvas, for which he had to tear out a partition in the 8th Street apartment; awed by the prospect, he wrote Charles he found it "exciting as hell."

Jackson was to look back on this period as one in which so many things went right, he thought they would go on that way and that maybe they would have if he'd "stayed with it." This was a favorite phrase, as was his "it works" about anything creative deserving praise.

DR. DELASZLO: When I met Lee I could sense she was going to take over and that would exclude me. Jackson had made enough progress so perhaps he was threatened. She became supportive; as an emotional dependent, he had a need to find a refuge source, usually in women. I respected Lee and thought that she was doing an excellent job with him; she knew exactly what she was doing and she was exactly what he needed at the time.

She was well grounded, had a strong will and was success-oriented. Also, she compensated for what he didn't have—life know-how, really— and she saw his potential and felt that he could do anything creatively. But Lee was very possessive and so she was threatened by anyone else on whom he was dependent. I don't think he could have functioned without Lee and this dependency of his was bound to end in antagonism.

I liked Jackson's work and though he said I could have any painting I wanted, I didn't wish to confuse the professional relationship. I have come to the conclusion that he was much more conscious in his work than I assumed. As to the termination of our sessions, I saw it as a natural thing. It had been a very nice relationship actually, and I had great sympathy for Jackson.

Lee brought the dealer Sidney Janis to see Jackson's work and he was so taken by *Male and Female in Search of a Symbol* (1943) that he tried, as acquisitions committee member, to persuade MOMA to purchase it; failing in this attempt, he had it reproduced in color in his book, *Abstract and Expressionist Art in America*. Later, at Janis's urging, MOMA did buy *The She-Wolf*.

Nothing sold at Jackson's opening in this his first show at Art of This Century, but Peggy Guggenheim was pleased by the reception of the work nevertheless and was soon calling Jackson the greatest painter since Picasso. It helped her to be patient while awaiting the large mural for her duplex, which finally was delivered in January of 1944.

JOHN LITTLE: Jackson had been staring at it for months, Lee told me. She had been away to see her father who was sick, and when she came back there still wasn't a stroke on it. She told me that in the evening, and when I saw her the next morning, she said Jackson suddenly got going and did it at one long session. It was Lee, I think, who gave it its title, one as accurate as she was: *Mural*.

• • •

The installation of *Mural* meant a tortured day for Jackson—it was a little big for the space—and Marcel Duchamp finally installed the work with a frame-maker. By the time it was in place, Jackson was far enough gone to walk naked into a gathering in Peggy's living room and urinate into the fireplace.

CLEMENT GREENBERG: Howard Putzel told me they had this great painter at Art of This Century and showed me some things in the back room. They were beyond me, but then I saw others a few months later and they weren't beyond me, but they weren't that good either. But I thought his first show there was good and reviewed it in *The Nation*. And when I saw *Mural*—it was great. People were saying it goes on and on repeating itself, but I told Jackson, "*That* is great art."

Mural was shown at both MOMA and Yale University in 1947, by which time Peggy was giving up her apartment. She offered the mural to Yale and was rejected, but the University of Iowa accepted it the next year.

CILE DOWNS: I graduated from Iowa in 1950, and they had a Benton in the lobby of the main building to show how proud they were of it. But there was big hostility about what was going on in New York. Philip Guston had been there and was a great favorite, but he went to New York and joined the Abstract Expressionists. This was a terrible thing, made him a renegade.

The Benton was a good painting and so was the Pollock, only it sure wasn't hung in the lobby. It was in this enormous barn called The Mural Studio, hung high up in the rafters over the end of the building where I worked. So I was familiar with it, and I was familiar with not thinking well of it because we didn't think well of the painter. Above the Pollock were girders where sparrows sat and let go their droppings, which fell across the Pollock—utterly appropriate. We would jeer and laugh about how it was getting better and better with each plop.

REGGIE WILSON: One didn't know where Pollock's work was going when I went into the military, but it was going somewhere—really moving. I wondered what the hell was going to happen to Jack, but when I came home I saw him in 8th Street and my God, he'd filled the place with paintings! He was so quiet about it, I thought he didn't know how good it all was. And I was overwhelmed by that *She-Wolf,* but he didn't say a word. He just showed the work.

Peggy renewed Jackson's contract in April and Sande wrote Charles that Jack was handling his "slight recognition" well: *Guardians of the Secret*

was in a show at the Cincinnati Art Museum that spring, and *Arts &
Architecture* carried an interview with him in February. In this Jackson
mentioned that he was impressed by the vision of American Indian art
and its plastic qualities with color essentially so western. He went on to
say that references to such work in his own paintings and to calligraphy
were not intentional, adding that only Ryder among the American paint-
ers really interested him. As to the Europeans, he was very drawn by the
concept of art stemming from the unconscious, and admired most Miró
and Picasso.

In May of 1944, the sale of *The She-Wolf* to MOMA went through, and
a reproduction appeared in *Harper's Bazaar*. This was the first work by
Pollock to be acquired by a museum. Jackson told Sidney Janis that to try
to explain his painting would destroy it.

Lee and Jackson spent part of the summer in Provincetown, a period
which gave birth to Pollock "statements" not wholly his. The elegance of
a much-quoted remark—"I choose to veil the image"—is less Jackson's
way with words than Lee's.

FRITZ BULTMAN: One evening when we were building our house
in Provincetown, Jackson was trying to get across to Hans Hofmann his
concept of the image: that you could paint from nature, which Hans was
doing, but that if you painted out of yourself you created an image larger
than a landscape. Hans disagreed with him in principle, and finally in
talking about the origin of the image, Jackson said, "I *am* nature." This
has been quoted endlessly in one form or another. Lee, of course, was
not in favor of any things she didn't control. She wanted to pull all the
strings—everything had to be hers or not at all. As Tony Smith said, "She
doesn't recognize the difference between power and *power*."

REUBEN KADISH: They were competitive then, so much so that
Lee couldn't work in the same house as Jackson, and I rented her a room
in my studio. Of course, he was only dedicated to the big time, so to
speak; Jack wasn't going to be a small person. But *he* would never have
tried rewriting history: Stalin thought he could do it in politics; Lee
thought she could do it in art.

Everything about Jackson has begun to build into absolute fantasy—it
levitates. The other day a student was sent to me by Dore Ashton for
help on a paper about Pollock, and he went into this thing about how
Jack did these Navajo Indian dances before he worked, he was so influ-
enced by sand painting! I think Jack had this pictorial idea of a western
personality and acted it out. Now everyone thinks this guy was a cowboy
who rides into town and things like that.

ROBERT MOTHERWELL: Lee inherited this power to destroy his-
tory; by rewriting history she destroyed the context within which Pollock

lived. When I told Brian Robertson, who did one of the first monographs
on Pollock, that there's an awful lot of information not in his book, he
replied to the effect that the condition set by Lee under which he wrote it
was that he speak to nobody else.

B. H. FRIEDMAN: I don't think most of the famous written Pollock
statements are by Pollock entirely. I don't doubt that Lee was in on much
of this and she was very loath to talk about any of that. When Robertson
did his book, Lee presented Jackson as a man who was just as interested
in classical music as in jazz; and then his being a reader and all those
books in his *library*—I just don't think that was the scene. Jackson was not
involved with serious music and he was not a literary man and he was not
an intellectual. To talk about the accuracy of any of Jackson's state-
ments—that Lee had some idea later which were sacredly Jackson's
words and which were casual conversations—opens up a huge box. I
think it's perverse—more than perverse, it's protective of a kind of
mythic reputation.

Due in part to a lengthy visit by Stella, that Provincetown summer of
1944 was not productive for Jackson or for Lee, who used Hofmann's
classroom as a studio. She was verging on a style she later called her
"mud period" and her work was little seen, except in the previous year at
the Riverside Museum shortly before she turned down Peggy Gug-
genheim's invitation to be in a show of women artists. Janis did re-
produce her *Untitled* in his book, but Lee had begun destroying work that
she wasn't happy about, with the result that there are few examples left
of this stage of her development.
On their return to New York in the fall, Jackson and Lee established a
long-term relationship with the homeopathic physician, Dr. Elizabeth
Hubbard, whom they had met the previous year through the Matters.
Dr. Hubbard's herbal remedies and naturopath approach were helpful
with Jackson's drinking problem, at least at first, and Lee's chronic ten-
dency to colitis was eased to the extent that Dr. Hubbard was recom-
mended to Stella and became her "favorite doctor."
Also that fall Jackson became more actively involved in graphics under
the guidance of the British printmaker Stanley William Hayter at his
Atelier 17, a renowned graphics studio transposed from Paris.

STANLEY WILLIAM HAYTER: I don't see members of the
Atelier as students but associates, and instruction is limited to guidance
with criticism solely technical. I have always approached the associates
with a Socratic manner by questioning, and all our devices at the Atelier
belong to whoever does them best. This idea that I taught Picasso, inci-

dentally, is bullshit. Picasso was a man who could take from anybody because he had enough wit to do so; since he did it better than they did, it's his. The people we wanted in the Atelier were those who were discontented with what they were doing and wanted to learn.

The great thing lacking in New York were cafés, a place to sit down and talk, and the Atelier when we were at 43 East 8th Street was that kind of place. Jack saw a lot of people of different nationalities there—André Masson, Marc Chagall, Miró, and so on—and Matta and Isamu Noguchi were frequent visitors. Jack, who by the way never mentioned his own father, had found a substitute one in Benton and in me a friend but not, as has been said, another older brother. He didn't treat me with any degree of veneration—we didn't play it that way—but he trusted me and I trusted him. The growth of the Pollock myth is troubling, so absurd in fact that a Paris neighbor of mine insists that he met Pollock there!

When half drunk, Jack could talk intelligently about the source of inspiration and about the limits of working from the unconscious; he pointed out that there is a problem when you have plumbed its depths in how to go beyond that level and produce further content. Later, when we drank at the White Horse, what horrified me and left me feeling helpless was Jack's drinking not to feel good but to *hurt* himself.

ISAMU NOGUCHI: Jackson, always quiet and diffident with me, never pretended to be more than what he considered himself to be; I also am prone to that attitude of being just a fluke. I like to think of myself as *guided,* and I think Jackson saw in himself a mystical link—a sort of medium. And Jackson was guided by a definite apparition, meaning Lee. She was the agent, be it angel or witch.

That fall Jackson saw Dorothy Miller, who worked closely with MOMA'S director, Alfred Barr, Jr., several times with her husband, Holger Cahill, the founding director of the WPA Program.

DOROTHY MILLER: Alfred and I tried to cover the waterfront in terms of seeing the dealer galleries, but because of the demands of the Museum we had to have them open for us on Saturdays; now they all do and close on Mondays. Even Peggy Guggenheim was accommodating— a crazy character very hard for me to get along with, as she simply hated women, but she did show Pollock's early things.

He, of course, was a legend in his own time—gentle and quiet—and had lunch once with us near the Museum. He didn't say a word—just sat there listening to Alfred talk all through the meal. When finally Alfred asked some questions, his answers were to the point. And it wasn't a strain, either—in fact, a very pleasant lunch, and I thought him very touching.

• • •

During the fall and winter of 1944 Jackson worked on what would be his second show at Art of This Century, scheduled for March 19–April 14, 1945. It was during this period that a friend and advisor of Peggy's, William M.N. Davis, together with Howard Putzel, persuaded her to increase Jackson's monthly stipend to $300, with Lee still to retain one painting each year.

The show, consisting of thirteen oils, drawings, and gouaches, had a good reception but poor financial returns. Peggy later noted that she never sold a Pollock for more than $1,000 and that Lee became a millionaire while she, Peggy, could only think what a fool she had been. As usual, there was adverse comment from the critics: ". . . explosion in a shingle factory," ". . . emotions not even his analysts could take." But in Greenberg's review, Jackson was the "strongest painter of his generation . . . not afraid to look ugly. All profoundly original art looks ugly at first."

Peggy took offense at Dorothy Miller's refusal to include Jackson in the 1946 traveling show she was then planning for MOMA, *Twelve Young Americans*. She complained to Alfred Barr, who told her it was Dorothy's show, not his.

DOROTHY MILLER: Jackson was very young and I just wasn't ready to show him. Although some work in his show was very big and very handsome, others didn't quite make it. The Museum only allowed me to do these shows occasionally, as they scared certain trustees out of their wits who, after a year or so, would say how wonderful it was to have Clyfford Still or . . . But I did show Jackson in '52.

Greenberg was beginning to be attacked by the cognoscenti of the art world for his championing of Jackson:

CLEMENT GREENBERG: Look, there was a lot there. He had that thing: "This guy's got to be a great artist," and without looking at the pictures. Also, he had Lee behind him, even if I do have to put myself there too. I went for his all-over approach from *Mural* on.

The Hayters rented a fishing shack at Louse Point on Gardiners Bay in East Hampton Township that summer, with a leaky roof, a hand pump, and no electricity. But Hayter, who had to go to New York for Atelier 17, found it too far by bike from the railroad station and turned it over to Barbara and Reuben Kadish, who invited the Pollocks to join them.

BARBARA KADISH: I remember Jack as this nice person with a sense of humor. Lee was furious, though, when he and Rube were racing on their bikes and hit fresh tar on a part of the road undergoing repair. Down both went and came back covered with it.

STANLEY WILLIAM HAYTER: This idea of being hairy-chested men and superior to women—bugger! Jackson owed a great deal to Lee, including a truly great clam chowder. Rube, Jack, and I used to dig the clams down there—it was easy then.

REUBEN KADISH: Whenever Jack disappeared, Lee would be frantic and blaming everybody. Of course, when he was drunk he was *impossible!* Lee would say for hours, "Jackson will be here any minute—Jackson will be here any minute." Then all of a sudden, here would come this guy—dirty, filthy drunk, falling all over the place. There are people-users who offer you no rewards, but with Jack there were a hell of a lot of rewards.

He had always been an exciting guy to be around: Phenomena—a storm, it didn't matter what—always excited him. When he hooked a blowfish and pulled it out of the water, the thing began puffing up. Jack was jumping up and down, he was so excited. He was a pantheist.

MAY TABAK: The roof of the house my husband, Harold Rosenberg, and I bought in Springs was leaking, so I asked Reuben Kadish if he would fix it. I didn't want Harold with his bad leg up there, and sculptors like Rube who work in metal are handy with tools. So Rube and Jackson as his helper came and climbed up on the roof, saying the first thing they had to have was plenty of beer.

While I got it, they looked at the view. It was quite beautiful then—no houses, just in the middle of nothing. Once they had the beer they started working, but by lunchtime they had run out of beer. I brought more beer, then made lunch while they told jokes, sang songs, and drank beer. But all the time Jackson was watching the children—our Patia, about three, and the little Kadish boys. He was crazy about children.

BARBARA KADISH: It was a lovely summer—not the two weeks it has been called, or the mere weekend Lee remembered—and Jack and Lee were very friendly. I never understood why people said awful stuff about Jack; I just remember this lovely person and what a nice time we all had.

The Kadishes bought a farm in New Jersey eventually, having looked at a house in Amagansett that summer with the Pollocks. While out there Jackson became intrigued by the idea of year-round living on Long Island's South Fork, but when the possibility became serious he changed his mind. However, after three days on the sofa in the 8th Street apartment, he told Lee they had to have another look at that Amagansett house, dismissing her objection that there was money neither for renting nor buying. Years later he said that on the sofa he realized two things: He would always be homeless inside; outside he had found home. Did he mean Lee or East Hampton? It wasn't the kind of thing you asked Jackson.

PART TWO

CHAPTER FOUR
"CRAZY ARTIST"

East Hampton seemed so much "home" to Jackson that he insisted they look for another house when they learned the Amagansett one was no longer on the market. The Springs general store owner, Daniel Miller, referred them to a real estate agent, Edward F. Cook, who told them some local history while showing them houses.

Springs, still called The Springs by preservationists, is a bayside hamlet in East Hampton Township, which includes Wainscott, part of Sag Harbor, Amagansett, Montauk, and the Incorporated Village of East Hampton itself. A self-sufficient farming and fishing community, Springs was as little affected by the Depression as it was by World War II. But the Village of East Hampton had already become a Long Island summer resort second only to Southampton by the time of the '29 Crash.

At the turn of the century, East Hampton boasted several large studios sited for the painter's preferred north light. Among the artists spending time there were Hamilton King, Maude Jewett, Thomas Moran, Childe Hassam, Winslow Homer, Adele and Albert Herter, and the sculptor John Hayward Roudebush. Visitors from New York's art world included Louis Comfort Tiffany, Robert Henri, and Augustus Saint-Gaudens.

In the early forties, East Hampton's economy, based on a mix of potato farming, fishing, and a wealthy summer colony, was showing the effects of the Depression and World War II gas rationing. The summer colony dwindled, so lawns grew wild, roofs leaked, gravel drives washed out, and bittersweet and bullbriers overran the gardens. Jobs were scarce; the young who had gone to war or to defense plants saw little future on the South Fork.

The new wave of artists appearing about this time did little to change the sense of desertion, even though their ideas of art and culture ag-

gressively challenged all standard notions: Max Ernst, Jean Hélion, Motherwell, Matta, Duchamp, Lawrence Vail, and Noguchi.

HELEN PHILLIPS: There were so many Surrealists there in summer that a pair of women all dressed up stopped me on Amagansett Main Street and said, "We're from Southampton. Can you tell us where we'll find the Surrealists?" The Europeans did stick together actually, and none of us had much money, which is why we were there. That and Provincetown being too far from New York.

EDWARD F. COOK: The Pollocks stayed in a house Motherwell had on Fireplace Road in Springs, not far from the house they settled on. Pollock had no money at all but access to some, I guess. Anyway, he knew enough about money to want to own instead of paying it out on rent with nothing to show.

The property Cook showed Jackson could be rented for forty dollars a month with option to purchase at $5,000, all cash. Included were five acres, a barn, several small outbuildings, and a superb view of Accabonac Harbor from its west side. The house was a standard turn-of-the-century farm design, with two floors, and front and back porches. There was a kitchen wet sink but no bathroom or central heating. Electricity and a water pump in the cellar were a great advance over the primitive conditions at Louse Point, but for transportation the Pollocks remained dependent on bicycles and rides from neighbors.

The purchase was financed by a $3,000 local bank mortgage, with the balance being wrung from Peggy Guggenheim as an interest-free loan to be repaid at the rate of fifty dollars a month in addition to all Jackson's paintings, except for one to be retained by Lee annually. Peggy, unwell, was worn down by Lee's daily visits to her sickbed and confessed it was the only way to get rid of Lee. (Neither realized that in fifteen years they would be in litigation over Peggy's not receiving her full due in paintings.)

The combination of the recent death of Lee's father and Jackson's concern for their new neighbors' sense of propriety led them to discuss marriage. Soon Lee was saying that after three years of having lived together, it was either marriage or farewell. She wanted a civil ceremony, but Jackson insisted on a church wedding. Arrangements were made with Marble Collegiate Church, but by neither bride nor groom. The ceremony was scheduled for October 25, 1945.

MAY TABAK: I made this big thing about it, telling the minister, "Understand, he is part of some remote thing I don't know anything about, and she is Jewish." He said God would understand.

Lee wanted Peggy Guggenheim, Harold Rosenberg, and me as witnesses. Jackson wanted only me. Lee was taken aback at not having Harold, but Jackson said it would just be the three of us at the wedding. Lee still wanted Peggy, just had to have her; then Jackson weakened because Peggy was advancing them money.

But then Peggy backed out, so the three of us went and the church cleaning woman was the second witness. The minister gave the most beautiful speech about "We are all different yet one." Then I took the three of us to lunch—Jackson didn't want to call Harold—and it was all very moving.

Jay Pollock, by now working for the Cuneo Press's rotogravure department, went with Alma that afternoon to call on the newly married couple at 8th Street.

JAY POLLOCK: I couldn't see any before-and-after difference in Jack, except he looked kind of sheepish.

ALMA POLLOCK: I felt awkward because of telling Lee it was nice to have her officially in the family—such a gauche remark. Anyway, the marriage gave Lee more control, which is why it took place. And it didn't take place until she was pretty sure he was going to make it.

When the newlyweds moved to Springs in November, Jay and Alma took over the 8th Street apartment, sharing it with the painters James and Charlotte Park Brooks.

ALMA POLLOCK: Our bedroom at 8th Street was small; the Brookses had the big studio room—and our bed was practically under a painting covering one whole wall, a very violent painting. You remember *Circumcision*? Well, we'd wake up in the morning and first thing there was this *Circumcision*! And that name on top of everything else to wake up to! You couldn't see anything except violence or—I don't know what.

The move to Springs was made for fifty dollars in a truck borrowed by May Tabak's brother, a butcher. The new house was cluttered with broken furniture and kitchen items, the barn with worn-out farm and road equipment. Jackson saved some of the equipment along with rusted tools for their design.

Both Lee and Peggy hoped he would drink less in East Hampton, but his November 10 letter to the Kadishes sounds as if the alcohol problem joined him in his new home. He hit a new low.

Jackson worked for his third one-man show at Art of This Century, scheduled for early April 1946, in an upstairs bedroom. Such work as

Lee did, aside from settling the house, was attempted in the living room where heating by stove was a problem. The kitchen had a range, however, and some Pollock family members came for Thanksgiving.

During that winter of 1946 Jackson painted his canvases not on an easel but on the floor. It seemed to suit his feeling for abstractions, and he would compare it later to the Southwest Indians' approach to sand paintings.

REUBEN KADISH: Jack's brother, Jay, had a collection of Navajo rugs, stacks of them. Jack, Sande, and I used to look at them, and we looked a lot too at the work in the Museum of Natural History. In a lot of Jack's drawings you can see motifs with such reference points.

PETER BUSA: Jack had a feeling for the transformation that the mythology of Northwest Indians have—a bird turns into a man or something. He thought the idea which Indians worked with was beyond Picasso's preoccupation with Cubism, and he would talk about the spaces around the objects. He liked the sand paintings for their flatness and he was intrigued by the spatial idea—which is negative, which is positive. But there were a lot of contradictions in Jack, like that tremendous sense of doubt about his work—how good it was—and about himself.

PATSY SOUTHGATE: The reason he put his canvas on the floor, he said, came out of his childhood. The thing he had really liked then was standing beside his father on a flat rock pissing. He was really tickled, you know, when he watched and said to himself, "When I grow up, am I ever going to do that!" This theory says "*Now* I'm going to show Dad!"

Native residents of Springs call themselves Bonackers, a proud claim stemming from Accabonac Harbor and Creek. Members of East Hampton's English settler families used to say of them that "Bonackers are Bonackers and that's enough for *them*."

FRANK DAYTON: That was quite a drive with a wagon and team on sand roads to Springs when I was a boy . . . I remember my first look at Pollock: He came along with a fellow I knew and I could see right away he wasn't from there. I asked this fellow later who he was. "Oh," he said, "that's just a crazy artist."

EDWARD F. COOK: Before long folks were saying he painted with a broom. Near everybody made jokes about his paintings, never thought they'd amount to anything, and neither one of the Pollocks was tuned into the community. It's surprising, folks who'd been there for generations would accept people like that. But they're pretty broad-minded except about outsiders working the bay bottom in a bad scalloping year.

MRS. NINA FEDERICO: When he first moved in he didn't have anything, so he came every day to my restaurant, Jungle Pete's, for eggs and home fries, toast and coffee. He was hungry and I wouldn't turn a dog away if it's hungry. Then he asked if he could borrow two dollars, so I thought what can you lose for two dollars? Later he bought a second-hand bike and would come evenings on the bike for beers; he didn't always get home on the bike. To us he was just a poor man in dungarees and a jacket, but he always paid back loans. I wish now I'd taken his paintings.

MRS. MARY LOUISE DODGE: There was a knock on the door one night and it was late for us, being used to wartime blackouts. Here was this fellow wanting to see the Justice—my father had been justice of the peace—and he had to see him because he'd lost his key. Why, he thought one key would fit all the doors on Fireplace Road! Well, it being that late at night, we were scared but when we came to know him, he expressed real sympathy on the loss of our dog. That was nice, we thought.

GEORGE SID MILLER: Pollock and I met up at Joe Loris's bar in the old East Hampton Hotel. He was new in town—somebody introduced him—and after we talked a while, he said, "I'm going to be a Bonacker same as you some day." I said what I tell them all: "You only got to wait four hundred years."

To some goody-goody people he was a bum, just someone to laugh at. Folks didn't think much of his work, didn't think he was doing anything. They didn't know what to make of it, let alone him.

ROGER WILCOX: Living in Amagansett year round—John Cage said we were on the right side of the tracks and the wrong side of the town dump—we saw a lot of the Pollocks then. They made a good team, and while he was drinking off and on, it wasn't to the extent of later years. Lee devoted much more time to taking care of him than she did to her work—she believed in him and he was difficult with her but supportive mostly.

Lee's own works in that period—they later became known as her little image paintings—bore a mosaic influence. She also worked on two sizable circular mosaic tables that Jackson helped her with. The larger of the two was given later to Valentine and Happy Macy, a Westchester couple living year round in East Hampton and both patrons of and worriers about Jackson. Jackson later explained that since they didn't seem to like looking at his work, the Macys might enjoy using Lee's creation as a coffee table.

LAWRENCE LARKIN: Those tables Lee got the credit for were made by Jackson. I saw one in his studio that was finished and one in progress, and he explained to me the way he worked on them. Of course, people could use tables and they didn't have to keep saying "What does it mean?" the way they did about his paintings. Maidstone Club friends and even Guild Hall patrons thought we had our Pollock painting as a joke or to be kind. It was ten inches high and ten feet long (*Horizontal Composition, 1949*), and we paid forty cents a running foot. Later I nearly cut it in four pieces for sale.

During that winter of privation and isolation, Jackson designed the dust jacket for Peggy's memoirs, *Out of This Century,* and by spring he had the work for his third show at her gallery well along. *The Key* was the last work done in the upstairs studio and belongs to the *Accabonac Creek* series.

The exhibition offered eleven oils and eight temperas (not all done in Springs) and demonstrated a further stage in the development from the Piccasoid and Cubist influence toward the all-over approach, with a technique uniquely Pollock's. The show did not earn the kind of praise Greenberg gave Jackson's *Two* (c. 1945), which he called the best painting in the previous year's Whitney Annual. Still, there was enough interest in Jackson's work to encourage him to move the barn and convert it into a studio during the summer.

The moving of the barn opened up the superb view of Accabonac Creek; conversion of the barn opened up Jackson's work. Before long he was finding the new working area too small—about 18′ × 24′. With his technique freed further, more and more he found himself painting not by brush but by pouring out paint straight from the can. In these so-called drip paintings, he used various devices to apply the paint from above onto the often unprimed canvas laid flat: hardened paint brushes, sticks, basters, funnels. Materials, too, were unusual: industrial commercial paint such as Duco, objects ranging from a cigarette to a shard of a Coca-Cola bottle, sand, ground glass, even a hand print.

These experiments developed gradually, but by late fall Jackson's production grew rapidly for what would be his final show at Art of This Century in January of 1947. Peggy had decided to close her gallery and return to Europe, causing Jackson much anxiety, although she tried to find a gallery to take him on before the show opened. Her lack of success was not reassuring.

JOHN LITTLE: They were really frightened, having no income, and Jackson was depressed. He would sit quietly, saying little ever, and it was a bad time.

• • •

That final show offered two groups of paintings—eight in the *Accabonac Creek* series and seven in the *Sounds in Grass* series—and his techniques for these included the use of both palette knife and paint tubes squeezed directly on the canvas. While the show was exciting for those able to read it in terms of the artist's development, there were the usual negative reactions in spite of Clement Greenberg's calling it Jackson's best show and writing in *The Nation* of the strength and tension in the work. He prophesied that Jackson would go beyond the easel picture into an all-over structure possibly akin to the mural.

CLEMENT GREENBERG: My beating the drum for Jackson had some effect, only the work didn't sell. After Peggy had gone to Europe, Jackson would get drunk and he'd call up at one in the morning, saying, "We don't have a penny! What the hell good is your praise!" Then I'd feel guilty that he'd become *notorious* without becoming *famous.*

In his application for a Guggenheim grant at this time, Jackson echoes Greenberg's thinking in saying he considered the easel picture as a dying form, with the future heading more toward wall pictures. His grant application was turned down, but Peggy persuaded Betty Parsons to take over the contract due to expire in 1948 and to give Jackson a one-man show.

BETTY PARSONS: Barney Newman, another member of the New York School with its energy and conviction, introduced me. I fell in love with the work of those painters. But Kurt Valentin [another dealer] said, "If *they're* good, I'm going blind and should get out of the business." I had seen some of Jackson's work at Peggy's, so terrific with creative energy and so American, and I spent a weekend with Jackson and Lee. At one point he sat on the floor and made a beautiful drawing for me which I call the *Ballet of the Insects*—it's *so* alive!

I was fascinated and told him I would like to have him. None of us, of course, had any money; my staff was all volunteer and I've always been on very thin ice with the gallery—very difficult but very interesting. It's part of my preferring to make a name than take one, perhaps. About his work I felt if it's too early it will right itself, so let it rip!

Betty scheduled Jackson's show at her gallery for January 5, 1948, after which the contract would expire. Jackson did have Peggy's monthly payments less loan repayment during this period, but Betty had only commission on works sold; Peggy received net sale receipts. Jackson, who replaced his lost Social Security card at this time, considered sign painting, fabric paintings, and even teaching as a way to keep going.

JULIAN LEVI: Jackson wanted to teach at the League and because I
had been teaching there so many years, he thought I could help place
him. I was careful not to hurt his feelings, of course, but because of his
behavior it couldn't be considered.

PETER BUSA: He wanted a job teaching at Cooper Union, but I said,
"What the hell would you teach, Jack?" He agreed with me.

Near the end of 1948, *Time* magazine ran a lead piece on the art page
headed "The Best?" Greenberg dealt with several artists besides Jackson,
such as Hans Hofmann and the sculptor David Smith, and it was to mean
much in the way of future publicity for Jackson—despite the fact that
The Key was printed upside down. By then Jackson felt he had mastered
control of his pouring technique to the extent that he could honestly say
the effect was not accidental but directed. The argument about that
continues, as does the question of the proper name for the New York
School style in which Jackson was becoming a leader: Harold Rosenberg
termed it Action Painting, the artist functioning in the "arena" of his
canvas; Robert Coates coined the phrase Abstract Expressionism. Other
names were suggested, including Abstract Symbolism, but the most accu-
rate (albeit undramatic) name was given the style by James Brooks: Di-
rect Painting.

In terms of material rewards, the show at Betty's was a bad start for him
with a new gallery. There were seventeen poured works, now considered
classics, but sales were slight and most reviews harsh. Robert Coates
was at least gentle about the originality of the work, saying that Pollock
was harder to understand than his peers but that there was tremen-
dous energy even if communication was sometimes lacking. And again,
Clement Greenberg championed his cause, stressing the importance
of *Cathedral*, and going so far as to forecast that in time Pollock could
equal John Marin as the greatest American painter of the twentieth
century.

BETTY PARSONS: We all helped in those days and we hung Jack-
son's shows together—Barney Newman and other friends—although
later at Sidney Janis's they had to wait to hang shows while they sobered
him up. Jackson behaved well at the opening, as he always did at mine,
but there was such hostility to the work—those reviews were terrible,
terrible. I felt so sorry for Jackson because of such few sales, there wasn't
enough being sorry left over for me to feel sorry for myself.

MILTON RESNICK: That was an interesting show. I went to it with
Bill de Kooning, only I didn't get something at first: Strangers kept
coming up to us to shake our hands. I looked at Bill and he said, "These

are all big shots. Jackson's broken the ice." And that's what Bill really meant by that famous line, that Jackson was the first of us to have success with people who were important. But that didn't make it any easier for Jackson; he was so nervous, in the middle of the opening he asked Bill and me to take a walk with him, get him out of there.

CLEMENT GREENBERG: Jackson wasn't capable of matching the image needed to appear in public, in official contexts—all the things that had to do with the world. But he made a point of dressing properly when he came to New York and had a gallery: tie, shirt, suit, all proper. He didn't want to look like a damned artist when he came to 57th Street, and I admired him for that. But there was the "I don't belong here; I can't act it; I can't do the right thing here; all these people and their pomp!" feeling in him. And they couldn't see the man or the genius. All they saw was a freak.

The poverty the Pollocks endured that winter brought them sympathy from their neighbors. The general store owner, Daniel T. Miller, said shortly before his death that it might have been easier had they not been city people and unused to the harsh elements, and that being "from away" made it harder for Bonackers to help them without offending them.

RICHARD T. TALMAGE: They were real cold—had to be, living in that big old house with just little stoves. There was a fireplace in the front room but the flue was no good, so they huddled around the stoves all winter—all they had.

JULIAN LEVI: It was a hard time—I'd take them shopping to East Hampton and help what I could—and they couldn't even raise one hundred dollars to buy an old car Jackson found. Yet there was always a pot of coffee on the range, and a neighborly country feeling to the house. It was harmonious then—any tensions were about lack of money—and circumstances kept them together. We'd talk only about practical things—gardens, chowders, and such—and that was mostly with Lee and me. As with Dan Miller, most of Jackson's conversation was an occasional grunt—he was all ears, few words. Even now I find the conditions they had to struggle with shocking.

BETTY PARSONS: I heard from people that sometimes there almost wasn't enough money to buy wood for the stoves, things were so bad. I tried to sell a few things by offering a discount—very unprofessional—and Peggy would have been furious. I even appealed to a couple of clients on a charity basis, an even worse mistake. Early that spring I managed to have Peggy let Jackson borrow, as it were, a few pictures

which would sell more easily and to keep the proceeds, replacing them with others so that Peggy was still getting hers—and she did, which is more than I can say looking back. A couple of times I felt so badly about the Pollocks' situation, my commission became theirs—whatever you want to call it. Never could such *small* money have been so huge for anyone!

The situation became so bad, some local people in Springs felt that the few townspeople on home relief were rich by comparison. As sympathy for them increased, however, it was accompanied by confirmation of the "crazy artist" speculation.

RICHARD T. TALMAGE: Even he said all he did was drop canvas on the floor and walk around it spilling paint. People didn't go along with his work; it wasn't painting, that's all. That was about the only painting talk he ever did; mostly his talk, what there was, had to do with the area. He loved Bonac Creek and all.

GEORGE SID MILLER: Pollock was famous with us early for dumping paint all over, and the stories kept growing. Cully Miller, a character here and odd-job man, was helping fix up Pollock's barn and was painting some trim—sash or something. He used a board about two feet long and maybe eight inches wide to clean his brush off, and threw it away. Pollock came along and said, "Jesus, don't throw that out!" He took the board and fooled with it, then looked around and took a can of rusty nails and threw them down on it and said, "Let that set." Cully said he got $1,800 for that board later.

PETER BLAKE: The Matters introduced me to Jackson, who invited me to his studio. I was absolutely overwhelmed—incredibly impressed. I'd heard a little about him but never seen any of his work, and it was— well, the sun was shining when I walked into his studio, shining in and into the paintings. It was like walking into the Hall of Mirrors at Versailles—dazzling, incredible! He didn't think much of architects, myself included. He'd say, "You architects think of my work as being a kind of wallpaper, potentially decorative." And whenever I said things about his work to him, there would be a smile—quizzical, not supercilious but a little pitying. It would say, "What can you expect from an architect?"

On the Pollocks' rare visits to New York they stayed at the 8th Street apartment with Alma and Jay Pollock and James and Charlotte Park Brooks.

JAMES BROOKS: I knew Sande well because he was my assistant on the WPA mural at the La Guardia overseas terminal, but Jackson I knew

only as being the up-and-coming when I went into the service and he was with Peggy Guggenheim. Her gallery was the start of the whole thing and—well, if you want to become an artist it's a good idea to stay out of the army, especially if it's five years.

At 8th Street, due to their staying in a tiny room, we got pretty well acquainted, although Jackson had a hard time talking, he was so shy. He was in conflict and with a few drinks he couldn't take things and would get pretty wild, but now there was no Sande to talk him out of it. I can't handle a drunk and avoided him when he was drinking, so I got the reputation of being afraid of him. As it happened, Jackson was afraid of other people when he *wasn't* drunk, as if he'd been put down or hurt. He was open to so many things, you know, and to be open hurts a great deal.

CHARLOTTE PARK BROOKS: Even at his worst there was an innocence about Jackson, but I don't agree with Jim that everybody felt as low as Jackson did. In terms of recognition for artists, the late forties were an exciting time. Nobody had any real recognition yet, or expected any, so there was a sharing among us.

JOHN LITTLE: I was staying at Hofmann's studio and would see them a lot (Jackson in bars such as the Hotel Albert more than I wanted to). One night a small patron had a very large nose which Jackson kept looking at, trying not to laugh. Finally, he drew my attention to it and the little man wanted to fight—was going to flatten Jackson's nose. Well, we were able to calm him down, bought him a drink. It wasn't that funny, the nose, but it was to Jackson—just the way he saw things sometimes. Lee was a better painter then and she would have developed as well, or even more, had there been no Jackson. As for Jackson without a Lee, it would be like American painting had there been no Hofmann.

I spent a weekend with them at Springs and they showed me a saltbox in Three Mile Harbor, what there was left of it. It moved me as did East Hampton's Main Street with hardly a car—just a tunnel under elms— and I bought it, roof leaking torrents and all. They were looking for company and used to come almost daily to see how work on my house was progressing and I would go back and have supper with them. The three of us would spend whole days in the woods like a family, and on the beach we would be the only people.

But at picnics beer would start him off and he would want to go to Jungle Pete's or someplace. Well, Jackson was that way—with drink he would tense up—and I would call him psychopathic. Yet he was a familiar man, like a lot I knew growing up in Alabama. He was a simple person—only complicated when putting on his act, which amounted to a nonsensical barbarism.

RONALD STEIN: They were lonely and would have me down a lot; because I was Lee's nephew and only still partly a kid, she wanted Jackson and me to get along. The conversations he and I had about art weren't the kind artists have but more like talking about hardware things. He was verbal with me but oblique, saying things I'd have to take to Lee for explanation; and if I didn't she would always question me about what he said. When something that was significant occurred to him, he had to say it right then in whatever form it took; it was irrepressible, like the way he painted: He'd go for a long time without doing anything, then the painting was all of a sudden sort of blurted out. But when he'd blurt words out they'd often embarrass him and he'd cover up with an attack of some kind. He never spoke of family, and when Lee did it was explosive—as if families somehow screw everybody up.

Although no joiner, in May of 1948 Jackson endorsed an artists' protest against a manifesto by the Boston Institute of Contemporary Art questioning the integrity of modern American painters. Also he approved the American Abstract Artists' Association efforts via Balcomb Greene to persuade MOMA to buy more art originating in this country and less from Paris.

PETER BLAKE: American artists were considered a bunch of hicks by the intellectual art world; any American worth his salt went to live in Europe. Kurt Valentin, dealer for the standard Europeans—Picasso, Moore, Lipchitz—was condescending. Jackson was to be the first and most important painter to change that scene; his work was to shift the center, totally—not Bill de Kooning, not then certainly, and it wasn't any of the others. Jackson and no one else shifted the art world center from Paris to New York.

When I joined the Museum of Modern Art, Bertha Schaeffer put on an exhibition of artists working with architects, and I wrote in the catalogue about Jackson's work in relation to architecture. Do you know, Alfred Barr took me aside and said, "I read what you wrote and it's very interesting; however, we really don't know for sure that Pollock's work is something that we would want to support." I was close to being bawled out and I was amazed.

Jackson felt very much rejected, though he would tease me about being his only friend at the Museum and make cracks about the institution. I left in 1950, but soon after the scene with Barr, Betty Parsons told me that he'd made an appointment to look at Jackson's paintings because everyone was talking about his work. Finally, Alfred decided that it *was* something he wanted to support.

Jackson's exposure was growing—in March his watercolor *Dancing Forms* was in the Whitney Annual and at the end of May he was repre-

sented in Venice through Peggy Guggenheim's collection at the twenty-fourth Biennale. Of more immediate benefit, however, was a grant from the Eben Demarest Trust Fund, obtained with the help of James Johnson Sweeney, paying him $1,500 in quarterly installments from July until the following July.

Soon after this boon, Jackson acquired a 1930 Model A Ford coupe, which became as well known locally as he would become internationally. He reported the car cost him ninety dollars, while Harry Jackson maintains that he lent him two hundred and fifty dollars to buy it. In any case, the Model A meant more than transportation. It became a refuge.

CONSTANTINE NIVOLA: He used to drive it in the woods exploring, and would come through ours almost every day then. He would lie in the grass—always wearing blue jeans and jacket, a uniform almost—and talk of ordinary, everyday things like cars. But he was always sad; he was looking for protection, reassurance. He never really smiled. When he was drinking he stayed away, but he liked our children very much, even left a used bike for them once all painted and fixed up.

CLAIRE NIVOLA: He was the adult I was always most happy to see. He used to pick me up and carry me in his arms, and the way he played with us . . .

Jackson's liking of children was paralleled by his fondness for animals. Among his were a tame crow, Caw-Caw, and Gyp, a part collie not unlike one of that name he had known as a child.

MERCEDES MATTER: Caw-Caw was the wickedest creature. When Gyp was eating, he'd light on his head and help himself to the dish. The creature was diabolical: We had an old, worn-out Chrysler with a canvas top in tatters and Caw-Caw would land on it to pull strips off. I'd shout, "Go away, Caw-Caw," but he'd go to the other side just out of reach. He was always stealing shiny things from backyards and dropping them in others, and he'd take clothespins off wash lines so the clothes would drop in the mud. He was causing such trouble in the neighborhood that Jackson clipped his wings. Lee was livid; there was a big fight about that. Caw-Caw ended up with a Bonack family. He was in heaven with all their shiny junk to keep busy with.

MARY LOUISE DODGE: There was an old boat in our yard being worked on and they had a hard time keeping up with that crow. Why, as fast as you'd lay a nail down, it would be gone. And clothespins—well, his bird was a famous crow in Springs.

GINA KNEE: Caw-Caw was lost near our place on North Haven but came to us when called. Then I took him back to Jackson and it landed on his shoulder. They nearly died with joy.

In October, Jackson's *Cathedral* was a work of contention at *Life* magazine's Round Table on Modern Art, a symposium in which an elite group including Aldous Huxley wondered why the work didn't seem to have any end to it. Nevertheless, with Greenberg championing Picasso's *Ma Jolie,* Pollock was for the first time in exalted mass media company, European and American. Word was spreading of his poured work almost as fast as theories of its origin were created.

HARRY JACKSON: He told me that he started dripping paint because he became so excited while painting the mural for Peggy Guggenheim, that he lost hope of keeping up with his excitement using a brush.

STANLEY WILLIAM HAYTER: There must have been hundreds of drip works at Atelier 17, and I wrote about unconscious drawing and how it can be developed. Jack and I talked about this sort of thing at the time when people used to come to me from all over the U.S. with their unconscious drawings. Among our tricks was a well-known one, the compound pendulum. A paint can is hung on two strings tied together, which is a classic example of discontinuous cyclic motion (it winds up and down again). The machine is childishly simple—just a can with a drip—and if you let it go, it makes an amusing pattern. Left long enough, it winds up making a disc or doughnut, but interrupt it and you get extraordinary and beautiful shapes.

Jack was doing things of this sort at Atelier 17, but he didn't work much with a lot of people in the print shop; he'd come in at odd hours and at night with Reuben Kadish when nobody else was there. We used to tease him, saying, "We're going to manufacture kits and sell them for a buck and call them Every Man His Own Pollock." He thought it was funny as hell.

A lot of our people said this was nonsense, that anybody could do it. That enraged me and I said, "Go to it, and I'll bet you that not one of you can make one square inch of anything that could be mistaken for what Pollock's done—what I would do, what the machine has done." And they couldn't because it's absolutely distinctive, more than handwriting. It's like attempts at faking Pollocks: You can't be fooled.

MERVIN JULES: Our studio on Union Square, Axel Horn's and mine, was a great big open studio where League models would pose without being paid. Artists would drop in, so it was a social place too. A mural Siqueiros did there was lost when the building was torn down; it

was painted in Duco. His contention was that Duco, being a product of the auto industry, fits the twentieth-century idea and, besides, it lasts.

Pollock would work at our studio occasionally—no one worked that way—and we all watched him. To prepare a canvas, he would put it on the floor and spatter it—that was the underpainting, spatter and drip— then let it lie there while he looked at it. Images began to appear for him. It was a stimulation, and he believed Michelangelo, who said he saw forms in clouds and such. Everything an artist sees becomes part of his visceral bank—exists in the subconscious. When the need arises, it comes forward. The underpainting would be dry when Pollock began to work over it, so it didn't show.

ROBERT MOTHERWELL: Siqueiros, whom Pollock admired, splashed paint over everything. To Pollock, having had the experience with him as well as his support, the idea of splashing paint on a canvas as if it were a float would come naturally. Then, at a given psychological moment, it's "Let's shoot the works." Nobody makes such a radical invention singlehandedly. But how could a guy have the nerve to let go out of the blue like that?

FULLER POTTER: Sure, Duchamp would use a can of paint on a string and the Surrealists were doing tricks like throwing things over their shoulders onto the canvas, making that accidental stuff which has surprise and strength. Like everyone else in their early works, Pollock also was doing a lot of thinking and trying, and the paintings were muddy. He told me—what was it?—he'd had eight gray years in the Village. Then all of a sudden this guy exploded into these works not done with the rational mind. It was a vomiting out of stuff buried in us over millions of years from our evolving, stuff which our conscious minds have no idea of. I thought the guy was crazy, and when he took me out to his barn I thought the work was crazy—but out of it came poetry. In Pollock's work the *paint* is talking.

JAMES BROOKS: It's unselfconscious; he made it happen without much thinking about it. That was his release. An artist never knows where to go creatively. Ortega says "Great ideas always come from the shipwrecked." And Jackson *was* shipwrecked.

REUBEN KADISH: On the Vineyard, Benton showed Jackson how to make drawings on ceramic plates and bowls. The way he did it was to take the glaze and pour it; though this was long before the drip work, maybe that's where Jack got the idea.

EDITH SYMONDS: Old houses on the Vineyard often have spattered floors, a technique few can do now. This angry artist got his anger

out by throwing the paint around, and being a real artist—a great artist—he couldn't help making a picture. Painters paint because something has to get out—to be projected.

PHILIP PAVIA: All that drip came from Gorky, a big drip painter. Gorky was the star of that world! I went to his studio many times with the sculptors Hague and Nakian—Armenians had an in—there were a lot of drip paintings. Like with Surrealists, Gorky did drip paintings before Jackson came along, but people can't admit how big an influence Gorky was on him—I don't know why.

BUFFIE JOHNSON: Lee influenced Jackson. She brought the idea home from Hofmann, who used drips but never as an entire painting. None of the Hofmann things looked violent, but when Jackson did them they took on a violence which is very peculiar. I saw them as violent then because I knew the man; now I see them as still marvelous but floating and *him* as more of a dreaming poet than I realized. A calm person using the same technique was Mark Tobey.

GEORGE MCNEIL: The freedom with which Pollock painted then, that was great. Everybody was changed by his work—de Kooning, Hofmann, who wouldn't give him credit. My work was changed by what he was doing in the sense of being freed. And he was able to project his frustrations—his work came from this . . . such a physical person, like a manic person.

But I had the feeling he was always pulling the art out of himself—like a magician. And that pioneering role, having to break through and all that, was a hell of a burden to carry. Yet he was able to make the bad influences such as Surrealism negate each other, so like a devil's brew they worked out well. I never cared for his dripped paintings, thought they were a mistake, but if people around you are expecting acrobatics it's almost impossible not to oblige, and I think it's a tragedy that he didn't consummate the beginning that he had.

MICHAEL LOEW: In comparison with Bill de Kooning and Gorky, what Pollock was aiming for was too far from the tradition of art. It enters another realm, the arabesques and the interplay of lines, and those surfaces so busy. But there was a greatness about the way the guy swung into it—so free and spontaneous, whatever came into his head.

JOHN LITTLE: Hofmann did drip work in Munich before coming to this country and teaching at Berkeley. There were portfolios along the

wall by my bed and one fell open. It was full of drip work on paper, which Hofmann explained had been intended for textile design.

PETER BUSA: Jack saw my drip works, and anyway Bill Baziotes had a drip period and so did others. the Surrealist dictum was that there is a free agent, a quality Jack called other than himself. He said there was logic in the free agent and in chance. I asked if he controlled the accident or used it, and he said, "What makes you think it's an accident when I know what I'm going to drip before I work?" During the war you couldn't buy brushes, which may have led to Jack to try his sticks. When I was teaching at Cooper Union, he yelled from the door, "Don't control it, *use* it. Let it be yours." That was it.

CONSTANTINE NIVOLA: It was the Surrealists, such as Breton, who had the idea of releasing the tension in painting without any preconceived notions, letting the spontaneity do the actual painting. Like the Dadaists, the Surrealists did this in an experimental way without aiming at any conclusions, and they never rested long with one idea. It was only in this country that it was repeated and made big; the size made it impressive.

Whatever they did here, it had to be large now. That was a novelty, that and the courageous, free way of painting. It had to do with the historical circumstances of the country—bigger, more important, protecting everyone. Artists are very sensitive to the power of painting in an historical moment. One should never forget that artists came from the familiars of the royal courts—the court jesters.

Jackson's own "moment" that fall of 1948 was becoming increasingly anguished—angry too, the effects of which were taken out on the Model A Ford so that there were days when he was back on a bike.

EDWARD HULTS: Up by the turn to Dan Miller's store, his bike wheels hit some gravel; then bike, Jackson, and broken beer bottles were all over the road. He got up and began kicking the bike—wasn't he mad!—cussing and kicking the bike. Mr. Levi came out his door, saw the mood Jackson was in, and went right back.

When Jackson was drinking, he'd give you short answers—cuss you out—but the next day he'd be sorry. Once he let a shovel drop with the blade up and when he stepped on it the handle flew up and just missed him. If he'd been sober, that handle would have hit him sure as hell. Of course, when I told him he should leave a shovel with the blade over, he called me an S.O.B. and said I should mind my own business. But another time when I warned him about leaving rakes with the teeth pointing out—a sure way to get walloped by a handle—he turned them all around and not a word.

The things he'd get himself into! After we put in a new pump, he took off the roof gutter above the cellar steps, then left the doors open. A squall hit, and such a valley of water ran down that he had three feet of it in the cellar. He told us he needed another pump, had no money, but would pay when he could. After pumping out the cellar and putting in the pump, we told him the bill would keep. And it did, until May, when he came into the plumbing shop with a check. I put it in my pocket without looking at it; later my wife said it was too much. When I asked him about it, he said the overpayment was interest—full six percent on our money.

CLEMENT GREENBERG: He had a feeling of helplessness, whether sober or not. He felt he couldn't go to the station and buy a ticket for himself. And contrary to the impression some people had, Lee wasn't so at home in the world either; she wasn't such a practical person, wasn't so good at doing all those things.

Before the end of October, Jackson went to the "Clinic," the East Hampton Medical Group newly formed by Dr. Edwin H. Heller, for a minor complaint and came out with treatment begun for a major one—alcoholism. It was to consist essentially of a kind of reassurance by way of fatherly advice that all was up to Jackson, who later praised Dr. Heller as "one doc with no shit in his bag." Regular visits were accompanied by prescriptions for a mild tranquilizer (probably Miltown).

ARLOIE MCCOY: Jack called and told Sande that this doctor in East Hampton convinced him that his alcoholism wasn't psychological or anything his mother did. It was a chemical reaction and he should not drink anything. Sande hung up and said, "Jack's on the wagon. If he can do it, I can do it." And Sande did.

CLEMENT GREENBERG: Sande was an alcoholic, but he got off it. He influenced Jackson, though I think Jackson would have been an alcoholic anyway; it was always there. Way back I thought Sande's influence on Jackson with respect to the myth of the West and the outdoors—that business of being masculine, though he was not a he-man—was bad. It gave Jackson the notion that he *should* be a he-man, but he didn't want to be. It only came out when he was drunk.

The financial stress was so great by November that Jackson wrote Betty Parsons pleading for an advance of one hundred dollars.

GEORGE SID MILLER: My brother, Dan, who owned the general store, felt everyone was entitled to a seven-dollar credit. "Beyond that,"

he said, "they'll never pay me." Now Pollock owed him close to forty dollars and of course the man didn't have it—wasn't just for beer, either. But he did have this painting with a white background and just real fine lines on it, millions of them. He says, "Dan, I'll give you this for the grocery bill. I think it's worth fifty or sixty dollars, but I haven't named it yet." Dan was close to Pollock so he says, "Then let's you and I sit down here and name it. Now, those lines there, I don't know where the hell they're going. So let's call it *Map of Russia* because I don't know where the hell *they're* going."

It was a deal, but after that son of a gun died somebody sent this picture of Dan's over to Paris for an art show. Dan said to me, "You think you're a big shot, don't you? Well, over there is two pictures: one loaned by Nelson Rockefeller, Governor of New York, and the other by Daniel T. Miller, of The Springs, New York." Later he told me, "Jesus, you know that painting's commenced to be kind of famous. Somebody called me from over there, will I sell it for $3,700?" I said, "Dan, tell him the figures are right but in the wrong order. Put that goddam seven before the three." And I'll be a son of a bitch if Dan didn't sell that picture for $7,300!

I told him, "Now, goddam it, you'd have sold it for $3,700, so give me the difference." He says, "Just you keep your mouth shut. There's a lot of people find out, they might want to borrow some money." And I never did tell about it until after Dan went.

The work, *Painting 1948,* enamel on paper mounted on canvas, is now in the Musée National d'Art Moderne in Paris. It went through numerous hands until this last sale, in 1972, reportedly at well over what Dan Miller received with George Sid's help.

Jackson's being "on the wagon" faced a severe test in December; he was committed to spending Christmas with Lee at the McCoys' in Deep River, where his mother would also be. In addition, there was anxiety about his second show at Betty Parsons, coming up in January, and he would later explain that such pressures had a way of cornering him as if they had wills of their own. He felt hemmed in by his house, too, and opened up the downstairs by tearing out the partitions between the dining room and kitchen, hall and stairs. He was helped by a retired circus clown, George Loper, and had enough optimism to claim that this alteration would make the job of installing heat and an upstairs bathroom all the easier some day.

RICHARD T. TALMAGE: He wasn't any great mechanic—had all his carpenter and plumbing work done, and wiring too, far as I know. He could tinker a bit was about all. I didn't get much meaning in his work, except he might have discovered that dripping when he was drinking.

Fact is, not many remember Jackson now. Living close by his place, I think about him some—maybe more than others.

EDWARD HULTS: He was reckless with tools and when he'd be trying to do something around the house he'd throw them around, kick them even. We put in a cold water line to an old sink in his studio out there and every winter we had to drain it and turn it on again for him. Finally I taught him how to do it, and there was that kind of crooked smile of his—"sheepish" one guy called it.

PETER BLAKE: Jackson and I became good friends through a project of Mies van der Rohe; like Jackson, he wasn't verbal but intuitive. Mies conceived of an ideal museum in which the paintings would be large walls, free-standing, and with sculpture. Jackson was intrigued by the idea of his paintings under a floating roof with space going through them almost, and shown as in a landscape along with three-dimensional objects.

I don't really feel that Jackson's being born in Wyoming meant anything. He was a kind of drifter, didn't have a place where he belonged, and if you had asked him where his home was he would have been at a loss. And there was that driving around all the time, a constant search for something.

CHAPTER FIVE
"A NATURAL"

Jackson came into my life in 1949, during a January thaw. I was a trespasser in the Stony Hill Farm woods at Amagansett; my wife Penny and I were hoping to pick up the farm before it went in a tax sale. On hearing a car laboring toward me on the woods road, I hid behind a large oak; I wasn't about to be found map in hand by a caretaker, giving the game away. But the driver was Jackson—although I didn't know who he was then—draped over the wheel of his Model A and in need of a shave.

He was slipping the clutch to help in the soft going, and its smoke, together with that of the exhaust, lingered after the car had passed slowly. I could see he was no caretaker, but one with whom to take care— a scruffy junk dealer maybe, or the town loafer taking out his discontent on a car. His mouth was half open, his long heavy forearms hung from a soiled T-shirt, and his glassy look straight ahead was for something far from the Stony Hill Farm woods.

Jackson's cruising back roads was not trespassing, I discovered later, but therapy: It helped him stay on the wagon. He had managed to stay sober while seeing the old year of 1948 out and the new one in; he had even handled hosting a wedding without having a drink.

HARRY JACKSON: I married Grace Hartigan in Jack and Lee's house; they stood up for us, were our best man and lady. We got married to go to Mexico—I needed extra dough on the GI Bill from the government, about thirty-five dollars more a month—but when we got to Monterey we were stuck at the hotel. So I contacted my mother, I contacted my folks in Wyoming, but it was Jackson who wired me money. It was the two hundred and fifty dollars which I had given him to buy that Model A, and he was broke. But it was Jackson who came through.

• • •

The next test for Jackson's staying on the wagon—"hardest riding one ever," he said—came with his second show at the Betty Parsons Gallery, which ran from January 24th to February 13th, 1949. It offered twenty-six works, some on paper; most were given numbers rather than titles to avoid the subjective, thus adding to viewer confusion caused by the poured technique and large size. Elaine de Kooning wrote of the surprising tranquillity of expression, and Georges Mathieu, a leader of the avant-garde, called Pollock, in a letter to Betty Parsons, the foremost painter today still working.

Among the works sold—not many and all painted the previous year—was *Number 5, 1948,* to a Parsons fellow artist, Alfonso Ossorio. The work was damaged in delivery to Ossorio's Macdougal Alley house, so Betty brought Jackson to have a look at it.

ALFONSO OSSORIO: Jackson agreed to repair it, and I drove this vertical panel to East Hampton for him. As it turned out, he repainted the whole picture, not changing it so much as enriching it. It was a wonderful example of an artist having a second chance, although it could have worked the other way: "I bought one painting but you have given me back another."

I remember the relaxed way he talked in his Middle West voice when it was about something which interested him. On a trip to New York he gave me a three hour lecture about the contemporary American art scene, beginning with the chauvinist critic Thomas Craven (a Benton champion). But that pleasant voice could be hoarse and fogged with liquor and cigarettes when he became aggressive, frightening women by chasing them around the house in a childish mood.

Jackson had a very clear historical sense of what had been happening in American painting, just as he had a very down-to-earth knowledge of Indian sand painting. He knew what it was all about—that they had a sociological/religious meaning, that they were stylized in certain ways. And he knew the connection between that and the Mexican muralists. It was the alphabet of that which then went into his work.

REUBEN KADISH: Jack's involvement with mysticism was connected with his pantheist quality, giving him a link with a kind of creative continuity. This was a pretty sophisticated guy whose interest in sculpture led him to sophisticated pieces, but Jack didn't go looking for sophistication; he looked for the statement. And he would go for the primitive before the sophisticated. And then those great stones he had piled behind his house toward the end.

While that second Parsons show would do much for Jackson's reputation, it did little to relieve his financial distress. Then Peggy Guggenheim

wrote Betty with a new blow: She had been unable to arrange a one-man show for him in Paris. As so often in moments of creative doubt—he knew where he was but not where he was going—Jackson turned to thoughts of sculpture. His approach served a purpose not unlike what drawing does for painting.

LAWRENCE LARKIN: Jackson worked one of Rosanne's pottery wheels and her kiln several times. I don't know quite what to call the pieces except receptacles about six inches high, round and wide. They were an attempt to make abstractions in pottery—an attempt to get two-dimensional painting into a three-dimensional piece—and were built up, went all over the place. His hands were very delicate but so *big*, yet he had wonderful control and, of course, talent for the wheel. Rosanne was very impressed: a great artist. And while Lee was wonderful with him, I couldn't use that term for her.

In late winter, the Pollocks felt safe in putting heat in their house: Betty Parsons had just advised them that MOMA was about to purchase a second work. But in order to have the job done reasonably, along with putting in a bathroom upstairs, they waited until Hults and Talmage were not busy.

EDWARD W. HULTS: It was always up to us when we worked, at our convenience, and when he owed us money it was always at his convenience. He dealt with us on everything, not her. She was always left in the background; I don't remember seeing her much more than I ever saw him on the water, even swimming.

Jackson tore out the chimney using a sledgehammer and almost collapsed the ceiling on himself. He had gotten the chimney from the roof down to the second story when I warned him to use some props under that floor. The next morning when I walked in, I came downstairs in a hurry. George Loper warned him too, told him, "If you don't let us put some bracing in, you'll *really* have that open space here you're after." Wherever he wanted us to bring up pipes he'd knock out a timber—never looked to check on any support. Why, if there'd come any wind the house would have collapsed.

Stella spent a few days with Lee and Jackson in late spring of 1949, a visit it was hoped might relieve the McCoys on a regular basis of her company.

FRANK POLLOCK: Lee never wanted Mother to spend any length of time in East Hampton. It might have interfered with their relationship, their friends, their coming and going. I don't have any idea

what she had against the family, but she tried to ostracize us; she did do that. Also, Lee tried to keep Jack from bearing his share of Mother. He never did, and our wives criticized us for permitting him to get away with it. I remember one time I spoke to him about it, but Lee was within earshot and interrupted. She said, "Jack's got his own responsibilities." She wouldn't even let me carry on a conversation with him about his responsibilities toward his mother.

ELIZABETH POLLOCK: When she visited him for about ten days, they were the highlights of her days. All she could talk of was Jack this and Jack that. Stella was an aged woman with no income, but he never sent her anything; what the other boys did for her she took for granted. He'd give her twenty dollars in a great, great while, and she'd talk about it with childish pleasure, couldn't get over it.

When he got successful he never once said to his brothers, to Charles and Sande who had helped him so and had always been kind and thoughtful, "Let me show some of your things to a gallery." Charles never felt hurt by that, nor did the boys ever criticize him; they just accepted each other. This upset me very much, being Jewish; we're open with each other. "You damn Christians," I told them.

The Model A was an easy car to spot on the empty roads that winter when I came out from the City to negotiate with the elderly owner of Stony Hill Farm, Mrs. Harry Hamlin. Even in its heyday few Model A coupes were decked out with spares in fender wells and a trunk rack, and Jackson was easy to spot too. The steering wheel seemed to support him and his glazed look, but in the cold the T-shirt was replaced by a Levi jacket and dark muffler. This I had a chance to see when I was exploring the area near the Farm and came across him at the town dump. He was sitting on the running board, a cigarette hanging from his mouth, eyes focused on the garbage. I saw him in profile from my car, but he seemed oblivious and I was glad for he was wrapped in more than a muffler: It was depression, and I didn't need to know more.

PETER BLAKE: I was intrigued enough by Mies's "ideal museum" project for Jackson's paintings to want to build a model. Although the model was only about four feet long and two feet wide, it would be expensive to make with its free-standing walls and floating roof. Alfonso Ossorio was kind enough to take care of the $1,000 or so, and when I was working on the model Jackson asked where we were going to build the museum. I said, "Frankly, I think it should be in that landscape behind your house. That's where all your painting comes from, that landscape." I was so taken by that view back there with the inlet; and Jackson's paintings were now enormous—eighteen feet by twenty feet, some of

them—and so expansive, like everything about America. By comparison, Picasso's *Guernica* is a mantelpiece painting.

Well, Jackson seemed very surprised by my site selection for a museum, but he gave me one of those smiles of his. And when in the model I set those big canvases of his—to scale, of course—between walls of mirrors so they became endless, kept repeating each other into themselves, I asked him if he had any objections. His face lit up and he said, "No, that's fine. That's *good*." But Jackson felt the model should have not only two-dimensional wall paintings but three-dimensional objects as wall sculpture. He said he'd try to do some pieces for it, which turned out to be about three inches tall to scale, made of wire dipped in plaster and painted in spots of color; they were like his paintings but in a three-dimensional way. People were intrigued by the concept, but it was all pretty theatrical and too expensive to build as the real thing.

Betty Parsons renewed her contract with Jackson in June of 1949, to run for three years. Although he liked Betty and respected her own painting efforts, Jackson found it hard to take the fact that she came from a *Social Register* background.

BETTY PARSONS: He hated it, and I never understood how I came to be a member of my family. He said, "The trouble with you is you're too sophisticated—to hell with you." He meant, of course, also my years in Paris trying to paint, but otherwise he was very nice to me. Jackson was a very shy man when he wasn't drinking, hardly opened his mouth; when he was drinking, he hardly ever closed it. He could be such a horror, but he was a good guy basically. It was just that he had a power, a force inside, that disturbed him. He had integrity and he was very attractive, you know, but disturbed—oh, very.

As Jackson's next-door neighbor, Justice William Schellinger, once said, he had a way of making you not so much watch *out* for him as watch *over* him.

JULIAN LEVI: Jackson was a good neighbor. He helped me buy some duck decoys from Justice Schellinger, a thing he had no use for but knew I was fond of. He got the price down in a way I wouldn't have dared, but then he knew the Justice well from the times the Justice took him home from the lockup. Another time Jackson asked what I wanted "all this junk" for—some antiques and my own duck decoys—then said something unkind about one of my paintings. Of course, he was drinking again, but he grabbed it and tore the frame off the stretcher. It had to do with his being unable to get a teaching job—that fantasy—and he shouted, "Painters should paint and not teach, goddam it!"

• • •

But Dan Miller, the general store owner, thought all this occasional nonsense worthwhile and took Pollock seriously. He even asked Jackson to join his Masonic Lodge. Jackson, Dan reported, turned down the invitation but was very pleased to have been asked. When Dan made his generalizations about the world, Jackson would just listen and grunt. He didn't seem really to participate—was just sort of there, enjoying it. Dan had a great curiosity about artists; he would ask probing questions and Jackson would try to answer them. He was verbal enough with a community member like Dan, who was a fairly strait-laced character and had been something of a drinker once himself.

JOHN LITTLE: Dan Miller was a power locally, but there wasn't anything he or anyone else could do about Jackson's income problem. Jackson asked me about textile designing—I had my own studio then—and wanted to try some. I don't know that he actually did, just that what he was after was to try to make some money.

Had I known how hard Jackson was trying to bring in some money, I would not have been as tactless about my formula for making money when we finally met. It was a raw April day at the Frank B. Smith Lumberyard in East Hampton, where I had gone to buy some lolly columns to shore up the stringers of what had been the Stony Hill Farm superintendent's house. My wife, Penny, and I had rented it for the summer for three hundred dollars with the understanding that any repairs to make it habitable would be done by us in exchange for what Mrs. Hamlin called giving us such a "happy" house. It was far from that—and looked it—but we were glad to have it, even though the heating system was rusted out. It would give us an opportunity to demonstrate what kind owners we would be for her beloved Stony Hill, however poor.

What attracted Jackson's eye at the lumberyard was our mammoth *old* Lincoln Model K four-door convertible. He looked the car over while holding a bundle of laths for making stretchers. "Every time I saw this thing taking up highway, I figured a guy with such a car—twelve cylinders, three tons, and about six miles a gallon—such a guy has to be so rich he doesn't know better, or so dumb he can't. Which is it?"

Neither, I told him. I should have left it at that. But I went on to explain that I fixed up cars—old, big jobs for the sucker trade—and that this one was about to bring in enough profit so I could buy a new station wagon which would suit a novice father better over the summer. I nodded when he asked if we were going to be here for the summer. Jackson shrugged. "Well, at least there won't be this heap crowding the road."

The Guild Hall in East Hampton, founded by one of its chief supporters, Mrs. Lorenzo Woodhouse, is a tasteful and conservative building

housing a theater and a museum with galleries which Mrs. Woodhouse had furnished with antiques and oriental rugs; in damp weather two open fires blazed. Until July of 1949, exhibits had shown either amateurs or the greats who summered in East Hampton, such as Thomas Moran and Childe Hassam. But this year's show, *17 Eastern Long Island Artists*, would be the first offering abstract works and the first welcoming painters who, however long they lived in the area, would be little appreciated either by local families or the summer colony.

LAWRENCE LARKIN: Rosanne and the Valentine Macys had a lot to do with breaking down the barriers represented by the Maidstone Club types who helped Mrs. Woodhouse support it. Originally Guild Hall had been looked upon as a bridge between the summer people and the old families—what the former still call natives—but not many of the latter bothered to cross it, even in winter with craft shows and square dances.

GINA KNEE: There was a breakthrough show, and a near breakdown of Guild Hall! They had to scrape the landscape to find that many painters, but what names some of them have become: James Brooks, my husband Alexander Brook, John Little, Jackson Pollock, Lee Krasner, Wilfred Zogbaum, Balcomb Greene, the Soyer brothers, Julian Levi, Ibram Lassaw—an array of gods now but to the white-gloved hostesses pouring tea and serving punch, barbarians and radicals. Had it not been for the director, Enez Whipple, Guild Hall might still be showing only members' still lifes.

ENEZ WHIPPLE: The members were very opposed to the work and felt that some of the artists were trying to make fools of them. I had very little contact with Mr. Pollock, who at a later show insulted Mrs. John Hall Wheelock and outraged the art committee. Of one large Pollock, members wondered if he had gotten drunk, then stuck all kinds of junk in it, even cigarette butts. And a Hampton Bays artist was so filthy, the wife of a board chairman had to wash her hands after he was introduced to her.

ALFONSO OSSORIO: A panel painting I did, *Klan Picnic*, had to do with the Ku Klux Klan having a picnic on the body of a Negro. Guild Hall wouldn't show such a thing in those days—it *was* a horrid picture— and they wouldn't show a nude until 1960. I remember Larry Rivers coming in with a full-size nude of Frank O'Hara; it was a very unsexy thing but Larry had already shown a portrait of his mother-in-law, Berdie, a fat old lady on a bed, naked. Eloise Spaeth had a disagreement with the board of trustees over it, and when Larry was carrying in the O'Hara nude he ran into the president, who had just come from the meeting. He

said, "Young man, I think you'd better take that right out." Larry didn't say a word, just turned and went.

ELOISE SPAETH: When Larry Rivers's mother-in-law nude was shown, word got around the Maidstone Club and a couple of the old boys came and put on their glasses. They had thought, "Oh, a nude female," but here was this sad, sagging old woman. We did regional shows every year; I felt the more conservative people had a right to see a nice landscape show if they wanted to, but the abstract artists wanted the museum to be a platform for them and nothing else. And in the community there is still the same little pocket of resistance: "I never go to Guild Hall; I can't understand that stuff!"

JOHN LITTLE: Jackson and I had been in a show and were taking it down on a rainy afternoon when Enez Whipple closed the doors of the gallery. We waited to see what was going on, and then she came back to apologize: "Mrs. Woodhouse was just here and I didn't think she should see this work." The work of the kind of local painters they liked to hang was shocking.

ENEZ WHIPPLE: As to prizes being given, I cannot recall any jurying for those early shows. But if prizes were being given, they certainly would not have gone to either Pollock. After all, many local people still see Mr. Pollock as just a clown and say of the work there is nothing to it.

 When Mrs. Hamlin asked me to take her to the *17 Eastern Long Island Artists* show in the summer of 1949, I thought she meant as a chauffeur, not escort. On the way she gave me a lecture about how badly Guild Hall had let the local people down by permitting such horrors in the building, let alone being hung; art had a place in our lives but not *that* art in Mrs. Woodhouse's gift to the natives. Mrs. Hamlin's white gloves showed the effects of time, and as soon as one of the tea-pouring hostesses pointed Jackson out to her with a warning, she pulled me to a vantage point for a good look.
 He was standing alone in a corner, arms tightly crossed, dressed in a tweed jacket in spite of the heat, and had on very shiny loafers. He looked very much "from away," and his rigidity bespoke either fright or anger. Then, as Mrs. Hamlin shook her head at the works on the heavily molded and paneled walls, his inspection of her revealed it was the latter. His gaze switched to me and changed to a look of contempt. To my relief, Mrs. Hamlin had had enough head shaking when the show began thinning out, but she paused at the gallery double doors for a final condemnation. Jackson was still in his corner but in a slouch, looking down. Mrs. Hamlin said that she supposed if she ever did let us have her farm, we'd have artists living in her trees.

Again, my encounter with Jackson had been a negative one; a way I would have liked to meet him was granted to Professor Reginald R. Isaacs, however.

PROFESSOR ISAACS: I was visiting in East Hampton and my host took me to a neighbor to go clamming. Later we were in his kitchen eating them when a woman came in, and I had a glimpse of a painting through the swinging door. I asked whose it was, thinking he was a hired hand or at most a Long Island clammer who didn't talk. He said only enough to let me know it was his, that he was Pollock, and that she was Lee. We bought our first painting that afternoon for very little though it was a lot to us then and a lot to them in a house where there were times there wasn't enough food on the table. It was an oil and lacquer on masonite—it's not listed in the catalogue raisonné. I paid ten or twenty-five dollars a month on some things I bought from Jackson—there were times when I couldn't do that.

On that first visit I was taken by the work as quickly as I was by the man. I thought he was the greatest painter of the century. We used to sit on the floor in the studio and he'd have his Bach, Vivaldi sort of things on. Sometimes there'd be strong sunshine with flies buzzing around, sometimes we'd just be sitting there with a beer and looking at a blank piece of canvas. We might visit Rothko, Motherwell, later on de Kooning. Jackson was a man seeking for his own expression—almost driven by it and sometimes finding it. Ours was a quiet friendship and for many years I have avoided his shows; I find it emotionally devastating. This is the first time I've allowed myself to think extensively about him.

The image of the solitary Jackson in that Guild Hall corner was erased by the jolt of a big spread *Life* magazine did on him in the August 8th issue, "Jackson Pollock—Is he the greatest living painter in the United States?" Arnold Newman had spent a day shooting Jackson at work— "drooling," *Life* called it—and in repose earlier that summer. Newman is still surprised by the fact that Jackson followed him to his car when the job was finished and asked if he could borrow one hundred and fifty dollars. It was a lot of money then, Newman points out, and he told Jackson that while he didn't have it he would try to raise it by the time he came back for re-shooting. But there was no re-shooting.

CLEMENT GREENBERG: The *Life* spread and all that—a lot of good it did him! The light spread on him and the work should have sold, but in those days American painting didn't sell. Still, he had Lee behind him all the way and he had me; I have to put myself there. This I'm shy of saying, but when he did those first all-over things I went for, among them was *Eyes in the Heat*. He told Lee, "That's for Clem."

JAMES BROOKS: When they put him in *Life* magazine he was naturally kind of pleased but also self-conscious. He was friends with the neighborhood around Springs and people were asking about him—kind of curious, you know. They saw him as a character but he was at ease with them before—much more so than with his painter friends or intellectuals. You know, after that you're expected to do a hell of a lot, being famous, and it made him self-conscious. He couldn't work at that, trying to be good or anything like that; the only way he could work was unselfconsciously. I think right then Jackson saw what was coming and was scared to death.

BETTY PARSONS: He thought fame was a huge responsibility. The more successful he got, the more nervous he got. They were all that way; Rothko, the more successful he got, the more nervous he got. And the more he drank. There was all that responsibility and invasion—horrible.

DENISE HARE: Jackson said to me about the *Life* double-page spread, "They only want me on top of the heap so they can push me off." That was articulated fear; he was *so* suspicious—even terrified.

Yet the next time Jackson and I spoke, again without a handshake or exchange of names, I had a feeling he might be enjoying the notice taken of him around East Hampton. We met in the Clinic parking lot—I had taken old Jimmy, Mrs. Hamlin's caretaker there, with a wheeze near a death rattle—and again I got Jackson's back up by saying the wrong thing. It started by my congratulating him on being in *Life;* I called it "finest kind," a Bonac expression. I think he considered my use of the phrase a presumptuous claim to being a true Bonacker.

He stared at the ground so long one I would have driven off if I hadn't had to wait for Jimmy and his wheeze. "What's so fine about *Life*? For me it's more like death." I told him that, as a stage manager on Broadway, I knew some stars who thought fame was pretty fine. It brought a look so quick it was more a stab. "They're performers, so they need it. But that shit isn't for a *man*. People don't look at you the same, and they're right. You're not your own you any more—maybe more, maybe less. But whatever the hell you are after that, you're not your you."

He gave the new station wagon a look, spat, and headed for the Model A with enough of a rolling gait to make me wonder if he had been to sea. Wilfred Zogbaum, then a painter and later a sculptor working in metal, said that the nearest Jackson had been to seafaring was the Coast Guard beach, and that if the walk had once to do with a frontier fantasy; now it was flat feet. As to *Life*, Zog bet that Jackson didn't mind his name linked to the phrase "greatest living painter."

B. H. FRIEDMAN: When I was doing my biography of him [*Jackson Pollock—Energy Made Visible*], Lee maintained that success meant nothing to Jackson. She said, in spite of Jackson being plunged into an area approaching that of the superstar, "He never cared about those articles in *Life*." I had to say, "Lee, the first time we were ever out at Springs, Jackson showed me stacks of copies on that supper shelf. He handed me one and said, 'This is part of the story.'"

FRITZ BULTMAN: In a way Jackson was Lee's creation, her Frankenstein; she set him going. And she saw *where* he was going, aside from the talent and all that, but he was devastated by fame coming to him. Still, he was very aware of success and told me to cotton up to Greenberg—but I couldn't. Lee was in control toward the end and very manipulative, just as she was not in favor of books about Jackson she couldn't control. The rewriting of Jackson's history has been done on the basis of her retelling history.

DR. RAPHAEL GRIBITZ: Jackson liked the company of people who could display a degree of sophistication, but he was defensive when it came to New York things. That made him aggressive, but although he didn't have an elaborate vocabulary—a provincial, he was afraid of foreign languages and exposure—it doesn't mean he couldn't communicate. By the same token, he wasn't saying everything he wanted to say, or as well as he wanted to say it. Yet he admired people like Gorky who could talk; and Rothko, he spoke a great deal of him. And he liked Franz Kline and James Brooks, but he didn't think much of Lee's painting. He said, "She's fooling around, kind of an offshoot of me, and I wish she'd stop."

He wouldn't talk about his work but would say, "Goddam it, don't you see? That's reality—in the trees!" We'd take walks at night and once he watched the stars through the trees. He said, "That's influencing our lives. Goddam it, of course heavenly bodies influence our psyche!" Then he'd give me this business of mysticism—a rather interesting discussion—confirmed by his Jungian exposure. He would squint when we discussed what his reality was. He would say, "What the hell's the matter with you? This is *it*." It would be a complete abstraction. He tended to be a little mystical, but that was encouraged by some of the charlatans around him. His appreciation of reality was not that of a rationalist; that is, his approach to nature was not rational.

He was never exposed to seventeenth and eighteenth-century France and when I talked about Paris he resented it: "It's *here*," was his answer to "Why don't you go to Paris, see other people? What the hell are you staying here for?" But "It's here," he'd say, "it's not in Paris. It used to be with Benton, but now it's with me."

• • •

Jackson was working during the summer for what would be his first one-man show twice in the same year, Betty Parsons having scheduled him for November. The show would include Peter Blake's model of the "Ideal Exhibit," the planning for which led to hope of Jackson obtaining mural commissions. He told Betty that they were the only hope for his financial plight and that he would pay commissions on any she brought in. Before long he was again nudging her to please send a check.

BETTY PARSONS: How hard Jackson could work, and with such grace! I watched him and he was like a dancer. He had the canvas on the floor with cans of paint around the edges that had sticks in them which he'd seize and—swish and swish again. There was such rhythm in his movement, which has to do with this incredible balance in his compositions. They were so complex, yet he never went overboard—always in perfect balance.

I agree with Meyer Schapiro when he says that the best things in the great painters happen when the artist gets lost, that something else takes over. When Jackson would get lost, I think the unconscious took over and that's marvelous. I'm always hoping it will happen to me.

John Little, who was a friend of my wife Penny's family, invited us to have a look at the work he was doing restoring his saltbox, adding that there would be a few friends we didn't know. I sensed who one might be, and as we parked next to the Model A, I could almost smell again the burning clutch. The gathering—Wilfred and Betsy Zogbaum, James and Charlotte Park Brooks, Jackson and Lee—was held in a lean-to kitchen still under construction with authentic period materials. My introduction to Jackson brought no more than a nod in return—there was no handshake—upon which he drifted back to a pile of mason sand. Then he began slowly turning an empty coffee mug round and round. Soon he was wholly absorbed in this drilling, a concentration consistent with his faraway look in the woods.

Lee was good at keeping him in her view without appearing to, and I remembered John Little saying that Jackson wasn't drinking these days. Lee came across as direct, bright, forceful; she didn't fit the saltbox moment somehow, but intensity gave her a kind of attraction that rose above the scene.

Jackson projected strength, and not only of body. His stooped position over the sand pile exaggerated the thickness of shoulder and short neck, but his arms seemed too long for his torso. I was to find that his height had a way of reflecting his moods; he could vary from giant to kid-size somehow. While he was not heavy as he would be later, there was a heaviness about him, one of mood, and it did nothing to refine the

features: nose fleshy, mouth a little slack, with dangling cigarette (later, I would think of him as born with a cigarette), chin strong and with a dimple, ears rather large. Jackson was balding above the furrowed brow, and his tobacco-stained hands, thick for a painter, looked as at home with the sand as a stonemason's. The eyes I remember as small, light brown, and bloodshot. But there are as many color opinions as variations in height.

HELEN PHILLIPS: He never looked at you straight, did he? He was always looking someplace else and I'm very conscious of that. I can't talk to people who won't look at me because it means they don't want to talk.

B. H. FRIEDMAN: I asked Lee what color she thought Jackson's eyes were and she said, "I really don't know." I left it blank in my manuscript and then weeks later I asked if they were greenish gray. "I don't know," she said, "they might have been." After more weeks—I think she told me she had discovered this with her analyst—she said, "I've decided his eyes were hazel."

JOHN LITTLE: There was so much else you had to look at about Jackson . . . I do know that Lee always asked me not to offer him drinks, on the wagon or off. But as a Southerner, one is offered refreshment in my house. Besides, Jackson was grown up, or should have been.

When Jackson tired of drilling sand with the mug, he headed for the gutted living room. I joined him presently, my uneasiness partly overcome by curiosity, and found him balanced on a hand-hewn oak floor beam looking down at the open foundation. I said something about the beam's being good forever. He had a flat, slightly nasal voice. "More than we can say. It's all right with me."

He looked up to give a sort of wry half-smile, then it was back to studying the foundation. My uneasiness built again in the silence, one long enough to imply that we'd had our moment, that it was all over between us. Then: "John says you're trying to buy Stony Hill Farm. A hundred acres and all those barns is a lot of farm for a couple who sure don't look like farmers . . . if you get it, I guess I won't be cruising those woods then but trespassing." I told him it would *still* be cruising, but that it would be a lot easier on his Model A if he didn't slip the clutch. "Could be, I guess, we don't see land the same way. I like to look at it, you only look *for* it." His next and last line for the day was followed by the half smile. "Anyway, it isn't every day I meet a guy who knows something about Model As—not lately, it isn't."

Sam Kootz mounted a show in the fall with the title *The Intrasubjectives*. It was a label he was not happy with, telling me that it said both too little

and too much: If the works had said too little it might have fit; however, they said so much we have yet to hear the end of them. Jackson was in good company—Gorky, Hofmann, Tobey, Motherwell, de Kooning, Rothko—and Harold Rosenberg contributed to the catalogue, writing that the contemporary artist begins with nothingness, then invents, and all the viewer has to do is to recognize the nothingness base to make the work intelligible.

Jackson's third show, the second that year at the Betty Parsons Gallery (November 21–December 10, 1949), offered over thirty works. Not all were numbered, and among them were muralesque paintings such as *Out of the Web*, in which there were cut-outs exposing the backing. Having earlier decided to disguise the image, Jackson now in a sense restored it through the abstract outline of the cut-out.

MILTON RESNICK: At his openings Pollock would look so nervous you'd think he was about to burst. Bill de Kooning and I took him for a walk to get coffee, being careful to go the wrong way so he wouldn't pass a bar close by. As we walked, he wanted to know what we thought of his show. We didn't know what to think, but I said it was a good show; Bill didn't say good things about it, though.

I was very curious about a big silver picture—it held and then dissipated, like you look and see something nice out of the corner of your eye and then it isn't there. But what puzzled me most about the show was that Pollock had cut a hole in one or two paintings and put pieces of driftwood in some. Again, I said it was a good show but I didn't understand why he had cut the holes and put pieces of wood on the paintings. He said, "What do you mean you don't understand? I needed forms." Bill and I looked at each other, thinking he had misunderstood, or he just didn't know: He had heard that word "form" over and over and didn't know what it really meant. See, people used to say things about form because they didn't want to use the words shape or complex; form covered more than just subject matter and shape. It had to do with something that you saw which wasn't exactly there. The person you said it about most was Picasso.

Well, Bill and I looked at each other again and thought we got to help him—to compensate for his misunderstanding us, and because in the pictures he put something there to make up. Bill is really a yellowbelly, doesn't like to get in trouble. So I said to Pollock, "Listen, you don't need all that." Understand, we liked him for being so naive, and it wasn't that he misunderstood; it was a lot of shit to begin with. He said, "You mean it? I really don't need it?" "No, you don't," I said. "The pictures are beautiful and that doesn't do a bit of good; with it you don't see the pictures, just that." Well, we got Pollock back to the gallery all right—and on *coffee*.

In Pollock's work people thought something was there that wasn't phony. And he found a way to break through people's consciousness about art by something which made his pictures boil the way they're interwoven—strange and beautiful. He got something into them that if someone else tried, it wouldn't be there. But Pollock didn't know this, and that not knowing was part of his anxiety. Besides, he *was* ordinary; like Bill said about that *Life* photo of him, "Look at that, him standing there: looks like some service station guy ready to pump gas."

BETTY PARSONS: I was so anxious for Jackson that there *be* sales, I gave discounts when I see now I didn't have to—imagine Roy Neuberger paying only $1,000 for *Number 8, 1949* and only after urging by Sam Kootz. Of course, Ossorio paid even less for *Number 19, 1949,* but then it was smaller and he was a friend-cum-sponsor, as it were. At least those who bought were the right art world names, most of them, and that's worth a lot. Besides, the show gave Jackson a lift—all of us actually—and God knows he needed it. Peter Blake's model for the "ideal exhibit" was also in the show.

PETER BLAKE: It was a pretty theatrical thing but people were intrigued, especially those interested in ways of seeing motion in endless space. Marcel Breuer was designing a house for Bertram Geller in Lawrence, Long Island, and the dining room needed a painting. I persuaded him to look at the exhibition with me after the opening and he was so impressed he arranged for the Gellers to commission Jackson to do what was actually a mural (*Mural, 1950*). When the Gellers sold their place, they found the work was more valuable than the house, and it ended up in the collection of the Empress of Iran. One wonders what the mullahs make of it.

Negotiations for the Farm continued, although we had moved back to the City. On one of my trips to see Mrs. Hamlin shortly after Jackson's opening, I stopped for gas near the garage where Jackson's neighbor, Justice Schellinger, was foreman. In that way he had of turning up whenever it occurred to me I hadn't seen him in a while, Jackson came by. He told the Justice he didn't know how they'd ever gotten by without a Model A expert in town and nodded at me. The Justice said they'd been lucky, that's all, and laughing, went inside. He had once said of Jackson that it was a shame he'd been born away because he was a natural to make a good Bonacker. When I repeated this to Jackson, I found that he had a full smile after all.

In an attempt to show up a city slicker, Jackson demonstrated how to start a Model A when hot by merely retarding the spark. I responded with a couple of tricks I was sure he wouldn't know; they were to facili-

tate necking, the fist being based on the ability of the gear shift lever to
be lifted and swung out of the way against the dashboard. I worked at the
lever, but it refused to cooperate. "I guess *my* Model A is a little special.
How about the other trick?"

That had to work, since it involved a shut-off valve well under the
dashboard which could be reached surreptitiously by the right foot of a
driver pretending the car had run out of gas, meaning a pause by the
side of the road. But as I should have known, there was no shut-off valve
and I was out of tricks. "I'll bet your luck with the girls wasn't much
better. Anyway, that shift lever's frozen in that position ever since I had
the car, and that valve leaked, so Bill took it off for me. But any other
tricks you got, let me know—always ready to learn."

For Jackson, 1949 was a good year; for Lee it was less so in terms of
work: She was doing rather Matisse-like color field abstractions with
geometric motifs, all but two of which she soon destroyed. For their
marriage, this was the best year by far due to Jackson's victory over
alcohol, he remembered in future years as having thought permanent:
"I was in charge of me, and all I had to do was stay with it. It worked and
I felt good about it, only now I see maybe I wasn't supposed to. And
maybe I wasn't supposed to have it made."

They spent Christmas on Fireplace Road, telling the McCoys and
Stella they would not be visiting Deep River because their recent stay in
New York had been too exhausting. This was just as well, for the recent
attack in *Time* magazine in combination with seeing his mother might
have been enough to knock him off the wagon. Citing the Whitney
Annual, *Time* found Jackson's work "a snarl" and called de Kooning's
Attic "a tangle." In sum, American art was in a bad way.

Between Christmas and New Year's, I came to East Hampton for what
was to appear a dropping in on Mrs. Hamlin at the big house on the
Farm; Jimmy, who was on our side and would be coming with the place,
had called me to say that her situation was getting so bad, I might want to
drop off a season's remembrance. Chocolates, I thought; gin, he advised.
Jimmy was in the wings during the meeting—the open fire to tend, logs
to bring in, kindling to sort—and while I worked my way toward her
commitment, I could see Jimmy in the hall reflected in a mirror above
the mantel, giving signals of encouragement or disapproval as might a
prompter offstage.

It was dusk when I left the big house, and the Model A loomed out of
snow flurries on Town Lane. Jackson opened his window to say that
he had seen me high-tailing at the Amagansett turn-off. "I figured this
has got to be an important ass-kissing day for you—got the Farm, or so
close you can taste it?" It was the latter, I told him, adding that I was
sorry not to have seen his show but that I had been rehearsing under-
studies for one of my kind of show. "You mean the opening; you were

sent a card, so some day you can ask me to one of your kind of openings to make up."

I was thinking it was a relief to be off Model As, when he asked what kind of cars stage stars drove. I told him that most of them were driven in hired limousines, but that Gertrude Lawrence had a chauffeur to get her around in a custom Ford town car. I should have left it at that, but I went on to say that the car reminded me of my grandmother's Model A town car, the body made by Brewster and her chauffeur so heavy—he had been a coachman—they had to raise the steering wheel so he could get behind it.

Jackson was watching the way the snow formed on the tar road; he didn't need any more city-slicker reminders. "Model A *town* car . . . sure takes all kinds." He closed the window and drove off, apparently not hearing my New Year's wishes.

When Alfonso Ossorio and Ted Dragon left for Paris in January of 1950, they turned their Macdougal Alley house over to the Pollocks.

ALFONSO OSSORIO: I was trying to be a painter, and here was someone who had found a viable expression, who was doing fascinating work that pulled together a lot of the education one had been given and made it blossom in a contemporary sense. You know, one studies the Pre-Romanesque and then finds the same passion and the same depth not in the year 800 or 1000 but *here*. That same passion was in the air again.

Then there was the personal thing about Jackson: Those two years when he wasn't drinking he was such a kind, gentle person. He did have his moody moments—one terrible weekend there was a misunderstanding and a friend of mine stayed overnight at the house. Jackson didn't want him to, but he didn't say a word from the moment the guest arrived until the moment the guest left. He saw it as an intrusion and, of course, I was being insensitive as I was once when I asked him to help me with some framing or mounting. He did it, but later Lee said to me, "You know, Jackson hates doing that sort of thing for his own work. Why the hell did you ask him to do yours?" It's one of the few times she criticized me directly, though he didn't complain about doing it. It was she who complained that I was taking up his time in the wrong way.

That winter of 1950, a social group—more accurately a discussion group—attracted Lee more than Jackson. It was made up of those involved in the contemporary arts, and was at first called the Artists' Club. In a short time it was just the Club, its organization minimal, its base in quarters above Hayter's Atelier 17 on East 8th Street.

PHILIP PAVIA: The Club had three hundred, maybe four hundred, panel discussions and so a lot to do with the making of American art; the

Abstract Expressionist movement grew out of the Club too. Jackson would come and stand in the back—later sometimes drunk—then Bill [de Kooning] and Franz [Kline] would take care of him. His favorite word about another painter at the Club was "contrived, he contrives everything." That was the worst thing he could say. He was mad at Tom Hess's book *Abstract Painting,* said it treated de Kooning better than him because he didn't come in until the last chapter. And during a meeting at the Club he threw it on the floor, calling it a rotten book. Pollock never had a critic really explain him; not even Greenberg explained him as well as Tom Hess or Rosenberg did de Kooning. When Greenberg was on a favorite, everyone else went down the drain like James Brooks—a terrific painter, great painter.

The women's movement was born in the Club. They would get up there and tell us off—aggressive, and the joke was that we'd make monsters out of these women and got even the wives to talk. They did, too— like Lee, wanting to compete against Jackson.

HEDDA STERNE: I went to the Club only once or twice. People were incredibly hostile to each other. Insults would fly from one to another, and they thought it intellectual discussion, this exchange of violent insults; such hostility is really fear. But the Club changed my image of Pollock. I was influenced by those stories of his violence at parties, etc., and to see this gentle, quiet, moving person was such a contrast.

He was even proud of being inarticulate, like Sandy [Alexander Calder], who pretended to be; for both it was a kind of protection. Jackson never liked intellectual talk, unlike Harold Rosenberg who spent almost three evenings a week with the de Koonings, which is where most of his painting vocabulary came from. Jackson was a social outsider and his gestures were that, defending himself against people. He needed affection—who doesn't?—but didn't know how to find it.

ELAINE DE KOONING: He had no patience with lectures and panels, so he would kind of storm in afterwards for the party. He was kind of the center of things, but when he was drinking again he would say to women, "You're a fucking whore"; it was just his little reflex. He started to say it to me, "You're a—," then just caught himself. It was almost like Huck Finn, you know. Jackson would break the rules and Bill and Franz would pick up on that; they admired it. I think all the male artists did, were very taken with that "Set 'em up, Joe" thing. We had all seen cowboy movies with a man swaggering up to the bar and saying, "Drinks are on the house," that sort of act of Jackson's.

Even though he didn't have the solid artistic background Bill and Gorky did, he was the worst one around with judgment on earlier artists—the previous generation, Gris and Picasso. He would say, "This is

good" and "This isn't good," instead of "What can I get from this?" He was always placing himself in an adversary position, but I sense that good artists are inspired by other artists and gain something from them. If you are all involved with your own ego, that's a wall against learning.

MILTON RESNICK: Jackson took up a role at the Club and it was impressive: saying things like "Who the hell are you?" as soon as he saw someone who looked important. He wouldn't accept talking things out as a means to understanding others; with him it was a challenge meaning a "You wanna fight?" reaction—that macho role. And—I never got this— in no time at all, Bill de Kooning was acting like Jackson! But why? He didn't have to.

Ideas there got ritualized pretty early; people were stuffed with them. There were always guys who would talk all night, and Bill and I would come out like we were choking. Once we left a couple of them we'd been sitting with and Bill said outside, "They're all baboons." "Come on," I said, "they're only climbing trees so they can see what's ahead. And nobody knows." Bill said, "Milton, they're baboons."

JIMMY ERNST: Pollock considered it de Kooning's club. I remember one fight he tried to start with Bill which ended with Jackson saying, "I don't need a club, I don't need to go to clubs," something like that. . . . There was a time when a strange element entered our lives, when people began to pay attention to American painting. It meant the end of a lot of friendships. More than just the Club fell apart eventually and some of it had to do with the new market for painting which didn't exist when you couldn't give a Pollock away.

Jackson was still on the wagon when Lee and he returned to Springs in March, and there his self-discipline soon faced another test. Tony Smith came for a weekend and was impressed by Jackson's completed commission for the Geller house. It was installed shortly thereafter by Giorgio Cavallon, on the back of a free-standing wall in the form of a bookcase Cavallon had built.

FRITZ BULTMAN: Tony was the man I feel I handed Jackson over to when I introduced them. With his knowledge as an architect, he was the perfect person for Jackson; also he was a person Jackson could relate to, being a man equally tormented, equally in hell. The relationship with Jackson was very positive and in those early years before Tony became a sculptor, his ambition was very hidden.

BUFFIE JOHNSON: Tony and Jackson were very close then, Tony going out there at one point practically every weekend. He brought

Jackson to my remodeled house on East 58th Street, designed by Tony, and while I knew Tony was a diabetic I had no idea he was also an alcoholic. I'm sure he influenced Jackson's work, as he was very fond of getting into the act and worked hard to influence mine.

It was this March, 1950, that Penny and I came to East Hampton for the closing of the contract to buy Stony Hill Farm, Mrs. Hamlin having finally decided to avoid the embarrassment of a tax sale. We were having a drink with John Little to celebrate when Jackson dropped in and for the first time shook my hand; his congratulations sounded sincere. I was careful to avoid offense and when the Zogbaums arrived, with an infant son the age of ours, the conversation turned to nursery problems. John was on the phone, so Jackson and I went out to look at the barn John planned to make into a studio.

It didn't take Jackson long to discover that except for being urban Eastern, my background had many equivalents to his: I was the youngest of five, an early rebellious school dropout, had had a speech problem (stammering), no interest in athletics and, a passion for machines. The fact that I had gone to work early as a builder of diesel engines and locomotives and been a ship's engineer started Jackson's usual stiffening, but it passed as he talked about how early he had learned to drive. He overlooked my lack of tact in saying that as a seven-year-old I used to drive an ancient Cadillac touring car alone in Southampton's Shinnecock Hills, but it brought one of his downward-looking pauses.

Presently, he shrugged. "It's one thing driving here in the East, but out West dodging coyote holes in wide open country is something else. If I got in trouble with the family car, they'd be looking for me to lay it on. With you, I guess, there'd be a chauffeur looking out *for* you. Anyway, Zog says you're not as full of shit as you sound."

"The Irascible Eighteen," as they have become known, were a group of artists who loudly refused to take part in a national competition sponsored by the Metropolitan Museum called "American Painting Today: 1950" and scheduled for the following December. The Irascibles wrote the Museum president, Roland L. Redmond, an open letter protesting that its juries were opposed to advanced art and accusing director Francis Henry Taylor of contempt for modern art. Rarely did the Abstract Expressionists overcome their isolation to act as a group.

The Irascibles were one of the few protest groups Jackson ever joined. He came in to the city on May 20th from East Hampton with James Brooks to be photographed by *Life*'s Nina Leen along with thirteen other conservatively dressed co-signers of the open letter to the Met. The result was the most famous group photograph of the Abstract Expressionist movement. (It included only one woman, Hedda Sterne.) One result of the Irascibles' effort was that Sam Kootz offered to give them a

show, but his gallery space was too small for Newman, Rothko, and Pollock, whose canvases needed, as Tony Smith argued, far larger space.

Jackson was one of six young artists (including Gorky and de Kooning) chosen by MOMA's Alfred Barr that spring, to represent the U.S. at the twenty-fifth Venice Biennale.

NICHOLAS CARONE: In Venice, I was invited by the sculptor Fazini, who was going to be on the jury for the Italian Pavilion, to have lunch with him, Morandi, Segarini, and Fontana—all three great artists. They decided to see the American Pavilion before doing their judging, and they had never heard of de Kooning, Gorky, or the other Americans. Morandi was considered the great painter in Italy; these were very so-phisticated artists, came from the Renaissance—metaphysicians, mind you.

So we go into this large gallery and in one corner was de Kooning's enormous *Excavation*, a great picture—a whole wall of de Koonings. And opposite the de Koonings were the Gorkys, and that was that gallery. Morandi was a tall man, six feet three inches, looked like a monk with gray hair combed forward onto his brow—a great painter from a heavy tradition. We're all in the center of the room, pivoting as we were look-ing, grouped around Morandi; he's really only talking to Segarini. He looks at the de Koonings and says in Italian, "These Americans are very interesting . . . They dive into the water before they learn to swim."

Then they turn around and look at the Gorky, but they're not inter-ested; that's a language they understand because it's in the tradition. And he says, "*Un po' sordo*—he's a bit deaf. The colors are nice, but they're not true accords—off. *Un po' francese*—somewhat French." They're not bowled over, not shocked, these sophisticated artists.

There was a vast opening into the next gallery and facing you from there was a big Pollock, one of the massive ones. Now they turn around and they look into the next room, and Morandi gasps, "Ah, ah . . . this is new. Vitality, energy—new!" It meant so much to me, what it did to Morandi. And this is not a schlock painter, this is a great painter—a beautiful experience.

There were times when I wondered if it were really Penny and I who had bought the Farm, Jackson seemed to be around so much. I had barely started driving in a corner property stake (to save the cost of surveyors doing it) when the Model A pulled up by me on Stony Hill Road. "Really staking your claim, like sheepherders fencing range. From what I hear, the way you stole the place is next to cattle rustling, at that." It was said kiddingly and I explained that to this city slicker three broken-down old houses and barns was no steal for 30,000, even if a hundred

acres came with it. I added we were in so far over our head, our lawyer warned we could end up in the same jam Mrs. Hamlin had been.

Jackson looked at the trunk of a hickory and nodded approvingly. "With timber like that, you'll make out. All you got to do is stay with it." I told him there was no danger of our not doing so; I had given up stage managing and we'd gotten rid of our place in the City to work full-time at getting the Farm on a paying basis. I added that I hoped to write part-time, maybe evenings. "You'll be dragging ass then—not chasing any, either. But the Farm will treat you right if you treat it right. If you don't—selling off timber or topsoil—you'll be sorry you ever heard of the East End. You don't have to be a Bonacker for things here to get to you, really get to you. Never dreamed such a place was, could be."

The line came with a horizon. When I reminded Jackson of what Justice Schellinger had said about him being a natural, he nodded. "He's the kind of neighbor I didn't expect in the East, and he's right about me being a natural. It's the next best thing to being a Bonacker."

The indefatigable Peggy Guggenheim arranged a show of her Pollocks at Amsterdam's Stedelijk Museum in mid-July of 1950, but Bruno Alfieri wrote a scathing review dismissing them. Jackson was enraged yet amused—Lee was not amused—for Alfieri finished his attack by writing that Pollock's work had just made Picasso a painter of the past. Peggy was not amused either, but the reception the works received in Brussels and Zurich mollified her. On seeing them finally in Italy, in Venice's Correr Museum, she felt that now Pollock was where he belonged historically as one of the greatest painters of our time.

FRITZ BULTMAN: Jackson received much more *real* understanding in Europe; the painters there were more shook by his work, realizing its importance. The early painters whose work was influenced by him were Europeans, and you can still see it there.

CHARLES POLLOCK: Jack was—is—understood in Europe. It had nothing to do with his never coming here [Paris]—he didn't feel the need—but in the sense of his work, if asked he would have said, "I belong here." He knew a lot about European art and was aware of its importance in his own development. But none of us had a passionate desire to visit Europe, and for me at openings it's all right to meet people and have them say, "Oh, you're the brother!"

The August 5, 1950, issue of *The New Yorker* carried an interview by Berton Roueché headed "Unframed Space," a phrase credited to Lee but originated by Peter Blake. Adding to Pollock myths, Jackson is quoted in the interview as saying his father had a farm near Cody and that by the time he was fourteen he was milking a dozen cows a day.

BERTON ROUECHÉ: My first idea was to write a Profile, which was rejected because Shawn [*The New Yorker*'s editor, William Shawn] said, "Let's wait and see what happens to his reputation."

Jackson had an uneasy manner, but I would give him a sense of humor though I can't think of any jokes. He was comfortable with me, because I had known Benton when I was on the Kansas City *Star* and because his distrustful attitude toward Easterners made a link between us. Jackson was certainly stocky, but gave the feeling of not being as tough and strong as his size made him seem; he was clumsy, not very physical and no natural-born mechanic.

These were Jackson's sober years, and in retrospect it seems like a pastoral period. Kay and I would walk up to their house at the end of the day and sit around their kitchen, having coffee and talking—about what I don't remember, but it certainly wasn't about art. We did do a lot of laughing on those afternoons; he was an amiable fellow, but there were those silences. The only times I was alone with him were when we went clamming and then our talk would be—well, clam talk. We used to go clamming in Bonac Creek down behind his house and he would use his toes, never a rake. These were hard clams and he thought it was easier getting them that way. He was a likable man—a big apple pie baker, and bread too—but troubled.

It was hard to separate that from the work he was doing, which I can't say I understood or was overly sympathetic toward. It was like reading T. S. Eliot: You respond without understanding what it means. But I felt he was deeply sincere in what he was doing, unlike Bob Motherwell who was always bragging that Pollock couldn't draw. Jackson was doing something which had meaning for him—Dan Miller saw that, and he wasn't joking when he defended that painting he hung in the store against the locals making fun of it. And Jackson had such integrity, honesty: When he got the Model A stuck on his place, I went over to pull it out with my car and my back bumper broke off. Hard up as he was—and he really was—Jackson insisted on paying for the damage.

Because of his financial anxiety, Jackson asked about work coming up at the Farm; he said that heavy work was for him, that he knew his way around demolition, and that he could handle any jobs. It was obvious that he had heard from the retired clown-turned-carpenter that I was about to convert our red barn into a summer rental; what Jackson hadn't heard was that it was going to be done on the cheap; I myself was planning to do the work he felt he was cut out for. "Okay, okay, but after you've hurt yourself—wrenched your back, stepped on a rusty nail—don't forget you know somebody who knows what he's doing and can take it."

Within a couple of days he drove from Stony Hill Road through the brush in the overgrown orchard to have a look at the red barn; instead

he saw the debris of the gutted interior. "If I'd only known you were starting, I'd have come right over. And if I'd known *you* were trying to do it—that you're in a bind with the place—hell, I'd have worked for nothing. I mean, that's what friends are for me: helper-outers. And stuff like those beams you got here: Shit, they're kindling to me—nothing to hoisting one of them."

DR. RAPHAEL GRIBITZ: Once on the beach, he wanted to wrestle with me. I was pretty stocky then and could wrestle well, but one of his ambitions at that moment was to put me down. I knocked him on his ass and he got angrier and angrier, so this wrestling with him reinforced my appreciation of him physically. He was strong and I was struck by his need to be well, to feel well, but paradoxically he was against establishment medicine. When we met, he said, "Do you do medicine? You don't look like a doctor." He had a hidden feeling that a guy who goes through all those years of training and discipline—which he never went through—that it was some kind of thing. But in his painting he was so disciplined, wasn't sort of floating around.

Friends of the Pollocks, none of them much better off financially, worried about their continuing poverty enough so that I tried to think of a way to employ Jackson. But there were two problems: I didn't have enough money to hire help for work I could do myself, and I didn't know enough about building to work with someone who didn't know much either. That way, I suspected, someone gets hurt and not only financially.

When I heard that Dr. Heller, who had been responsible for keeping Jackson on the wagon, had been killed at night in a car crash, I knew the loss was important for him. I tried to cheer him up by pointing out all the doctor bills he'd be saving. "Shit, that's not it! I hardly ever paid him and it never mattered, but what did—it's like I was telling you, he was what friends are for—Dr. Heller helped, goddammit! But that's the way I want to go, only not in the hospital the next morning. I want to go *then*."

During the summer Jackson met Hans Namuth, a friend since a nude artists' picnic at Provincetown shortly after both of us had returned from World War II. Hans, along with Irving Penn and others, had studied photography under Alexey Brodovitch. His meeting with Jackson was to lead to a distinguished career as a photographer of artists.

PETER BLAKE: I introduced Hans to Jackson when I was working on the idea for the ideal museum. I said to Jackson, "Wouldn't it be great to have a painting that wouldn't just be hanging in midair but that was transparent, that you could see the landscape through, and so on?" He was intrigued, and I told him that there was this tempered, unbreakable glass and he could look into the possibility that it might accept paint, that

paint would stick to it. I told Hans, since he wanted to make a film about Jackson, that he and I had been talking about painting on glass.

In October, Jackson was represented in a circulating MOMA exhibition called *Calligraphic and Geometric: Two Recent Linear Techniques in American Painting,* by *Number 13, 1949,* later replaced by *Number 12, 1948.* Also in that month, his *Number 8, 1950* was in a show at the Sidney Janis Gallery, organized by Leo Castelli. Janis had taken over Sam Kootz's space across the hall from the Betty Parsons Gallery.

BETTY PARSONS: Eventually finally, I moved to West 57th Street and now everybody is on the west side. It was very threatening because Janis could subsidize his artists—guarantee sales—and I could hardly guarantee myself.

That Jackson had been letting Hans photograph him that summer was unexpected; he seemed too shy, it had to include being camera-shy. Even more surprising was letting Hans film him (in association with film editor Paul Falkenberg).

HERBERT MATTER: I did quite a few photographs of Jackson, and I had thought about a film, but it was difficult for him and I didn't want to ask. Also, I was too much involved with one on Sandy Calder at the time and they wouldn't have gone together. I am sorry I didn't film Jackson, though. He worked in his painting completely, naturally, really wanted to be *in* the painting, and his pouring and dripping from a stick helped him feel that sort of contact. Having his canvas on the floor was all part of this being in the painting, of course, and it has to do with the way I always think of him: like a farmer, part of the earth, the trees, the whole landscape out here.

Jackson told me that being filmed surprised him too, but that he hadn't found the movie camera distracting. "When I'm working, working right, I'm in my work so outside things don't matter—if they do, then I've lost it. That happens sometimes, I guess because things get in the way of the flow—like roots blocking a soil line. But the movie, the way Hans works, was no worse than a still camera, and it wouldn't have happened maybe, either, if Lee hadn't kept at me. A camera whirring away is easy compared to that. Maybe those natives who figure they're being robbed of their souls by having their images taken have something."

Jackson spoke these words one day just before the noon whistle when I brought him some tools. He was still at his morning coffee. The table was littered with Lee's and his attempts to write a telegram to *Time,* which in its November 20th, 1950, issue had quoted from an Italian article critical

of his work. It reported that he had visited Peggy in Venice. It was headed, "Chaos, Damn It," and chaotic was Jackson's state until we went outside to look at the tools.

What *Time* was trying to do to him, he felt, was as transparent as the painting he had done on glass for Namuth's film. "What they want is to stop modern art; it isn't just me they're after, but taking me as a symbol sure works. And taking myself, I'll let you in on something: Maybe that sheet of glass is unbreakable—anyway, it took my weight when I tested it—but I'm not. And *I'm* not about to be tested, thanks."

The painting on glass (*Number 29, 1950*), filmed dramatically by Hans, is now in the National Gallery of Canada, Ottawa, complete with soil paint, enamel, wire lath, mesh, pebbles, string, marbles, and a lot of Jackson's released tension. Hans shot Jackson through the glass from below, making him seem a part of the work.

HANS NAMUTH: Jackson had talked about being *in* his canvas and I wanted to show that. We talked about showing him coming through the picture; then I thought that if I could photograph him from below while he was painting on glass, we'd have it. He liked my idea.

PETER BLAKE: I had told Hans that maybe he could dig up something where he, Hans, would be under the glass and Jackson could paint on it. I think I found a supplier—Pittsburgh Plate Glass or somebody—it was Herculite tempered glass and when it gets hit, it shatters into tiny pieces and doesn't kill you. So they got this piece, maybe four feet by eight feet—it isn't made in huge sizes—and they rigged up this thing.

The last day of filming was on the Saturday after Thanksgiving, Hans having been obliged to be in New York on the holiday (he insists it was in October; others join me in calling it that Saturday). It was to be celebrated by a communal feast with wine but very definitely no liquor, and I think our contribution was both wine and Penny's notable Yorkshire pudding. There were ten of us: the Pollocks, Alfonso Ossorio and Ted Dragon, Betsy and Wilfred Zogbaum, Peter Blake, John Little, Penny and I. Gina Knee was to have been there as well, but she had a feeling a storm was brewing.

GINA KNEE: I don't mean one of nature's, but Jackson's. And if I had cajoled Alex into coming [her husband, the portraitist Alexander Brook], since he wasn't fond of Lee—she wasn't pretty enough—there might have been one of his. The reason I sensed Jackson's storm a-building was having met him on the street in Amagansett after mention of a bad Biennale review in a magazine. While it wasn't that bad, he was *very* upset. I didn't try to console him but reasoned with him: how good

he was and how wonderful that he was in that show. He brightened a bit, but I thought, "Oh—there's more than that churning inside of him." Altogether, I had a feeling of upheaval in the offing, that this might be a Thanksgiving feast one would leave feeling—hungry.

TED DRAGON: We prepared most of the dinner in Lee's kitchen, I think. They wanted the traditional thing: creamed onions and all that stuff with the turkey.

Due to its being two days after Thanksgiving and having already had turkey, Penny and I were certain it was roast beef, hence her Yorkshire pudding.

ALFONSO OSSORIO: I have it in mind that it was a Thanksgiving celebration, but whether it was on the Thursday I don't recall. I have a feeling it was turkey, but again I don't recall. I think there were tensions that existed in Jackson in an equilibrium that if simply tilted in the right direction would—well, I think they were coalesced by Hans, acting as a catalyst.

TED DRAGON: I don't think Jackson was acting in an antagonistic way toward the people there—not like looking around and saying, "All right, you bastards, I'm going to show you." I think it was a complete other thing which we don't know—I mean I don't know.

CLEMENT GREENBERG: Do I know what was going on in Jackson? I know that we were sitting in his car at the station just before that time and I had an intimation. I told him I wasn't sure his upcoming Parsons show at the end of the month was going to sell.

It was dusk by the time Jackson and Hans finished filming, late enough so we wondered how they could see to work.

PETER BLAKE: It was a bloody cold day, a mean wind out of the northwest. I was near the dining table out in the kitchen/big room, all set full of stuff by Lee. Hans and Jackson came in literally blue—you know, frozen—and I saw Jackson go across to the sink, reach down, and pull out a bottle of whiskey. He filled two water glasses and said to Hans, who had never seen him in action, "This is the first drink I've had in two years. Dammit, we need it!"

ALFONSO OSSORIO: Jackson went straight to the bottle and filled a tumblerful of bourbon. Then he poured it down and Lee went white in the face.

TED DRAGON: In an aside I asked Lee why she was *so* upset. She said, "You have little idea what you're asking about. You just don't realize."

Jackson may have had another glassful before we sat down; I do know he ripped a heavy strap of sleigh bells we had given him off the wall and swung them at Hans with a gesture more than teasing. Hans ordered him to put them down, but his wife, Carmen, told him to leave Jackson alone. There was tension in the air, which Lee broke by saying we should sit down for dinner. Jackson dropped the bells on the floor and lumbered to the head of the heavy baroque table (a gift of the Macys') and dropped in the chair. As we sorted ourselves out, Lee's seating arrangement was ignored and Hans ended up on Jackson's right. I'm not sure who was on his left, other than it was a man—possibly Zog—and I was farther down on the left side of the table with Penny across from me.

Lee was at the far end and we worked hard at pretending nothing was going on with our host, now glowering at Hans. Then an argument in low tones between Hans and Jackson began and I looked down in order to avoid catching Jackson's eye. It was clear a process over which we had no control had begun.

PENNY POTTER: Hans didn't help the tense moment, saying something irritating to Jackson. I wanted to say, "Shut up, Hans," or throw something at him because he was being so pompous, authoritarian. But there were too many unknowns.

I heard the word "phony" used by Jackson just before he stood up, then his heavy breathing and one of the dogs scratching. Jackson said quietly but with purpose, "*Now?*" His hands were under the ends of the table, the long arms allowing him to stand almost straight, and his eyes were on Hans. Hans started to rise but, on Jackson's stiffening, thought better of it and came out with a drill sergeant's command: "Jackson— no!"

Jackson nodded slowly, oblivious to us, his mesmerized victims, and took his time before his second "*Now?*" It was quite a bit louder; at once Hans shouted, "Jackson—this you must not do!" Jackson lost no time with a roared "*Now?*", drawing it out. At the same time, he heaved the table upward. For an instant, there was danger it might upend on top of Lee, but Jackson didn't get it beyond a forty-five-degree angle before it tipped to his left and rolled over.

When a plate on the floor finally stopped spinning, the silence was complete. It was broken by tension-released laughter I recognized as mine; I had gone over backward under the avalanche of food and wine. I

lay helpless in the gravy, laughing, as Jackson crunched through the broken glass and china on his way to the back door. He slammed it behind him, we picked ourselves up, and Lee announced that coffee would be served in the front room. Then she and I cajoled the dogs out to join Jackson to keep them from the glass-laced gravy puddling on the floor, and we started mopping up.

All of us understood that far more than the celebration had been destroyed. The drink Jackson and I had a couple of days later was the least welcome of my life and to cover the defeat I felt in him, I said how sorry I was that he had been so upset. There wasn't time to find the right words to urge him to go on the wagon again because he laughed—his first full laugh, and bitter. "Shit, I wasn't upset! The table was."

CHAPTER SIX
"GOT IT MADE"

From that night on, his life would be different. Alfonso Ossorio has pointed out how curious it was that when Jackson was not drinking his work tended to be wholly abstract but that when he was figures would appear. It's a guess, maybe a wild one, but in a sober work period the creative discipline is better controlled—in this case holding to the product of the unconscious—but with alcohol there is a release so that what comes easiest comes first, such as the emotional links to memory and their visual expression. This is not the kind of speculation Jackson went in for but even if it had been he was too worried about his second show at Betty Parsons that year (November 29–December 16), his eighth one-man show in as many years. Its thirty-two works included some of his greatest: *One, Autumn Rhythm, Lavender Mist.* (At the time they were shown with numbers instead of titles. All were on canvas, except for the *Number 29* on glass that was made immortal by Namuth's film. Alfonso Ossorio bought *Number 1, 1950,* which he maintains was named *Lavender Mist* by Lee and I maintain was named by Clement Greenberg. It was the only sale.

BETTY PARSONS: The show was a disaster. For me it was heartbreaking, those big paintings at a mere $1,200. For Jackson it was ghastly; here was beauty, but instead of admiration it brought contempt.

CLEMENT GREENBERG: A good Pollock show would have one successful picture, two unsuccessful, and so forth. The shows were usually overhung and you found out of twenty pictures six or seven that were terrific. The others weren't so hot. That's the way Lee herself felt. But this was Jackson's best show, and up came Elaine de Kooning, who

said the show was no good except for one painting—the only weak picture in the show, the one he painted when they were working on the movie. The show was so good, it's unbelievable. It flabbergasted me at the time, to have only one failed picture, the one that everybody from downtown liked, but I have learned better since. That was a terrible down, that show. It was *there,* that something in Jackson that was so pure, so *right.*

TED DRAGON: One night, when I could still play the piano after dinner, Jackson sat on the steps from the hall looking at *Lavender Mist.* Afterward he said, "You know, it all ties together—it's all art. For me everything is art, no matter what."

PETER BLAKE: Jackson would control himself at openings—his own, anyway—but later he would be drunk. We'd all take off to the Village or somewhere for a bite, and Lee would say, "Jesus—we're in for another night."

Always curious as to how others handle their problems, Jackson was fascinated by actors suffering from stage fright. "Even for stars who know they'll get a big hand, openings must be hell. With mine I'm dead way inside me. Afterward—well, I made it again, only then there's the waiting to see, and waiting can be all you get."

The Pollocks stayed on at Macdougal Alley after the show closed. It was not a good time: There were many late nights at the Cedar bar, for some an extension of the Club but for Jackson it was an arena where he was the star rather than de Kooning. Both were "action" drinkers.

Jackson didn't mention his financial plight when he wrote Alfonso and Ted, who had returned to Paris. But among the woes he did mention were the failure of potential mural commissions to come through; Tony Smith's delay in getting to the drawings for a church project which would include either stained glass windows or murals designed by Jackson; that he found New York unbearable but was climbing out of a severe depression. He also pleaded that they get in touch with Peggy Guggenheim on his behalf. The sense of despair registered in Paris; Alfonso replied with a two hundred dollar advance toward future purchases and committed himself to continue doing this monthly.

The reply by Jackson was written in the last week of January 1951, and projects a different feeling: He admits he had been drinking, but was no longer. He was being treated by his and Lee's homeopathic physician, Dr. Elizabeth Hubbard (soon to be my family's). Also, he was experimenting with drawing on Japanese rice paper; and he had survived the impact of the opening of MOMA's *Abstract Painting and Sculpture in America* in which he was represented by *Number 1, 1948.* (This work was later

damaged in a fire at MOMA. Of the loss, later repaired, Jackson said, "A guy who's been singed by fate wouldn't feel right if his work didn't feel the heat.")

In February Jackson juried a show in Chicago which he thought less of than the flight. On his return he reported to Alfonso and Ted that a book project with Alexey Brodovitch was in abeyance but that his work was in *Vogue*. The following month he executed a will accompanied by a letter of instruction; its provisions came as a shock to his family on his death, to friends a matter for wonder. One of the more pleasant events of the winter was his meeting younger artists, on whose thinking and work he had a major impact.

PAUL JENKINS: Meeting Jackson was an assault on the moral senses because in a frontal attack he would question your very being. I think of him somewhat like Melville's Billy Budd. The only way he could find expression was by some violent gesture, but underneath he had a very fine sense of decency and was a very moral man. I was almost inflicted by his presence.

He was in quite a bind trying to reach the truth in painting as he saw it, in the Jungian sense trying to reach the unconscious and not get involved in that André Breton Surrealist muck. When you think of those erudite Surrealists around Art of This Century and their cynicism—that alone must have chilled his blood. I don't think Jackson wanted to deliver their kind of blow, the shock motif; he didn't want to shock the bourgeoisie. He awakens us like a flash of light, and his presence was something that had gone through fire and existed in fire—as in being driven to alcohol, there was an inward rage that couldn't find an outlet.

By the end of April, the Pollocks were back in Springs full time. There was an obvious change in Jackson, though; When sober, he had a quietness about him and his silences were even longer; drinking, he was noisier and in his part-kidding way there was menace. I felt a kind of mute appeal in both conditions but didn't know how to respond other than to be careful around him. This was made difficult by his dropping in at the Farm at night, insisting it was just for a moment and that that was why he'd left the Model A idling.

PENNY POTTER: The old car would come putt-putt up the driveway and Jeffrey would turn all the lights out, hoping he'd go away. And sometimes I'd turn them back on and Jeffrey would go upstairs in a snit—very angry. He thought he was going to rape me, or pee on the floor, but I said, "Jackson would never do that here." I suppose I would have given him a drink if he'd asked for one, but he didn't. To talk he had to have a few, though.

He was interested in what it was to be an actor. We found a lot to talk about in terms of what you go through creating a painting and creating a character role—long, complicated conversations. Then there were the Indians of the Southwest; Jackson hadn't lived with any tribes or anything, I think it was more just the general atmosphere, the landscape that appealed to him.

It bothered me, the Model A left idling with low oil pressure and little cooling so that it boiled over. I used to tell him to turn it off, but he saw it as a game and never failed to outwait me. The last time I objected, I rose to turn it off myself but he was at the door before me, all business. "Try it. You'll be sorry you even know where the switch is."

That spring of 1951 brought Jackson further exposure, although he was left out of an event in which one would have expected him to be featured: the seventy-fifth anniversary exhibition of painting and sculpture by seventy-five artists associated with the Art Students League, held at the Metropolitan Museum. Jackson does appear in a "partial list" of lesser-known artists associated with the League. But eight years after his death the League would mount another anniversary exhibition, elevating him to a high station indeed: *American Masters from Eakins to Pollock.*

STEWART KLONIS: We didn't think he was of much importance; my board of twelve wouldn't go for him. We used to think it was a joke, that splattering. In fact, Reginald Marsh did a splatter painting for a Burlington, Vermont show and entered it as a joke. I went to Jackson's house in the early fifties, and he wanted to give me a black and white drawing. I said I couldn't take it, and I couldn't. I thought his work was terrible, couldn't see anything there.

Jackson's *Number 1, 1951,* a watercolor, was in the Whitney Annual, and a chicken-wire construction in papier mâché was in the Peridot Gallery show *Sculpture by Painters.* It was mounted flat on a door on the floor and bore abstractions of the kind he had been doing on Japanese paper.

After the show, Jackson did some fast fitting of the piece to get it in Ossorio's car: He jumped up and down on it until it *did* fit. Back in East Hampton, misshapen but still sculpture, it was left outside Jackson's studio. "It's going to stay there until it sort of melts into the environment. I don't know if it works now or not, but it sure will then. It's kind of the way I see us . . . part of all that's around us, only we don't really see it. Ever try just listening up there at Green River? You can feel what I'm trying to say, maybe." (Green River is the Springs cemetery where Jackson is buried.)

PENNY POTTER: I think that piece Jackson tried to destroy is the one I wanted for a hanging fixture as a chandelier in the workhorse barn we were converting for a year-round rental. It would have been perfect for that high ceiling, with rubbed-off white paint over these old boards. Jackson came to look and he said I was right in terms of texture, only that he wanted it to die a natural death, not by catching fire from the bulb. Then he told Jeffrey the idea was only a gimmick, typical of a woman. Both of them had some growing up to do. Jackson didn't have time to do his.

Peggy Guggenheim's *Surrealist and Abstract* show with nineteen of her Pollocks toured Europe before summer; two Pollocks were shown in Japan, and in May *Number 1, 1949* was in the famous 9th Street show sponsored by The Club and chosen by Leo Castelli. In Paris there was still no one-man show, but Michel Tapié hung a Pollock among French and Italian stars.

LEO CASTELLI: I was impressed by that immense painting in Peggy's house [*Mural*] when I got to New York in '41 from Paris, where I had a gallery showing Surrealists such as Max Ernst, Leanor Fini and so forth. All the artists here were dissatisfied with their galleries, and Bill de Kooning and Jackson encouraged me to open my own gallery, but in 1951 I didn't feel up to it—had no money, and the moment was not right for me. But there was Janis whom I used to see often and who was complaining that he couldn't find good European material anymore; it was getting more and more scarce, more and more expensive. Since Janis and I had a good relationship and had done a few shows together, Bill said, "What about getting me into the Janis gallery?" They all wanted that because of its great European painters: Duchamp, Léger, Klee, and Mondrian. It was *the* gallery.
 I told Sidney that de Kooning was dissatisfied with the Charles Egan Gallery and knowing his work, he said, "Well, with great pleasure," and rapidly their business was concluded. Later on, Jackson came along and said, "You got Bill in; I'd like to be there, too." But Janis said, "You know how much I admire his work—a great painter and all that. But he has a difficult character, always drunk and wild, impossible to deal with." The fact is that Jackson wanted to be in good company, with the best painters. Janis was a generator with sales of Léger, Giacometti, and all that, and he got everybody; I didn't have to do anything, Janis did.

Jackson, although intrigued by the Janis possibility, seemed ambivalent. He was loyal to Betty Parsons and had written Ossorio and Dragon that she had promised a show for Lee who, he felt, would have a good reception on the basis of her present work.

BETTY PARSONS: I didn't believe in having husband and wife in the same gallery. Jackson knew this—he said they shouldn't be with the same analyst either—but for Lee he could be persistent. And I felt if I didn't show her, there would be problems; if I did and it didn't go well . . .

ALFONSO OSSORIO: There wasn't much sympathy between Clem Greenberg and Lee, particularly by him for Lee's work. Lee painted in an upstairs bedroom, on the wall of which a variety of canvases had been tacked with all the spillover of paint—it was a mosaic, a palimpsest of edges. I'll never forget Clem, supposed to be looking at a recent work on the wall, but really looking at the surrounding wall and saying, "Gee, that's fascinating." The horrible thing is that the wall *was* interesting. It was not unlike the house in Springs Mike Goldberg had later with Norman Bluhm. They were big splatterers, young splatterers, and they produced an environment in the living room perhaps more interesting than their forms.

CLEMENT GREENBERG: I don't think Lee was much of a painter—all brass and accomplishment. But for his art she was all-important, absolutely.

The Namuth film had an exciting debut at MOMA on June 14, 1951.

HANS NAMUTH: Historical things began to move for me now.

Jackson was not happy about his narration; his voice does sound flatter and more nasal on the soundtrack than it was, although tension improved his speech rhythm by speeding it up. He felt the score by Morton Feldman was just right for the film, and its concentration reminded him of his own work and the way it sometimes felt in process.

MORTON FELDMAN: They came to audition me, Lee having scouted me out, an unknown composer. John Cage was there, and I scored for the film as I would for choreography. It was the beginning of my life, really; I hadn't had entree and now people were talking about me. As to Jackson being camera conscious, I think he was too much a part of what he was doing. His voice in the narration is the result of the primitive recording; it all done on a shoestring [$2,000, according to Hans Namuth], and my fee was a small black and white drawing [ink on Japanese paper, 1951].

It was unusual how quickly that relationship of ours became intense; when Jackson liked somebody, he kind of took over—he was reaching out for people always. He had great insight into me, even if in a night

wandering anxiety he called up my wife from whom I was separated and woke her up. She told him she didn't care if he was Rembrandt, you don't do that.

CONSTANTINE NIVOLA: Lee didn't like the movie and I understand that. She should have tried to destroy it because to see him painting is really defeating; it shows him throwing paint and talking such nonsense. It makes it all too easy and shouldn't be shown.

Jackson's summation of his feeling about the film came up when I asked why he never went to movies. "Movies keep you outside looking at the outside. I want to look in, like a personality or soul X ray. I don't know about photography, anyway. Does technique and equipment add up to art? I figure if you click the shutter enough, *something* right has to come out of it, but even then it's more a mirror image than an act of creation. The camera is outside, that's the trouble—it *reproduces*. And don't start rattling off big names like Stieglitz at me. What he did for artists by showing them [in his gallery] is worth all his camera work."

Discussion with Jackson wasn't easy; his lines were spoken so slowly and with such force. And you never knew where an argument with him would go—he could be hurt, angry, contemptuous, and a lot of other things. But as time went on the danger of his being hurt was the most important, and when he was hung over, it took very little to do it. He would look surprised by hurt, as if it had sneaked up on him—and that could make you feel the real shit he was about to call you.

In a June letter to Ossorio and Dragon in Paris, Jackson wrote of an important creative development, one he predicted would make purist non-objectivists unhappy. He had been drawing on canvas in black, and found images of earlier periods coming through his abstractions. He was uncertain about this development. He and I had joked about my seeing images in his abstractions because of my being both color-blind and blind in one eye. I used to outline them for him, although he insisted that it was imagination and kept returning to the matter, alternately annoyed and amused.

EDWARD T. HULTS: It was one of those times a canvas covered nearly the whole studio floor—hardly any room to walk around it—and it was covered with paint, but he told me to walk across it. "Go ahead," he said, "you won't hurt it." It was dry and as I crossed, I had to stop halfway and laugh. I told him there was this horse's head right in the middle of the thing. "Where, where?" he says. He ran over to me and I outlined it with my finger. "By god," he says, "there is!" He got a small can of paint and threw it right over that place. The way it spread, I asked how I was going to get across. "That won't hurt, just get a little paint on your

shoes." I can still see him, the way he tore that top off the can and threw that paint at it, saying, "Now you don't see no horse's head."

For a few years still, Jackson took pride in his vegetable garden, which gave him a link with his neighbors and impressed friends.

FRITZ BULTMAN: Jackson was such a very *human* being, yet the public has him pegged as a wild man. I really see the gentle side of him: the cook to some extent, very much the gardener.

DR. FRANK SEIXAS: We didn't do any bartering, as some did for services, and he didn't give us a painting. What he did give us was an eggplant—the best, most glorious, purple shiny eggplant. That was our memento from Jackson.

TED DRAGON: One day he took us out to the garden to show us his eggplants. He spent some time polishing one with spit, then said, "Now, there's *real* color."

JULIAN LEVI: Lee may have given him the title for the *Sounds in the Grass* series, but certainly the feeling in them is his. We don't think of Jackson as a poet, I suppose because of the hazard words were for him. These words of his stay with me, although he said them between pauses: "You can hear the life in grass, hear it growing. Next thing, there's a dry spell—doesn't take much in Bonac sandy soil—and the life is gone. Put your ear to it then and all you hear is the wind."

The intuition for which Jackson was noted had more to it than insight into people. It was uncanny, the way he could turn up at inconvenient moments as if he had felt something going on of which he had to be a part. It didn't seem possible when I was enjoying the quiet of the long-disused dairy barn on a Sunday afternoon, planning its conversion, that I heard the Model A's approach through the night pasture. Next was the squeak of its rusty door hinge, then Jackson's face at a cobwebby window.

He came in, took his time looking around, and gave an admiring whistle. "What a studio for a sculptor! It's got a manure carrier track and hoist so you don't have to lift heavy pieces, and it's stucco and plaster, so Zog or David Smith won't burn it down with their welding. Concrete floor, too. Hey, look at these stanchions—what a guy can do with steel like that. We'll want to open up some of the loft for headroom, put glass in the haymow doors up there, a couple of good-sized skylights . . . Hell, there won't be a sculpture studio can touch it! I'll give you a hand, so let's get at it, goddammit!"

It was Jackson's longest speech to me. I tried to ignore his let-down as I explained the dairy barn wasn't going to be a studio—Zog and everyone else had the same money shortage we had. It was going to be a stable, a boarding stable, and if all went well there'd be a riding school and horses to rent, meaning the wood roads would be bridle paths.

When words finally came they were run together in his shock. "Horses, shit! This is going to be a studio, goddammit, not a lousy stable! Why did you buy the place, if all you want is money? Bunch of cathouses in the city would bring you more money and you could pimp for them, your own whores. Horses, chrissake!"

The rage I had felt dormant in Jackson was now in his face, and as he went quickly to the Model A it was in his voice as well, strangely high-pitched, cursing horses and all those who had anything to do with them. What worried me was that I could find no explanation for the horse phobia; what worried Jimmy, who had overheard this was did we want a poor "divil" hanging around who was daft, and daft was all he'd ever be.

HARRY JACKSON: Jack would never get on a horse. Sometimes at night we'd go to that ranch at Montauk—the oldest the Anglos had in the States, damn near as old as the Spanish—and go to the corral and watch the ponies. They raised good quarterhorses and we'd sit on the fence until I'd jump in there and ride one of them; take my belt off, put it around his neck and ride him. I'd beg Jack to, but he'd always say, "No, no." But he loved going out there and their never getting up and firing a gun over our heads; he loved that, but he would *not* ride.

He grilled me all the time about the West: "Do you ride for days?" And I begged him to come to Wyoming with me. "Come on out, you've got to come back." And I wish he had, because he'd have gotten some of that New York crap out of him—I love New Yorkers, love it all—but he had it sideways. And Lee had a goddam hold on him, terrific hold—right by the ying-yang, like a goddam kosher icicle.

Betty Parsons's inability to make sales for Jackson was making him increasingly anxious, and the enthusiasm for contemporary art he found in Chicago didn't reassure him sufficiently. His feeling was that Betty had to enlarge her circle of clients, and soon.

ALFONSO OSSORIO: The Museum of Modern Art had pictures going out all the time and on a map of the continent were different colored flags for each artist, so that they would know where each picture was. But with Betty, what drove Lee and Jackson insane was that she had no long-range plan; also that her map of works location was absurd. This was in the days when mailing was not done commercially but by an addressograph in the gallery with those little plates going clank, clank on

the machine manned by volunteers, and she would have two shows opening every three weeks.

Once, one of Jackson's large canvases [possibly *Number 24, 1950*] which had been sent to that summer theater [Hilltop Theatre Art Room, Lutherville, Maryland] hadn't been put back in the racks when the show was returned. It was put together with the scenery flats at the theater and it was saved only because one of the young apprentices the next year when they were cutting up flats to make new sets said, "Gee, that looks like a picture." So that had a happy ending.

A minor distraction that summer, but the kind of thing that Jackson took seriously, was a long interview about his working ways with a temporary neighbor, William Wright. It was played by a Westerly, Rhode Island radio station, and excerpts eventually appeared in *Art in America* (August–September, 1963). It contains the kind of statements that sound like Jackson's but rewritten by another, as in "Each age finds its own technique . . . I deny the accident [in poured work] . . . technique is just a means of arriving at a statement."

Our plans for the Farm to produce rental income seemed so far from being realized, I picked up a car for resale which had been in storage since the war. It was a 1941 Cadillac four-door sedan, with low mileage— spotless, rustless, and at two hundred dollars the next thing to costless. But instead of taking a quick profit, I offered it to Jackson at cost. When I said he could take his time paying for it, he shook his head. "You'd better say never . . . What a green—only an old geezer could've driven around in that outhouse bottom color."

The free trial Jackson accepted was short. "You said a day, but the day felt so long, even the clock in the Caddie stopped. I can't drive around in a Sunday-go-to-meeting car—it's family style, and I'd look like what I feel like, your dead geezer. Maybe if I painted it my way, but shit—I couldn't do that to a Cadillac."

In spite of being off the wagon, Jackson had a productive summer. His next show, scheduled by Betty Parsons for November 16–December 15, 1951, would have sixteen oils and five watercolors, or drawings as some call them, and become known as the black and white show. Black paints were diluted to bleed through the canvas and, as in the drawings done earlier in the year, images were allowed to appear. "Last winter my work felt like me, cornered in same way. But with this show coming up—well, I got it made."

While Jackson was trying to find Ossorio and Dragon a suitable place to buy in East Hampton, they were trying to find a gallery for him in Paris. Both were successful: Ossorio would buy The Creeks, the sixty-acre Herter estate on Georgica Pond that had been for sale at about the same price as the Farm but was far too grand for us, and a show was

arranged for Jackson at the Studio Paul Facchetti with which Michel Tapié was associated.

In addition to finding a home for them, Jackson found a car for himself. It was a 1947 Cadillac convertible, dark blue, much touched up and redented, complete with fishtail rear lights and lancelike bumpers, weathered top, and cracked leather upholstery—a dreamboat and just what Jackson wanted. "She'll burn a little oil—means smoke but helps lube up the valves—and the rubber isn't so hot, but tires come cheap in retreads. But don't go on bouncing up and down on that front bumper— I know 'weak in the knees' means worn shock absorbers too. And suppose it did cost twice what it should, it's three times your old geezer's Cadillac."

Jackson's newest long speech, and a fast one for him, ended in a cloud of blue smoke and jerking of the worn automatic transmission as he took off. But the car was sporty in a tired way, and Jackson was all smiles for once.

BERTON ROUECHÉ: Oh, how he gloried in that secondhand Cadillac! The idea of owning a Cadillac meant a great deal to him; it was a status thing. And he certainly didn't want to maintain the Model A humility.

If it hadn't been for the old geezer's Cadillac, Jackson told me, he wouldn't have gotten this dreamboat. He was grateful. I told him not to be, but not why: Both the town Chief of Police and Dan Miller felt I should have known better. The Chief said that Jackson had been a menace only to himself in the bike years and when he drove the Model A there was time to get out of the way, but with this dog of a Cadillac, well, I was to tell him the Chief had his eye on him. Dan Miller, from whom I bought gas occasionally to oblige Jackson, lectured me on responsibility, saying that one of the best things about Jackson was that he didn't realize his own importance, but that along with it went another unawareness: He had no idea of his power, in this case his danger to others. I was to think about what I had done in having given him a taste of what it's like to have your foot on real horsepower.

PATROLMAN EARL FINCH: He was a drinker, but gave us no real trouble. As to his driving, there wasn't that much traffic and we had other things to worry about.

ED HULTS: When Jackson was thrown out of Sam's Bar he got a brick and threw it through the plate glass window. They called the cops right away and Bill Schellinger went up and got him home. The way I calmed him down when he got in trouble in bars was by kidding him out of the thing.

GEORGE SID MILLER: The Town Police would tell him, you know, "We're going to lock you up." But they didn't; they'd take him to their office and sober him up—they'd *never* put him in a cell. They were pretty good boys, local then; now—hell, the cops are from up-island.

Tony Smith persuaded Jackson to do a silk screen edition of six of the black and white prints, and Jackson made a couple of trips to Deep River while Sande was working on them. There was the usual tension with their mother, Stella, and Arloie was worried about Sande.

ARLOIE MCCOY: Sande was doing commercial silk screening, barely made a living for about five years. Sande was too much of a perfectionist and he had to do all the business things himself. It was too much for us, so he took a job with a small company doing silk-screened electronic circuits.

During the fall Jackson's drinking was on an alternate-week basis, with the result that one week he'd seem to be in a kind of suspension; the next a bit glassy-eyed, talkative but in control. There were a bad couple of days after a return from Deep River, and Dr. Hubbard referred him to a biochemist with a Svengali air, Grant Mark. It meant rather complicated therapy: Mark's formula for soybean paste, mineral emulsions and natural foods, with emphasis on proteins and salt baths.

ALFONSO OSSORIO: I remember Jackson coming out of Grant Mark's office and saying he should eat no fowl that can't take off at fifty miles an hour, such as wild duck, and his range of understanding was enough to see the humor in it. Then there were all those bottles of emulsion to drive back to East Hampton.

B.H. FRIEDMAN: There was a lot of urine testing, and there were boxes of kosher rock salt they used for baths. We went into a bathroom and there were rows of these boxes above the tub. I said, "What's that doing here?" I thought maybe they were preserving meat or something. But Jackson's medical history is shocking.

DR. RAPHAEL GRIBITZ: I was totally unsuccessful in getting Jackson to what I call reasonably good therapy. He was taking zinc injections, copper injections, from a group of people who were exploiting him to an excessive degree. Jackson had a deep-rooted problem and I wanted to know at least he had a chance; this way he had no chance at all.

JUDY SEIXAS: He was into any fad that came along, always grasping for ways to be healthy and looking for means not only from within but

from outside—it could be homeopathy or anything else. Lee had some roots in life, but Jackson—I think he must have always felt on a ragged edge.

Jackson never admitted to me that he was an alcoholic, instead several times he explained why he wasn't. He looked kindly on Grant Mark's efforts to improve his general well being. Lee was treated by him also, a couple of her paintings being accepted in lieu of fees. Later Mark called them Pollocks, saying that the fact they were signed with Lee's initials was because he didn't want it known that he had been trying fabric designs. And Jackson cited Dr. Fox (whom he saw over the years occasionally and to whom he gave a painting, *Number 4, 1951*) as his reason for maintaining that his dilemma wasn't a simple matter of alcohol. "With me it's some kind of chemical derangement. Once my chemistry is figured out, alcohol will find its own level. Anyway, I've proved I can do without it, can turn it on and off like a beer tap. As for Grant and his minerals, they are bound to put lead in my pencil."

Lee's first solo show was to open at Betty Parsons October 15, 1951, and it offered large works marking a transition from her Cubist forms of the past four or five years, using space in a way that predicted a more confident future.

BETTY PARSONS: It was worse than I feared. Not a work sold, and while large they weren't *that* large. It had to do with the times, maybe if people were going to buy a Pollock it had to be that and not a Krasner, maybe—later Lee destroyed all but two. I felt badly for Lee, in a way worse for Jackson, because of his problems. While I've always introduced somebody new, it's been under different circumstances. I still have shows in which nothing sells and I'm always amazed when I do sell an unknown—they can be both exciting and depressing.

Alfonso Ossorio's show followed Lee's and also fared poorly. None of this reassured Jackson about his future with Betty. Nor was there a positive reaction to a show at the Chicago Arts Club in which his work appeared with that of de Kooning and Ben Shahn. The artists were prompted to consider the matter.

ALFONSO OSSORIO: I was present at that extraordinary meeting where seven powerhouse artists were thinking of leaving Betty. I was younger than most of them and certainly less famous, but I'd been with Betty longer—my first show with her was in '41. Betty was on one side, I was between them if I remember correctly, and on the other side were Barney Newman, Mark Rothko, Bradley Tomlin, the two dentist sculp-

tors [Herbert Ferber and Seymour Lipton] . . . Clyfford Still wasn't there but anyhow, someone. They presented their ultimatum: Either you cut down on the frequency of shows and give us some sort of assurance—contract of some kind—or else we'll just have to leave you.

Betty said, "Sorry, I have to follow my own lights—no." I looked across and there she was, sitting slightly pigeon-toed with one flesh-colored stocking and one gray stocking, facing these seven glowering figures. She took those leavings rather hard, yet she realized why they happened. They hadn't been rude to her, but it was very embarrassing when I left that fall—suddenly to realize that twenty years have gone by and it's time to move. Still, she was always very nice afterward. She felt betrayed only by one artist and that was Stamos. She did, you know, feel that she was making a contribution to others by showing all these unknowns, making these discoveries, and she was.

BETTY PARSONS: I went through some bad losses, and I was very upset when Hofmann left me. I couldn't subsidize, you see, but Sidney Janis could guarantee them. I could hardly guarantee myself. Rothko said, "I'm doing you no good and you're doing me no good, so we better part company." And Jackson, when he left me in the spring, was very upset; he told me he hated leaving. You know, I borrowed $6,000 for each, which I gave them for living expenses. Before he died, he said, "I doubt I should have left you."

B. H. Friedman interviewed Lee about the black and white works, which Lawrence Alloway rightly called black paintings since no white was used. She was at a loss to explain the new exposure of imagery as much as she was to what led Jackson to the limitation of black. These paintings are on unprimed duck sized with Rivit glue to give a harder surface for the commercial paints used, Lee added, and some were cut in sections, a decision made difficult by the undefined limits of top, bottom, and side.

Ossorio wrote an introduction for the black and white catalogue, originally intended for the spring show at the Studio Paul Facchetti in Paris. He wrote that the Pollock vision makes irrelevant such terms as figurative and nonrepresentational because of the feeling of the remorseless continuum in which the end is the beginning, a conviction Jackson applied to his theory of death.

Ossorio and Tony Smith had each bought a work before the opening, but the show was commercially a shock for Jackson; no large work sold, very few of the smaller ones, and even the signed limited edition of prints in the $200 portfolio found but few buyers. Critics were reassuring, even if they had to speak of his getting away from a blind alley and dead end, and Dore Ashton wrote of Jackson's absolute sense of how to deal with space in the drawings. Greenberg in *Partisan Review* called

Pollock in a class by himself, and the best painter of a whole generation. One painting, *Number 7, 1951*, was vandalized (later sold to Professor Isaacs).

BETTY PARSONS: They came in and cut the canvas and wrote four-letter words on it. I had turned the lights out and gone into my office, not knowing someone was in the gallery, and found it the next day. It must have been somebody off the street who just got irritated by the work. But, oh, how I loved those works. I'll never forget that marvelous show.

MILTON RESNICK: He did something that a lot of artists thought of doing: He faced things in his work that made him look back on earlier work and see if he could do it better. Truth was important to him, but I think he suffered for his honesty.

FRITZ BULTMAN: Now I think they are among his very best pictures; he had the whole drip thing behind him so he could deal with the image again. He had the strength to do that, and the image was central to Jackson and everything that grew from it. The drip paintings, which are the most beautiful, do hide the image, but it was very, very strong.

ALFONSO OSSORIO: Jackson went back to the image very consciously and the images are very complex. It was the first time that I had seen the conscious and the subconscious simultaneously attempted visually. He didn't do it the way Blake did and transfer it to the Old Testament; he was absolutely here and now, and in himself. They were tough images and they were not seductive on that cotton duck with the black gook on. He broke another taboo of niceness of finish and things.

Jackson often started with a figure and veiled it with linear patterns, and there are several works where obviously he started with a series of figures and then covered them. That was one way of working, but it would be just as true to say that he started with a feeling of the interlocking unity of objects and objects and feelings. Of course, that is a tension very difficult to maintain and it was something that he wished to relate to his own problem, the more difficult problems yet to be solved. He was too interested in the real problems of painting and art to continue duplicating *One* and another splendid show of silver and gold with the endless possibilities.

PAUL BRACH: I think what he was doing was refreshing his symbolic vocabulary. I thought many of the paintings were really corny, just straight drawings blown up to be paintings. What interested me about Jackson was the mythology buried in the field, and when he couldn't keep the field going any more he went back directly to mythology.

BUFFIE JOHNSON: There is a despair influenced by Tony Smith's when he was drinking but Tony's was much darker, just as he was more intellectual.

DR. VIOLET DELASZLO: I felt a reaching out, a seeking of help in the black paintings. I asked him after the show, "Where do you go now as a painter?" He didn't know. In those paintings there was a foreboding of death; it is very specific.

After the closing of Jackson's show, a couple of works went across the hall to the Sidney Janis Gallery for inclusion in the *American Vanguard Art for Paris Exhibition* with Baziotes, Brooks, Gorky, Gottlieb, Guston, Hofmann, Kline, Matta, Motherwell, which then moved to the Galerie de France. For Betty it coincided with the completion of her contract with Jackson, Peggy Guggenheim's having already expired, but she was able to persuade Jackson to let her continue representing him until May in the hope that she might generate some business.

The desperation the Parsons disaster caused in Jackson hit me hard the next time he and I met. It was at the Zogbaums'—at least it's my next memory of him—he was standing out in the driveway by the Model A. He asked if I had ordered Jimmy to close the logging road through the woods from Stony Hill by felling a tree on it. I told him it was done to keep out-of-town people from hacking away at the holly trees, now Christmas was close. He kicked a Model A tire. "I wondered, that's all. But if you don't watch it, that old greenhorn will be giving *you* orders. I know the kind, give his right arm to stay on and takes yours off you once he's in good. But I guess servants is what you're used to—let him play you for a sucker."

It was an unpleasant moment, saying more things than I could cope with. I was glad Jackson avoided me the rest of the evening and I remembered Buffie Johnson's account of Jackson's pursuit of Dr. deLaszlo.

BUFFIE JOHNSON: His face lit up when I mentioned she was coming, so I asked him for a drink. But Lee called to say he had to help her prepare dinner for guests, and we went on to the Macys' for dinner. Before long he lurched into their house, far gone, and he and Violet deLaszlo went into a huddle in the corner of another room for a long time. He left peacefully then, and he said later he would never get over how helpful Violet was. And help Jackson surely needed.

Christmas was no more Jackson's favorite season than mine, and while he made it through what he called the "Santa shit" well enough, New Year's weekend was too much for him and his dreamboat. The Cadillac

went off the road at the Louse Point intersection on Old Stone Highway in Springs, December 29, a Saturday night. It mowed down a string of mailboxes, clipped a telephone pole bringing down a wire, and farther along was stopped by a scrub oak.

ALFONSO OSSORIO: We went over to his house the next morning and the police came. Jackson had a hideous hangover and looked like death, but he was eating.

TED DRAGON: And you remember how grossly he could eat. When Jackson had drunk a lot, he always ate with his hands.

ALFONSO OSSORIO: When the police came in, he didn't get up or make an apology. He left it for the policeman to be the guilty one because he was intruding on this poor fellow who was simply hungry. Jackson couldn't have handled it better—the scene went off like a dream.

That afternoon Jackson called me, dismissing my regrets about his loss. "It's a hell of a way to finish up what should have been a good year. The thing is, now I got to get a car and I wondered about the old geezer's." I explained that I had traded it for an army surplus truck which would be just the thing to tow the Model A with. This he had left outside by the studio for weeks, not even bothering to shut the windows, and its battery was as dead as the car looked. He didn't want to see the Cadillac; as far as he was concerned, it was totaled, since he had only liability insurance and nothing to fix it up with.

Jackson was the first driver I had come across who in an own-car accident didn't blame the car; he even thanked the Cadillac for his having no more than a sore chest from the wheel, adding that maybe he hadn't deserved such a good car. When I explained the effect weak shock absorbers could have in combination with power steering, his face said I'd made a friend for life. "That's how I'll explain it to the Chief when he gives me that eye of his: She was weak in the knees."

Then he went into the long history of his near misses with cars, one so long I realized it took a topic he felt at home with, such as cars, to free him.

HARRY JACKSON: It's a lot of crap about Jack not talking much; he talked my goddam ear off one long night, drinking beer in the kitchen. Jack brought out *Cahiers d'Art* and analyzed Tintoretto in great detail, explaining the composition of this and that; what he was doing was bringing me pure Tom Benton: Venetian Renaissance to Tom Benton. Tom to Jack, Jack to Harry. Then he analyzed Braque, Picasso, Juan Gris, and Matisse, but he wasn't that crazy about Matisse. He talked

especially about composition that night, and Lee came down several
times to say, "Jackson, come on to bed—you're going to be so tired and
you've got this and that to do," something like that. But we went on until
dawn with Jack describing Tintoretto and weaving a spell: "See, it goes
back over there, and then over here, and it never goes off the can-
vas . . ."

It was good to see Jackson in the Model A again on the roads, and it
was good to see how well he had taken the disappointment of the black
and white show too.

CHARLES POLLOCK: Jack and I left that '51 Parsons show to-
gether and we went into a little bar on Sixth Avenue just around the
corner from 8th Street. We sat at a table in the back, then Jack showed
the waiter the catalogue. He said, "I want you to see this. I'm a goddam
good painter!"

"FINEST KIND"

The financial plight of the Pollocks in the new year of 1952 was so severe it replaced concern about Jackson's drinking. Friends did what they could.

ALFONSO OSSORIO: He wasn't making as much as a mason laborer and occasionally it would be very clear that a big roll of cotton duck was finished. Where were they to get three-hundred dollars to buy another? So the few thousand from us over the years did help—five or six major pictures and a few at moments when it was especially helpful. We were buying more of his work than anyone else; the galleries weren't doing it, the museums weren't. We urged my brother Robert to buy three.

I offered one night, in post-midnight generosity, to give him ten thousand dollars, which in those days was a lot of money. It was just so he could relax for a year, and I meant it. But then I realized I couldn't do it, period, so I didn't. He brought it up, saying, "Were you serious?" and I said, "Well, Jackson, let's think about it . . ." It was very ungenerous of me, but—I don't know how much good it would have done anyhow.

ROBERT MOTHERWELL: Jackson was the first artist I knew well who mostly talked not about art but about money. People in Europe would have regarded it as not indelicate but almost obscene to talk about money. One night he called up Sidney Janis in Buffalo at three A.M. and screamed, "This is Jackson Pollock and I hear you like my work. Why don't you buy one?" Knowing Sidney Janis, he would say, "Okay—for fifteen dollars."

FRITZ BULTMAN: Hans Hofmann bought a couple of things ear-
lier. And I got my sister [Muriel Francis] to buy *Shooting Star, 1947*—
anything to help out.

Others were helpful in ingeniously tactful ways financially, such as the
Macys and particularly Hildegarde Helm, to whom the other mosaic
table went. Jackson admired her small but fine collection of Cubists and
Expressionists, and on a couple of evenings when he came by on his
nocturnal Model A visits, over drinks she would flash reproductions of
other works at him for identification on a complicated wagering system,
by which she gave him odds and then doubled them. Jackson never lost.
"I don't get it, the way she seems to want to lose. She said she went to
some horse boarding school down south with your sister, so maybe it's a
game the rich kids from up north played there?"
 The school, Fermata (in Aiken, South Carolina), boarded genteel
equestriennes, not horses, mounting them well and teaching them little.
The wagering was designed solely to benefit Jackson, but it came to an
end when Lee implied that the Helms encouraged Jackson's drinking.
 That Jackson in his darkest hours did not simply give up was due, it
seemed to me, to a combination of his therapeutic need to work and to
the faith of others, particularly Lee.

GRACE BORGENICHT: Clem Greenberg introduced him just after
I had opened my gallery; I went out there and he drove me around in
that crazy old car. I was excited about the work, though it was pretty new
for me. I bought a painting and sold it, having bought one at Betty's
before—silver and things on paper. It's amazing how worried he was
about the critics; he felt he wasn't really recognized and said, "Here I've
been painting for years, ready for a show every year." It was so pathetic,
and he was so tortured. But those are myths, his demanding a $10,000
advance and that I get rid of things in my gallery!
 I was showing Jim Brooks, and Jackson came in and disrupted an
opening—probably jealous—which cast off a very unpleasant feeling.
He was in pretty bad shape when I first knew him and trying to get help
for his drinking. At one point, he went to a hospital to dry out—a short
stay—and didn't have any money, so I helped him out. He was so deeply
troubled and so depressed—always spoke about wanting to leave Lee.
He was looking for someone to take care of him, looking for a mother.
And then there was that suicidal drive; it was so strong it was almost
contagious. There was no way I could handle him.

SIDNEY JANIS: When I opened the gallery in 1949, Lee and Jack-
son spent a whole afternoon with me while I was hanging the Léger

show. Lee, a very intelligent person, was the ambitious one, but—it's true—a little pushy. With the public not ready for such work, Betty wasn't the only one who would have had trouble selling Pollock. He was very careful about where he stood in relation to art and artists, wanted to be in a strong gallery with strong artists. He was an intuitive artist, to the extent that the work becomes part of the self.

A creative loss that winter came with a meeting to consider the church Tony Smith wanted to design, utilizing Jackson's work.

ALFONSO OSSORIO: The church was to be a hexagon, like a honeycomb, interlocking and cantilevered, and Jackson was to do the undulating ceiling with a band of stained glass going around. We organized a meeting at Macdougal Alley to present the concept: Tony, Ted and I, Jackson, Eloise Spaeth—Sweeney, Happy Macy, and Father Ford of Columbia.

You might have thought one of the Catholics at least would have said, "Very interesting," but not a word—the proposal was a disaster. Tony walked out, Jackson was glum, and I was no help in showing slides of a mural known as the "angry Christ" I worked on for a Philippine church—made some of the old guard furious. Father Ford made sense in saying, "You should always get the patron's favor before you present the idea." I told him he was so right.

ELOISE SPAETH: There have been so many conflicting stories, but I do know that Tony was troubled by the design not being published in *Liturgical Arts*. My late husband, Otto, Maurice Lavenow, and I liked the concept, but we felt no pastor in the U.S. was ready to build such a church. We *had* to discourage Tony and Jackson.

Although Jackson was curious about religious institutions, he was judgmental. "Churches are okay if you got to belong to something to feel safe, but artists don't need that . . . they're part of the universal energy in their creating. Look—existence *is*. We're part of all like everything else, we're on our own, goddammit!"

At this stage of Jackson's alcoholism, the amount he drank was related directly to the pressures on him, so that the less he could afford to drink the more he needed to. And the more he did, the greater were the pressures upon those close to him.

PETER BLAKE: I came out three or four times and stayed with the Pollocks because Lee said that each night when he was drunk, which was every night for a while, he would take off in his damn car and disappear. She would sit there alone waiting for him, or for the police to call saying that he'd been killed. She couldn't stand it, couldn't stand being there by

herself, and wouldn't I come out. What Lee needed was somebody, she said, who could help him up the stairs when he gets home carrying a load from his drive. But she explained that he hated to be touched when drunk, and since you couldn't get him upstairs without touching him, and because he had never hit me, I was elected.

I do know that he was capable of incredible violence, and I think there were times when almost everyone in a given room was scared shitless by it. Jackson would come in and break up parties, appearing at ones he hadn't been invited to, come reeling in and make a pig of himself. Later, when it got worse, people would flee on sight of him at the door.

ELOISE SPAETH: The Macys were at our house for dinner, just the four of us, and when we were having coffee in the living room in came Jackson, high as a kite. You know, we didn't quite know what to do with him. I offered him coffee and he sat down and sort of rambled along—very sweet but discombobulated. Then there was a knock on the door; a friend was looking for him. He went docilely off.

HARRY JACKSON: Motherwell didn't have any idea how to talk to that sonofabitch, scared to death of him. Jack and I were incredible friends, but when Pollock got black with me—it's a certain strain of folks that have that—he had it good. It was really a mean look, got very heavy and black, like a goddam cur dog—he had that edge to him. He went out and got drunk one time and came back from that Montauk ranch, driving on Fireplace Road, when he got out to take a leak. Then he was going to knock the shit out of me, so I said, "You're not going to knock the shit out of anybody, Jackson." So I knocked the shit out of him—hit him in the nose, hard, and it was just all there was. And then, "Aw, shit, goddam," laughing and having wonderful fun. We were friends, and so we spoke the same goddam language.

Pollock detractors found, they thought, ammunition in the black and white show: The imagery was indebted to Jean Dubuffet; the use of black borrowed from Kline, de Kooning, and Motherwell—even though Jackson alone was using solely black. But Jackson was impressed by Dubuffet, with whose work he had become familiar through Ossorio, and he was drawn by what many thought its ugliness.

ALFONSO OSSORIO: In addition to liking the work of Dubuffet, Jackson liked the fact that people *didn't* like it, that here was someone trying to do something different. As to how far the liking went—well, there's no doubt they looked at each other's work with extreme attention and understanding, but with Jackson thinking that Dubuffet didn't go far enough and Dubuffet thinking that Jackson was too easy, perhaps.

I took pains to have them meet, and we brought the Dubuffets to East Hampton. The idea was that we would have dinner at the Pollocks', but Jackson decided that life would be simpler if he and Dubuffet didn't meet. With the host missing, it was just the four of us and it was rather embarrassing. Lee talked, Dubuffet talked, we all did like mad, but there was a big gap. So the plan for a meeting didn't work and I have no recollection of seeing them together.

The long-awaited one-man show in Paris opened at the Studio Paul Facchetti on March 7th, due in part to Ossorio's generosity, and had a catalogue introduction by Michel Tapié and photographs of Jackson by Hans Namuth. As usual, the impact on the art community was large, sales few: Two paintings were bought by collectors, *Numbers 14* and *19* (both done in 1951), and Tapié himself bought two small works at a discount of fifty percent. The exposure would mean important sales in the future, but for the present only a little over $1,000 was realized.

For Jackson this latest disaster coincided with a severe physical reaction to Grant Mark's therapy. "It's like being skinned alive. And instead of putting lead in my pencil, he must have taken some out."

"SAM" DILIBERTO: When I was tending bar at the Cedar, it was the outsiders who mostly would get physical. Pollock would only put on his act. Was he worth his weight in trouble? A draw. You had to like him though, and later when he'd be banned for the trouble he caused, there'd be this bear's head outside looking in the little panes in the door, wanting in with his buddies, Kline, de Kooning, and the rest. A teddy bear outside, grizzly inside.

PENNY POTTER: He brought out one's maternal instincts; he had a great need to communicate and he was so obviously miserable. He said to me more than once that sometimes he felt as if his skin had been taken off, and later, he talked about being like a clam without its shell.

HELEN FRANKENTHALER: There was an element of dependence, and a rage as well as the alcohol drama; true of many artists. One had an awareness of his childhood traumas, complicated by a strange mother involvement, and strong male/female sides; again a common artist's syndrome. We met at Clem Greenberg's at a time he was not drinking. He was sitting on the floor—gentle yet rough, fragile but thick—and suffering.

LARRY RIVERS: Helen and I went to Springs to see Pollock and he was very gracious—then. Helen was younger than I, maybe didn't know the way she was going to go, and she picked up on the abstract thing

more than I did. But it was exhilarating to meet him in that studio with all the trappings of the very foremost artist. There were huge canvases, like piles of them, and all so *serious*—only I just saw him as a typical artist.

And then at lunch in his house—Lee was gracious too—there was heavy talk. Afterward, Helen and I walked by the sea: We were going to be great painters, really devote ourselves to *art* because of the guy— move to the country, even *be* what he looked like.

On April 9th, Dorothy Miller's exhibition of *15 Americans* opened at MOMA. As with some of her other shows, many Abstract Expressionists were represented even if women artists were absent, including Lee.

DOROTHY MILLER: I always wanted to please the artists, so I asked Jackson if he wanted to hang his own gallery. I would have stood over him and if I hadn't liked it would have said so. But he said, "Oh no, Dorothy. You do it just the way you want it." That show was my best; I tried for variety and it was quite a gathering, not a stream of people who thought alike.

Jackson would wander into our 8th Street apartment, sometimes very drunk and sometimes very quiet—the latter, I think, because when he came to a quiet place like ours he became quiet too, out of courtesy or feeling. A year or so later, he came with Lee and he was a little drunk. He said to her, his hands over his face in agony, "Don't look at me like that— don't look at me like that!" I think she hated him and was probably staring at him with hatred.

A woman friend who was an analyst was over one night when the doorbell rang. My husband, Holger Cahill, said, "I'm sure it's Jackson, open it." And the analyst, hearing it was Pollock, whispered, "Let me talk to him, let me talk to him"; she'd seen his work at the Museum. So she dragged him in the front room and we went to the bedroom. He was drunk, but it was a long talk—nearly an hour—and then she said he became very quiet. Finally he left and she said, "Oh, God, if only I could work with him. I'd give my soul to work with him."

In May, having fulfilled his commitment to Betty Parsons, Jackson joined the Sidney Janis Gallery. It did much for his morale, and that in turn meant less drinking. "This time it's got to work . . . this is *the* guy, they don't come any bigger. Only lunch with him is like with that Old Testament God across the table . . . it can make you feel like his breadstick—broken with two fingers, not even noticing."

SIDNEY JANIS: I was very much impressed by Jackson and we would have lunch together. At such moments we would discuss some of his anxieties and they would subside. We really hung his shows without

him, then he would come in and pass on them. We were friendly, but I didn't feel I was serving in a father role for him; maybe he did.

Lee did the whole thing, gave me first choice of work to show. We did more Pollock exhibitions than any gallery in the world, but we had great difficulty selling his bigger pictures, which we were offering at $2,500. One we reduced to $1,500 for a man in Baltimore, and he came back and said, "I can't buy it because my wall is four inches too short"—$1,500! We did have great difficulty with Pollock and he didn't make a living his whole lifetime; he was always a little in debt. We lent him money—it didn't run into big money because there wasn't big money around at the time—and when we sold a painting we took a percentage off ours so that he would have *something* from current sales.

The noon whistle blew as Jackson came to have a look at the Farm water tank Jimmy and I were cleaning out, letting the residue of the collapsed roof and what looked like drowned squirrels and a few birds accumulate on the ground. Jimmy gave Jackson the smallest of nods, one barely returned, and went to lunch. Jackson admired the view of the ocean from the hill on which the water tank stood, said once again that we must have done something right to have found such a place, then nodded at the disappearing Jimmy on the other side of the orchard. "Only an Irish Mick could eat after handling this shit, and you've been *drinking* it. I've got enough Irish in me to know that whiskey was made to use instead of bad water, was around it as a kid some . . . but now booze is like women: picks you up easy, lets you down hard."

My question then about what his father was like might as well not have been asked, and in the silence I mentioned that my growing up was rough too. "It's supposed to be lousy, so the rest of life will seem easier . . . only it isn't. The real growing up is away from mothers . . . Fathers are a cinch, once they can't lick you . . . To be free, we got to unload mothers, we got to."

I found Jackson's mother awesome in her silence and dignity the few times I saw her on East Hampton visits. Each meeting meant Jackson would be sober but not really there; Stella would be very much there, reminding me in her solidity of a bulldozer at rest. She must have said something more than this to me, but this is what stays with me: that I should look on my worries about the Farm as a boon because care and work are what make home and life.

ALFONSO OSSORIO: The mother was obviously very powerful; you could tell just by talking to her. Off the top of my head I have no recall of his talking about his father.

TED DRAGON: Lee never really liked his family.

ALFONSO OSSORIO: But Lee never said anything except that it was a lack of understanding of what he was up against and what his work involved. In that sense they were not supportive; that was the way Lee couched it to me, the only thing I ever heard.

TED DRAGON: They didn't get along, they really didn't. I remember that if a visit was in the wind, them coming or anything, Lee'd be very upset. They upset *him,* you see.

ELIZABETH POLLOCK: This remarkable woman *may* have gone to a country grade school—I doubt if she read more than newspapers—yet she accepted intuitively association with Negroes and Jews, she was so lacking in suspicion and was so open. Don't forget that of five Pollock sons, three married Jewish women and independently. They had need of the kind of warm emotionalism you get in the Jewish woman.

The summer of 1952 brought a gradual change in the sociology of the town of East Hampton. The summer colony, centered on the Village area, saw an influx of new money; it was resented by what was left of the old, prewar money. In Springs, local families selling property to artists no longer called them "crazy." While the Pollocks drew some artists, what the area offered in terms of light, landscape, and reasonable living costs was more important. A neighborhood loss for Jackson was that of Justice Schellinger; William Baziotes was buying the property when he, too, died.

CONRAD MARCA-RELLI: When we bought the Schellinger place and I told friends we were getting a house right next to Jackson's they said, "You're out of your mind. He'll wreck your house, he'll do this and he'll do that." Actually, I was a little concerned, not knowing him well. I had sat next to him at a party in New York after the war—he was sober, shy, very uptight. He didn't say a word for some time, so I didn't either. Finally he said, "You're very silent, aren't you?"

After we'd been working on the house, he came over one night in his kind of stumbling way. The mortar was drying fast for a fireplace I was building, so I said, "Come in and sit down, but I've got to finish this." He said, "I'll help you," but I said, "Don't please. I'm just getting it up and all I need is one false move and the whole damn thing will come down." I kind of nudged my wife, Anita, to get Lee over and take him off because I was nervous, his being high and my trying to work. Well, she hadn't been gone a minute before Jackson says, "Where's Anita?" I was embarrassed and said, "Well, she just stepped out." But then he did something which really touched me: He looked at me and said, "You didn't have her go get Lee—oh, no! I wasn't going to do anything wrong."

I really felt like a heel, he was so wounded by my mistrusting him—felt terrible. From then on, I treated him square, whether he was drunk or not, for I knew he would never break a thing and he didn't. Once he came over drunk asking for me when I was out, and Anita told him to come in and have some coffee. But he just kissed her hand, he was so sweet and nice, though he was high, just said he'd see me and left. Do you remember Jimmy Dean? With Jackson there was that headstrong, romantic view of life—the youthfulness of the great dreamer.

As luck would have it, Jackson witnessed one of my miscalculations when we had our first bulldozer. I hit a tree trunk accidentally while cutting through a bridle path, and a sizable limb snapped and just missed me on the open seat. Backing, I saw Jackson and his look of amusement; it unnerved me so that I swung the dozer clear too fast and the blade caught the tree and ripped it out like a bad tooth. Jackson came close, his face contorted, and I shut the rig down. "Don't you know a tree can feel, chrissake?" It was a near shout, his breath bringing a smell of booze strong enough to overcome that of diesel fuel. I told him I was more concerned about how the dozer felt, being broken in so fast. "Shit! Worry about what you're doing to *yourself*, shredding a living thing like that into splinters. And don't think it can't happen to you, only different—worse."

He told me to get in the Model A so he could show me a little western driving to help my dozing technique; I was too thrown by seeing he was on the verge of tears to object. "All it takes is the feel of the wheel so you're one with the car—You can come as close to a tree as you want, and no limbs dropping on you either." He went closer to an ash than he could have meant to, then zigzagged downgrade and fetched up in loose dirt of the opposite shoulder. "Next time you kill a tree, goddammit, think. And remember, things in nature feel—maybe different, but they feel." He took it so easy driving me back to the job, only his look of relief kept me from thinking I had dreamed this close call.

NICHOLAS CARONE: Conrad Marca-Relli took me to meet him. On his wall was a narrow fifteen-foot panel of his and he was listening to Charles Ives—not Bach, Beethoven, Monteverdi, Palestrina—but Ives, linking him to something in the primitive American culture. And then he said, "If you could paint with the intensity of those eyes of yours, you'd be something." And after saying, "What the fuck are you involved in?"

He had a very intimate way of looking at work, looked at my work for hours. That was the first time I had an experience like that—a person looking at it the way I wouldn't, noticing the way the picture sort of moves to the right or the left, you know. And there might be certain images with psychological meaning and he'd say, "Watch out for that," or

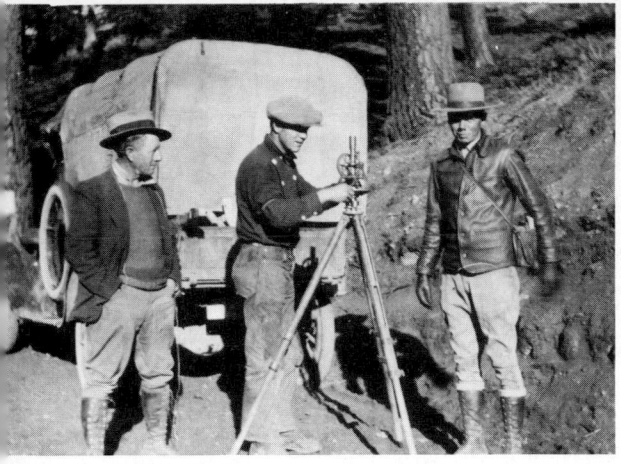

L. R. Pollock, Jackson's father, with a survey crew. Probably Kaibab National Forest, Arizona, c. 1927. *Courtesy Frank Pollock*

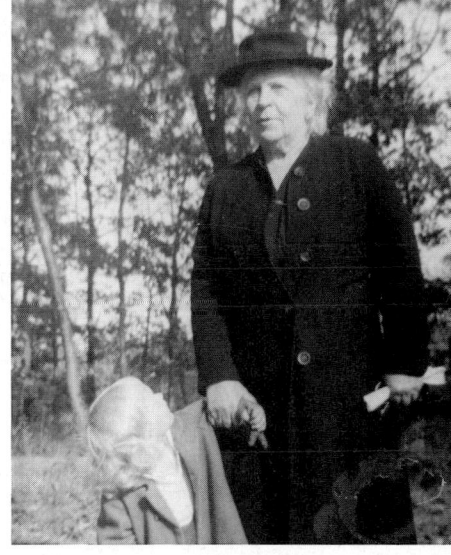

Stella McClure Pollock and grandson, Jason McCoy. *Courtesy Elizabeth Pollock*

Brothers Jackson, Sande, and Frank Pollock with Betty Nelson, a friend. *Courtesy Frank Pollock*

Reuben Kadish at 8th Street apartment. *Courtesy Reuben Kadish*

Jackson at Provincetown, Massachusetts, 1941. *Photograph by Bernard Schardt, courtesy Nene Schardt*

nford "Sande" McCoy, James Brooks,
oie Conaway McCoy, at Deep River,
nnecticut, c. 1946–47. *Courtesy Charlotte
k Brooks*

Fireplace Road house, rear view, with pile
of stones "doused" by Jackson. *Courtesy Pris-
cilla Bowden*

Jackson with Caw-Caw, spring c. 1947.
Photograph by Herbert Matter, courtesy Mercedes Carles Matter

Jackson's studio, East Hampton, 1950. *Photograph by Rudolph Burckhardt*

Jackson "finishing" work a second time for photographer.
Photograph by Rudolph Burckhardt

Lee and Jackson at his studio door, 1950.
Photograph by Hans Namuth

Jackson in rare laughter at Betty Parsons
Gallery, 1951. *Photographs by Herbert Matter,
courtesy Mercedes Carles Matter*

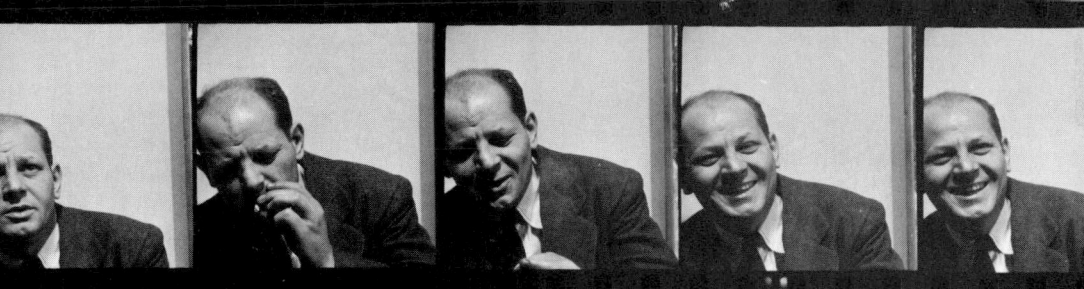

Alfonso Ossorio in The Creeks music room, East Hampton, 1952. *Photograph by Hans Namuth*

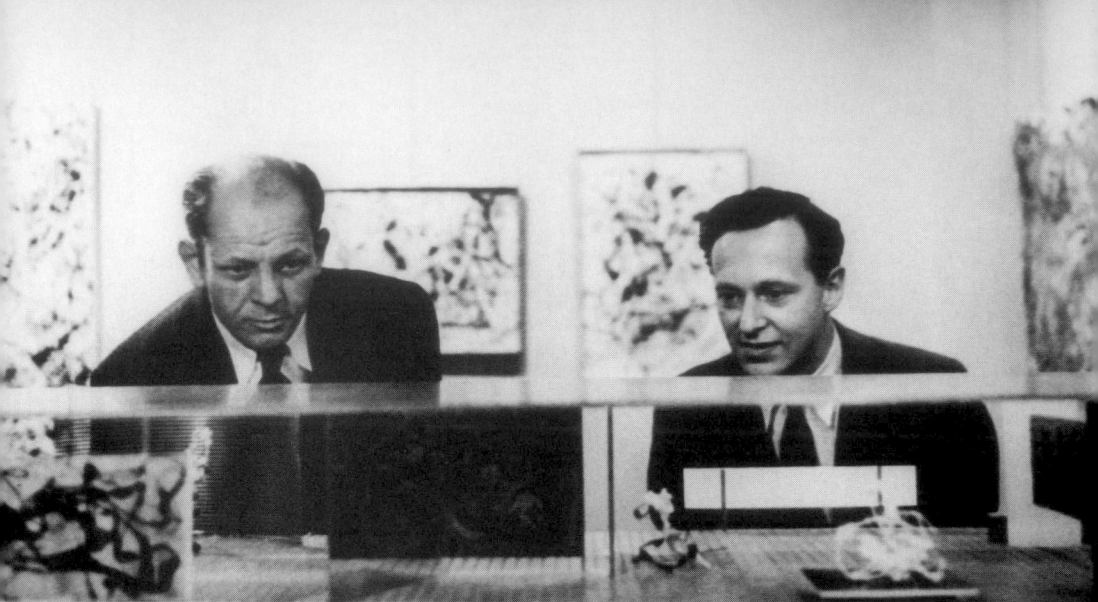

Jackson and Peter Blake with Peter's model of the "ideal museum," Betty Parsons Gallery, 1949. *Courtesy Peter Blake*

Jeffrey Potter in Stony Hill Farm woods after Hurricane Carol, 1954. *Photograph by Penny Potter*

Patsy Southgate, Springs, 1956. *Photograph by Robert Beverly Hale*

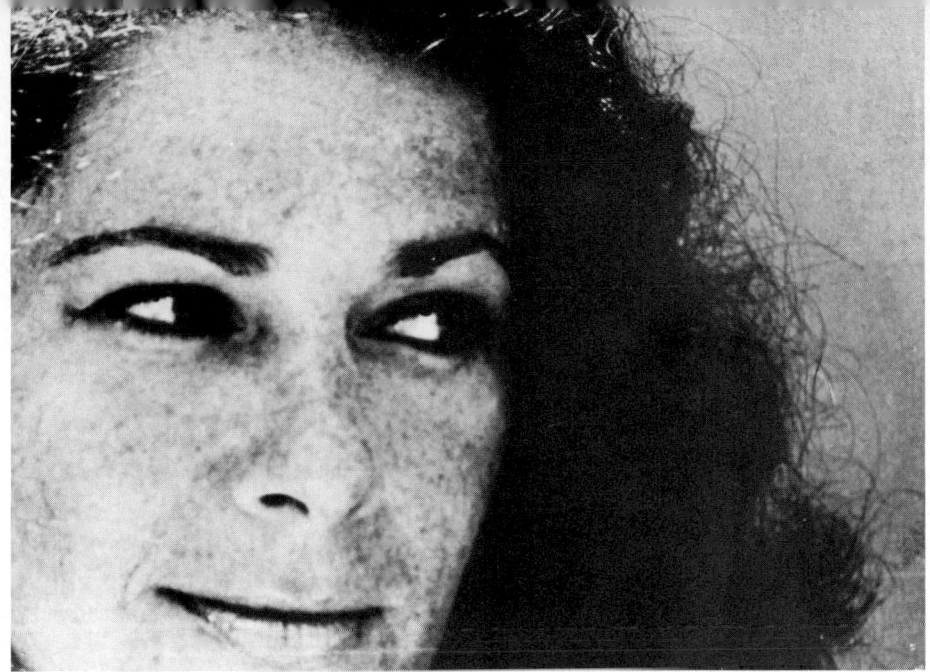

Ruth Kligman a few years after Jackson's death. *Photograph by Carlos Sansegundo, courtesy Ruth Kligman*

Jackson at Springs, summer, 1956. *Photograph by John Reed*

Boulder as grave marker, Green River Cemetery, Springs. *Photograph by Priscilla Bowden*

Lee Krasner Pollock, 1977.
Photograph by Renate Ponsold

"And here it's going in this direction." He would read things in it, you know, looking as though he's talking to something there, like *he* was painting that picture and on a kind of psychedelic trip of the visual experience. He judged by the unconscious imagery, not by three-dimensional form, reading the pictures in the Jungian sense.

It wasn't verbal so much as an intense communion of the moment, an empathy. I was open to anything coming, so whatever he had to say was meaningful—my work was being *judged* by somebody very meaningful, and with the marvelous things he said to me—"You got it, got it good, and don't worry about what they'll say and about de Kooning"—he gave me something that is not given. The best I ever got was from him; it was an empathy out of a psychic relationship. I feel him. I can feel Jackson's presence. And his pictures—they're symbolic of a man who's alive; he's giving us a sort of energy.

Robert Motherwell was the first of the wave of "crazy artists" to have a house in the summer colony bastion of the Georgica area. Although he was accommodated by admission to the Maidstone Club, its members were as dubious about his work as they were about his Quonset hut style house adapted for him by the French architect Pierre Chareau. It offended the taste of the summer colony with conventional shingle "cottages," and when one of these, the Erdman house, was sold to a member of the new art world, Leo Castelli, the lines were drawn. Among those who would stay in the Castelli house were Elaine and Willem de Kooning, who was well into his classic *Woman* series.

LEO CASTELLI: Jackson's relationship with de Kooning was rather strange: there was competition between the two, so it was friendship with enmity. As at the Cedar Tavern, where there were fights occasionally, one could feel a tension in their company.

WILLEM DE KOONING: Jackson was *very* important, but—how do I say it? He did a lot, but he didn't do enough; he didn't live long enough, Jackson. He was a little paranoid about his greatness, but we all of us thought he was good—more than good.

ELAINE DE KOONING: Jackson didn't have the solid background Bill and Gorky did, and they were mutually exclusive as far as approaches to painting were concerned. There was a great deal more improvisation in Jackson's approach than there ever was in Bill's; in Bill's the effect is of slashing strokes, but his way of working was very much controlled. I mean, he would sit and look for two hours for every five minutes of painting. That was not Jackson's way at all, and in Jackson's there was also the kinetic thing—the emotional.

Jackson was hostile to Bill's utilizing the figure, the *Woman* series, and would use some of his pejorative terms like "that shit," and so on. But figures had begun to appear in his own work in an extremely facile way—not worked on but as a kind of decision like, "Well, now we'll have a figure," and then a figure would appear in those great sweeps like Masson. It wasn't out of, let's say, study of the figure that went on for years and years and years like Bill did.

I think Jackson's ego was his problem in painting. So many artists work out of anger—possibly all. Anger is a fuel, that's the motivation, you know—Cézanne, Michelangelo—and writers too, like Flaubert. There's that tremendous anger, even with the artists who seem to be full of lyrical, gracious statements like Degas and Matisse.

With Jackson I was very aware of the focus, the concentration, and of the rage that was in that man—the desperation that was there. It's very exciting and very interesting, but it doesn't have the scope of the inclusive artist. His greatness has to be qualified—like Bill's sentence which is constantly quoted, "He rocked the boat"—no, "broke the ice." There was definitely something there, but on the other hand the ice was breaking up all over the place. I've always felt that Jackson's work is tranquil in expression, but—my opinion is that his was a narrow road.

LARRY RIVERS: De Kooning is a more placid person and really works on his things. Pollock filled up his canvases until he couldn't fill them any more and stopped there. His kind of work wasn't a thing where you go back to erase, putting paint over it and putting things on top of that. Bill drew, and if you draw with a pencil you erase; if you bring that attitude to painting it means that you paint a while and then you paint over that to, in a sense, put something new on top of it. Pollock's things don't seem to have that and that's why there's a certain freshness and beauty there.

NICHOLAS CARONE: Jackson always talked about de Kooning, but he wasn't bowled over and knew that the area he himself worked in was beyond de Kooning. De Kooning was used as a competitor because those around him were ambitious, they were going to ride de Kooning. Pollock was not in their realm; that area of depth psychology was something they didn't believe in, really. With him it was a do-or-die thing to paint; he would have died early if he hadn't painted. Even though he became successful, that was not his aim.

MAY TABAK: Lee had adored de Kooning, thought he was the greatest painter in the world. As soon as she got hold of Jackson, she switched and would have nothing to do with him. He was a brilliant talker, Bill, even as he asked questions he was brilliant—but now he was one of "the

boys" Jackson would wander around with, looking for someone to get some drinks with. Lee hated them.

WILLEM DE KOONING: Jackson—yah, he would put on that tough guy act, you know? But he wasn't such a pain in the ass he really needed those tranquilizers doctors gave him. Sure, he called me "Nothing but a French painter," thought I was doodling off maybe. *But*—Jackson took on the responsibility of being a *painter*.

Jackson was threatened to some extent by the de Kooning invasion of his local turf, yet he gave the impression of respecting Bill's work and liking the man, even if he had to fall back on rather juvenile lines with which to attack him. "That Dutchman, what's he know about the East End? Shit, he doesn't even know how to drive. Got 'City' written all over him . . . I've gotten cornered some way again and there's no breaking out . . . It'll just get tighter and tighter until . . ."

Jackson was still rugged enough to drink along with Bill and others, yet produce in the studio the next day. As the summer neared its end, his work concentration increased with his first show at the Sidney Janis Gallery pressing him on. "This is one show that's going to work, got to work. We're all pros in that gallery, and what I'm showing . . . it works."

A large oil on canvas that would appear in the Janis debut on November 10, 1952 was *Number 11, 1952*, better known as *Blue Poles*. Its fame rests not only on its size, six feet by sixteen feet, but in part on the possibility of its having been worked on also by Barnett Newman and Tony Smith during a drinking session; perhaps most of all because of its historic price for a twentieth-century work: It was acquired by the Australian National Gallery in 1973 for slightly over $2,000,000. It had been bought for $6,000 by Dr. Fred Olsen from Janis in 1954; Olsen resold it a couple of years later to Ben Heller for $32,000. In addition to enamel and aluminum paint, the work has pieces of glass from the basters Jackson used and in the lower right area, a piece of a Coke bottle.

What Jackson, who put so much into the painting in one way or another, got out of it was about $4,000. Lee's view of others having worked on it is put simply: "Hogwash!" She remembered Jackson painting in the poles with a two-by-four as a straightedge. But, as Stanley P. Friedman points out, the Australians may have a bargain in owning a masterpiece by three great Americans rather than one.

CLEMENT GREENBERG: Lee took *Blue Poles* to her bosom like you take a crippled child to your bosom. She knew better—she *knew* better! And Jackson knew *Blue Poles* wasn't a success.

• • •

ALFONSO OSSORIO: Oh, they might have played games. There are many drawings of that period in which Jackson dealt with verticals and I have one. If you want to be very precise, I think these are very definitely enlargements of spermatozoa.

PAUL BRACH: It's a painting that doesn't feel as if it happened all at once. The verticals feel after the fact, like a consciousness that the rhythm and the pulse in the field wasn't strong enough. But Pollocks, no matter how many times they are worked on, do *seem* to have happened all at once.

BEN HELLER: Collaboration? Fig leaves! That's an old war-horse that's been, I think, sufficiently answered enough times not to have to require any more comment.

HARRY CULLUM: One night we went there to fix that old kerosene Salamander stove you gave him—wouldn't light right and smoked like a bitch. Pollock had most of the floor covered by this canvas, and any floor that wasn't deep in buckets of paint was all broken glass. He'd been painting barefoot in all this stuff, and there he was—blood on his feet, in the painting, all the hell over. Talk about crazy artists come to Bonac! Pollock was "finest kind." [This Bonac phrase is equivalent to the local double affirmative "yes, yes."]

Jackson had hoped the Salamander stove would get the studio up to a working temperature and himself along with it, but it did neither in really cold weather. He called it his "vertical blowtorch"; lighting it took some doing, then it sounded like a jet taking off.

Stressing the danger of fire, I insisted that our initial lighting of the Salamander be done outside the studio, and when it went into its jetlike sound effect Jackson was mesmerized. "That's what I call power," he shouted over the roar. But we could have done without Lee as a witness, along with her prediction of loss of his studio and their future. He told her we weren't kids anymore, but her look said she didn't buy it.

SIDNEY JANIS: I thought about his work in that tinderbox construction and that he should store some of them at a warehouse, the Home Sweet Home Warehouse. He thought favorably of it, but—well, it was a case of the money. But luck was with Pollock. With *Blue Poles,* for instance, the canvas had to be taken off the stretcher and Jackson came in, pretty much under the influence. He began ripping it off and Lee was shocked. The staples flew off like machine gun bullets, but he knew how to handle it.

JOHN COLE: *Blue Poles* was going to be in that first show he had at Janis and he asked me what I thought about it. Well, I never gave Jack-

son very high marks on anything *except* his painting; sometimes I thought he was pretty dumb. Anyway, he got so nervous about that show, he asked us to come to the opening. Then he wondered if we'd drive Lee to it; then if we'd drive *him*. He was afraid to drive to New York on his own, he was so shook up.

Aside from *Blue Poles,* the show was notable for three major works, *Numbers 10, 11 and 12* (1952), the last being mentioned favorably by several reviewers. It was bought by Nelson Rockefeller and when it was badly damaged in a 1965 fire at the Governor's Mansion in Albany, there were still enough Pollock detractors to spread the word that it had never looked better.

Art News, under the aegis of Tom Hess, voted the show the second best that year in its January 1953 issue, with first place going to Miró. Jackson's reaction was that Miró could have it: "Those guys need prizes. Me, I don't go in for contests, never did. I just paint." Frank O'Hara called the works of that period astonishing in their accomplishment, and in his 1959 monograph on Pollock singled out *Blue Poles* as a great masterpiece of Western art. Clement Greenberg, however, did not review the show of nine large works, among them a triptych.

CLEMENT GREENBERG: In '51, the black and white show, he was still good, but in '52 he began to wobble. Lee came up to him and said, "When you were off booze in '49 and '50, *look* what you did! But since then, back on booze, do you do *real* pictures?" He didn't take it amiss that I thought the show was bad and he didn't react to Lee; he sort of accepted it. Now, that's what is remarkable: He didn't fool himself—no argument, no talk like "Maybe you didn't see it right."

SIDNEY JANIS: Pollock had a very sharp eye, and although he didn't have the education of a Matisse, his instincts and his eye made him worth listening to even if he wasn't articulate. His very brief way of speaking about art with me—I've been around a long time—was such a relief; some of the artists are so verbose, and at the end nothing is said.

As Jackson's personal problems grew, his court also grew. A part of it was composed, however, not of art world members but a new group of "from away" people—young college types mostly, some veterans, all of whom saw themselves as burdened with impressive antecedents socially and financially. They worked hard at becoming part of the local community, or at least looking and sounding something like it, and even harder at trying to make a living from the sea and bays. Ted Lester, who ranked first among ocean haul-seine captains and whose crew usually beached

the biggest catch, remarked that their teeth looked too well brushed and their wives too pretty. Those of Peter Matthiessen and Sheridan Lord, the writer Patsy Southgate and the painter Cile Downs, became even closer to the Pollocks than their husbands did.

JOHN COLE: I don't think any of us were really accepted by the local people except for Dan Miller, who carried me on credit and genuinely liked Jackson. But what can you expect? I was third-generation summer people, a grandmother having built the first house on Georgica Pond and a grandfather a founder of the Maidstone Club. But when there was lots of work, the local people didn't resent a city guy house painting.

I went to see Jackson because I was looking for fishing customers. Once I knew him, I thought my idea absurd; he could make small talk about fishing but that was all. And this talk of his clamming all the time is bullshit; he could just about do the garden.

I worked for the Pollocks doing interior painting while they were living in the house, so I arrived each morning not too early and just walked in on their lives. That was the catalyst, working in the house, that got me so involved in their lives—and in their tensions and in Jackson's drinking. He didn't work with me, wasn't interested; Lee did all the color selection and told me which room to paint and so forth. She was the primary reason I spent time with them—she seemed to depend on me.

Pretty soon after I started working there, I got involved when he was drinking as a buffer between him and Lee. My phone would ring at night—late, like early morning—and she would ask me to come down because she was worried about Jackson. He'd be out, driving the Model A all over the place, and I'd be called by the police sometimes to take him back to the house. I'd go in my Model A and we'd get him out of some ditch.

He was not a mechanic at all, and he was a terrible driver; even sober he didn't pay attention to what he was doing. He had no affinity for machinery, not just his car; it could be with a Waring blender, he just didn't *know*. I worked on his Model A sometimes to get it started, but as the fisherman used to say about a Model A, "If she's got fire and gas, she'll go." At night when I'd be in the car with him, he'd seem to be getting closer to the edge all the time; finally I got pissed off by having to put up with it.

Other times he would be there and Lee wanted me because he might—well, she was worried. He was such a bad drunk and it was always a dull, painful, angry time. I had a drinking uncle and he'd pass out, but Jackson hardly ever passed out. That was another problem: He got really drunk so easily, with no redeeming features. He never said anything charming; there was no fun; he never even sang. All he did was

spit, drool, sneeze, cough, snot and piss. He was a mess, a real pain in the ass.

Mostly when I knew him he was drinking, although it was erratic: For weeks nothing was happening, then all of a sudden there'd be this tremendous tension in the house and Lee would come and look at me and shake her head. People were afraid of him drunk because he got kind of physical, but it always seemed that the destructive thing he felt was more wanting to hurt himself than people he was with. I could feel violence in him, knew it was there, but was never exposed to it.

Jackson was the only person I ever met who was *driven* to do his work and there was no way of his resisting it. If you have a rocket up your ass and it's lit, there's no way you're going to change the course of your life. Whatever he did was in some way a result of those rockets moving him through life; I think he was born that way, *propelled.*

But there was a sweetness to him—absolutely. He gave me two paintings, oils—and good ones. I gave the bigger one back because I didn't think it fair to take it, didn't think he realized what it was worth. The other one, just a nice little sketch on one of those masonite squares (*Green and White, 1950*), I got $15,000 for. Coe Kerr told me later that I really blew it because it resold for $205,000. I told him that much money would have corrupted me and anyway, the $15,000 paid my debts and got me to Maine. Jackson would have understood, more than he would have comprehended *Blue Poles* at two mil.

In adversity—and the lack of sales at the Janis show made this such a time—Jackson even when drinking would make generous gestures toward those he was fond of. The number of friends who were given works is legion—a surprising number disposed of them soon after his death— but his kindness took other forms also, such as rendering services and offering sympathy. He was a good listener, helped by his intuition, and awareness of his own problems made him open to those of others.

CLEMENT GREENBERG: When I was having difficulty in analysis, I preferred visiting the Pollocks to anyone else. Jackson would say, "Get in the car." We'd park by the sea or by the dump with a view of Gardiner's Bay because he wanted me to get away from people and calm down. He was wonderful that way, and once I asked him for advice—that anyone could ask Jackson for advice! But he loved it—a change from being a patient.

CAROL BRAIDER: It was more than kindness with Jackson: If you were in trouble, or he was with children, he would be as gentle and lovely as a mother. And he kept confidences, no matter how drunk.

LOLY ROSSET: He came up to my husband, Barney, and said, "If you don't treat Loly well, I'll . . ." Barney was frightened by him.

BARNEY ROSSET: I felt the best thing was to keep out of his way. But in all those physical incidents Jackson was invariably the one who got hurt. Others might fall, but Jackson would break a leg.

PETER BLAKE: He was generous in many ways. His *Lavender Mist*— so very subtle, almost monochromatic—I told him I wanted to buy it. I couldn't, but he said, "Listen, pay me $50 a month for two years—that's $1,200—and it's yours." Well, I didn't have that either . . .

ROGER WILCOX: He said that people doing good for others are really doing it for themselves because it made them feel good. His generosity had to do with that, and he'd say "The hell with thanks. I'm doing it because I like to."

With me, Jackson had a slightly different way of putting it. "Doing things for people is one way to be sure I'm alive and it isn't always that easy to be sure lately. Shit—we got to keep reaching, to and for others. If we don't, we're a lot less than animals . . . are less, anyway, a lot of the time."

In his gentleness there were times when Jackson didn't seem to make a distinction between people to whom he felt close and animals. "In a bark you can hear a life story, if your ears are tuned. Maybe I should have been an animal therapist—a lay therapist, non-objective. Dogs got a high charge of psychic energy and if one fits your flow, you got a one-man dog—which is why they stick around graves . . . also it's why they shouldn't sleep on your bed—they can drain your astral body—but if you got to have a dog when you sleep, or a woman, find a cover for your psychic self . . . worry will do it."

CHARLES POLLOCK: One reason the family is fond of animals is they don't need much talk. Our parents, unlike some who require talk so they know they're alive, didn't need talk in the house.

ALFONSO OSSORIO: Jackson was given his choice of our poodle's litter. He chose the runt, an obvious throwback to some earlier form of ill-bred poodle.

TED DRAGON: It was the wrong shape, the wrong size, the wrong color, but it found the right home. Oh, how Jackson loved that dog!

In a joking way, Jackson could be kind about not competing for friends' girls also. "I always try to keep hands off David Smith's Ben-

nington students—don't want to trespass. They're hot numbers, which sure makes for hard teaching." A retrospective show, almost simultaneous with the Janis exhibit, was arranged by Clement (Greenberg, at Bennington College that November). Although small—eight paintings—it was a new step in Jackson's career, being a retrospective. It didn't help his mood, though; I wondered if he felt past-tense.

At the end of 1952, I tried to lift Jackson's somber mood by telling him that being a hero in his own country wasn't half as bad as being a philosopher there. He made a face at the alcohol-free eggnog our hostess, Happy Macy, had poured. "Maybe. The corner they got me in is more like what Harold Rosenberg wrote about Action Painters . . . How does it go? Vanguard painters have a zero audience; the work gets used and traded but not wanted. I'm like my work—used, not wanted." He put the eggnog down on a table and looked at it so long, it seemed tactful for me to mingle with the other guests.

He had been having rough times with Grant Mark's emulsions and ways, as well as late nights at the Cedar. Worse, he was kept hanging on what he called his hope rope, news of sales by Janis or the proceeds from those of his Paris show. For some time I'd been throwing Jackson a greeting when we met in order to get a response by which to judge his mood. From "How are things going?" I had shortened it to "How's it?" For response he had been using that Bonac line "finest kind." He liked it almost as much as Justice Schellinger calling him a natural.

The last time I saw Jackson in the old year, or maybe the first in the new, I gave the usual "How's it?" There was no "Finest kind," or anything else, as he squinted from the Model A along deserted Stony Hill Road. Then came more sigh than word, a drawn out and very low "Sh-i-i-t."

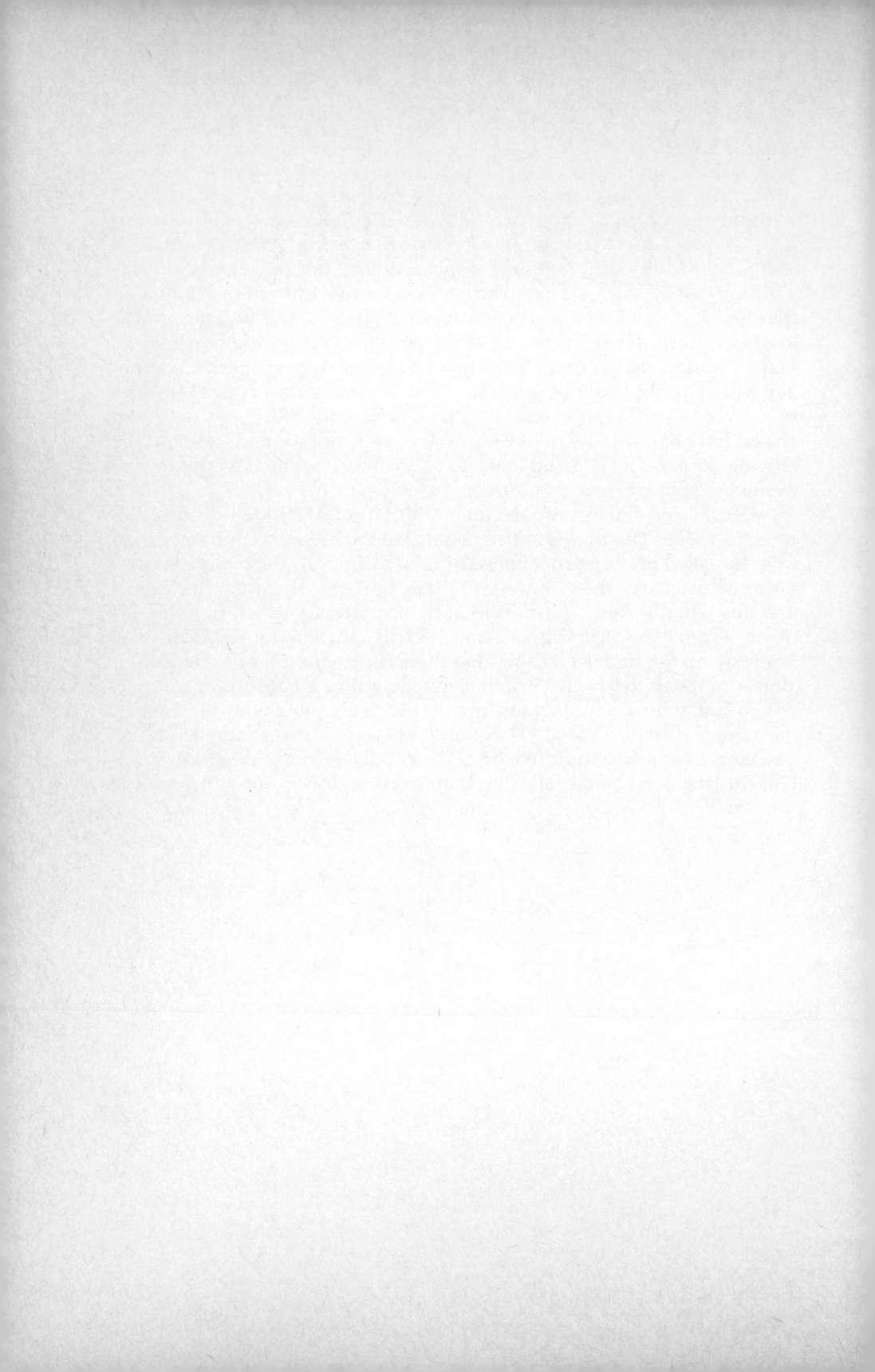

PART THREE

BREAKING DOWN

Jackson seemed in a state of suspension in 1953. He was drinking heavily. Good news from Janis was as overdue as money from Paris; hopes of controlling the alcohol problem were in abeyance; and there was Lee. "The freedom you get in your work, when *it* works, doesn't happen in marriage. Used to be I felt locked in to us, but now like maybe I'm going to be locked *up,* and I don't mean a nut house . . . You know a cornered guy is a dangerous guy."

FRITZ BULTMAN: Lee had been a friend since 1938 but, fond of her as I was, her drive was tiresome. When she was trying to involve Jeanne Reynal in a project to do with Jackson's estate, Duchamp warned Jeanne: "If you let that woman in your house, she will soon drive you out of it." That is something with Lee one had always be careful about. Still, Jackson himself was manipulative; his use of Lee was as strong as her use of him.

DOROTHY NORMAN: Lee may not have been so ambitious in the beginning, but to have to be with one who is greater than you are creates a kind of jealousy. But Jackson felt weak, so he had to pull her down; then, too, her help made him feel inferior, so he raged.

REUBEN KADISH: In the early days Lee and Jack got along very well, but they were competitive—so competitive that Lee couldn't work in the same house with Jack, and I rented her a room in my studio.

ROBERT MOTHERWELL: My recollection is that Lee, from those earliest days, was determined as a political strategy to separate Pollock from his contemporaries—as though he were Venus arising from the sea.

MAY TABAK: One reason Lee didn't like the "boys" was because they didn't treat Jackson as if he were more important than anyone else. They just didn't think he was; and he wasn't more important than some of them.

MILTON RESNICK: When you were in his house, Lee covered up for him; if she heard music she would say that it was Beethoven something or other, she was so used to "educating" Jackson. She was always trying to bring things around for the intellectual side of Jackson, only he'd be opening clams or something. That was the domestic scene, yet people say he did deep thinking. What deep thinking?

CLEMENT GREENBERG: Lee was the one who really got to him and she was right. He could talk about art only with her—well, he could with me too when she wasn't there. Art was his justification as a human being, because he felt inadequate in other respects. But Lee was his victim in the end, *and* a better painter than before.

STANLEY WILLIAM HAYTER: Most men are dependent on some women to support them, one way or another. This idea of being hairy-chested men and superior to women—bugger! I don't think we would have had much production out of Jack if it hadn't been for Lee, or even survival.

JOHN COLE: You felt that it was part of her destiny to be supportive of this person with a recognizable continuity. But then his death gave her a freedom to become a creative being.

NICHOLAS CARONE: Lee saw from the beginning that he was something strange; she saw he was some kind of genius. This was a woman who would have staked her life on that; she fought the whole art world defending what she knew he was and what contribution he was making. I take my hat off to her for that. So she took care of him; you don't let go of a Jackson. You have to watch him every minute, and more: A woman taking care of such a man is not just feeding him and darning his socks; she's living with a man who might flip any minute. Think of the tensions she lived under! Lee knew she was dealing with a powder keg.

ELEANOR WARD: The relationship was very, very curious. Once at dinner there was a bowl of peaches Lee had made, which Jackson wouldn't touch. She said, "Now, Jackson, they're good for you. Eat them." He picked up a spoon like a child being told what to do. On the other hand, a group of us were dancing once and he said to me, "Can you imagine being married to that face?" I was shocked he could say that, knowing how good she was to him.

JOAN WARD: Jackson told me, "Without Lee I wouldn't have survived long. I'd be dead if it wasn't for her."

ELAINE DE KOONING: Bill was going under, and after twenty years I came back. It was owed to the survival of Bill; he was surrounded by people who were pouring liquor down his throat. But being independent in my own person was very important; it wasn't a competitive thing, it was just between me and myself. Lee then was kind of the opposite of competitive with Jackson. She wiped herself out.

RONALD STEIN: Lee had loved Jackson intensely, the way a young girl would love a hero: as a man, as an artist, as an image. The difficulty began when her physical and mental strength began to break down and she became less and less capable. Then deadly alcohol changed love to drudgery: Jackson left boyish pranks and carryings-on—that polarity from being mystical to being boyish—for a going down.

There was an unholy alliance! He might have been a genius, but he was a common drunk. Yet Lee made him a famous man by nurturing and promoting his genius. I can't imagine his eminence as an artist without Lee. These were heroic, dramatic people, like Hollywood people; but what was important about them was that these two people nurtured each other's talents far beyond the usual relationship between an artist and his wife. No matter what their personal lives were, it never touched upon their integrity. That's what made them unique.

Land meant a great deal to Jackson and not only because of his love for the Bonac landscape. Land to him also meant Gardiner's Bay, the Atlantic, the sky, the weather. They were parts of a whole in which he felt as right as he could. And he loved owning land. His Fireplace Road property abutted a small woodlot to his north, about one hundred by one hundred feet, which he'd had his eye on. It was bought by the plumbers Richard Talmage and Edward Hults before it went in a tax sale; then the realtor Edward Cook became a co-owner.

While the partners don't quite agree on details about how Jackson eventually came to own this small piece of land, they do agree that Jackson was outraged he wasn't given a chance at it initially. Hults told Jackson he could have it at the going price of $7.50 per front foot, a total of $750, and as Mrs. Hults wanted to own a small Pollock, going for around $250, he accepted a check and his wife was to make a selection. Although that part of the deal was never consummated, Jackson made plans to move a small calf barn which had been Justice Schellinger's onto the site as a studio for Lee (now owned by her nephew, Ronald Stein).

Jackson was so angry about not getting the property, I told him about the old farmer who denied he was land hungry, just wanted what was

next to him. Jackson had already heard the story. "Where I come from you never knock a man's wife or his land—only the other way 'round."

EDWARD F. COOK: He went wild when he heard about it, that I hadn't been to see him—really mad about it. Eventually, he came to my office and made a fuss, using four-letter words about it all over the place. My office was a little place then and everybody heard every word as he ranted and raved at me, so I had to kick him out—told him he couldn't talk that kind of language with women working there. But I got to thinking about it afterward, so I gave him that piece of land.

He felt terrible about the way he acted and told me he would give me any painting I'd like to have. I looked over his things and took one of them home, but my wife said, "I won't be able to sleep with that thing in the house!" When I took it back to him, he said, "What's wrong with it?" I told him what my wife said and he said maybe she just didn't like that one and I could come again and pick one in its place. Well, I just never did get around to it.

The spring of 1953 meant a couple of changes in the domiciles of the Pollocks' winter circle of friends, if a group so small can be called that. The Berton Rouechés moved to a remodeled house on the Farm with a view of the distant ocean—Jackson objected, "It's plain wrong to look *down* on beauty"—and the John Coleses took over their house in Springs. Minor changes even for a small community, but after a grim winter one tries to find hope in such things. That he had survived it Jackson found rather hard to believe. "I keep thinking what we all need is fresh air and room to breathe in. But then I look around and that's all we got."

He also kept thinking, or at least telling me, that before we were through on the Farm, Amagansett would be ruined. "You take a nice farm, even if it's more like an estate, and when your crop comes in all it will be is money. That's going to stick in your craw." My defense—that so far we had done a lot of seeding with no harvest—brought the fast retort that farms are not real estate developments, and why hadn't we stayed in the city "fancying up places for fancy friends?" This was a slam at Paul Lester Weiner, a city planner and first tenant in one of our conversions, whom Jackson referred to as "Paul Lester Hot Dog." (That was a nickname coined by Robert Rosenberg, an architect always worried about Jackson driving through his plate-glass dune house.)

In all this bitter talk there was a reflection of Jackson's unhappiness and intimations of a certain loss of direction in his work. Being outside the art world, I was more difficult for him to attack, but my money worries about the business and the Farm made for small targets to keep busy on. He would snipe away at projects, such as a scheme for sod growing. "Why not asphalt your fields and have the world's largest park-

ing lot on the phoniest farm in the East?" For a man who had trouble talking, he could be more fluent than I needed. And when it seemed a membership in the Devon Yacht Club might bring me contracting jobs, Jackson was disgusted. "You join those shit-ass members? Talk about fakes—Jes*us*!"

DR. WAYNE BARKER: I think Jackson was trying to utter something almost incomprehensible to himself. I know people speak of his dancing in his paintings, but to me it's more like talking. I think there was a process—the old, primitive process—of the need to utter. Jackson took in a lot of experience, relations with people and ideas; he'd seen therapists and all, and since he was a philosopher he had to ask, "What does it mean?" I think he had trouble saying it—a lot of people might understand him better had he been a writer—and I think as a philosopher the best he could do was an approximation.

There's an utterance there, but it's a lot like trying to understand brain-damaged people or those with an autistic or dyslexic factor, or psychotics, or somebody in an altered state of consciousness. Jackson the philosopher liked to talk, but he had trouble expressing what he saw and in that sense he was inarticulate. When he drew you into a conversation, later you'd realize he had *you* doing the talking, you'd be acting for him and in that sense he was dependent on you for the conversation.

I had sympathy for Jackson's speech problem—or gift—and he was the first person to tell me how lucky I was to have stammered as a child. "You get by with women because either they feel sorry for you or don't take you seriously. Words are the best thing you got . . . they're what it takes to really shit women, which is how we get next to them."

Mornings, a perpetual problem for Jackson, weren't made any easier by being hung over much of the time. He used to say it was hard getting to his coffee, then getting done with it and starting his day. He had a feeling that the transition would be made easier by having something to take his anger out on, something "I can give a good kick to." I had just the thing, an old two-cylinder garden tractor with a mowing attachment; it was as mean as machines come, never failing to kick back so that your hand on the starting rope ended up with scraped knuckles. This monster was a present for Jackson, and as he nursed a knuckle after starting it, I could see it had been the right one. "Just what I've always wanted. And the garden . . . Talk about being cultivated, wait'll you see my kind!" His garden was one of the best things about Jackson, although his dedication lessened eventually.

WILLEM DE KOONING: One time I had this machine to mow the lawn—I'm not very good at these things, you know. He came over and

was shouting at me, making fun, things like that. Then he took it out of my hands and went all over, like at the Cedar Tavern once when he found one of those mops you use on the floor. He was swinging it around and under those booths you sit in, and it was a lot of fun making people's feet and things wet.

CONRAD MARCA-RELLI: The grass was overgrown in back of my house and I asked if I could borrow that mower. He says, "I'll come right over and do it." He brought that machine, but he started mowing in designs—all over the place! I mean, it was like his painting—he'd take it this way, that way, and like it had no limits. But when he was finished, it was fine—we were *mowed*.

By summer I was wishing I had given the garden tractor to James Brooks, whose work Penny and I preferred to Jackson's. The latter was insisting we select something in exchange for the tractor. He said he was getting a kick out of the way it kicked back.

PENNY POTTER: Jeffrey had put us in a very difficult position. Suppose I didn't like anything; one can't say "No, I don't like any of your work." But I had no choice, so we went into their house, where I spotted a watercolor on paper; then he took us out to the studio and we looked at a lot of things; then it was back to the house. I told him that I loved the one I spotted but that I guessed since it was on the kitchen wall, it must be a favorite of his. He said, "No, absolutely. If you love it, you have to have it. But it's only a watercolor and besides, the tractor has two cylinders, so you'll have to take two." Lee backed him up, so there was no discussion. He insisted and that's how we ended up with two.

The one Penny picked is actually not a watercolor but sepia ink on mulberry paper. The one *I* chose—actually on rice paper and a bleed-through of Greenberg's birthday present—is described in Sotheby's catalogue of 1959–60 as "Black, pink and white coloured ink on paper." It is in the Scottish Museum of Modern Art, Edinburgh, having been the first Pollock offered at a public sale in England. Since I can't recall Jackson mentioning his Scots ancestry, he might have preferred it to hang in Ireland. And I would have preferred that he had the proceeds—now, that is. Looking back, I wince; the work brought the same as Jackson's biggest sale: $8,000 paid by Ben Heller for *One* (1950) in 1955. Carone asked Jackson how such an historic price felt. Jackson thought, nodded, and said, "*Good*."

For some time Jackson experimented with papers, finally coming across the product of a pretty unique master papermaker.

DOUGLASS M. HOWELL: When I went to the door, there was Jackson. He was all eyes, most silent, and after each step asked, "Now what do you do?" The way he was using his eyes I could see he was intuited; he didn't need an education, not with those eyes to see and the way he was drinking everything in. I am sorry not to have had a more intimate relationship with him—our contact was on the intuitive side— but there was his wife in the picture.

My paper is of fine damask tablecloths, no glue, sizing, or chemicals, and made by my own equipment designed and built from the ground up. Jackson had about fifty sheets, and his work on them will still be around in a thousand years. Beautiful paper ages like brandy; the Chinese dug up what they called water leaf paper going back to B.C., water leaf like mine.

He left silent as he came. It was phenomenal, that silence and all his drinking in—and you could feel the force of his telepathy. He stopped outside with his back to me, thinking deeply, and I could feel the sense of reflection. Then he turned around; it was a telling moment as in Greek drama. He said, "Do you know many men would be pleased to send their sons to work with you?"

It was hard to know what was behind Jackson's silences and the one time I took the risk of asking him, he said that deciding to grow a beard took a lot of thinking. By the time he'd grown it, summer had arrived. I told him it looked like a winter beard. "That's where I am still . . . I got my own seasons and I'm always behind—like with everything else." The beard looked lonely somehow.

DR. WAYNE BARKER: Jackson fitted into the landscape pretty well, seemed right with things, things like hermit crabs. He was sort of like a hermit crab, or some animal that has a cave or sanctuary. He'd make these little forays out—conversational gambits, kind of—which would sort of invite you to pursue them. He indicated a certain availability, almost like flirting with somebody at a party, but with no intention of follow-up.

I usually made some kind of response to let him know I heard him and if he wanted to pursue it I was perfectly willing to listen, but if he'd gotten into technical aspects that called for a critical remark on my part, I probably would have denied the gambit. I didn't see myself as working with him therapeutically; it had to do with my perception of him more as a human being than as any particular labeled human being, even as an artist. He didn't present any of the special mannerisms, like "I am a painter," "I am sensitive," or whatever. He struck me really as many people do out here, as maybe needing some growth, maybe needing some better conceptions of the world which can be gotten through human experience, including seeing a therapist as part of the human experience.

What Jackson was really expressing with his "I'm no damn good" was that he was feeling miserable, or morally bad, or incompetent. And that

is my feeling about how he felt: incompetent. Now, I'm from the West, not the far West as he was, but I know this mixed feeling of incompetence when you're involved with eastern intellectuals and so on—you feel incompetent. Part of it is that it's not the way you behave back there, not if you were raised there. You don't necessarily feel incompetent in other ways—sexually or whatever—because most of the time you can wade through women in the East—you know, brush them out of the way. Jackson's feeling of incompetence had to do with his being a hungry guy, I think—intellectually and emotionally.

He was searching, and I think it was both an intellectual and motor thing. I think he was one of those people who give the impression of immaturity because they are seeking in a sense for a magical "other," whether it's another person or an idea. And this had something to do with his questions: "Is Jung the answer?" Or "Are Jung's ideas the answer?" He was looking, as many intelligent people are, for that other element that will complete the self, make it self-sufficient either in a relationship with another, or religious ceremony, or idea. And there was misery seeking company more than conversation; like Marilyn Monroe when she and Arthur Miller summered on the Farm asking "What do you think of suicide?" It's a way of sizing you up.

My impression is that his painting served as an activity, a place, a thing—call it what you will—wherein being in action, that notion of doing something and seeing what you've done, gives you a sense of "I did that." He found his painting a satisfying motor activity; that was the one time, I suspect, when he really felt in action—or in motion.

The winter and spring had not been productive for Jackson, but work comes in many forms and among them is improving a studio for future use. George Loper, the former circus clown, undertook this project. Jackson helped on the shingling job, but he was actually more in search of local companionship than in being useful. The studio ended up fairly tight but not fully insulated; the shingling was complete by summer. "I'd give a lot to be as old as that circus clown and split shingles like him," said Jackson. "He's as good at that as Harold Rosenberg is at splitting hairs, only Harold doesn't make much of a clown. But it's what critics are mostly, clowns—or shit-asses."

ALFONSO OSSORIO: Jackson could be hurt by critics—shocked, even—but I don't think he ever changed a line in response. Of course, Clem Greenberg was in the background as the important critic giving encouragement to Jackson, but he wasn't the only artist Clem was writing about—there were Dubuffet, Still—and Clem was very prescient, had an enormous influence on the next generation. In his early critical writings Clem was quite removed from the artists as personalities, then

he became involved in their careers. Actually, Clem and Dubuffet got along like fire and water: When Clem asked the Dubuffets to dinner at a restaurant, after the first course the meal was finished at separate tables.

I never felt any great warmth, no real rapport, between the Pollocks and the Rosenbergs, although May was a wedding witness. You would never see the Rosenbergs there casually at dinner; there was a definite break, which involved the Rosenbergs' passionate devotion to Bill de Kooning. Harold got along better with Bill, liked his work better.

MAY TABAK: My husband, Harold, would talk about Jackson's work with him, but not as an art critic. Harold was affectionate with Jackson; the approach that worked best with him was man to man—mostly it was man to boy—and it was like Harold was the elder brother to Jackson. Harold could tell him he'd had enough and Jackson would obey. Once Jackson was going to take a leak in the car and Harold said, "You're *not*! You're going to wait until I pull over, then you will get out."

Harold would never make derogatory statements when an artist begins to do something because you don't know where it's going. And when they were alone, Jackson and Harold *could* talk, though they wouldn't talk Heidegger, say. But that doesn't mean Jackson wasn't knowledgeable; you had to learn how to read him. There were some writers one night at our house, very few artists, and there was a serious discussion during which Jackson kept saying, "Ah, a lot of shit!" So finally Harold said something to Jackson Lee never forgave him for: "Listen—you've had more than you need to drink. What you need now is not to go on interrupting but to go upstairs and take a nap." Jackson smiled benignly, as if a big brother was looking after him, and went up.

Lee turned on Harold and said, "He's a famous man and you speak as if he was just anybody." Harold said, "Don't tell me who's famous. But if there's going to be anyone famous here, it's me and not that drunk upstairs." Everybody laughed and Lee was in a rage.

MILTON RESNICK: They were mean to him. The only way to get rid of Jackson was to make him drink, and Harold did it purposefully. I couldn't believe it. But then Harold was against the idea that art could be like a physical exercise. He claimed a physical action cannot be a correspondence between the unconscious and a work of art. In other words, action painting meant to Harold that you couldn't *think,* and Jackson represented that. Harold was fighting for a point of view representing de Kooning and got the benefit of reporting on the whole new movement in art.

NICHOLAS CARONE: Harold Rosenberg provoked him, so Jackson went after him a little bit. It was a kind of not very pleasant repartee;

he practically said, "What the hell do you know about art, anyway?" And Harold said, "Just enough to know that you paint like that monkey." That monkey in a lab doing abstract painting was famous, of course, but it got to Jackson. Harold never really liked his painting, and a lot of people benefited from his attitude, riding Harold's power.

Harold's physical size was a threat to Jackson, and his one bad leg made him all the more so because "Guys can't clobber cripples." Jackson was both in awe and in contempt of his brilliance: "He's got his from his books, mine's from life—from feeling. Knowing isn't in the head, crissake! Knowing, the *real* knowing not the knowing *how*, is inside. That's why kids are good critics; their knowing is natural, so they're open to experience. Harold's so charged and slippery he should have been an electric eel."

About Clement Greenberg, however, Jackson was almost as reticent as about Lee when he wasn't using her as an example of "women." A couple of his thoughts about Greenberg stay with me: "He knows, not just by being quick"; "Maybe he doesn't seem it, but that guy can *feel*." Greenberg seemed a combination of patron, mentor, and career mover, and Jackson's seeming obsequiousness when they were together made me uneasy. That wasn't the Jackson I knew nor, as it turns out, was that the real Greenberg.

CLEMENT GREENBERG: Jackson had a huge respect for intellectuals, but of a superstitious sort: "Oh, so you've been to college!" I've seen this with others and I say, "Go to college so you can say so, and get over this awe of intellectuals."

HERBERT FERBER: Greenberg's publishing so much about David Smith and Jackson was detrimental to people like Rothko, Kline and de Kooning. Finally Rothko, a very tough guy, told him, "Do me a favor. Don't *ever* write about me."

CILE DOWNS: Lee hated Clem. He didn't like her work, that was part of it; she hated, too, his power in Jackson's career, that it wasn't legitimate. Finally she started thinking maybe it was legitimate—as if it wasn't Clem's judgment but her opinion now. I wasn't chummy with Clem; that would have been forbidden. Lee expected extreme loyalty—one of her failings and, yes, one of her virtues. If she didn't receive extreme loyalty, the ax descended.

ELAINE DE KOONING: Clem acted as an unpaid PR man. It came from his heart's blood, you know; he meant every word of it, but he performed *services* for Jackson. Period. I expect more than anyone, any

dealer, Clem was responsible for Jackson's success at that time; if it hadn't been for Clem it might have been another ten or twenty years in coming. I sense Clem was bitter, and he was right to be bitter, for Jackson was not particularly grateful. Of course, no artist wants to feel that he's obliged to somebody; they feel the work does it. Well, the work does not do it.

HARRY JACKSON: Clem was a great backer of mine; in fact, at one point he said, "Harry is the strongest painter since Pollock." He was supporting me strongly. In 1955 I discovered that Clem wanted to be a Svengali. I don't Svengali for anybody; there's no way on earth. So I said, "No, Clem." I didn't physically throw him out of my studio, but I ran him out the goddam door.

WILLEM DE KOONING: Clem was the kind of guy knew all about everything. He comes into my place—I was painting, paintings all over the place—and he says, "You can't do that, and you can't do that." So I just said, "Just leave me alone, will you?" It was the most ridiculous thing, you know. I said, "Get out of here, get out of my house." We've had to leave each other alone. It was kind of innocent on his part anyhow. Clem was not so bad—a bit of a joke.

PAUL BRACH: Jackson was flattered and grateful that Clem spoke for him. One night I watched Jackson sit back and smile, letting Clem do all the talking; it was the way Bill de Kooning did with Harold Rosenberg. But also Jackson was suspicious and perhaps overly impressed by this big-city, East Coast Jewish radical intellectual.

NICHOLAS CARONE: A few of us were talking at dinner about criticism, about art in general, and I asked Jackson, "Who the hell do you know who understands your picture? People understand the *painting*—talk about the technique, the dripping, the splattering, the automatism and all that, but who really knows the picture, the content?"

He was a little defensive, because I'd been griping about critics and artists riding one another's career. I waited, then said, "Well, who? Greenberg?" I knew what Greenberg meant to him and I knew how one has to be very careful with a man who's supporting you internationally—not so much with Jackson but with Lee there. I waited, then again, "So tell me—*does* Greenberg know what your picture is about?" Finally he says, "No. He doesn't know what it is about. There's only one man who really knows what it's about, John Graham."

During the summer of 1953 Jackson's behavior was increasingly unpredictable. Now that so many of the Cedar Tavern regulars had come to East Hampton, he seemed to feel he had to do a sort of summer-stock

version of his usual center-stage role at the Cedar. "A lot of these guys play it safe . . . a limb can get awful shaky if you're alone out there, and the corner you get pushed in—not by them but by that horseshit art world that belongs to dealers and those young ass-kissers coming up. Some days I feel big, real big, which is maybe why the corner is getting tighter . . . when a car keeps breaking down, they fix it, but me . . ."

LEO CASTELLI: I consider all the pranks and things like that a superficial aspect of Jackson's personality, for I thought he was quite a marvelous human being. I liked him very much, but there was nothing a friend could do about his despair. He was one of those *poètes maudits*.

There were times when he was in an excellent mood and I remember with pleasure evenings at his house when Lee prepared marvelous dinners. He would be thoughtful, quite articulate when he wanted to express something, and it was a very sophisticated atmosphere there. He was very sure of himself, incredibly sure that he was a great painter, and there was no doubt about that. He would affirm it constantly, not in a blustering manner but with true conviction.

Yet he felt insecure, and he used to come to the house in terrible shape. Very often we were terrorized: He would run around all over the house and I remember my wife Ileana trying to hide delicate vases. Then there was that Larry Rivers sculpture in the driveway; he hated that thing and though he didn't crash his Model A into it actually, he wanted to.

LARRY RIVERS: He really did try to run down with his car that piece of sculpture of mine in Leo's driveway; Phil Guston told me he was with him and persuaded him not to hit it, so I don't think he did actually. But I thought it was interesting that anybody *could* have done that; the piece was just straight cement, done so badly on a technical level that it finally started to deteriorate. I think this youthful endeavor of mine was a little bit of an eyesore.

Pollock did sort of see what I was about, which is that I put down something that really interests me—a story or something recognizable, something you could actually talk about and point out to the world. Given the power of that generation a little older than me, I found that these guys were doing it and doing it so much stronger and already being paid attention to. When Pollock told Selden Rodman, "I don't care how many times he erases it, I know what he's up to," he meant the realism is there—in other words, I'm not fooling anybody. I could rationalize the erasures on an art level or that I like the line or the shadow realism underneath, then make a further line. What was evident was my aesthetic place, that I really was interested in realism, and even though I introduced abstract elements that wasn't my main concern. Well, he was right, even if he had to have it in this kind of brutal line of his.

And I think he *was* brutal with those gratuitous remarks. I don't think he thought about me much, but yet I think he singled me out in a way. I did begin to represent a break—I mean everybody out there was doing this thing and was happy with it, but back there is a guy who was not total old-hat, cornball from another time—a younger man who's sort of saying, "Well, what's wrong with this, fellows? I mean, is this all right?"— actually putting it up for their approval. I was interested in their opinions—they were artists . . . I begin to see, and it happened later than with those guys, stuff drawing in on us as we get older.

ROBERT MOTHERWELL: Pollock was getting very drunk at a party with the Castellis and de Koonings, and my wife and I left around midnight. I felt something was going to explode, and while I'm not cowardly—I was always ready to strike back if he struck me—I didn't want to be around. A car freak, I had a beautiful little MG convertible, one of the first in America, and I always parked it in front of the door on the circular driveway, which was blind. . . .

As we were getting ready for bed I thought, "I wouldn't put it past that bastard Pollock to come zooming in in that Model A, and with the circle blind there wouldn't be a chance not to smack into my beautiful MG." In my shorts—this is unlike me, a passive, inactive man—I got out and put the MG around the corner of the house. Then, just getting into bed— bang! Pollock was tearing around the driveway in the Model A and my MG would have been demolished. There was in it—I don't know, five years' savings—and Pollock would have been apologizing the next day.

TED DRAGON: We forget the gentle, outgoing quality of Jackson when at peace. And such a generosity that when I admired a small picture in the studio, he picked it up and gave it to me—to Lee's horror, I think. Even when he was blotto he seemed to divine space and make simple things come alive; when he touched something it was at once *formed.* It was like the way, when calm, he could join a group at our big parties here at The Creeks and his peace seemed to flow out of him to reach everyone—he was quite unique in being able to do that.

And there were times when he'd sit for hours on the terrace saying absolutely nothing, completely relaxed; this would be in periods of not painting. But when I was with Jackson I never thought of him as an artist; we talked of gardening and practical things, though it was hard because of his silent seriousness. He loved stories about Schumann and his going insane, about Clara, Liszt; then he'd say, "Well, play the goddam thing."

ALFONSO OSSORIO: Lee called once and said, "For God's sake, you've got to come over and get Jackson out of there." He had put large

black and white canvases against the windows in the front room where there used to be a partition, taken a bottle and gone in and turned the volume up full. They were all early jazz classic records—Louis Armstrong, Old OKeh records I knew at Harvard back in the forties. He did that several times, obviously experimenting with his psyche full blast.

LELAND BELL: I'm a jazz drummer and when I talked to him about jazz—nothing. He had no interest whatsoever in jazz, and I don't think he had a feeling for any music. He didn't *know* and he didn't care.

BEN HELLER: He didn't know nearly as much about music as other things, but he could hear well. He was interested in the warm jazz and the minimal knowledge I gave to him. We played different music on different days and listened to Schönberg, Debussy, Stravinsky, something or other, Bartok in the more modern era, or we'd go back into the pre-classical world and so forth. A lot of his identifications were with people who were breaking the mold, trying to break out or had something to say in their work.

MORTON FELDMAN: He liked having music around, sort of. And jazz—well, you don't have to be an expert for that.

BERTON ROUECHÉ: I don't think of him as a jazz expert, but he liked Dixieland, I guess. And New Orleans jazz, too, which everyone was playing then.

LARRY RIVERS: We were playing at Jungle Pete's and he'd come around in the evening from his afternoon drinking and be there still at nine o'clock or something like that when we'd start. He didn't know whether to really acknowledge me or not—"Eh, Larry." Then he'd ask for cornies like "I Can't Give You Anything But Love, Baby"—"Tha's a good tune"—practically on that level of dopey songs. It wasn't like a drunk coming over but like from a Hollywood movie. In the Jungle Pete's scene this wasn't a heavy painter with an accomplishment behind him; Pollock was a figure of derision . . . actually, he wasn't that bad.

By September, Jackson was facing the fact that 1953 was about to be the first year in nine that he hadn't had at least one show on an annual basis. He did, however, have a painting in the Janis *Fifth Anniversary Exhibit* at the end of September, and in October he learned that he would have a show there for the month of February. Four current works were sent to Janis, and unsold works were returned from Paris, an embarrassment he shrugged off with a line to the effect he wasn't sure "francs work like dollars." Nor was he sure about using titles instead of numbers for his works.

SIDNEY JANIS: At one lunch I told him numbering his works was going to be all bollixed up one of these days and why not think about titles when working? He said, "Good idea, good idea." After the pictures came—we were going to hang the show the next month—we were all sitting there when Lee was called to the telephone. I said to Jackson, "Did you come up with any titles?" He shook his head. "Couldn't think of a thing. Lee and I were pondering over it." While he was talking, Lee on the phone spoke of a "sweeping effect." Jackson started and went right through the whole damn thing, giving those beautiful titles. When I told Lee they were all titled, she couldn't believe it, they had been struggling so. But he had been thinking, and from that time on he titled his pictures.

PATSY SOUTHGATE: When I would name them something or other, he would say, "That's exactly what I was thinking about when I was painting it, so we—I am communicating with you." Then he would say, "What do you think that is?" I'd have to guess and name that one. He always named his paintings after a fair number of tries, but I think he liked the idea that he was communicating in speaking to me about them. One title was, I believe, *Easter,* but I can't be sure [probably *Easter and the Totem, 1953*].

CLEMENT GREENBERG: I titled *Lavender Mist,* which seems prosaic to a lot of people. When Ben Heller was into culture, he bought the picture he sold to MOMA called *One;* I had called it *Lowering Weather.* He thought *that* was too prosaic and asked Jackson to change it, get another title. Jackson sat deep in the sofa and finally said, "One."

Titling and signing works were both difficult for Jackson. "Signing is more than goodbye, it means the picture is *fixed* in time—it's done, and there's death in that. Signing is like lettering on a headstone, saying yours and *done*." The one painting I am sure I titled at a late afternoon or evening session over drinks, *Ocean Greyness,* brought a laugh from Jackson. "Sure, because you're color blind and all your trucks are grey. What an eye for me to get titles from!"

CHARLES POLLOCK: I've always had a hell of a time with it, titling. I got it in my head I ought to have another professional name than Pollock, and used the initials CP, also Pima. Jack thought it was a silly idea. As for signature—extremely difficult; it's an interruption. Some I've signed on the back even."

Of the titles in the Janis show—*Ocean Greyness, Unformed Figure, Sleeping Effort, The Deep* and *Ritual*—at least two were mentioned at those sessions, and *Ocean Greyness* we discussed at the Guild Hall's *17 East*

Hampton Artists in July. While Jackson came up with many, Lee often made the decision. But for "with," Jackson substituted the "and" in *Portrait and a Dream,* a work I've always seen as close to a self-portrait. And any title that came from a true believer such as Patsy Southgate was afloat as soon as uttered.

PATSY SOUTHGATE: I was twenty-five when I met Jackson, and his work scared the pants off me. I resented it at first, then I just loved it. Finally I couldn't bear anything else. He was accused of throwing up this obscure wall of paint and defying people to try to see through it, or see into it. But he said that wasn't what he was doing, that he was opening himself up and all you had to do was *look* to see it. I always found images; I think he did, too. He said to everybody that he took the image, broke it up, and put it together again—which is what abstract painters said they do.

It was thrilling to learn about abstract art, riveting. He and Lee talked endlessly about the theory behind it, although sometimes she disputed Jackson, saying "How dare you do all this subjective stuff which can't be understood by them?" He talked of his hatred of anything that had to do with French painting in particular and European art in general. He felt that the American contribution he made was much better than anything that had ever been done because it was more personal and soul-searching—romantic and imagistic—and that it was almost sacred to break down the image and re-form it out of your own image. It was a *very* creative act.

As the eldest son, Charles Pollock had the greatest concern for their mother, Stella. Things had reached the point at which he spoke to Lee and Jackson about taking her in, explaining that she shouldn't live alone because she was no longer able to shop and do her errands, and that $100 a month would hardly be enough to live on. Lee's view was that the decision should be Jackson's but that his own problems must not be complicated. Charles brought Stella to Fireplace Road for a visit in October of 1953.

FRANK POLLOCK: The solution of her staying at Jack's did not happen, as Stella did not wish to. I think she wasn't comfortable. She *said* she had to get back to Deep River to work on clothes for herself and Jason [Sande and Arloie's son] for the upcoming winter. But I think Lee was on guard, probably thought Mother was a burden, or would be, if she were to come to East Hampton to stay with them.

ARLOIE MCCOY: She'd had a heart attack, and at one point they said that East Hampton was where she should be. In spite of his fame,

Jack didn't have anything to help her with. He and Lee were not in a very happy situation and she didn't need that aggravation; the strain would have been huge. We didn't want her to go, and why should an eighty-year-old woman go through all that?

JAY POLLOCK: Alma and I had Stella staying with us for weeks at a time. And Charles and I were sending monthly checks to her—Frank helped too.

JASON MCCOY: She was a fixture in our house, well corseted, and did marvelous handwork. She was with me all my childhood and when she finally left there was a terrible sense of loss for me. But I think Uncle Jack's creative energy had little to do with Stella's stitching away. It was part of the miracle.

CLEMENT GREENBERG: Jackson was helpless in the world, and this came out of being so self-centered. He was so helpless he expected you to feel sorry for him, and that's why he couldn't think about his brothers and his mother.

Peter and Patsy Southgate Matthiessen lived about a half mile north of the Pollocks on Fireplace Road in a house owned by Fred Lake, a genial art collector in a small way and later the local mainstay of the Nature Conservancy. The Matthiessens' nine-month-old baby, Luke, had been born in Paris where Peter was a *Paris Review* founder along with George Plimpton and William Styron.

PATSY SOUTHGATE: I think people in Springs lusted for company—were thirsty for new faces—and my routine was to put Luke in a stroller and go up the road every day and visit Lee. I was interested in role models, since my mother had been unable to boil an egg, drive a car, or anything. So I would check on how Lee did her cooking and her gardening, painting, her general life—this type of thing. She and Jackson just loved Luke.

I always felt that it was really sad for Jackson not to have had a kid but that Lee was simply delighted not to have one. He liked other people's children and Lee took a vicarious pleasure in it—they both did. He often said he wanted a child, but the other side of the coin spoke of fear of having one. I have a very strong feeling that if Peter and I had been killed, Lee and Jackson would have snatched ours and taken care of them. But I also had a feeling that this was a kind of trip he was laying on her, like "You would never have children and look, we could have had this adorable thing." She would probably say, "Oh, shut up. You wouldn't want it if we had it now; we couldn't handle it."

MAY TABAK: Everybody assumed he was afraid of the responsibility of children, but it was not that. Lee told him *after* they were married that she would not have children with him because he couldn't be counted on for the long haul. There was nothing he could do about that. I don't know if Lee could have children, just that she said there would be none.

BEN HELLER: Jackson was very upset about not having had children, at least on this night. We talked about it and he said, "You know, I wasn't just shooting blanks all these years"—meaning that he wasn't sterile.

B. H. FRIEDMAN: I think I hinted in my biography of Pollock that there was need for something like sons, whatever that means. I talked to Jackson a lot about that kind of thing—the one thing I never discussed with him was art—and my recollection is that I did ask about children and that the answer came from Lee but with Jackson sitting there and accepting it: She said that none of them could afford children in the Depression. I felt it was a little too bland, something that had been said often.

RONALD STEIN: Financially they couldn't think about next week, much less about children. Then once it was clear the way Jackson's life was going to be, there was no room for children. He was a full-time job; so was she.

On the several occasions Jackson talked to me about fatherhood, it was with the kind of wonder that he felt about the beauty and surprises of the Farm. About both, in spite of the mutual exchange of worries that made up many of our meetings, he tended to be offended by what he took to be my casual attitude. He didn't see offspring as a natural occurrence so much as an expression of will and consequent risk taking. "How can you get such self-confidence to re-create the self? Sure, I know there's a mother, but the *idea* is the father's. So the kids are too. Mothers are just the agents, the giants that better turn us loose—or watch out!"

As usual, Jackson became increasingly tense as he faced the opening of his month-long February 1954 show at the Sidney Janis Gallery.

SIDNEY JANIS: He behaved himself except when in his cups. Lee was very cooperative and we did more Pollock shows than any other gallery. In this show there was more castigation about the resurrection of the image by abstract artists; they hated the return to the figure, just as they did in his '52 show with us. But Pollock anticipated the whole Expressionist image today, two or three generations later. It was done as early as the black and white paintings, and he influenced the whole stain

movement. With the public there is a necessary gap, if the artist is one of vision, between him and his audience, no matter how perceptive. It takes time for their power of understanding to catch up.

Jackson knew that Clement Greenberg was not favorably impressed and that some critics would be praising him for the very qualities his peers saw as regression. But Frank O'Hara was deeply impressed by *The Deep,* comparing it to Manet's *Olympia* as a technical masterpiece; Dore Ashton was moved by *Portrait and a Dream,* calling it one of the truly great works of her time; Thomas Hess wrote of Pollock being on the edge between violence and the decorative, and reaffirmed his international standing. Others, such as Stuart Preston in the *New York Times,* congratulated him on leaving the impersonality of abstraction and on actually painting as opposed to dripping. For what turned out to be Jackson's final show of current work, the Janis exhibition of February 1954 was less a climax to a career than an occasion for the same debate between champions and detractors that had been going on since Peggy Guggenheim was first urged to take him seriously.

CLEMENT GREENBERG: When Jackson fell off the wagon at that table upset night [Thanksgiving 1950], I knew he was gone. He was never going to come back, and in fact he stopped painting. But they had to get him painting again, and the hell with that; it was all so misguided. Jackson knew he'd lost the stuff; he had lost his inspiration. But all this "Jackson's not painting, Jackson's not painting"—it was awful. And then Tony Smith dragging him drunk out to the studio to get him started painting again—so ill-advised.

In his 1951 black and white show Jackson was still good; in '52 he began to wobble; in '54 with the '53 paintings, his only bad show, that's when people called me and said, "Now, at last, I see what you see in Pollock"—a common irony. At the Carnegie International there was a 1953 Pollock hanging next to a painting by a Dane, Carl Henrich Petersen, a damn good painter. Jackson asked me what I thought of his picture here and I told him it wasn't as good as Petersen's. Then we talked about *The Deep* and he said, "I was on to something there and I just missed."

What happens with painters, poets, composers, you have this run; you know somehow what you can do next, but then the inspiration is false. You can see this in Picasso after 1925—he had some run! And Jackson . . . well, he had his ten-year run.

During the rest of that winter of 1954–55 Jackson alternated between rage and despair, both of them at least quiet. And it was then that a process I think of as Jackson's death trance began. At one attempt to get

him to a healthier topic, I asked how it felt to have really made it. We were standing by the living room fireplace in the big house at the Farm as he studied what was left of the glowing logs. "Lousy . . . When you've done it, turns out you're done for—in yourself you're nowhere and no one . . . you're caught, only nothing's holding you . . . you got to go somewhere, to the edge of something, but there's no edge . . . crissake, we came here alone but we don't got to go alone. The way I see it, we're parts of a hole, like a glove turned inside out. And outside of the glove, the hole, is a reality we can't imagine because it's endless—the universe holding existence together . . . no shit."

ELEANOR WARD: You felt constant inner turmoil, as if he were trying to bring things out. There was an innocence—in spite of the Cedar scene, where I don't think I ever saw him sober—that was very endearing. It was to do with his sweetness in helping Nick Carone tear down walls in that lovely old house he found for them in Three Mile Harbor. There was Nick's beautiful Adele who anyone would have flirted with, but Jackson never did. Of course, with all that despair . . . I think he was able to express a great deal of it in his painting, and I think if he had lived he would have expressed it a great deal more—gone on painting, been greater and greater. I don't have the foggiest about what direction, other than it wouldn't have been realistic.

NICHOLAS CARONE: Lee called me one night. "Nick, could you come over?" she says. "Please come over. Jackson's been out all day and I don't know where he is." It was about two o'clock in the morning, but I knew how concerned she was. Their house was so cold, I kept my coat on in the kitchen where I sat with her. She told me that she had been on an afternoon errand and when she came back he wasn't home—some Bonackers had taken him riding around, probably stopping at bars. She didn't trust them, didn't know what might happen to him. Some of them were wild.

So we sat there, waiting, and drinking coffee in the cold of that kitchen. Lee would get up and look out a window every now and then; whispering "Where is he?" Or when a car would pass, she'd say "Maybe he's in it." There wasn't much to say; we just waited and waited, and I could feel her anxiety about what they might have done with him. She was frightened to death about his taking drinks, and I thought about Van Gogh and that image of being possessed. But I don't think he had anything near what Pollock had that night when he finally came in.

The door swings open and he's wearing one of those hunting hats, a wool hat, and he comes in like a brute, wild. And he looks at me, "What the fuck are you *doing* here?" I thought, my god—the way he was acting—he's come and he's going to kill me. Lee wanted him to sit down

because she was nervous about how drunk he was and his mental state, and she was right to be. He was *violent*—making a scene—and then in a rage he was yelling and screaming, and you'd think he was losing his mind: "I've done it, I've done it, you fucking whore! What more do they want from me, what do they *want*?" I've never heard a tirade of profanity in my life like that, never—but with *violence*. Try to understand the intensity of that moment in winter, three o'clock in the morning, and his coming in—wham! I saw us there being killed by a madman.

And here was Lee babying him, offering him milk, then more of his profanity. And he was standing there, losing his mind, yelling and screaming. Then he jumps up, grabs at that chandelier in the ceiling, and it came down on him. He goes over on his back against a big flower pot. He hurt himself and he was lying there on the floor with Lee asking where it hurt, was he bleeding? Maybe it was the shock, but he calmed down—exhausted, almost out. Then she wanted to try giving him milk and told me to go, it would be all right now. She'd take care of him.

In speaking of the more difficult times as a neighbor on whom Jackson felt free to drop in, Julian Levi told me that whenever he was about to give up on him, the sense of Jackson's integrity and commitment saved the moment. After some years, he added, it occurred to him that what was reaching him was not those qualities but something far more important: genius, however special—even limited; genius.

PATSY SOUTHGATE: We were in the relationship at first of Jackson the tutor and we the students in abstract art, and what a spectacular world he held up for us! But I'd never seen an artist going to his death for his art. Jackson let us see his guts, and in so doing the giving up his life. The encounter with Jackson changed my view of art and my way of seeing all things. It changed my way of relating. Jackson changed my life.

DAVID BUDD: Meeting Jackson was a turning point in my work and in my life. He was a hero—the thing about him was that he was *right*, and the paintings were right. When Ossorio took me to meet him, he asked if I'd like to go out to the studio—at the time for me it was unthinkable— and he spent a long time with no talk, pulling out paintings, just painting after painting. That hero for me is still: I was talking not long ago to a friend and I turned on the sidewalk and there in a window was a Pollock. It jolted me like an electric shock—after thirty years it looked like it would be done *tomorrow*, it was so good. So you have to stop talking and just look. That's super power, super magic, super whatever!

CHAPTER NINE
"TO THE EDGE"

In late winter of 1954, there were obvious changes in Jackson: He was becoming heavier, physically and in his mood. His patchy but thickening beard seemed to express perfectly his attitude of "If you crowd me, watch out." Part of this reflected what he called "heavy stuff" at the Cedar—once bourbon, now more often scotch—and beer in Bonac. "Beer isn't really drinking, it's horse piss."

"SAM" DILIBERTO: Tending bar, I could see there was like a night Pollock and a day Pollock at the Cedar. When secretaries and businessmen were in at lunch he was a different man; you wouldn't know he was there. But at night with his kind of people, artists, sometimes you'd wish he wasn't. Kline one night was at the bar talking baseball when Pollock came in and wanted to be recognized. So he elbowed Kline. "Hi, Jackson, be right with you." But the story went on and Pollock elbowed him again. "Do that once more and I'll knock your clock off," Kline said. He always said "clock," not block, one of his things. Pollock *did* elbow him again, then flung Kline's cap up onto the top shelf behind the bar and ran out. Kline shook his head and just chuckled. There was the same scene a week later when Kline was there; but then Pollock pulled a switch on him: He flung his own hat onto the shelf and ran out.

You know, the painters weren't so bad—mostly they were just noisy; it was the outsiders apt to get physical. Of course, when Pollock would get rough he was a pain; he would upset me by sweeping stuff off tables onto the floor. I would add the broken stuff to his bill. And he was strong: He pulled a table out from the wall and held it out with his arms level, so I had to yell at him—you know, with that crowd from Jersey and uptown, somebody might get hurt, broken foot or something. And another time

he was helping a woman into her chair, gave it a little push and she ended up fifteen feet away. Sometimes the act was too much and then it was "Leave!"

MERCEDES MATTER: When he would make his Cedar entrance, he reminded me of cowboys making theirs with guns drawn to shoot up a saloon: "You guys think you're painters!" Then he'd do something aggressive, hit someone. Jackson was *so* insecure, and so uneasy about other painters being as good.

NICHOLAS CARONE: Jackson didn't like Bill de Kooning's post-*Woman* series because he saw it as a response to all the fanfare Bill was getting. He had been all for Bill's earlier things—that narrative stream of consciousness, Joycean approach. As they were sitting at the bar, Jackson said, "About that fucking picture at the Guggenheim, Bill— it's not up to your standard. What are you trying to do?" Bill got very angry, but Jackson phoned me, all upset, told me it was because Bill didn't understand. He said, "Bill is my *friend*. I believe artists should have a brotherhood." And that's what he wanted, brotherly love, and he would attack for that. Then he went on, "He thinks probably I'm jealous or something, but I really have great admiration for him." Bill just didn't know how to take it from a spiritual brother.

DAVID BUDD: Bill and his group lived in the neighborhood so the Cedar was the watering hole for them. But it wasn't as it was in Paris with sitting around quietly all night, drinking coffee and talking intellectually. Franz would talk, Bill was knowledgeable, but Pollock . . . Usually everyone was drunk when it got late and the word "whore" was used a lot— "You're a whore." "No, you're a whore." Mostly it was only tearing shirts, yelling at each other, pushing each other—they had a good time. The Second Generation was doing a lot of this playing around, too, trying to get close to their kings—this king, that king, always room for a few kings. With Jackson, it was something else: He wasn't painting and that was even more interesting.

LARRY RIVERS: He'd come into the Cedar looking like some kind of manic-depressive—that or stone drunk, aggressive, and really horrible. And he had this kind of brutal line with Johnny Myers: He'd go like this, devouring an ice cream cone, then ask if he'd sucked any good cock lately. And he'd come over to me—I was the first in the art world to have a reputation for taking drugs—and he'd go like this, like shooting up. If a guy there was too short, he'd say, "Hi, Shorty"—a bully, anything to annoy, to be brutal. But one night I was there with a girlfriend who was pretty, and I went to the bathroom. While I was in there, he asked her if

she'd like to leave with him—I think even went so far as to ask if she'd like to make it with him.

DORE ASHTON: He always greeted me nicely when we met at the Cedar—recognized me, knew my name—and never flirted with me. He was *au courant* about what was happening, coupled with what painters can get out of the air, and I didn't feel this was an illiterate cowboy. I was moved by him those few times we met.

As the days grew longer, Jackson spoke of how slowly time passes when it isn't needed. "Sure, there's time for thinking but that *really* slows up time . . . two things I need: some money, just tide-me-over money, and something to work at to get me back in my work—only part-time. Something like your contracting jobs maybe; I'm a mean post hole digger . . . done ax work where trees are *trees*, goddammit—sort of all around handy, I call me."

This just couldn't work out—I already had Jimmy, a good worker, and I couldn't afford to pay Jackson to do my work for me even if he'd been up to it. But April brightened things for him: Barbara and Robert Beverly Hale began fixing up what had been a sort of poorhouse on Fireplace Road.

BARBARA HALE: It was a sad little house—the previous occupant had been driven home dead by his horse and his last meal was still on the table when we were shown the house. But it took on a happier life and a noisier one, and I still find old liquor bottles when I dig in the garden; Fred Lake used to pay the old man for odd jobs with them because he was on relief and wasn't allowed other income.

Jackson helped clean out the house, loving every moment of throwing old furniture and clothes out the upstairs windows. The day he finished scraping down the walls of a downstairs room, he spent a long time drawing on the plaster as if it were a textured mural. We came back the next day discussing how to preserve it, only to find Cap'n Gil Miller. He had just finished giving the wall its prime coat of paint, and there went our first Pollock.

ROBERT BEVERLY HALE: But other walls he only scraped looked just like Pollocks. Jackson became a kind of fascinated mascot while I spent months in the back of our place working on an octagonal tower where Marcel Duchamp could play chess with me. Jackson would squat on the ground and squint up at the work; he taught me a lot by his quiet presence—by personality more than actual education.

I had faith in Pollock, which is why I battled for him at the Met, finally persuading the trustees to acquire a small poured work (*Number 17,*

1951) [as curator of American art, Hale had been a secondary target of the "Irascibles" uproar]. After Jackson's death, it was traded as half payment for *Autumn Rhythm* at $20,000. One of the trustees said a work that big must have *some* value.

Perhaps because of my years of teaching anatomy and figure drawing at the Art Students League, Jackson spoke doubtfully about teaching. I told him about the student who explained to Whistler that he was self-taught; said Whistler, "You couldn't have had a worse teacher." Jackson chuckled for days over that.

Jackson was curious about these drawings of mine that the Japanese liked, done with the brush vertically and ending up with a calligraphic effect. I explained that having been trained as an academician, no matter how abstract I wanted a work to be I always had to put in a figure. Jackson said, "I'd cut off my arm before I'd put in a real figure." But then he volunteered to show me how to work with his pouring technique and we spent some time together. I worked up an abstract style really over a weekend. I don't know what Jackson genuinely thought of them, but he was always kind to me even when he was drunk—must have been difficult.

NICHOLAS CARONE: Jackson was at our house for dinner and asked, "How the hell can you teach *art*, Nick?" He couldn't be eloquent—there was this churning volcano inside as if he'd suffocate while trying to get things out—and I agreed with what he was after: You can't teach a young painter to be an artist. What you can teach him is the language of art—the nature of his instrument, the plane, the two-dimensionality, how to analyze a form and reduce it to a geometrical symbol. He said, "Well, it's got nothing to do with what I'm involved in, the cosmos." But I said the plastic language *can* be taught, and he said, "Maybe you're right, but if I had to teach, I would tell my students to study Jung."

The artist is never happy until he finds the well of the unconscious; then, if he has a life force, there is engagement, an encounter, and he becomes illumined by the generating force as an icon. Jackson *knew*—we talked about this—and his statement is religious. He was a genius and a genius is a phenomenon; it is someone possessed and Jackson was possessed—absolutely. He said that John Graham understood that infinite well of the unconscious, but tapping that source is very dangerous. Jackson had a life to him that synthesized this; it was a do-or-die thing with him to paint. His validity as a painter is in his life force, and I think he would have died if he didn't paint.

By late spring, Jackson was cruising the Farm area more often because his friends Peter and Patsy Southgate Matthiessen had moved into one of the remodeled barns.

PATSY SOUTHGATE: He would throw his car keys in the bushes at a party when he was getting drunk—just go out to the car and throw them away, then go back in and have a few more. The next day he'd be driven back and spend it with his hangover searching for them in the bushes and brambles. He was self-protective enough to see trouble coming—in spite of everything, he did have a sense of preservation about himself.

His concern for preservation applied also to the first joy to come into his life for a long time: a green 1950 Oldsmobile convertible.

CONRAD MARCA-RELLI: The dealer Martha Jackson was getting nowhere in negotiation with Jackson for some of his works. Finally, she asked how he would like that convertible out there and he pricked up his ears. He gave her two oils on canvas [*Number 5 and Number 23,* 1951, titled *Elegant Lady* and *Frogman* by Martha Jackson], so she left the car right there; the deal was consummated.

LARRY RIVERS: That car was once given me by Martha Jackson. We were supposed to make a trade on it, and I often think if we had—I mean, with a convertible you go around with the top down, and the way he was thrown out in his accident . . . Anyhow, I had that car for a few weeks while we were dickering. It was beautiful but I have a feeling that either she had begun dickering with him and saw a greater profit, or that I didn't have anything really to offer and she wouldn't have made enough money. She wasn't just getting rid of the car, she was trying to make more money from it than she would just putting it on the market. *I* was supposed to get that car.

It was good to see Jackson so pleased, and for a while he wasn't drinking. "*These* shock absorbers aren't weak in the knees, so it makes for pretty fair riding on the wagon." He said he'd been thinking about letting Lee use the Model A, the clutch being almost gone, anyway. "What Lee needs is a tough car—plus a lot of time as a slow learner."

PATSY SOUTHGATE: I took Lee's side strongly from the point of view that This Woman Is Not Being Treated Fairly. I mean literally, Lee had two pairs of britches to her name, was trapped in the house, and didn't know how to drive. Jackson didn't want her to, but *he* had mobility. He would go off, had this large studio, this person making delicious food, and pretty much what he wanted. And so before I knew what was happening, I undertook to teach her how to drive and in return she was to teach me how to paint.

She sent me home with some paints, told me to make some paintings, and so I struggled over this thing. I took it back to Lee and said, "I think

we have to admit that I have no talent at all, so let's start on my car and forget the paint." She had absolutely no self-confidence and was extremely difficult to teach. She had to take her license test a couple of times, but she did get her license finally. Then she was liberated: She could go shopping, see friends, be on her own. Jackson didn't like my teaching her at all; if you give people a car and a license, they have independence. I don't think he wanted that.

Transportation was almost a secondary use of cars for Jackson, particularly the Model A. "Some days I just sit in it back there by the studio . . . guess the way its upholstery is all shredded is all me." Then too with cars there was a competitive element, along with showing off, a touch of sadism and when Clyfford Still summered at The Creeks—contempt for his Jaguar.

JIMMY ERNST: I had just bought a used Ford V8 convertible. Jackson looked at it with envy, a look asking, "Why do you have it and I don't?"

What the look was really saying, according to Jackson, was far from that: "Just what an *uptown* painter would have, all shiny to take your date wining and dining—shit." But this was before he had that uptown dealer's shiny Olds.

ROBERT MOTHERWELL: Igor Pantuhoff was in a Provincetown bar about ten years ago and told me he remembered that MG of mine. He said, "I was sitting on the Pollocks' porch when you drove by in it once. Pollock said that nobody who drives such a car *can* be a good painter. It really shattered me, and he meant it too."

ALMA POLLOCK: When he got drunk anything could happen. We could have been killed in that old jalopy; Jack was at the wheel and we almost hit a tree—terrifying! It was insane—you took your life in your hands when you got in a car with him. I said I'd never—well, I never did get in a car with Jack again.

WILLEM DE KOONING: He spotted this sports car outside an Italian bar in the Village, so he was trying to open its door. I told him he was out of his mind doing that with all those Italians in the bar watching. I didn't want no battle with those Italian guys; they smash you all over the place. I said, "They'll kill you in this neighborhood." Anyhow he couldn't open it, so he gave up. We sneaked away.

JAMES BROOKS: One reason why I was always afraid to drive with him is because I expected him to kill himself in an automobile and I

knew he wanted not to do it alone; he wanted to have someone with him. After a few drinks he would get a little mean; he'd kid around, trying to scare you. There was always that thing, "Did I scare you? Did I scare you?" A lot of drinkers do that kind of so-called kidding, you know, but they're almost trying to bring you to really die.

FRANK POLLOCK: Once, when dining with him and Lee, we got to Montauk Point and Jack got to driving the damn thing so fast I was sure we were going to veer off the road.

"Jack," I said, "I want to live. I've got a family—I've got a son." I thought he was out there to kill himself—kill us all. I'm serious.

RONALD STEIN: Lee asked me to drive to East Hampton with them in the Olds but wanted me to drive. They picked me up at 79th Street west of Park Avenue and Jackson said, "*I* am driving." Lee got in back and before we were settled, Jackson floored the accelerator, tearing east against a red light across Park Avenue in mid-afternoon traffic. It was like a Hollywood chase movie with tires screaming, horns blowing, bumpers crashing, and cars up on the sidewalk. We sped over to the East River Drive on the wrong side of the street through opposing traffic and red lights, even passing a police car.

When he got on the Drive he stopped dead and cars piled into each other behind us. Lee said, "Jackson, let Ronnie drive." He shook his head and Lee said, "I'm getting out right here." She did, and I don't know how she got across the Drive. From then on we had as nice a leisurely trip as you could ask for, didn't go through a red light the whole way.

Jackson was showing his aggressive, overbearing wife that he was the master even if it was going to kill her. He had wanted her to back down and she wouldn't, so no apologies when she arrived next day by train. Of course, then all hell broke loose, like a bomb had gone off; I could only take the arguing for one day and went home. It was too intense.

CONSTANTINE NIVOLA: I took Le Corbusier to see Jackson—he was suspicious of Abstract Expressionists, calling them noisy and trying to get away from discipline—but he was pleased Jackson had his book. He said of Jackson's work, "This man is like a hunter who shoots without aiming. But his wife, she has talent—women always have too much talent." Then Jackson drove us to New York, carefully and without a word, and Le Corbusier said to me, "This man *does* know how to drive a car."

MILLIE LISS: Joe and I had a Model A too, and we called it after me, Millimobile. We were going to get more ice for a Zogbaum party, but Jackson said he'd get it at Dan Miller's store and asked me along. On the

way back, he asked me if I'd like to go to Paris in *his* Model A—laughing, he headed for Louse Point. He said the best way to get to Paris was just to drive into the water and there's Paris. He did drive right up to the water; then we came back to the party and people looked at us—the way he was laughing. It's the only time I was asked to go to Paris in a car by water.

BARBARA HALE: Jackson was always sort of around as I was trying to fix up the house, and it became impossible. I thought of him as an innocent, childlike person but not when in a car.

ROBERT BEVERLY HALE: Jackson took on newcomers like us, always dropping in. I still don't understand how he was able to get me at night in that open car and drive one hundred miles an hour, loving it. I died every time.

When Franz Kline, the de Koonings, and Ludwig Sander rented the "red house" just east of Bridgehampton for the summer, Carol and Donald Braider moved their stock there before opening the House of Books & Music in East Hampton.

ELAINE DE KOONING: Jackson came to the "red house" in the morning kind of drunk and was chasing me around, so I called Bill at the bookstore; they were bringing books to be stored in the basement. When Franz and Bill came, they threw their arms around Jackson and began to horse around—there was a great deal of that hugging, you know, when they got drunk. They were all just embracing in a rowdy way and suddenly Jackson was on the ground. His ankle was broken and he was absolutely indignant. He said, "I've *never* broken a bone."
He felt it was insulting; his myth of invulnerability was shattered and it bothered him. All kinds of rumors started about that to-do with Bill, but it was just absolutely animal spirits. And Jackson had to leave that ridiculous little car of his there, that flivver, so Franz and I learned how to drive.

CAROL BRAIDER: We got him into the station wagon and took him to the East Hampton clinic. The nurse, because Jackson was obviously drunk, was unnecessarily tough; Jackson was unnecessarily angry. I had to tell him not to use such language on someone only trying to help.

Lee told several people she was certain that "the boys" had gotten Jackson drunk to get rid of him, and that he was made immobile meant he would stay gotten rid of. It didn't, though it left Jackson feeling sorry for himself. "I've been watching flies in the studio, the way they try to get out of spiderwebs and never make it. Like me, they push right to the

edge . . . that edge where death is. All you know about is death in the War, not *dying*. There's no death in dying—it's all pain.'"

NICHOLAS CARONE: He saw through other painters, young ones on the make and the gang who'd made it or were about to, and that's one reason he was so difficult with them. He wasn't recognized as he is now; it was becoming de Kooning's time, along with his followers. Jackson said, "Fame, success, is what they're after. But that's not what it's about." You could've given Jackson a million and still he might kill himself the next day. Why? Because when the true artist has realized himself creatively, he doesn't need to live anymore. Jackson was just waiting it out; he had done it.

CILE DOWNS: Around Lee we were taught nothing but derogation of de Kooning; she knocked him all the time. But I never heard Jackson do that or knock anybody respectable among contemporary painters.

Often when Jackson would return to his feeling of being cornered, Lee was mentioned. "What's good about Lee is she doesn't take any shit from anybody—even me. But then I've learned a couple of things about wives: Never pick a looker for one, and never try for anyone else's. Maybe you think she's a great screw but the real screwing you're going to get, if he's any kind of man, is from him."

It was a summer of work more for Lee than for Jackson. Eleanor Ward had scheduled a show for Lee at the Stable Gallery early in the season.

ELEANOR WARD: This very strong woman was not easy to work with. In East Hampton I told her that I thought it was a good time for me to select her show. She said, "*You* select *my* show? *I* am selecting my show and I am hanging it on both floors." So I answered, "Lee, then there will be no show, unless it is on one floor and I select it." That's the way it ended because she wanted a show. And I realized that if I once let her gain control over me, I would just be putty.

CILE DOWNS: Jackson didn't pay Lee's work much mind or respect. I remember her appealing for his help when she had come down with colitis, she was under such a lot of stress. She lost all this weight and you'd really think she was going to fade away, but she was working still. She came downstairs and handed him this jar for the mucilage stuff used for sizing and said, "Please, Jackson, will you bring me some more?" It was out in the studio and he wouldn't go—just being ornery.

I mean, when you looked at her, all frail and in a little wrapper, you could see she couldn't go out in the weather to get it. She needed help

and he wouldn't give it to her. I thought, "He doesn't want her to be an artist." For Jackson, Lee represented a competitor in the house. Of course, I'm very loyal to Lee and resent the way people criticized her for using pieces of his work in her collages.

TED DRAGON: I remember Jackson writing us to Paris about how nicely Lee's work was going for her Parsons show. But on the other hand, he wouldn't give women credit, you know. We were joking about it this morning, the way Jackson would say "very interesting" when someone confronted him with a painting—that was his standard "out." I heard him say that over and over again, especially when these kids [Second Generation] would bring things to him.

ALFONSO OSSORIO: He made only a couple of criticisms about work of mine and they were precise—very much to the point.

Freudian symbolism, which had a way of coming up whenever Jackson referred to the mystique of psychoanalysis as an experience all creative people should undergo, was something he took seriously enough to be able to kid about. Of my excavating, be it by dozer, crane, or tractor shovel, he pointed out that I was really digging into "Mom—back to that old womb with a built-in tomb." If he watched a tree being felled, it was "Cut your old man's pecker down to size that time, all right." Or if a job of fine grading was done (never too easy in sandy soil), it would bring, "At it again—trying to stroke Mom."

Dreams, which he said were of great importance to his understanding of others as well as himself, seemed to be in short supply. "I have an edge dream, off and on. I'm sort of way out there on my own, moving slowly to the edge but not to a cliff, and it's not a void either . . . What it is, what if *feels* like, is just more me—on and on. I guess it's like that inside-out glove image, another part of the hole."

Silences after he spoke now had a new element, one that heightened the uncertainty as to whether he had finished speaking. It felt as if he might weep—worse, really break down and cry loudly, endlessly. Only once did I try breaking the moment by a jest: I told him that every time he spoke of parts of a hole, I found myself thinking of his Wyoming birth and saying to myself, "Off to Jackson's hole again." He looked at me with a hurt I'd never seen in a man. He walked away without a word.

FRITZ BULTMAN: We talked about psychotherapy quite a bit, I being in treatment, and we talked about the imagery that came out of it. I wasn't prepared for his shift back to the image, but now I think they are among his very best pictures because he had the whole drip thing behind him and could deal with the material again. I understand the need for

representation, drawing from the model all the time, though I work totally abstractly. And Hofmann at the end would have painted from nature out of doors if he had had the strength. As Tony Smith pointed out, it was from Hofmann that Jackson's calligraphy came, but the image was central to Jackson and he did have the strength to go back to it.

The image was *very* strong, however well hidden in the drip paintings; it is in that work that the hidden sexuality comes out. I have a little drawing from the time he was doing the all-over images, and I know that behind *Shooting Star* [1947] there was something painted and then covered with a drip. These are all very ambiguous—very violent, very ambiguous—and I've always felt that the drip was like a veil drawn over something that even he couldn't say.

CILE DOWNS: Lee said in his presence that Jackson had trouble working because the idea, or the image, of his mother came over him so strongly that he'd see her.

CAROL BRAIDER: He was very worried about the image having come back—very concerned. But he hadn't been before.

IBRAM LASSAW: After the figure reappeared, he seemed terribly unsure of himself. He asked me what *I* thought, this master of modern painting on the international scale. After all, he helped all of us and influenced artists of other countries. I was surprised, but I told him if he was following instinct, he was doing the right thing. It led to his wanting me to show him about welding sculpture—he spoke several times about it.

HARRY JACKSON: I wanted to paint realistically and study painting technique, and I brought him a book on the techniques of the old masters. Jack said, "Oh, *no*. You can't read that stuff. You can't do that anymore, Harry." We were at the kitchen sink in Springs, washing dishes. And I said, "I don't understand that word *can't*." He got black—like it was a deep personal thing going on, like something was after his goddam family jewels.

His behavior ever worse, Jackson was beginning to feel deserted by friends and peers. And he was racked with doubt. "But at least I don't worry like you running a 'dozer on the edge of a cliff and afraid of going off. When I push to the edge I know what I'm doing."

CILE DOWNS: He would often say, "You don't understand." I would say such things as "Jackson, do you think you would be able to paint something just because you think it would sell?" I didn't understand what he was doing, why he seemed to have given up painting. I didn't

understand why anybody would paint that way, especially as it seemed to cause him to cry so often.

CONRAD MARCA-RELLI: Halfway through dinner at our house once, he asked me to go get some beer with him; but he went right on driving to the "red house." He wanted to see the boys and he wouldn't let me call home at first—"Don't, crissake! Lee will know then where we are."—and when I did, he listened in. So there he was, hopping around in his cast, and they were drinking and shooting craps. He wanted to shoot with them, but Bill and Franz treated him like an orphan. They'd say, "Stay out of it, Jackson. You're too drunk, keep out of it." It was like he was only an outsider there . . . it was really sad to see him treated that way. Lee didn't trust them there at all: When we came back, she said, "I know those people. They're trying to kill him, they're trying to kill him."

PETER BLAKE: I began not to see him very much, though I went out a couple of times fishing with him in that funny little boat of Zog's— Zog caught most of the fish, but I think Jackson was hung over. Petty, my second wife, was pregnant and having trouble—had lost a baby, then another—and whenever Jackson came over he would get so crazy. I don't mean that he would attack her, but I was afraid he might fall on her. I was withdrawing from him but he would show up nonetheless— got to be a terrible bore. When he died finally, I hadn't seen him for about nine months.

TED DRAGON: We had this very beautiful old white French piano and Jackson was banging away at the keys, then got an ice pick from the kitchen and started to hack them up. I should really have kept the piano as a . . . of course, the next day he'd call up and be terribly apologetic.

ALFONSO OSSORIO: There was a sort of vicious humor to it all, such as his chasing Rosalind Constable all over the house when he was tight. She really got frightened.

TED DRAGON: With women he *could* be frightening. And then with the kindly couples who weren't really part of the art world, like the Larkins . . .

LAWRENCE LARKIN: When he went on those terrible drinking spells we didn't want to see him. We were afraid of him, seriously, of his anger. And one simply had no control over him—or he over himself.

For many of us the next day's apology was harder to take than the previous night's behavior. It was as if he had to indulge in a self-flagellation which somehow included you, the by now not-so-innocent victim.

MAY TABAK: He had a lot of friends on various levels, but now it was only on certain levels he could join them—even the boys.

IBRAM LASSAW: Everything was an insult when they drank, part of that Lost Generation thing of the twenties that spilled over into the thirties, with the artists as the lost souls. Charles Pollock in Paris, whose life has been dedicated to art, is not part of that world at all, but the others, look what has happened to them all.

When I asked Harold Rosenberg how he thought the action painters would end up, he gave a "harumph," then said that the work would last but that some of them were on the road to a violent grave. This was around Labor Day, 1954, just after Franz Kline drove head-on into another car on Main Street with a shaky old Lincoln he was trying to learn to drive. Jackson, who was giving him pointers, was the only person hurt and because of his reputation, it became his fault. Of his cut lip, he went around saying "That's how she nibbles"; of Kline, "I should've let *him* instead of Lee have the Model A."

Hurricane Carol brought out the best in Jackson, who helped friends in the most exposed areas first. He tried to persuade the Joseph Lisses at Louse Point to let him save their refrigerator by throwing it through a new picture window.

CONRAD MARCA-RELLI: His basement was a little wet, and he said that since my place was lower than his we should go over and see how it was doing in case of flooding by Accabonac Creek. I told him I wasn't going to get flooded—the sun was out and the storm was over. But he looked up and around, like a bird you know, and said, "I'm not going to get flooded, but you are."

My jeep was in the driveway and Jackson says, "Get that jeep out of there. Then we got to take your paintings, all your stuff, and put it on tables." I said, "Jackson, you're exaggerating." But to please him, because I thought he was trying to impress me, I put up a few chairs. Do you know, in about a minute there was a flash flood: The car was under water, there was four feet in the house, and we were wading in it. I couldn't believe it, but he *knew*. "Now," he says, "open all the doors, come back to my house for coffee, and in a couple of hours we'll be back and the water will be gone." And that's the way it was.

A few days afterward, though, with the weather crisis past, things returned to normal.

JAMES BROOKS: We were driving with Lee and Jackson up the bluff to our Montauk house, and all the way up that winding road she

was after him, hollering at him, treating him badly—nagging, nagging. He was so upset, he said, "I'm going to hit you with a brick if you don't shut up." But she just kept after him until we all got out of the car and looked down from the bluff at the wreck of our studio. After looking at it for a while—nobody was saying anything—he started crying.

October brought a lift to Jackson's spirits, as the Solomon R. Guggenheim Museum bought *Ocean Greyness.* On a visit to inspect the electric screens we had installed at the stable to avoid flysprays in the hope of developing DDT-free manure for sale to organic farmers, I mentioned a project he might want to be involved in. His enthusiasm was instant. "To use your clay and mix it with manure for stabilizing dunes by planting perennial rye grass has got to work, especially if you get that Chicago stockyards manure they burn for nothing. And there would be money in it for us . . . only, there's Lee, and Janis. How do I tell them I'm now in horseshit?"

With the first frosts he didn't understand how it could be winter again, since that was what it had felt like all summer. "It isn't that I'm cold all the time from bad circulation. It's like winds blow through all my empty spaces. Some nights I can almost hear them. I don't know where they're from or where they're going, just that they sure don't give a shit for me." Hoping to get a smile for his sake, I asked what the winds sounded like— fallen leaves? "Dollar bills, crisp ones. And do I ever need them!"

PATSY SOUTHGATE: We forget these people's struggle in the Depression. They met, most of them, and got to be artists in those goverment programs. Out of their poverty came a sort of defensive bond— and with Jackson so terribly unaccustomed to money, it became sort of too fine a thing. I think that was one of the reasons it was so hard for him to call Sidney Janis for funds, and I think his view of money would have made a lot of luxuries way beyond his capacity to enjoy. He was almost like "professionally" poor; money stood for corruption. This was before any American artist had made a lot of loot except for a Norman Rockwell, someone you could spit on. It wasn't considered quite cultured to make money, so the starving artist was still very much in vogue.

ALFONSO OSSORIO: Their financial plight was very serious. Jackson suggested that perhaps he and Lee might move to The Creeks, live here. Well, I didn't know how to put it but finally said, "I love you both very much, *but* . . ." I'm afraid it may have changed our relationship rather.

It had been a poor year for Jackson on just about every level. There had not been a one-man show, and little work. In addition, as he ex-

plained, every time he turned around there were questions but no an-
swers. "If a writer came up with what I got from where I been . . . shit,
he'd need more than a lifetime to set it all down."

NICHOLAS CARONE: Pollock is probably the only artist who took
the conscious and the unconscious as a theme and followed it through.
His technique made him famous because it violated tradition, but the
technique was simply to get at the quick dialogue he needed. De Koon-
ing was accessible to people because people could hook into the tradi-
tional in his paintings—you know, a beautiful line, a nice passage.
People go for the stuff that's understood, so it was now de Kooning's era
and Jackson had to exist in that climate. But it was that genius Matta who
made Gorky, and Gorky made de Kooning.

 You can't discuss beauty apart from the unconscious, which John
Graham understood. Pollock's relates to Goya, who was damned; to
Rembrandt, damned; Michelangelo, damned. But Picasso doesn't have
this; he wasn't touched by demons. He's a great artist with a talent that's
mind-boggling, but genius is something else. Picasso is a historical phe-
nomenon who plays tricks like a juggler; but Pollock is a new phenome-
non, a new energy. He broke the barrier in touching on the unconscious,
and he dared go into the unknown and came up with images that are
frightening.

 Lee had a show of collages from recycled earlier work at the Braiders'
House of Books & Music before her show at the Stable Gallery.

CAROL BRAIDER: The bookstore had been a plumbing shop and
the little gallery was in a former car shed at the back. It was instigated by
Ossorio and Joan Mitchell with a policy of selling nothing over three
hundred dollars. We gave Lee her first show since Betty Parsons dropped
her, but Janis came to an opening and advised the painters to pull out.
Then Martha Jackson came out to the "red house," made deals with the
painters, and came over and took their stuff off our walls.

ELEANOR WARD: Lee's show at the Stable didn't go particularly
well—Betty Parsons bought one, which surprised me—but it got fairly
nice reviews. Jackson, though, was at the opening and well-behaved,
otherwise he wasn't around much.

RONALD STEIN: When Jackson walked into a crowded room or
opening like Lee's, people turned to look at this famous man. He seemed
bigger and taller than anyone there, and he *glowed*. I remember looking
at him in that pin-striped suit and bench mark shoes and thinking,
"Wow, what a feeling that must be." All the women moved in on him and

he was shaking hands—no Peck's bad boy at that opening. But I thought, "What happened to the drunken cowboy I admired so much?" It bothered me that he could make that transformation. And it bothered me because that transformation meant it was no longer Lee's show; he had ended it then and there on his entrance. He knew what would happen, so it was a sonofabitch of a thing to do: to come in sober, no breaking things up, no punching people in the nose. He was feeling his power, and Lee had lost control. She was capable of giving the butcher hell who gave her a poor cut of beef; Lee did not reserve her rage, she went right at it.

ELEANOR WARD: Although people expected Jackson to put on his act, he came drunk to my gallery only once and it was hideous. It wasn't the beast in him but the child speaking when he insulted this lady [his victim was the wraithlike, genteel spinster, Miss Kay Ordway, who left much of her collection to Yale]. She was sitting on the stairs and Jackson went up to her, this well-bred, sensitive person crippled with a limp, and said, "What you need is a good fuck." It was ghastly—Kay fled in terror.

CILE DOWNS: He treated women with a nice respect, paid attention to them. A lot of the men didn't and, looking back, I consider them a very sexist bunch. It was part of their macho posture, the strutting, and they overdid it considerably. I think women suffered from it, especially the wives.

Lee treated him like a very overprotective mother, but he was always rude and ornery—childish and crying. The way he treated her is the way a bad boy treats his mother, trying to get away with things, seeing how far he could push her. And Lee coddled him a lot just like a mother. Of course, he had a lot of problems about his real mother.

NICHOLAS CARONE: It's funny how these guys didn't want children. They can't take the responsibility, they're so egocentric, so they ruin their women. There's a mother need there, incestuous on a psychological level, along with a narcissistic element. I don't know that Jackson liked women—was erotic, passionate—but I think he would've frightened a girl.

MURIEL KALLIS NEWMAN: We were in a booth at the Cedar and my husband had to go to the bathroom, so Jackson swung around to my side and by that time he had drunk enough so that it was noticeable. We were talking about analysis—being in analysis was sort of chic—and he began to pound the table saying, "Why do I suffer like this?" It was said with such anguish it was frightening. Then he began to lunge at me, and I thought what am I going to do because I was sitting on the inside. Then

he began to sort of climb on me, but at that moment my husband returned.

AUDREY FLACK: One night at the Cedar, Jackson came in and there was a hush, then excitement took over. He came over to me at the bar, which I'm sure was the first time we talked. I was about ten years younger than anyone else there, though I wasn't a babe in the woods.

 All I wanted to do was talk art with him—I was passionately involved with art—but it was a little scary. Much as I admired him, it was upsetting: This huge man tried to grab me, physically grab me—pulled my behind—and burped in my face. He wanted to kiss me, but I looked at his face: a stubble and a debauched, very sick look. There was a desperation, and I realized that this man whom everybody adored, idolized, was a sick man. An artist like him was like a movie star to me, but this beeline he made for me at twenty scared me. He was so sick, the idea of kissing him—it would be like kissing a derelict on the Bowery.

DAVID BUDD: We were at the bar with a girl and Jackson came up to her and said, "You got great tits—want to fuck?" She got up and left, Jackson calling, "What's the hurry?" He had a lot of sexual bravado when drunk and would come on with the women to make some macho competition for their men. At Jungle Pete's one night, he was groping at the women on the dance floor with people saying, "Cut it out, Jackson." Then just as the band stopped, someone shouted, "Get out or I'll kick you in the balls!"

HERBERT FERBER: I remember a party at which Pollock took off the shoe of a girl sitting next to him—a very wealthy girl with extremely expensive shoes. She was protesting, but he tore the shoe into small pieces and threw them across the room.

JOAN WARD: He took me to dinner at an Italian restaurant on Thompson Street; I think he was probably lonely. He had no small talk. He saw some people across the room he knew and went over, sat down and was talking away. It went on and on, so I finally walked out. But then he called when my mother was staying with me. After she told him who she was, the conversation went on for a full hour. My mother thought he sounded like a nice man.

ELAINE DE KOONING: I never felt he was really interested in women. All that chasing he did was an act, but he had to—if they made sure to lose him. If you just stood there, the running would be the other way.

DENISE HARE: Jackson related to women only as an adolescent—sometimes as a difficult adolescent.

B. H. FRIEDMAN: The women I interviewed spoke about him almost as you would about a child.

PETER BLAKE: Women wanted to mother him, and did. If he'd become old and a period piece like de Kooning, it would have been awful for him. So maybe he was lucky after all.

CILE DOWNS: One night he was really sounding excited about how wonderful women were. I think he said that he had told a shrink about how he loved them, they're so—you know, "They're so beautiful—their breasts, their shoulders, their ears, their ankles, their noses, their wrists," and on and on. We kind of laughed, and it was nice in a way.

PATSY SOUTHGATE: He made a few passes drunkenly, in corners at parties. I handled them in the usual awkward way you do—"It isn't right, Lee is my friend"—and they made me nervous because of Lee. She wasn't aware of them, at least I hope not. And he never referred to them later, you know, apologies and stuff. The apology I remember is the night he put his feet through the windshield of our car, being taken home, because he'd thrown his keys in the bushes again.

ROBERT MOTHERWELL: In the early days in Springs, I had a particularly beautiful wife, a Mexican Brigitte Bardot—part Indian, German, Spanish, and looking like a ballerina. One week I went for the Pollocks to take them shopping but nobody came out of the house. Finally, I blew my horn and Pollock came out and very sheepishly mumbled that he couldn't come with me. I asked what had happened. More mumbling. Then it dawned on me that Lee had forbidden him to see us anymore.

As I reconstruct it, that week both Lee and I went separately to New York for a day or two and apparently Pollock had taken my wife out—I imagine they used my car. Anyway, Lee cut off the relationship just like that, but I never felt any hostility from *him*—or that he was anything but a bad little boy. My suspicion, my intuition, tells me that his problems, as with de Kooning, had to do with women.

ELIZABETH POLLOCK: There was only one woman in the house when Jackson was growing up, Stella. My conviction is that unlike the classical Freudian imprinting, Stella totally lacked those kinds of overt and subtle conditionings which would—could—have nurtured in Jackson his peculiar sexual complexity.

I always had vague intimations that his apparent fear or even dislike of young women somehow was tainted with emotions nourished by that kind of smothering affection. After all, Jack had been her baby, a little

blond doll, and the last of her sons. I think his social behavior was rooted in some form of sexual trauma; I don't know how he fulfilled himself sexually, and I don't think the parents warned the sons about anything; it wasn't the kind of family that talked beyond superficialities. He wasn't undersexed but frightened of sexual relationships. The kind of tenderness and commitment he would have to give a girl he was incapable of giving anyone.

CLEMENT GREENBERG: He was hostile to women. He said it himself: "I'm angry against women and so is David Smith."

More than once Jackson was made to look ridiculous by being set up to take a woman outside at a party, only to have her return saying "No go," with an amused thumbs-down gesture. "Look, they talk about more fish in the sea when a guy loses his girl, but we're the fish. Dames got their hooks out for us and if they've got dough, watch out . . . they're all over me, always were. They're in my work and they'll be in at my death."

Another aspect of Pollock's sexuality that seemed ambiguous to some was his possible homosexual tendencies. Talk of this sort was popular for a while after his death; Lee saw it as just another weapon devised by her enemies. Jackson had a way of knocking gays almost as if he were speaking of poor weather; they were useful to take venom out on. He always used the word "queer," but was careful that the label was not applied to himself. "A lot of times I'd rather quietly hold a woman, just lying there by her, than screwing. I guess to you with kids and a beautiful wife, that sounds queer—I mean funny."

ELIZABETH POLLOCK: I have an idea that a shy, insecure, and unsuccessful young man couldn't function with girls sexually and I imagine he was traumatized by this. But I never thought of Jackson as homosexual. I am very aware of that and saw no sign whatever.

REUBEN KADISH: Jack's affairs were not always sexual. There were girls he was in love with, girls with whom he might have spent a night, but . . . what the problems were I don't know. If he was ever involved with gays, it was in a very romantic way. I don't believe it was there.

B.H. FRIEDMAN: I never saw Jackson do anything blatantly gay; nor did I see any of the kind of discomfort that generally characterizes homosexual dread when the guys made him feel, you know, terribly uncomfortable. But there was a macho quality exaggerated at times: At the Cedar a fellow Benton student came up and Jackson was rather rough

with him. The first words out of Jackson's mouth when the guy left were, "You know, I used to fuck Mrs. Benton." I thought: Even if it was true, why is he telling me that? I asked Lee if she had any sense of it and she said "Absolutely not. He would have told me. Jackson told me everything."

DAVID BUDD: I think Jackson was aware that in society's eyes to be an artist was queer in the nonhomosexual sense, and it's not far from being that kind of queer to being "queer." Another fear was of women, I think, and in it was an aggressive drive so that he set them up in order to be able to reject them.

CILE DOWNS: He was very tender with the men, I thought, but there was something forced and unnatural about his relationship with women. I recall that the last time we saw him. We had just been eating a large steak—neither Ruth nor Lee were there—and he says, "Ach, look at that juice—like menstrual blood."

ALFONSO OSSORIO: I'm sure that at one stage or another in the life he led in the far West, he had a statistical incident that could be listed in the Kinsey Report. But I don't think there was anything there more than the growing up of a sensitive and good looking man. I don't think with Jackson there was any indication of homosexuality; I never felt any. And there was no talk about fairies or fags.

LARRY RIVERS: Frank O'Hara and Pollock did not relate—I mean, Pollock with his "These guys are fags"—I don't think Frank thought about him for a minute. The funny thing is that a lot of Surrealists were gay, right? Or a lot of people around them were. Pollock got the idea eventually that Frank was a smart man, interested in art, had a following on the strength of it, and some respect. I know that Frank thought a lot of Pollock's work.

All of them gossiped about Pollock, but I don't think they ever dreamed that there could be any, you know, rapport. I think he had that old-fashioned thing—like, he was a *guy* guy. I have a feeling that in any army barracks he could sit back and there'd be ten guys standing around with their cocks out jerking off, but they're talking about *women*. But today you can come along and think, "Look, they're exposing themselves to each other, exposing their genitals to other men." To say that's gay is, I think, really very fancy.

Tennessee Williams met Jackson in Provincetown and found him attractive, which may have given rise to the theory that Williams's *In the Bar of the Tokyo Hotel* is based on Jackson.

FRITZ BULTMAN: Tennessee saw him as Hart Crane with those elements of self-destruction. But the hatred of gays isn't true; I think it was almost—almost a mask with him, part of the macho thing. Certainly there was a dormant gay quality and he resented it in himself—he didn't know how to handle it. There was such a confusion in Jackson, I think it's probably true that he came close to being asexual.

NICHOLAS CARONE: I don't think Jackson was secure sexually, in that he was like Hemingway—something wrong with the macho act.

BEN HELLER: I don't think Jackson had a very satisfactory sex life.

BERTON ROUECHÉ: My feeling was that he had no strong sex drive at all.

ELAINE DE KOONING: Anyone like Jackson or David Smith, anyone who tries too hard—it's like people in the Village that beat up gays because they have to act macho. Oh, I definitely feel there was a latency there.

WILLEM DE KOONING: *No!* The suggestion that he was gay is crazy! We used to kiss each other drunk, roughhouse, but he never was not knowing the difference between a friend and a gay. It's the most bizarre idea I ever heard in my life! Do you understand what I mean? If he was, he couldn't *paint* the way he did.

REUBEN KADISH: Jackson cultivated all ends of his personality. He was a different man on different occasions for himself, and he was a different man for different people.

I didn't get the feeling Jackson's not working bothered him financially, for as he pointed out more than once, hard work had little to do with bringing in money, unlike our driveway jobs. When we were trying salt stabilizing instead of oil or blacktopping to make driveways look rural, he argued rightly it wouldn't go over: The people coming to the Hamptons now liked the status of blacktop, just as they kept lights on all night for reassurance.

CILE DOWNS: Jackson and I had a little project generating, all part of trying to get him working again. I had been in the print shop at Iowa, and he said, "I might—just might—set up a print shop here." For a while we talked of where and how we could do it, and when we'd be able to get a press and so on. I thought it would be such fun to work with him on prints because I would be in charge of the technique and he'd be in charge of doing some work—maybe he'd really get to work then.

Lee was not in this at all—never said anything—and of course things never started to happen; they were forgotten almost as soon as they were said. It's hard to say how sober he was during these meetings.

PATSY SOUTHGATE: Jackson felt he didn't deserve things and he didn't want to trouble the big boys—dealers, shrinks, collectors. It was like his being unable to call Sam Kootz for his money, or Sidney Janis. It was as though it was their money, not his. Janis had him on this shoe-string allowance and Jackson would tremble—had to get very drunk—to call him and ask for some money. It was sort of like troubling Dad, you know, for his allowance.

There is some confusion about the next fracture—or fractures—Jackson suffered, but it was most likely in February 1955. I remember a full cast and Jackson saying that he wished it were "only my joints and shit that get busted."

JOHN COLE: They used to have wild games of touch football at Zog's and at Bill de Kooning's when he bought a house across from Green River Cemetery. They tried to get me to play but I said, "You guys are crazy to play that rough." Jackson got a full cast and crutches out of it.

CILE DOWNS: We never knew what to do when he became aggressive, except not to respond in kind. Then he'd get sort of hurt and we'd have to be sympathetic with him. He used to like to roughhouse with Sherry [her husband, Sheridan Lord], only it would change into wrestling. This time Sherry didn't want to, but Jackson did and promptly fell on the floor, saying, "I broke my ankle." Lee had been trying to get him not to, and he knew his bones were brittle . . . It was such a dumb thing to do, I wasn't even sorry for him.

In the spring our new angle dozer was delivered, and although Jackson wouldn't give it a try—he never did more than sit on any of our rigs, actually—he said it was just what was needed to make a berm [a bank] along Fireplace Road to give him privacy and cut down on the noise of cars which was beginning to be noticeable. "If we make it high enough and flatten out the top, I can plant things up there and take walks at dusk." I explained that if we built it as high as he'd like, it would mean moving the house back to make room; and besides, he'd have no breeze in summer. Next he wanted a white board fence such as the Farm had so his place would look wider, until shown the expense and maintenance it would mean. Finally he settled for a post and rail fence and we gave him our quantity discount on the material, and it is still there if a little shaky. When we worked for Jackson he always worried about holding us up for payment.

It was rare for him to see a film, even rarer to sit through one. But once he returned from the City with a strong reaction to some Alcatraz footage: "Those poor bastards know why they're jailed, and can see and touch all the shit holding them in. But a guy cornered in a cell—he can't see or touch, only feel, he's a prisoner in solitary where there *isn't* any prison." I was able to pick up only that he was desperate, much too near tears, and in need of what I couldn't guess.

DR. VIOLET DELASZLO: I was working with someone and he just appeared—no appointment or call. We met in another room and I sensed that he was seeking out friends in his despair. I remembered his black and white paintings at the Parsons show and their foreboding of death; also that I had asked him where he would go in his work now and he didn't know.

He wanted to come back into therapy and I would have liked another chance to help him, but we left that open. It would have depended on his frame of mind and, most certainly, first making an appointment. This was an interruption. Also, on this visit he was quite drunk and tried to make advances.

ISAMU NOGUCHI: I am prone to Jackson's attitude, what he considered himself: just a fluke. The role of the Great Man, maybe even the return of the image—I think he was forced into these by Lee. I understand that dependence, but he never talked about his pre-Benton life, nothing. We just knew he came from the West and was this golden boy—a new American myth riding out of the sunset, a phenomenal hero but a tragic hero. Then he had to go, that's all . . . cowboy has to go.

CHAPTER TEN
"OFF THE EDGE"

As the winter of 1955 gave way to spring, Jackson said it was nothing to him. "I've gone dead inside, like one of your diesels on a cold morning. I need a booster for the self-starter to get me turning over—a sex-starter, so my sap will flow." On my telling him that a pretty girl would take care of that, he nodded. "A girl to crank me up . . . I'm the guy knows where." He needed more than that and more than the Braiders' House of Books & Music, where he spent much time over coffee.

DONALD KENNEDY: When he walked into the store, no matter how crowded, you always felt a presence—it was as if he were glowing. Lee was always aloof—she just couldn't see you—I said maybe a dozen words to her my whole life. But with Jackson I felt a *person*. I only worked there after school and he just saw me so he could have someone to do something with. He'd say, "Come on, Don, we'll do some drawing together."

We'd go to a beach and then I'd go off to draw and he'd go off to draw. Then we'd look at the drawings and he'd say, "Put the statement down on the paper, don't worry it." Or, "You're overcrowding the areas—be more free. If you want to work in color"—I used to work in pastel a lot— "blend the colors together." He let me look at his work but never talked about it. And he never talked about composition; he was solely interested in how crisp and clean the work could be. He never used color; it was ink or charcoal on paper, maybe Conté crayon. He loved to draw and he was a terrific draftsman. It always felt so easy, being with him—I was comfortable, and he was gentle but imposing like a Brahmin. Of course, a kid didn't pose any threat or challenge to him, but he was a human being who cared.

• • •

Kennedy explains that in summer when he wasn't at school he saw Jackson in the mornings and he was more lucid. I recall Jackson wasn't always lucid even then. "The way it is now, I drink and not know I have. . . . Some days when I haven't, it's like I did nothing but."

PATSY SOUTHGATE: He always had one eye on the scene, on the effect he was making. It was like a little boy: "How much can I get away with? I've already thrown the cereal on the floor; now suppose I throw the milk on the floor." There was an innocence, but he was very shrewd in his charm. His charm embarrassed me because it wasn't adult; there was this childishness to it: "Gosh, I'm just a kid, I'm not an artist. So I want special privileges, so give them to me." It was undignified and I wished he wouldn't do it. I don't think he had to do it, but he felt very young, very threatened and vulnerable all the time.

ELIZABETH POLLOCK: His alcoholism was a cowardly ploy, permitting him a violence—physical and verbal—for which he need assume no guilt.

The problem, as Jackson seemed to see it, was with others. Still, a couple of Alcoholics Anonymous meetings in Southampton were tried and at least a taste of Antabuse—"That shit'll start you drinking instead of stopping you"—and a guide to how-not-to's didn't work with his I-don't-have-to's. "I need answers, not orders, and you don't get them at meetings . . . that's for lonelyhearts and mouth runner-offers. They *got* to drink; me, I only drink if I feel like it."

FULLER POTTER: He was too red-hot for AA. He threw everything to the winds, that guy. He couldn't bear slowing down, had to go all the way out, overboard with that flame. Some people just can't put that flame out; Pollock with his "Fuck them!" couldn't take it and lost control. Yet he had a life, and what a mess—frantic, desperate, all the way.

DR. RAPHAEL GRIBITZ: I'd seen him come out of a bender—twenty or thirty cases of beer—and it, with the obscenities, was disgusting. But when he was in remorse, being sorry, *that* was horrible, terrible! I felt I could try a scare tactic with him. I told him what he was doing to himself physically; that was my foot in the door. As a resident at Bellevue I had to go to the alcoholic ward when an alcoholic patient was sick for reasons other than alcoholism, and the alcoholic ward—phew!—in there I saw eighteen Jacksons. I used a technique called the *Schreckheit*—a terror tactic used by the Nazi beasts at Rotterdam—and I'd ask, "What kind of crap are you pulling? What do you mean you've got to go on a

bender—you're full of shit!" And if he was sober, hung over and painting, I'd say, "What the hell's happened—you've been peeing all over yourself for two solid nights! You sonofabitch, your entire bedroom is full of piss—who are you kidding?" He didn't like it, but he took it from me—from Barney Newman, too, but not as well.

There were a few solid people around Jackson then—Jim Brooks, John Little, Hans Hofmann sometimes, his brother Sande once in a while—and they lent a note of sobriety. But the others, lots of them were very questionable characters; he was saturated with satellites who either bordered on charlatans and knew nothing of medicine, or who felt that drinking aided his psyche so he could be more creative. They were as damnable a bunch of bastards as I have seen.

ROBERT MOTHERWELL: The alcoholism was essential: It let him pull out all the stops. It is not unlike racing cars, which you brake and drive in entirely different ways than an ordinary car. Without the alcohol there might not be the work.

ISAMU NOGUCHI: Jackson told me he couldn't do this weird poured work unless he had been drinking and listened to jazz—perhaps not his exact words. He was very lucid as to why he had to drink: It was to overcome the blockage or whatever it was.

CLEMENT GREENBERG: Look, I felt sorry for him being an alcoholic and sorry for him being married to Lee, but I've never known an alcoholic I didn't like. I've never known one that didn't have *something* in him. He told me that he had tried to paint when drunk way back and decided it was no good. But I did watch him painting drunk once—that birthday card for me, a pen and ink gouache [1951]. It's the only thing he ever did drunk that he saved; from then on, he was religious about that—wouldn't touch liquor and a canvas.

CILE DOWNS: I was with Lee when she bought the goodies for months—and he drank phenomenal amounts of beer. It was horrible, I couldn't see how she did it—you know, clunk down that quart of whiskey—but she explained that it would be much worse if he got in the car; she was scared to death every time he went out in the car. She didn't know if he would kill himself, she didn't know who he was going to see.

Spring brought nothing positive for Jackson and his lethargy deepened.

DORE ASHTON: There was a Mark Tobey show at the Marian Willard Gallery. When I came into the gallery, I saw a man in a very long overcoat with the collar up—it was spring and not cold. I watched this

person who looked familiar, watched how seriously he looked at the paintings. When he moved, I saw that it was Jackson. I was shocked because he looked awfully thin and had big black circles under his eyes. He and I sat down and we talked quietly about the paintings, Oriental art and Tobey's interest in it. He admired the work, was very respectful. But the whole time he sat there in his overcoat with the collar turned up yet it wasn't cold. I was feeling sad and—I felt very alarmed. He looked a desperate man.

ROBERT MOTHERWELL: I had invited de Kooning and Kline and maybe sixty others to a party at my Upper East Side townhouse. I knew that there was an effort to replace Pollock with them and he wasn't asked; I didn't want him to get wildly drunk and disrupt everything. Then, after all the people were there, to my astonishment the doorbell rang. Pollock was standing sort of sheepishly and asked if he could come in. I don't think he was with Lee.

He was absolutely sober. De Kooning and Kline were high, and the two of them began to taunt Pollock meanly as a has-been, etc. He had every right to get drunk or to slug them, but in fact he just took it. Obviously, he had made up his mind to keep his cool and after a while he left. The party went on until I don't know when, but I couldn't believe Kline. It was the only time I ever saw him like that; it wasn't only kidding but profoundly aggressive. I don't know whether it was de Kooning egging him on or . . . strange way to see Pollock for the last time.

LEO LERMAN: I was in the Madison Avenue Schrafft's, not feeling well at all. Jackson was there that night—mostly at ten there were AA members—and he was with a group of people whom he left to come over to me. His concern for me was remarkable, as we weren't close. He went into a harangue about the approach to health through natural foods and healthy living—salts, minerals, and so on. He wouldn't sit but didn't seem drunk, and I remember I was eating one of Schrafft's fudge sundaes with lots of whipped cream. He didn't mention that, standing all this time by the table, but he was asking questions to do with my illness. It was a kindness, and he was so gentle—persistent but sweet. I was touched that night, and I like remembering the incongruity of Pollock being so nice in Schrafft's.

Clement Greenberg's classic piece in the spring issue of *Partisan Review* hit Jackson hard and was celebrated by his detractors as vigorously as it was condemned by his supporters. Greenberg, who had reviewed neither the '52 nor the '54 show, now wrote of the latter that it was the first show that had pictures so forced, and that while the color was pleasant, it was because Pollock wasn't sure how to handle it. While crediting him

with two or three fine works in it, Greenberg added that the black and white show marked Pollock's peak. He then credited Clyfford Still with liberating abstract painting in a way that Pollock had not managed, and in so doing he had avoided the decorative quality of Rothko and Newman. Jackson's reaction was mild, partly because he had expected it. Lee was outraged.

My inept questioning of Jackson as to what he was really doing in his work brought the annoyed response it deserved. "You don't go around asking huge questions like that, goddammit. If you don't get it, crissake, just forget about ever writing and go on making love to your bulldozers." He was angry at more than my obtuseness, of course, but my asking next how he saw himself didn't help at all. "Shit! All I am is my art."

CONSTANTINE NIVOLA: The whole idea with those of that period was you *do* it; you do not talk because of the release of the subconscious. It was something new, this kind of automatic painting; the Surrealists had not worked this way. The French would say of de Kooning, "As painting, we can recognize this." Of Pollock, *"This* is not painting! Only in America could it happen."

NICHOLAS CARONE: Jackson going around in his paint-spattered jeans was a hippie before hippies were, and historically it's important: It let artists project themselves, which is what you have to do now to make it. There came a climate of search for the philosopher's stone, a form of gold rush with everybody staking their claim without knowing what they were after.

PAUL BRACH: It occurred to us younger painters that the Abstract Expressionist style was not our invention but a gift from our elders and that we'd had a nice ride. We, the sons of Red Army generals who'd gone into and out of the Benton school, inherited a successful revolution. The metaphor is Second Generation Bolshevik.

WILLIAM KING: In Abstract Expressionism there was nothing going on except high-voltage rivalry like with movie stars. Art should produce pleasure and it isn't there—wasn't in them either, the way they looked so unhappy. Commercialism killed most of the modern painters, thanks to the careerist critics and dealers. They should be ashamed of what they did to Pollock, though, devouring him to the last morsel. He was a wounded leviathan in a school of piranhas.

For some time Lee had been having counseling sessions with a psychotherapist, Dr. Leonard Siegel, whose approach was akin to the Sullivanian. Jackson also consulted him regarding their marriage, and in early

summer he was considering therapy with another practitioner of an offshoot of the Sullivanian approach, Dr. Ralph Klein. However, Jackson still had faith in the Jungian approach.

DR. WAYNE BAKER: He would ask questions along the lines of, "Is any therapy apt to do what everybody thinks it can do?" I got the feeling that this guy was too serious for any of the ritualistic things to work well. If you define intelligence as the ability to see or to hold two or more contradictory ideas at the same time, Jackson was very intelligent. But if you then define wisdom as the ability to do something about those contradictions—put them away, resolve them—then he didn't strike me as having a great deal of operational wisdom. If one had to give a general impression of Jackson, I would say he was depressed. Other than with the hermit crab allusion, there was none of the schizoid here, to use labels.

Obviously, if somebody says repeatedly, "I'm no damn good," and so on, you're working with what in the jargon is called a narcissistic problem, if thought is disturbed by this preoccupation and self-concern in a schizophrenic way. If it's the feelings that are concerned, you're dealing with a depressive. But I avoided saying the kinds of things I would with a patient in sessions, so what I ended up doing was just offering Jackson a sporadic, very low-key friendship, sharing the space and the time, without trying to do much about things.

DR. FRANK SEIXAS: You were right there, in at the depths with Jackson. But, you know, I don't think he was just neurotic; I think he was a lot sicker than that. He had some big problems.

DR. RAPHAEL GRIBITZ: He was in agony, tortured, and headed for disaster, and my theory is that Lee should have been tougher with him. But she took so much guff—what she took from him! I suppose she just gave in to the terrible medical treatment that he got.

RONALD STEIN: Lee was not into medical doctors—orange juice, carrot juice, and analysis is not a cure for alcoholism. If she had been properly dealt with medically, she wouldn't later have refused to take cortisone for her arthritis because it might be bad for her health; yet here was a woman dying because she couldn't move. And her colitis—that's in the family and probably psychosomatic, only they would go to doctors who would prescribe corrective medication and it would disappear. But Lee? She would go to witch doctors.

Summer was barely begun before Jackson was complaining about the loss of winter quiet and how hard "from away" people made things. "Between the way they creep along the roads as if they didn't know what

a throttle's for, and gawking at us on Coast Guard Beach and Louse Point . . . what I'd really like is a dry well to live in down at the bottom, have it always night so there'd be no light to look up at. You could lower me down on a crane hook, then cover the opening with brush so the wellhead wouldn't show."

Jackson decided to work with Dr. Ralph Klein at this time, but the sessions were largely exploratory on both sides and were interrupted by Dr. Klein's regular vacation. "The good thing about this guy Klein is he's so young, he isn't full of old-time shit. He's open to the psyche and doesn't know it all, so he can learn." But Jackson was not open to the psyche or much else. His depression and anxiety, together with his not having painted lately, made for a case with a dim prognosis.

PATSY SOUTHGATE: I recall how Klein thought he could understand Jackson, but I don't think he understood him in the slightest; he was a callow youth. Jackson was in despair and doing a lot of weeping, which I never minded except when I felt they were sort of crocodile tears and he'd be peeking through his fingers to see if you noticed him.

If a beloved of mine needs treatment I'm always anxious for them to have the best, but here was Jackson talking about this thirty-year-old sort of nonregulation shrink. I mean, why didn't anybody say, "Hey, wait a minute—how about a second opinion?" My guess is that like with his dealers, Jackson didn't think he deserved the best. So he ends up with this younger guy who was nonthreatening.

In July Jackson received a passport in which he is described as being now an inch taller, 5'11". It was applied for in the hope that Lee and he might go to Europe, but I didn't give the venture much of a chance. Jackson felt safe, or as safe as he could, in Springs.

CONRAD MARCA-RELLI: He had respect for the ancient world, wasn't the kind of revolutionary we have today who speaks as if it's all crap to be forgotten. He loved Picasso, Matisse—from Piero della Francesca to the Renaissance painters—and Morandi. But three weeks before we were to sail he told me, "I can't take a chance. I'm worried that if I get drunk there's no one there to help me." He had this fear of not speaking the language and getting in trouble—he knew he was going to get in trouble at some point, drinking so much. Years back Europeans would say to me, "Oh, you know Pollock? How I'd love a conversation with him." You can imagine their conversing with Jackson: All four-letter words and that would be the end of it.

NICHOLAS CARONE: He was very conscious of being an American phenomenon. That's why he never wanted to touch Europe because

that would taint his image of coming from a tradition that was wholly American.

MILTON RESNICK: I told him I didn't know what he'd do there, that I wouldn't go if I were him. Then he said this: "I have to get away. I hate art—I hate it. And I hate all the people."

In August, when we used to joke about midsummer madness, Jackson said how lucky I was to go to the beach only for bulkheading and bulldozing jobs. "If I don't show, they wonder what's wrong. If I do, they know." He meant the bloated condition he was in due to much drinking and little eating.

BEN HELLER: He was like a big bear in the surf, a big burly bear, and when it was difficult I'd kind of hover over him. He couldn't swim and I'd pull him out, assist him.

B. H. FRIEDMAN: One evening when we were walking the ocean beach I had to unwind. I plunged in and Jackson, saying something to the effect of "If you can, I can," followed. There was quite a strong undertow and I saw him being beaten by the waves. I thought he might drown. I don't think he could dive breakers—his splashing was more like a dog swimming, with a lot of thrashing around. I got out as fast as I could. Which meant *he* had permission to get out, you know?

The beach was a place he loved, and I remember his staring at the formations of the water—you know, the way it would soak into the sand. And I remember him letting the sand run through his fingers, and of his loving the landscape there. I asked if Melville didn't mean a lot to him because of Ahab and the *Moby Dick* interest. I suspected he had never read it—that it was something that had been assigned and he talked about after maybe reading a little bit. If Jackson had been on a talk show such as we have today, Cavett saying, "What are your favorite books?" Jackson might say *Moby Dick*. But I don't really know how much it meant to him.

The change from summer to fall brought change in Jackson. He said that now with the crowds moving back to the City, he'd be able to get some work done. He had decided to continue with Dr. Klein and this time he was going to stay with therapy until *he* decided he was "clear." By then people around would have gotten used to another Jackson Pollock, "Not a new one, the real one. It's my last chance."

We were in the stable yard, where I was unsuccessfully watering a broken down gelding with a founder I had saved from the horse butcher. Jackson said something about this being a gift horse with a mouth you

couldn't even open, a line as lame as the foreleg I was feeling. "Really go for cripples, don't you?" He was looking at Jimmy in the stable door; that Jimmy had to have heard angered me. I straightened to look at Jackson, wondering if the time hadn't come to say he could find better suckers to work over. There was nothing anyone could say.

On his trips to the City for sessions, Jackson would go to the Cedar, providing himself highs to counterbalance the lows involved in therapy.

BEN HELLER: I'd hear from him sometimes Monday afternoon, so we spent a lot of those nights together. Going into Tuesday he'd be drunk and I'd take him somewhere to try to sober him up, talk to him or whatever. It interfered a bit with business and it sure as hell interfered with private life. The phone would ring, then you'd hear a low voice, "Ben . . ."

At one particularly painful time I pointed out to Jackson that Schoenberg had stopped composing for ten years and two or three years for a painter was nothing compared to that. I guess Jackson drew some modest comfort from that, but he was miserable, miserable, miserable . . . He was a good poker player though—oh man, a terrific poker player! He would bluff, he would dare, he would stare you down, and he was tough to read. He didn't give a shit.

LEO CASTELLI: He came to see me one day in very bad shape; he said he couldn't paint anymore. Then he sat in front of *Scent* for a long time, looking at it and looking at it. *Scent* wasn't dipped but painted by brush [c. 1953–1955, possibly his last work]. I saw him feeling terrible; it was indicating that he couldn't paint anymore, that this really was something he could no longer do. He was so *very* disturbed.

EMILY TREMAINE: Janis arranged our visit to him and Jackson was really so gentle and polite. I'd heard these horrendous tales of his drinking bouts, so I thought he must *really* be on the wagon. He had no beard, I'm sure, because I hate beards so, and I remember thinking it's too bad he's an alcoholic because if we go out again he may not be so nice. We were so involved in the pictures, we don't seem to be able to remember if *she* was there.

I wanted to have about three pictures that day, but he showed us so many it was difficult to choose. He brought them into the house, though I wish we could have been in the studio so I could have seen some of the larger things I got involved with later. I took a lot of numbers and told him we'd get back to him, but in Europe I remembered we had forgotten to call him. Then one thing led to another, and by the time we said we simply *must* call him, he was dead.

P A U L B R A C H: At the end my wife and I knew they were in real trouble. Lee was saying, in effect, you better straighten out or . . . She was into suffering—"What I put up with from this man!"—and he was into being bad. I sensed there was something very strong holding them together, but the situation was too loaded for tenderness. Lee, the way I tuned into them, was trading on the trajectory of his fame, although not admitting to herself how much she was putting her own work and self aside from his. She lived those last years in fear of his self-destructive forces, and she was right to be afraid that he would destroy himself. There was so much anxiety in their air, any tenderness would have to be too loaded.

In his loyalty to old friends, Jackson did a good turn for Philip Guston by persuading Sidney Janis to take him on. Janis had known Guston's work earlier, but the new large work praised by Jackson made Janis decide to give him a show the following year. In part it led to Guston appearing at MOMA's exhibition *Twelve Americans*. This was a real service for a fellow painter, though it did not fully compensate for Pollock's having torn Guston's work off the walls of the Charles Egan Gallery in 1952, not to mention his having tried to push him out a window after Guston's opening at Janis.

From November 28 through December 31, 1955, Janis held what turned out to be the last show in his lifetime: *Fifteen Years of Jackson Pollock*. Jackson was ambivalent about it, but Lee was for it, I remember. At least one doubter worried that the few examples of current work, smaller than his classic period, suggested Jackson wasn't sure if he should stay with pouring or go into brushwork. But *Search* now is considered superb, and *White Light*—almost called *White Lightning* until it was pointed out to Jackson that's the name for sweet mash whiskey in the Smokies—has a shimmering magic. The critics mentioned no recent work and their reviews had a past-tense sound to them.

As 1955 came to a close, Jackson reported a dream about that well he'd described in the summer. "Down in it everything was dark and quiet, just the way I wanted. Then the sand walls started running, a cave-in, but I wasn't buried, just out in the open with all the darkness and quiet that ever was."

W I L L I A M K I N G: Pollock singlehandedly destroyed American art and in doing it he painted himself into a corner. I guess he must have felt like a freak, but even if he didn't, he still had to croak.

Jackson resented the arrival of the new year. "Goddammit, I'm not through fucking up the old one yet." There were references to that corner crowding him more and more, and now when he talked, his arms

seemed to thrash about as if he were trying to fight himself out of it. But the fighting was really against himself.

CLEMENT GREENBERG: It was Jackson's horror of violence that made him flirt with it. One time in the Village we were with Paul Jenkins and some people and I told Jackson, who was tight, that he'd have to shape up. He grabbed me and pushed me up against a van. He pulled his arm back, closed his fist—the way you see tough guys do in the movies. That was all there was to it, except I still remember the cracks in the sidewalk I stared at while waiting. Paul said later, "God, you didn't seem to think anything was going to happen." I knew Jackson and I knew nothing was going to happen.

But with horror of violence was horror of being hurt. When he and Lee were staying near me at Bank and Hudson Streets, Jackson showed up horrified because he'd run into a cop—staggering—and the cop must have been frightened of his size and the dark, so he beat him across the calves with his nightstick. This was violence, and Jackson kept saying, "But he *beat* me across the calves!" It was like at the Cedar and other places: Every so often you'd have to jump in and say to the bouncer, "Look—this guy doesn't mean anything."

REUBEN KADISH: We were in the Cedar, and while I was having a drink he had double shots of scotch. I was thinking how many doubles can you keep drinking when he grabbed me by the throat and dragged me outside. Then he started punching me and finally hit me in the face—a full-fledged punch in the face. I pushed him against a car and he started to cry.

February brought the famous attack in *Time* on "The Wild Ones"—de Kooning, Motherwell, Rothko, Guston, and others in addition to Jackson. This piece also saw the birth of the "Jack the Dripper" phrase which caused Jackson to spend days of saying "shit" and Lee to utter outraged shrieks.

BEN HELLER: We were in a 52nd Street bar and decided to go down to the Cedar, he was getting so difficult and we were getting so nervous. On the way out, he said something to a guy and the guy knocked him off his feet. We had to pick up Jackson and haul him out.

At the Cedar we were standing with our drinks at the bar and Jackson, feeling all this anger, punched me in the arm halfway between the shoulder and the elbow, that nice muscle spot. He would keep hitting me there, and finally we took him to a place on the corner of 8th Street for coffee and he did some more punching on my arm every so often. They were pretty strong punches, and I tell you my arms were *sore*.

• • •

Jackson's half smile turned up once again in February when he re-
minded me that the previous spring he'd been worried about his sap not
flowing. He went on to say that I wouldn't believe what he had come up
with, it was so much better than a self-starter. He described it by using
terms popular in used car ads: "cream puff," "late model," "barely bro-
ken in," "loaded with extras." On my saying it sounded even better than
his Olds, he added his new model was faster, too—a lot faster; she'd been
a Seventh Avenue model, sort of an art student. It was then that I
learned we were talking about something more dangerous for him than
wheels.

Almost as many people claim they introduced Ruth Kligman to Jack-
son as there are people who claim they knew him intimately. In her *Love
Affair: A Memoir of Jackson Pollock*, Ruth says she was with a painter at the
Cedar when Jackson first came over.

AUDREY FLACK: Ruth Kligman was from New Jersey and was
working at the Collector's Gallery. She wanted to organize a show, and
liked my work very much. She had a good eye, and was beautiful, nurtur-
ing and comforting—and very bourgeois. I was the first person Ruth
had met in the *real* art world and she wanted me to teach her how to
paint. She wanted to meet important artists, but she'd never heard of
Jackson Pollock, Franz Kline, or Bill de Kooning. She wrote their names
down on a little piece of paper and I drew her a map of how to get to the
Cedar; I was through with the place. She asked which one was the most
important and I said Pollock; that's why she started with him. She went
right to the bar and made a beeline for Pollock. Ruth had a desperation
and a need.

I didn't meet Ruth until early in the summer of 1956, When she and
Jackson, in the Olds with the top down, stopped by the white fence in
front of the Farm. I remember nothing of what was said—not much was,
probably—but I do remember his grin, his arm around her and the
finger with the missing tip caressing her shoulder bare above the halter. I
saw what he meant about "loaded with extras."

JAMES BROOKS: He was having a hell of a time, just desperate for
companionship, and Lee was pretty good at bringing him down; she
could corner him. When we met Ruth, he was self-conscious—about
Lee, about her too—and we liked her. He felt good about her,—you
know, a pretty, voluptuous gal, thinking he was the greatest man in the
world, and in love.

The reports Jackson delivered from the Cedar that spring sounded
forced, with no mention of love but a lot about sex. "I know I've talked
about a last chance, but this is the really last chance, goddammit!"

NICHOLAS CARONE: He showed me a snapshot of Ruth and asked what I thought—he was like a child. The taste of some American artists in women is something! In Italy artists marry the most beautiful women, but here it's witches.

LARRY RIVERS: Ruth was pretty, I guess. Even at his age of forty-four, you can drink a lot, be out of it and everything like that, and still get it up, right?

DAVID BUDD: She was still practically a teenager, and she had on a red dress with a silver fox. I thought, "Oh, *well*! *That* could drive someone over the wall."

WILLEM DE KOONING: She must have cared for him a lot—kind of cared for me too, later. She meant it but not like, you know, a great passion or anything like that. She was starting to paint and she wasn't stupid about it either—did some nice things, wasn't bad at all. She *could* have become a painter but nobody takes a person very seriously when they're just starting to paint, particularly if it's a woman.

During this last spring for Jackson, Carone had been urging him to see Samuel Beckett's *Waiting For Godot.* Having seen it early in its run, I avoided mentioning it in order to spare Jackson what I knew would be its enormous impact.

NICHOLAS CARONE: This was a new experience, touching on areas we cannot figure out, cannot name. I was really impressed, but Jackson wasn't interested. I kept after him, telling him this writer had something I didn't think even existed, and at last I talked him into it. He says, "Okay, I went to that play. Only I couldn't take it. I walked out."

But Jackson went back to *Godot,* once with Ruth Kligman and then by himself to part of a matinee. He told me that he had promised to have three tries at sticking it out but still couldn't. "I felt my guts being pulled out backwards every time. Like one of those births they have to drag you out, cut you out." Ruth writes that he wept openly during the performance they attended, until his loud moans forced her to drag him out.

PATSY SOUTHGATE: Jackson said he could barely mention *Godot* to Ralph Klein without weeping. Jackson cried a lot by then—burst into tears at the drop of a hat. With this there was the anguish of thinking Klein hadn't understood the point he was trying to make about how he felt about *Waiting for Godot.* He said how young Ralph Klein was and how could he possibly understand Jackson; and I don't think he did understand him.

That, Jackson told me, was what he talked about in his sessions, movies and plays—in terms, I guess, of his despair and why he was always weeping. He thought *Godot* expressed his despair, that it was the most brilliant play of our time. He identified very closely with being the bum with bum's clothes—no money, nothing to eat but a carrot and a turnip, always waiting for Godot and Godot never shows up.

JAMES BROOKS: Jackson was talking about going back to the Bowery and staying there. He had a fantasy of going back down and just being a bum, of getting away from all this responsibility and just—just not fighting anymore and not trying to live anymore.

Ruth wrote that her therapist advised her to end the affair after having death dreams about Jackson, but that Jackson's advised him the relationship was valid. Actually, Jackson was no longer capable of a valid relationship with anyone. The only thing he could relate to was the very one he should have been frightened of instead of Ruth: cars. It didn't take a therapist to be worried by his driving and to wonder how he kept his car on the road.

Ruth's book goes on to say that she went to a job with the Rattner School of Art in Sag Harbor as a monitor and had not realized how close it was to East Hampton. She was barely unpacked before Jackson was on the phone; then, on that, her first day on the South Fork, she and Jackson were in the Olds off to the Elm Tree Inn in Amagansett. He was sober and in clean clothes; the Olds gave him another dimension, and his taking the wheel was like taking command.

PROFESSOR REGINALD ISAACS: When we arrived in June he was consistently inebriated—very fuzzy. On one occasion he wouldn't come to the table, on another he left it. He drank White Horse now and I couldn't keep up with him. The plan had been for him to paint a family portrait, but he was too involved with the bottle.

We walked on the beach, and in earlier visits I used to wrestle with him. He was bigger than I, and I thought it a great accomplishment when I could stay on my feet. This visit he was very corpulent—I felt something was really wrong—and I did something to him emotionally by throwing him on the soft sand. He had mellowed a bit, talking less about how much he disliked French painters, which in the early days was a constant theme—how they were gaining fame with derivative and shoddy work.

On the third day we realized and he realized that he couldn't paint the portrait. He had intended a lifelike portrait, his impression of us. But he didn't even go through the preliminaries. He said, "Stop here on the way back in the fall. Then I'll really be in shape to paint."

PATSY SOUTHGATE: We talked a lot about Ruth and we talked a lot about Lee; he was very excited about Ruth and terribly afraid of Lee,

desperately afraid of Lee. He felt Ruth was the exact opposite of me and he used to say that all the time—that he loved me as a friend and he loved Ruth very much. I was also in his mind associated with being a friend of Lee's, so I represented the kaput side. He viewed the whole thing as an amazing adventure; he wondered if he could pull it off with Lee, keep Ruth going along. Like a little boy, his dream was to have both.

Ruth felt she had been sent onto this earth to help Jackson enjoy things and she thought she was the only person who could do that. She was terribly young, you know, but I think she was sincere about him. As to her being accused of being with others, she wouldn't consider anyone else.

MAY TABAK: Jackson never behaved like a lover with her; I'm not sure that he could. Even if you're not a drunk it doesn't work like that.

PETER BLAKE: One thing highly dubious in her book is the claim that Jackson practically raped her blind drunk. I don't see how he could rape anybody blind drunk because he would fall on a couch, lie there, and snore.

CAROL BRAIDER: If an "art bobby-soxer" hadn't gotten him in New York, now that summer was here, a chippy would have in East Hampton. As for the "Lee doesn't understand me" line he handed out, most of us would say, "Oh fuck off, Jackson!"

NICHOLAS CARONE: I saw them together a few times and it was not intimate, not romantic—just being together. I was very close to Rothko before his suicide, saw him painting his last pictures which nobody knows how they were done. I saw him drunk, drinking out of the bottle, and painting with his pants down and his ass showing—painting without looking at the canvas, painting with his left hand. He was painting black pictures we haven't seen yet, but they'll spring them on us, you watch.

There are parallels in that they both were dying here; this country will kill you, but at that age a man should be getting alive. I saw that killing of Pollock and of Rothko. I told Rothko not to worry about the affair he was having because he felt so guilty; he'd thought he couldn't get it up anymore and told me, "I found out I'm a lover." I said, "Then don't carry it around like a weight, enjoy it. Go rent a villa for the girl, have a good time, fuck her ass off—replenish yourself. The Europeans, the Matisses, they were getting energy from their lives in their *old* age, and you— you're worrying about guilt and about the million dollars you made. It'll kill you.

PATSY SOUTHGATE: When our New York trips coincided, Jackson and I would take the train together to or from the City. It was like I

was put in charge by Lee of getting Jackson out of Pennsylvania Station where there was a bar he used to hang out at. It was a matter of getting him on the train; then there would be a lot of talking all the way to East Hampton. He never wept on the train going in—he was always frightened then—but coming out there would be tears, and I felt it was genuine when he wasn't drunk. The therapy situation was very frustrating for him, the not being understood or thinking he wasn't. He had a complete transference with Klein and as with all transferences, a sort of godlike quality was attributed to him. I would think, "Lord, I hope this guy realizes what he's doing and what's brewing inside Jackson's head." It was very touching to have Jackson attribute godlike qualities to what I thought might be a very mediocre shrink.

In June Jackson was doing a lot of planning about the Fireplace Road property. A building he had earlier moved onto the land was to be a house for Lee; the original plan had been for it to be her studio—and a small dairy building would be a studio for Ruth. She, Jackson decided, was going to surprise Lee with her talent "once the dust settles. Right now it's pretty dusty." His main worry seemed to be about the dogs; who was to have which. In this Ruth was no problem, having a white kitten which Jackson didn't take to. He said that if he still had Caw-Caw there sure wouldn't be any white kitten.

In May he had been notified by the Museum of Modern Art that twenty-five of his major works would inaugurate a series called "Work in Progress," raising his hopes. He told me that he had a lot of money plans so that Lee would be provided for in her old age—not far off either, he gave me to understand—and a lot would be for Ruth because she'd never had nice things or a real chance. "You can stick that last-chance shit I said. There's going to be chances for all of us, lots of them."

But when I saw him with other people—usually now not with Lee—there was a sodden air about him: His mouth seemed always wet from the last sip and the eyes about to produce tears. It made me wonder how he expected to "get in real shape for Ruth. She's never seen the real me."

According to Ruth's book, his mornings after being with her were terror-filled due to having to face Lee. But one Sunday night, Ruth writes, a new fear was born: Lee, outraged by their having spent the night in Jackson's studio, demanded that he decide between them. Then, since Jackson couldn't make decisions, Lee did—several of them. She was going to Europe in three days; he would not see Ruth in the meantime; she, Lee, would give herself time to consider the situation until her return in three weeks or so; Jackson would too, in addition to cutting the shit—"yours and hers both," as he told me later. But things, as they did

lately with Jackson, took care of themselves, starting with Ruth moving into the Fireplace Road house the afternoon Lee left.

One of the first things Ruth noticed on her tour of inspection was a mound of big stones in the backyard. The pile still there is smaller than the one Jackson directed us to place when he hired our tractor shovel to follow him around the field. He had walked in front of the rig, and each time he pointed down there would be a stone invisible from the surface. It was uncanny, a form of stone dowsing. At the end of the day the operator asked Jackson what he wanted a pile of such big stones for. Jackson said he'd show him and climbed to the top of the pile. Then he urinated at the sunset.

Jackson was becoming increasingly cut off from his friends. Things had been growing distant enough before he moved Ruth into Fireplace Road, but by that action—which was widely seen as his forcing Lee out—he shattered many people's sense of loyalty. Much of Ruth and Jackson's time together seems to have swung back and forth between tears and rage, interspersed with explanations and apologies. Ruth's fears began to equal Jackson's in intensity: She was afraid of what would happen to her, particularly on Lee's return. Jackson was afraid of what *was* happening to him. And some friends were afraid of what was happening to themselves for being in their company.

CHARLOTTE PARK BROOKS: Jackson was pretty tough with Ruth. It was not a good feeling when they came to see us in Montauk; it was a strain. And then, of course, there was his drinking.

CONRAD MARCA-RELLI: We'd been on an informal basis before Ruth moved in—he'd come by to see me and I'd go by to see him—so we went over once. Ruth came downstairs and he was half tight. We stayed ten minutes and left.

CILE DOWNS: I was nice to Ruth for his sake—dinner there, and we took her to the movies. Something about movies disturbed Jackson intensely. Things struck him so heavily emotionally that a movie of any emotional content couldn't be borne. Also, maybe he just wanted to drink; he would leave the film and go out to a bar and meet us afterward.

She was sweet to him and I think he had a real affection for her, but goodness—I couldn't imagine it ever working. At the time, he talked about it being serious, but I don't think it was. He talked about leaving Lee before I ever met Ruth, and I remember Lee saying, "I will *never* give Jackson a divorce." And believe me, we knew about *that*.

I can't imagine Jackson and Ruth being a couple for long, and he was hostile to her—really rude, mean to her—although I never saw any

physical violence. She said, "Why have you turned against me, Jackson?"
The whole situation was intolerable; I mean, Jackson was not a monster
and he must have known he was doing a horrible thing bringing her into
the house. Her clothes were even in Lee's closet. It was an act of his
terrible rage against Lee.

 The problems on Fireplace Road ranged from Ruth's attempt to paint
in Lee's studio to Jackson's anger at a male friend of Ruth's for dropping
in on them. When his friends visited Jackson, some ignored Ruth; nor
did he always remember to introduce her. Ruth also reports that there
were days when he spoke of feeling like a fake; that he was no good, a
fucking phony, a shit. But at another time he said there were really only
three painters: Pollock, Matisse, and Picasso.
 When B. H. Friedman and his wife, Abby, were originally invited to
spend the last weekend in July, they had expected to find Lee.

B. H. FRIEDMAN: Jackson told us rather sheepishly on the phone
about a girl. I don't know what phrase he used, but sort of a "You'll have
to play it by ear, but if you feel uncomfortable about coming . . ." Any-
way, we came. I was rather surprised that Jackson could have taken up
with a woman like this; the image was not East Hampton. She was
dressed up—overdressed and over made-up—and because Jackson was
sleeping a lot and drinking beer so heavily that weekend, we were thrown
into more intimate contact with Ruth than we otherwise would have
been.

ABBY FRIEDMAN: She had an Elizabeth Taylor aspect, also a bit of
a Katherine Grayson look, only of a more voluptuous, feline kind. She
was coquettish, very affectionate.

B. H. FRIEDMAN: By the end of the weekend we had sympathy for
her. She talked in a rather feeling way about Jackson not allowing him-
self pleasure. "I've been talking to him about wanting to travel," she said,
"and about why not, instead of his being in some uncomfortable little
room at the Hotel Earle when he comes to town, get a little *pied à terre*. I
even suggested Park Avenue, but he won't let himself do anything like
that." I think Jackson didn't allow himself much, and in comparison to a
man like Picasso, who handled his career marvelously, Jackson was a
hopeless child. He got no pleasure from what should have been mature
satisfaction for a man who was as big a figure as he was even in his
lifetime.
 I think that there was a puritanical thing about Jackson, and awful as
some of the janitorial jobs in the thirties must have been, there was still a
longing for that as being pure. There was a sense of fear about corrup-

tion by money, fear of corruption by comfort and luxury of any kind. Of course, the phrase *pied à terre* in connection with Jackson Pollock is a strange one and Park Avenue makes it stranger still, but I think with all Ruth's ambitiousness there was a desire to loosen him up, to free him of the puritanical hangups.

Jackson talked to me in a way I hadn't expected about his marriage. I don't think anyone can compare his relationship with Ruth to his relationship with Lee—the shared interest in art and so forth—but he was considering leaving Lee. I said his decision was difficult and he couldn't lightly throw over a relationship of this long a duration.

There was a lot of driving that weekend with the Friedmans—it was a way to see things instead of people, who might not approve of Ruth—and an afternoon tour took them to Dorothy Norman's.

B. H. FRIEDMAN: Jackson was driving just unbelievably recklessly.

ABBY FRIEDMAN: I told him to stop the car—"Either *I* drive or I walk." He was very hurt and suddenly became a teddy bear. He drove very slowly and got us there, but he couldn't cope with going in.

DOROTHY NORMAN: When Jackson earlier came to lunch, he mentioned Ruth and said, "I must solve my dilemma." There was no way to help. At our lunch his rage was tempered, just as in the studio he was secure and in the house insecure. He fainted at that lunch, then in leaving—well, he tried to make an advance. Jackson was a man out of control . . . there is no single word for it—not psychotic, not psychopathic . . . I am in doubt.

Things were at a low point the following weekend, and a letter from Lee in Paris didn't help. Its tone is forgiving, Lee having assumed that Jackson would find Ruth impossible and herself necessary, and her return was scheduled for just after Labor Day. Her being in Paris still was due to Peggy Guggenheim having made it clear that there was not a room to be had in Venice, least of all one of hers.

ELEANOR WARD: I was staying at Nick Carone's when Jackson came and left Ruth there in the front seat, never mentioning her or that she was just sitting out there. Jackson was scared—scared of Ruth, scared of being left alone, just scared to death.

NICHOLAS CARONE: I think he was disillusioned. He went through the act of getting rid of Lee to bring in Ruth with the romantic notion of filling in a moment of his life, an interlude, then realized it was

shit. Also, he realized that he *needed* his wife, so he'd staked all on a move that didn't have any substance. Lee understood the psychotic problems and knew that he was miserable. And she knew that the real value of his work was more important to her than it was to him; he thought that everything had to do with monetary value, but that had nothing to do with it—it was the same with Rothko.

When Clyfford Still wrote Jackson about the *Fifteen Years of Jackson Pollock* show at Janis, he gave Jackson a moral lashing: They were above painting for dealers and Jackson was letting himself be cashed in on, that sort of thing. Clyfford could be brutal, and here were two artists who had set themselves apart from the art world, yet now one had sold out. The letter hurt and it had a lot to do with Jackson's depression that summer—I never saw such weeping.

While Ruth was in New York that last week [her book says she told Jackson she had to see her analyst], we asked him to dinner after he told me he'd seen a wonderful dog hit by a car, a dog that had been hanging around his house a day earlier. He said he'd taken him to the vet and would we take it if it pulled through. I told him I would if he's such a wonderful animal.

Jackson came to see me a couple of days later looking terrible—like a guy ready to drop dead, he was so low. We had invited him to dinner and he said he couldn't, he was so depressed. And he *was* depressed. Then he said, "I really came by to tell you that the dog died and . . . I'm just so *sorry,* I got to go home." That was a dog he didn't really know even. He was in such a classical depression, any doctor would have taken him in. Jackson was ready to die.

DR. RAPHAEL GRIBITZ: I don't know how many times Barney Newman and I put him on the train for East Hampton when he was stoned before *she* moved down there. It was very unpleasant, not so much that he was abusive, but that he didn't want to go back. I knew he was killing himself and I broke it off somehow—I couldn't take it.

CAROL BRAIDER: With Lee gone, at least I didn't think a late-night call might be about Jackson and his shooting his Zen-and-the-Art-of-Archery arrows not into the kitchen wall but into . . .

ALFONSO OSSORIO: Lee and I crossed each other on the Atlantic, she bound for Europe and I returning. I didn't call Jackson because, you know, I thought, "Let's wait and see what happens." And a thousand things had piled up and it was partly because I thought, "God, I don't want to get involved now—let him find himself and then call." It was always Lee and Jackson that Ted and I knew; it was not Jackson alone, and there were enough complications without my pushing into a new relationship.

The last time I saw him was at Penn Station for the East Hampton afternoon train, the Cannonball, and Jackson wasn't really drunk but full of beer. It was difficult for him to get down the stairs; he had one hand on the railing, one around Patsy Southgate. His analyst had left him, Lee had left him; he was in bad shape and on his own.

An "analyst," the word Jackson used for his psychotherapists, gives the patient a referral when unavailable. However, Jackson's condition was such that he was barely up to dealing with Dr. Klein; to consult with a stranger would have been beyond him.

PAUL PETERS: Jackson would come in, usually weeping, and ask if he could stay awhile. He'd lie down and sleep a bit. Even if he didn't, hardly anything was said, it was just weeping. The last time I saw him he was again weeping, and again nothing was said. There was nothing to say, so I just held his hand. But now I think about it, I guess that said quite a lot.

Ruth telephoned Jackson on Friday night, August 10, asking him to meet the morning train, and said that she was bringing a friend for the weekend, Edith Metzger. The news did not help Jackson's despondent mood.

PENNY POTTER: The day before Jackson died, he came to the Farm with some tools in the back of his car that Jeffrey had lent him. He was going to take them out, but Jeffrey said not to bother and went off in his truck. We remarked later on what a lonely thing Jackson then said. "Good. That'll give me an excuse to come again." Jackson was sober, I remember, and I went into the house, where I was cooking something. He stayed quite a while and played with our six-year-old son, Job, and I watched out the window as they threw a ball. He left finally, was so obviously miserable. He said to me that sometimes he felt as if his skin was off.

I left Jackson at the Farm because I couldn't be around his pain. But it went with me.

CHAPTER ELEVEN
GREEN RIVER I

At dawn, Saturday, August 11, 1956, there was a heavy ground mist. The cool ocean air mixing with the rising warm air from the land kept things humid and still right into night. The mugginess brought with it lethargy and weariness; any ambitious plan was bound to go sour.

I had stopped at the Farm to make a couple of phone calls on the way from one job to another and was caught by Jackson.

He wanted to borrow a building jack to make a show of leveling up the studio for Ruth, and leaned against the truck. I really didn't welcome one of our looking-at-the-ground-and-sighing encounters, and I happened to have the jack in the truck. I took it out, but he refused help in putting this hundred-plus pounds of danger into the Olds. He fell over backward and lay on the gravel cursing. My attempt to help him up brought more cursing, and my warning of what damage the jack could do loose in the trunk, if he hit anything on the way home, brought still more.

When he tried to lift it a second time, I pushed him out of the way and dropped the jack into the trunk more heavily than I meant. That brought the rambling announcement he wasn't going to ask me to join him and the girls he was going to collect at the East Hampton station; that would teach me to tear up somebody else's car.

My final warning of what damage the jack could do ended in his outraged incoherence and with it a swing of his right arm that could have been either an attempt at catching his balance or a not-so-playful swipe at me. I sidestepped, he stumbled against the open car door, and then I said something meant as a jest to the effect that maybe if I got him a really big stone with the tractor shovel, he might keep out of sight under it for a while. "Goddam right!" "And really out of sight and for a really long while?" "Goddam right!"

Bloodshot eyes squinted at me while his mouth twitched. I realized that we were being taken over by a process. I shouldn't let him drive, I knew, especially with the possibility of the heavy jack breaking out of the trunk at a sudden stop to crush him. I also knew he wasn't going to let me stop him. Jackson half crawled into the Olds shouting "All along I took you for a friend, you 'finest kind' shit!" Then he was gone, drooped over the wheel, gravel flying.

Ruth writes that by the time their train came to a stop at East Hampton, she was sorry she had asked Edith Metzger for the weekend. And when she saw Jackson she was greeted with an unpleasant surprise: he was dressed in dirty clothes and looked in bad shape. A second unpleasant surprise occurred when he took them to a bar near the station, Cavagnaro's, instead of going home to Fireplace Road. A few morning drinkers watched while Ruth and Edith had coffee and Jackson had beer. Ruth suspected he was postponing the return home and soon found out: Her white kitten, Blanche, had disappeared. She tried not to suspect Jackson, and after a search bordering on the hysterical, reassured him that cats have nine lives. Blanche's, though, were all used up.

AL CAVAGNARO: He had come in for his eye-opener, a double—if you'd start your day the way he did sometimes, you'd be in the same fix he was. That was about 10:30, before train time [meaning he had not dropped off the building jack at his house]. Most places refused to serve him after he threw that brick through the window of Sam's Bar, but he never gave me trouble. I'd kid with him, and once he had confidence in you, you could handle him.

When they left here, he wasn't too loaded. Trouble is, he was an odd duck: He played like a real fox when he was drinking, so sometimes you could tell when he'd had a lot, sometimes you couldn't. But this morning if you said he was half bagged up, you'd be about right. I wish he was alive today—used to bring artists in and they were pretty good drinkers. You don't see many good drinkers anymore.

According to Ruth's book, Jackson drank gin—something new for him—while she made lunch. He went upstairs for a nap after lunch, having failed to persuade Ruth to join him, and she and Edith went out to the studio. When she finally joined him in the bedroom, Jackson was weeping and told her his sadness was a sickness. He washed down an early supper of famous Dreesen's steaks with gin. There was much discussion about whether to go to The Creeks for a concert sponsored by Ossorio and Dragon to benefit Guild Hall. Finally, according to Ossorio, Jackson telephoned that they would soon be on their way.

ALFONSO OSSORIO: Not having seen him much because of his involvement with this girl, I thought his coming to the concert would be

a way of seeing him again. The concert was held in our music room, but there were so many people the terrace doors and courtyard windows were open. A maid took his message that they would be late and this confirms that right up until eight o'clock he intended to come. I think the concert had been going for about an hour before the next call came.

The actual sequence of events after this is confused enough, along with multiple retellings by others, to compare with *Rashomon*. As described in Ruth's book, what followed their leaving Fireplace Road does not jibe with others' recall or, indeed, with Ruth's later inquest testimony.

ROGER WILCOX: I stopped by Jackson's car at the airport road near The Creeks driveway and Jackson told me he wasn't feeling well and might not go to the concert after all. But when I mentioned this to Ruth a few years later, she insisted that the meeting had not taken place that night and that they'd had no intention of going to the concert.

Roger's two companions, his wife, Lucia, and Frederick Kiesler, are deceased. Certainly, between shock and injuries, Ruth's recall of that traumatic night almost has to be unreliable.

ERNESTINE LASSAW: Ruth wanted to know where the accident happened when she came back and we drove her to it. She had no idea that was the place.

Shortly after 10:00 P.M., Ruth writes, Jackson drove the Olds very fast north along Fireplace Road toward home. Ruth was in the front seat next to the right door and Edith between them; Edith began screaming in fear at the speed and Jackson's condition, and Jackson laughed madly. At their pleas to slow down, he drove still faster, and on a curve he lost control of the car and it headed for some trees.

FIRST NEIGHBOR (mechanic): From the door I see lights shining up in the trees south of my house on Fireplace Road. So I grabbed a flashlight and run up there, a hundred yards or so. A convertible was upside down on the shoulder of the west lane. It was an Oldsmobile, a '50 I'd say, and facing north toward Gardiner's Bay. It was on the curve near that dip in the pavement used to be there, where the county road's concrete ends and the town's blacktop starts.

A woman was maybe ten paces in front of it, crawling on her elbows. She was cussing me, every word in the book—state of shock, seemed to me. I had a real job getting out of her had anyone else been in the car. She says, "Jackson's there, Jackson's there! He was driving." Then she

said about this other girl, so I run to the car and a woman's leg was sticking out from under. There was gas spilled, too.

Next, the one in the road is screaming, screaming, and screaming, "My Jackson! My Jackson! Take care of my Jackson!" I looked all over, but I couldn't find him anywhere. Jackson just wasn't to be found.

SECOND NEIGHBOR (bulldozer operator): With that horn blowing so long, George says, "Bub, let's take a ride, go look." The girls was just talking, so we jumped in the car. He stopped with his headlights on a girl lying in the road. There wasn't anyone around, just this girl with her head toward that piled-in car and blood on her coming out of her scalp. I looked at her face, what I could. She had bangs squared off behind, and blood had run down the sides of her face and up across—scalp wounds bleed like hell, anyway.

We had to holler at her with the horn blaring; she must remember that, her head must have rung for a week afterwards. I says, "Any more with you?" "Two more," she says. That minute I looked across the road. It seemed to me like there was somebody standing there—like somebody waiting to see who was going to do what first, or who dared to. I may have been seeing things, but I looked several times to see if that figure was a tree or something.

What bothered us was that horn blowing. Really irked us. We tried to give the girl in front of that piled-in car some attention. She was like to panic but trying to hold on. George covered her with a blanket from his car, and I'm looking across the road again at a somebody—if it was a somebody.

THIRD NEIGHBOR (welder): A car was upside down, making its headlights high, and I pulled off the road where I wouldn't hit anything with those lights blinding me. It's a good thing I did, too. A girl was on her stomach right in front of my bumper—maybe five feet away, honest. Boy, that scared the hell out of me! I hadn't seen her, not in all that glare.

She couldn't move a muscle, just kept hollering "Alice, Alice!" That's the most she was saying—most that I could understand, anyway—"Alice, Alice!" Her face was all blood and dirt; I wanted to get her off the road, but she screamed every time we come near her. So we took off our jackets and put them over her. You know, I couldn't blame her for the screaming.

I moved the car out to protect her; she couldn't be seen flat on the road the way she was. I mean, I almost hit her because of the lights, and that scared me more than the accident. Why, for weeks I had a hell of a time sleeping.

FOURTH NEIGHBOR (truck driver): Lights were shining up in the air and I was down there within three or four minutes, but a couple

others were ahead of me. One was a colored man, Mr. Harris, and he was scared to go near. He used to stutter, Mr. Harris, and this particular night he was doing some stuttering. He's passed away, but he was a gentleman, Mr. Harris.

Anyway, this night a woman was lying broken—I think she broke her legs. She was on the tar, more or less in the road, either in shock or unconscious. She may have said something, I couldn't swear. But if there'd been any kind of blood I would definitely remember, because that would just pull me to pieces. One headlight—I remember this clearly—was shining right on top of the trees. It was eerie . . . real eerie like, you know.

FIRST NEIGHBOR: Any accident's the same way, first thing you do is try to save lives. Now, I knew the girl in the road was still alive, so I looked under the car. I figured there might be two there, but I knew one was a woman from that arm outside. And there was her foot, too, buried in the dirt right up to the ankle. There was just room to get my head and arms under. I didn't find any pulse; her head was up next to the back of the front seat with a pillow between them, and one side of her face was against the pavement. It was like—I can't explain it—like she just settled down for a nap sort of, know what I mean?

One leg was along the side of the car and one against the seat. It was like she had been bracing herself and then the leg and arm slipped outside when the car went over. She looked perfectly normal except for that foot buried in the tar. She was a beautiful, nice looking girl, and it made me churned up inside. She looked like a little angel.

SECOND NEIGHBOR: The girl's arm sticking out of the car was black as . . . black, that's all. From what I could see looking under, with any luck she would have gone in that well where a convertible top comes down between the tinwork and the back seat and been protected. If she'd been lucky, only . . . well, she wasn't going to come to any harm now.

People came and wanted to pick the car up, get her out. "Pick it up, pick it up," they kept saying. You know, it was *heavy*, that Olds. So I said, "*You* pick it up, go ahead. I ain't laying a finger on it, I ain't picking it up. If you can't hold it and it comes down on that girl, or you harm her without being covered by the law"—we didn't have the Good Samaritan Law like we do now—"you do injury to her, you've had it."

I could smell gas around the place—I don't know if it was a full tank, or what—but there was enough smell there for butts to ignite. I asked them to put out cigarettes, told them, "Them in the car, it isn't going to do them any harm, and the one in front—we can probably drag her around. But you could have a couple bodies burning, you know.

The horn was still blowing and I felt through the grill where the wire comes down. It was hot, *really* hot, and when I pulled my hand out the skin was white across it—not blisters, open like, but white across it. I asked them to go down and call a doctor, an ambulance—call the police. That's what I asked them, but somebody said a call had been put in already. The reason I didn't holler for any third person—the girl in the road said there was two more—I didn't know who to holler for.

THIRD NEIGHBOR: The girl on the road was still conscious and she was screaming terrible. We heard later that she didn't have hardly a solid bone left in her body. We got a flashlight from my car but the wreck was down so low we couldn't see inside, didn't know how many people were in it. And I didn't know whether the girl inside—of the arm I saw outside—was still alive.

By that time people saw it and wanted to turn the car over. More kept coming, arguing they were going to do it and we kept telling them they weren't. I had some time with those Bonackers—nice people, don't get me wrong—but you know what they are when they got their minds made up. They just had the idea nobody was going to tell *them*.

The horn was still blowing and red as an ax handle, fire red. And gas was running all over and we couldn't get the lights off, neither. We tried everything, but there was no way to get hold of a battery terminal. We couldn't reach the dashboard switch with everything down flat—see, everything was right down flat.

FOURTH NEIGHBOR: Ernie and I were under the car to this woman—not the woman that got broken—and the car was on top, definitely on top of her. I'm not sure she was pinned, but she was in the back and, like everything else, upside down. Christ, Ernie's built like a bulldozer and probably could have lifted the damn car if he wanted. I remember I started pulling on that arm and him saying, "Leave her alone. That's the worst thing you can do if she's seriously hurt."

That's the same night five or six school teachers got killed in Shinnecock, so it was forever before the coroner come—that lady doctor from Southampton, seems to me. But this woman was already dead. She was dark complexioned, like a native type—attractive, very attractive, and not mangled or torn up. She had a dress on . . . I don't know why I'm thinking about this, except she was very attractive and her dress was right up. I pulled it down over her knees, not that I'm such a proper person or anything. But I did.

FIRST NEIGHBOR: I went on looking for Jackson and it seemed like a hell of a long time up on that rise in the trees there by myself before the cop come. He didn't know whose car it was. "Pollock's car," I said.

The accident looked funny to me, the way the car hit nothing. I can't understand how a car can be upside down, you know, just laying in the opposite side of the road. The thing was laid there like somebody just plopped it over upside down—and then not finding Jackson. And I tell you I walked in the woods and I looked and looked. I mean, a person is big enough to see, right? Hell, I never had a drink, I was cold stone sober! Then I come to my senses: Maybe I wasn't back far enough, you know? It didn't seem possible anybody would be that far back in, but I searched and still couldn't find anybody.

THIRD NEIGHBOR: The cop and I each had a flashlight and we were looking in a big area when we come together just about the same time. Pollock was way up in the woods, that's why no one could find him, and we near fell over him. He looked like an old dead tree lying in the brush.

CONRAD MARCA-RELLI: It was weird, kind of lonely up there, and really dark. For a moment I thought Jackson was asleep, but his eyes were open. I felt it can't be serious, he's just stunned or something. There was a police car with a spinning light on top and I ran down to ask the cop. "He's dead," he said. "He's dead."

PATROLMAM EARL FINCH: This sticks in my mind because it's highly unusual: Pollock was thrown a good fifty feet from the car. It was like he was planing in the air, elevated about ten feet off the ground, because it was that high on the tree trunk his head hit. He might have survived if he'd missed it.

I knew he was dead from the look of him. You couldn't move a body then until the coroner come—there's nothing to do when they're dead except keep the curious away—and it was so dark up in there I don't think I covered him. Dr. Abel come finally and I showed him the girl under the car. He said, "Did you check?" I told him I had, then held the light while he went under the car. Next I showed him Pollock and he said, "Jesus!"

DR. WILLIAM ABEL: It was all bad. I pronounced the woman dead and she was sent to Fred Williams [then the Yardley and Williams Funeral Home]. The woman who was alive was sent to the Southampton Hospital and, of course, painkillers are not given prior to examination due to complicating diagnoses.

THIRD NEIGHBOR: The girl in the road was screaming terrible and kept screaming until the doctor got indignant finally and told her to shut up or they'd leave her. The ambulance guys were trying to get a

litter under her and it bothered me that with that much pain he didn't help her with something. I'll always remember that.

When the cop turned Pollock over, there was a little blood run down from the forehead—no other damage except for the neck swollen like a balloon from the oak he hit. When the car climbed those saplings and was flipped back, he flew out of it like an arrow in a real straight path. The blood or the neck the way it looked didn't bother the cop any and it didn't me—then.

SECOND NEIGHBOR: The girl under the car, there wasn't a scratch on her nowhere. She had a great big white party dress on and she was a pretty girl, and it looked like she had taken that pillow and held it against her face, seemed like she was trying to protect herself. She was very young and it made me feel kind of—tender. Anyone else, make them feel the same way.

JERRY GAGNEY: A call came in for my wrecker, but I told them, "No way. I won't touch it." I've set guys on fire cutting them out of wrecks with a torch, but this—I didn't want the car at my place. I told them, "Take it and hide it back in the woods someplace." I just didn't want it around because of him, because of friendship.

THIRD NEIGHBOR: When the coroner come all he did was take a look, didn't take any time at all. But the night was a long one, what with not finding Pollock for so long. Sure was.

FOURTH NEIGHBOR: The cop wouldn't let us go, had to measure on the road and all, so it got late—and cold . . . Not that it matters, but I think I'm one of the few in Springs that really admired Mr. Pollock.

ALFONSO OSSORIO: A maid gave the message and I told Ted to stay at the concert in order not to alarm everyone. Marisol was at the scene—I remember that wide-eyed, impassive young sculptor staring at the body—and if I am not mistaken, I covered Jackson's face with a handkerchief. Clem mentioned another person, a perfect stranger, being killed. That upset him very much.

CONRAD MARCA-RELLI: Clem said, "The sonofabitch, he really did it." I was hurt by it, but he meant he wished Jackson hadn't died. He closed his eyes with a handkerchief and may have left it there.

CLEMENT GREENBERG: When Alfonso told me on the terrace at The Creeks, I felt very angry at the death—swore and threw my glass into the trees. At the scene I couldn't look at the body any farther up than the legs, I couldn't.

THIRD NEIGHBOR: Somebody ripped the horn wires out and then it was quiet up there until these three guys come and were cussing him to beat hell—called him all sorts of damn fool, said he *ought* to have been killed. A bunch of fellows standing over a body and hollering like that, makes you wish you had a baseball bat and start swinging.

CAROL BRAIDER: A lot of people came to the bookstore and there was a lot of fast drinking. Everyone was talking about Jackson's friendship with *them,* not about him. When I heard somebody say, "That goddam Jackson, always fucking me up," I went around offering reserpine which I was on then.

CONRAD MARCA-RELLI: Nick Carone and I talked until three in the morning about the loss, Jackson's image had been so strong. Suddenly you felt this hole, this silence; as time went on it got more and more.

MIKE COLLINS: He was a close friend, even if I was only ten—used to give me rides in the Model A rumble seat and let me watch him draw, which I didn't think was crazy the way most did. My parents slowed up as we passed the Olds upside down and I knew he had died all right, had to. I cried most of the night.

Penny and I were at a late party in Southampton that night and our return found an excited babysitter at the door. She said accusingly that "that Mr. Pollock" had killed two women with his car and then run off. I asked Penny to take her home so I wouldn't be tempted to drive to the scene and try to sneak the jack away; I was certain that was what caused the accident. Then I remembered my afternoon association of the horse I finally managed to kill with the death Jackson was owed; I was so shattered I could neither speak nor listen to Penny on her return. In the morning she said that avoiding the accident site wouldn't be easy, maybe for weeks. I told her that avoiding Jackson would be a lot harder, maybe for years. It has been.

Friends who went to the house that night from the accident scene didn't get much sleep either, but they at least were accomplishing something. It was 3 A.M. when Clement Greenberg finally reached Lee in Paris, where morning was well along.

PAUL JENKINS: When Clem called, my wife Esther answered, then I spoke. He said, "Jackson is dead. Take it easy." Lee was only a few feet away and immediately divined it.

CLEMENT GREENBERG: Lee only knew that Jackson had got himself killed. She broke into hysterical laughter—scary, but she was *laughing*. Then Paul took it into his head that I was to blame and cut off the conversation.

PAUL JENKINS: Lee looked in a corner and saw rolls of canvas and said, "You know, poor as Jackson and I were, we always had plenty of art materials." Then she insisted on the need of returning as quickly as possible. We got to work on a plane reservation at once and after numerous calls, I finally got her on a flight that night.

Helen Frankenthaler called, not knowing anything, and came over. We all tended to Lee, but she became more and more solemn, resigned, strong. She was thinking in terms of her house, her dogs, her canvases, all the flammable things. Her whole life was at stake. We drove to the Luxembourg Gardens, then to the Bois de Boulogne, walked, sat, talked—we just spent *time*. Now and then Lee might have a brandy and by the time she was ready to get on the plane she was wobbly.

Lee told us about a dream of Jackson's—I suppose it was prior to coming to Paris—and it is a lasting image. She saw Jackson crucified on the cross and his hands were covered in green mold. As to any guilt on her part about Jackson's death—no. I think he consciously wanted her to be out from under, didn't want her to be around when he made that final step. I think he was protecting Lee, and I said this much to her when we sat on the couch and held hands. He was on his way out and I believe that everything he did at that time was because he didn't want her to suffer the consequences—and that in her presence he wouldn't, or couldn't.

HELEN FRANKENTHALER: Lee was in a state even *before* the news. Naturally she was in a frenzy of grief, rage, loss, panic. And then there was the guilt, a loaded subject.

HAYDN STUBBING: I was there making frames for Paul and I must say, Lee was in a terrible state. She blamed herself for having left, then felt even more guilty at not being there at that moment. But his death freed her.

Elizabeth Pollock, too, was called by Greenberg, and she in turn called Charles. None of the family knew about Ruth.

CHARLES POLLOCK: My first reaction to Elizabeth calling was that something had happened to our daughter, Jeremy. Jackson's death was very disturbing, but he had lived his life—a dangerous kind of life—had been drinking too much, was driving too fast, shouldn't have been driving at all. People claim it was a suicide, but I don't believe that at all. After

the news from Elizabeth, I called Sande immediately, saying "Goddammit, he's done it."

ARLOIE MCCOY: We were in New York for the evening and came home about 2:00 A.M., our fourteen-year-old daughter Karen having answered and given the caller the number where we were. She was afraid to wake up Stella, who had a heart condition. It was a shock to Stella on the surface when Sande told her, but she took it well. She wasn't a demonstrative person, and in a way Sande was pretty inarticulate.

We weren't surprised that something violent happened to Jack because he'd been pulled out of so many scrapes by Sande. It was a huge loss for him; we had dreaded it, but the last time I saw Jack he seemed very strange with that beard and so heavy. It was not a suicide, but he had such a death wish for a long time it gave us a queer feeling. I loved Jack because Sande loved him.

FRANK POLLOCK: It was a shock, the first tragedy in our family. I was shocked by some of those photos of him, and I had been shocked seeing him firsthand, the beard and the bloat. I detest those pictures and wish I was never shown them.

ALMA POLLOCK: The last years Jay and I missed entirely, thank God. He was still Jack, not as in those photos. But we realized that when he was drunk anything could happen.

According to Ruth's account, she was told of the death by Dr. Abel in the hospital. (Hers was the first interview I conducted for this book in 1971, she being the last person who saw Jackson alive. Lee, who was not in favor of the book—she said there was no story in Jackson the man but only in Pollock the artist, and that it had been told—was to have been my last interviewee, mainly for fact checking. Completion of the manuscript coincided with her death.)

RUTH KLIGMAN: It *had* to happen. Jackson was schizoid, berating me, and he couldn't be stopped. Edith was scared by the situation with him; she was a victim, but she always was. He was a victim, too; he had to die. And I was a victim.

The news was a shock to the Cedar regulars; they were used to Jackson walking away from his accidents. It made Jackson seem real after all.

"SAM" DILIBERTO: We didn't have a jukebox or TV at the Cedar, on account of the artists didn't go for it, so for about a week there was no way to liven the place up. Strangers would look around after a while and

ask, "What's wrong here?" The place was like a funeral parlor. And it did mark the end of an era, like when we moved from the old place in '63— the Cedar, sure, only not the Cedar.

Robert Beverly Hale was asked to identify the body on Sunday but simply was not up to it.

CONRAD MARCA-RELLI: The body was in a back room—just on a table, covered. A policeman came with someone else there—maybe the undertaker—and said, "Will you identify this man, who is he?" He uncovered just the head and I told him, gave my name and address. The head showed the beginning of a bluish mark on one side—this was before he was embalmed—and when Lee arrived from Europe there was a question of whether they wanted to have the coffin open. They decided not to open it because he was too badly disfigured, but I never could understand that. Maybe it starts getting really bad later, so they thought it would be too bad a sight to look at.

The cause of death was now established, legally at least.

DR. ABEL: The system then was very casual: The coroner could farm out autopsies to local physicians, and John Nugent I don't think did an autopsy all the years I knew him. Most autopsies were done by people untrained in forensic medicine—in some of the county there weren't even physicians—and so things really had to be obvious and gross. I would doubt, though I don't know it for fact, that samples were taken of the various organs or that material was taken from them to check for alcohol or drugs.

In this case the funeral director, Frederick Williams, assisted Dr. Francis Cooper, acting for the coroner, with the autopsies.

FREDERICK WILLIAMS: The immediate cause was due to compound fracture of skull, laceration of brain, laceration of both lungs, hemothorax, shock. A compound fracture of the skull means the actual bone part was protruding through the skin, and laceration of the brain means that part of the skull pierced the brain. Cause of death in Edith Metzger's case was fracture of neck, laceration of brain, shock.

The bodies were pretty mangled, as far as the upper extremities were concerned; Pollock had quite a few abrasions on his head and face. All we did was prepare—preserve—him and place him in the casket. The girl was embalmed by my wife and was delivered to the Bronx. As I recall, there was someone who wanted to come in—who did say he'd like to photograph Pollock while he was in here. I told him it was not permit-

ted because the family did not authorize it. We don't allow any of that; there are a lot of people who—we as funeral directors call it morbid curiosity, photographs like that.

HANS NAMUTH: I was at the funeral parlor in hardly any time at all. The body was dressed in blue jeans and he looked beautiful. I asked to be allowed to photograph him, but I didn't want to sneak a picture.

Patrolman Earl Finch's police report described the male body identified as Jackson as being dressed in a black velvet shirt, gray pants, brown belt, blue shorts, brown socks, no shoes, no jewelry or identification on the body. The examination of Edith Metzger's body found it to be dressed in a blue print dress, three white half slips, white undergarments, stockings, no shoes. She was wearing a strand of blue glass beads, one yellow metal ring and one metal ring with a yellow stone. She carried no identification.

A lot of people did a lot of things that Sunday, many of them to protect Lee. John Little's wife, Josephine, was joined at the Fireplace Road house by Carol Braider and Alfonso Ossorio. She and Cile Downs wanted to remove indelicate objects before Lee got back, while the men tried to find out who Ruth's friend had been.

CILE DOWNS: We washed dishes and so forth and put Ruth's things in piles—at least all the things we could recognize as hers—to get rid of them. The grief over Jackson was a little too deep to start right away, but after maybe a week it was really terrible—we missed him. Now I kind of wonder why we did because he was in such a painful state, had such painful experiences. One suffered with him, suffered everything, including what he was doing to you as well as to himself.

CHARLOTTE PARK BROOKS: I was confused about which things were Ruth's or Lee's, but we just had to clear out Ruth's before Lee came home. I had a terrible time with Lee much later because I was talking to Ruth at an opening when Lee came in. I was devastated when I found out how strongly Lee felt about it.

ROGER WILCOX: Lucia called Sidney Janis with the news. He called back to say that somebody should watch over the studio to be sure that nothing was stolen. Lucia said, "But Sidney, no one's going to steal anything. There are no art dealers around."

MAY TABAK: When I was told the news I began to cry. Harold was holding me when in walks this guy who kept coming up with evidence that this whole group of artists were phony and didn't know how to paint; at their

head was Jackson. When he asked what was wrong and heard the news, he said at once, "Well, now—if we can get de Kooning dead, there's some hope for American art." The words are imprinted on my memory.

WILLEM DE KOONING: Still a *young* man with that dumb accident. But me—I don't drive, so I've been painting all these years. When characters like ourselves drink a lot, maybe some voiceless quality comes out and then you want to die. It is hard to understand—like that girl from the Bronx, she was just here that one day and she found her death.

HERMAN CHERRY: I was staying with Jon Schueler on Martha's Vineyard, and Bill de Kooning was there with Joan Ward. Benton had heard the news on the radio and took it hard. Bill hired a plane, and Rube Kadish and I hoped Benton would come with us. But he said he just couldn't take it. Rita, I remember, opened a drawer and it was filled with Pollock clippings and reproductions. They saved *everything*.

Some of us thought that there was a little bit of hope that summer; a dynamic was there. Lee was away for the first time—it is not an unusual combination to be both dependent and, in wanting to be free, to have hatred—and he was even getting Dr. Klein out of his hair. Why that particular timing? . . . With the terror that motivates despair, things begin to move around and there's a possibility of getting out of a rut. Those some of us were *very* shocked.

Two ladies on the Guild Hall art committee appeared that Sunday morning to claim a painting that had been promised for an exhibit. John Little barred their way to the studio, saying that the painting would leave only over his dead body.

Traffic at the accident site was heavy on Sunday—some cars speeded up to get past it, others slowed down for a look—and some of us went out of our way to Accabonac Road to avoid it.

IBRAM LASSAW: I kept a piece of shattered glass from there for years—not in a morbid or ghoulish way. There was so much shock that I didn't think of making one of my death masks and when I remembered, it was too late.

GIORGIO CAVALLON: It was awful, those trees so scraped and bent over. No one did anything about them—as if the trees weren't saying something to everyone who passed. They were there forever and—I don't understand it.

ROBERT BEVERLY HALE: As I approached the spot Sunday morning, a fireball crossed the road and went straight for those trees.

I've seen a couple in Maryland but nothing like the speed and size of that one.

The South Fork buzzed with accident talk. There was much I-told-you-so chatter, but as with me, it was hard for many to think of Jackson as having been a person the last year or so. Our sympathies were with the Jackson who had started dying a couple of years ago. It made it easier to mourn and to judge—and to forgive ourselves.

Sunday having been a day mostly of acceptance and reflection, Monday was a day for planning. But without Lee present, our plans had to be tentative; on her flight home, she decided definitely on a Wednesday funeral. She had more definite questions too: Had Jackson been alone? Was it suicide? How drunk was he? What had been the situation with her whom Lee could not refer to by name?

CILE DOWNS: I visited Ruth and I was very moved by her. I had sympathy for her because she'd been kind to Jackson and I knew he'd had affection for her. Ruth said, "Jackson loved me; I know he did." I said, "Yes, I think he really did." And that was the truth. But then she started talking about this painting that Jackson had given her, and that she would never have now.

PATSY SOUTHGATE: There were some things not cleaned out by Josephine Little and Charlotte Brooks—more dresses than I knew there were and Ruth's diaphragm—so I took them to Ruth in the hospital. She didn't look much banged up to me. In fact, she looked great.

B. H. FRIEDMAN: We did what we could to comfort Ruth in the hospital, but one of the first things she said was, "What are you going to do about my painting?" I told her I would speak to Lee about it and that's all I said. I couldn't say, you know, that I'd give it to her or anything. When I spoke to Lee about it, very uncomfortably and several months later, Lee said, "She's getting her insurance; if she wants a Pollock she should buy a Pollock." This I reported to Ruth, but Ruth has it in her book that I had promised to get her the painting.

The arrival of Lee's flight from Paris on Monday was well attended. Ben Heller, having just seen her in Paris, had driven to the airport to help her with customs. Ossorio and Patsy Southgate came in from East Hampton, and Lee's nephew came out from the City.

RONALD STEIN: Lee had called to say she wanted me to meet her, but with so many other people there, I was superfluous. She decided to drive to East Hampton with Ossorio because it was more comfortable

than my old car—a limousine or something. I stayed with her in the house, then my mother came the next day [Lee's sister, Ruth Stein].

I had expected Lee to be a basket case, so I was astonished at her control. She and my mother had an enormous fight because Lee wouldn't let her help. For Lee the more severe the crisis, the better she was—as long as she was in control. As for family, it was only important that they were there.

CILE DOWNS: When I came to the house to greet Lee, it was full of people. Lee came up and said "Don't say anything," and put her arms around me. She seemed to be in total command of herself—we'd been breaking down and crying—and she was making graceful statements about things to the Brookses and a whole group. I remember thinking, "Golly, that woman is amazing. She's just come home and this terrible thing has happened, yet the grip she has on herself." Well, it's what Lee was like.

CLEMENT GREENBERG: Lee was collected. But she was already reverting to her old bad self, and when she told me I was to speak at the funeral, I said "How about Barney Newman?" No. "How about Tony Smith?" "No—you." I didn't feel flattered in the least. Again there was hysterical laughter.

I said, "The reason I won't talk is because he got this girl killed and I want nothing to do with it." Others have thought my refusal was for moral reasons, but it had nothing to do with morality. It had to do with decorum and that's all. And I also told Lee that I didn't know anything about this girl, "But if we talk, we talk about her." Lee had her fit and that was it.

I remember thinking too that when a hero dies you sacrifice somebody on his funeral pyre. I was to be the sacrifice, to stand up there and cover for his getting this girl killed. I knew enough of the story by then, about the way he thwarted this poor girl—she never even got to the beach. It was all pathetic. I couldn't forgive Jackson. I still can't.

PAUL JENKINS: You've got the tribal thing, metaphorically at least, of becoming the human sacrifice. We mustn't ever forget that Jackson *took someone with him*, much the same as did mythic creatures—a bit of them didn't go alone. This is not a conscious thing but definitely from the unconscious.

Funeral plans were refined on Tuesday with Lee totally in charge. No detail was too small, it seemed, for Lee to deal with: Would Stella and Charles be staying at The Creeks, Sande's family at the Farm? Did Jim Brooks not have a dark suit to wear as a pallbearer? He had one now—Jackson's.

CONRAD MARCA-RELLI: Lee was like a sergeant directing a maneuver—very strong-willed about what was to be done and who was to do it. She was very much in control of the whole situation and I think it was her feeling that she was called upon now to take care of all that was, and was to be. Theirs hadn't been a relationship of two people who love each other and then a tragedy happens; it was a tense relationship with much love/hate involvement on both sides.

BEN HELLER: Control is necessary if you're in a situation, a relationship, like Lee was with Jackson. You have a feeling you've got to carry the flame, the reputation and so forth, and that was her way of dealing with life. She did not collapse on somebody's shoulder and become a puddle; her control has to stay, so she had a kind of sardonic, ironic detachment just as she had about Jackson and his life.

JIM BROOKS: She said she thought that maybe she was responsible for what happened. I told Tony Smith that—maybe she'd told him too—and we decided to tell her it wasn't so. She wondered if I would go—if we should go together and see Jackson at the funeral home—see what condition he was in, what he looked like. I'd heard he was swollen, his face all swollen up, you know. I said I didn't think we ought to do it.

FREDERICK WILLIAMS: Mrs. Pollock came to look at the funeral home and decided it would be much too small. She was going to have a cemetery memorial—planned to put a couple of his paintings out there—that's what she said.

 Because I knew him, it is my guess that I was delegated to consult the Reverend George Nicholson, pastor of the Amagansett Presbyterian Church, who also conducted services at the Springs chapel. I remember his lack of concern about not having known the Pollocks or their East Hampton art world, and his asking whether Jackson had been a good man. I told him Jackson was the best and he said then he'd find the best words. They turned out to be from Romans 8, dealing with glory and the greatness of the Spirit. And the choice of Green River Cemetery on Accabonac Road in Springs was also appropriate; Jackson, preferring Accabonac to Fireplace Road, often drove past it.

MRS. NINA FEDERICO: That's a nice, quiet community up there, Green River.

SUPERINTENDENT JARVIS WOOD: I went to see Pollock when he first came here—calling as an elder for the church, you know—but he didn't seem very interested in our church. When he used to come to the

store, I knew him some that way. There's sure no river at Green River—I don't know about that part of the name, but the way I understand it a man named Sam Green Miller lived up there years back. Pollock was one of the first artists in there, if not the first, but now they want in there bad. One party from away wanted to pay for a survey to be sure there wasn't no room next to Pollock—called me on the phone, that's how bad *he* wanted to get next to Pollock. People still keep asking for a plot close by, nearest they can, and I keep telling them there's nothing.

Mrs. Pollock didn't buy just one plot but three for $300. They lie in a wooded corner not used until then—biggest and highest section. That wood sand up there makes for good digging, but you have to shore up sometimes against cave-ins. It makes for fine drainage, too. You'd be all right there for twenty-five years, easy.

WILLEM DE KOONING: I lived across Accabonac Road from Green River, so it felt natural walking evenings where my friends are. I don't know how this one guy got in there [an artist not admired by Bill], maybe through his wife—I forget her name. But Pollock, he's with the other artists and that's nice.

Lee was not the only one to exhibit an iron self-control. Stella was like a stately monolith in her impassivity.

FRANK POLLOCK: When we came, Mother was on a daybed in one of Ossorio's houses, lying there weeping. I remember saying to her, "You can't drink and drive." Mother said, "Ossorio said he only had three beers"—in other words, he had softened things for her. She was really broken up and died within a couple of years.

ARLOIE MCCOY: Her heart attack was before that death, but one of her brothers' wives then died, and after that she stayed with a sister in Pittsburgh, then went back to Irma to take care of her brother Les. Even though he was well off from his lumberyard, there was no water in the house, and Mother Pollock lived that way until the end—a big beautiful car of Les's, a Cadillac, and no plumbing.

CILE DOWNS: Lee did have a problem with Jackson's mother, and I remember her saying once his mother had destroyed all the spiders. There were spiders in the house—Lee liked them and their webs—and on a visit his mother swept the walls down and out went all Lee's spiders. I thought, "Oh gosh, there's symbolism in this, and I don't know where it will end."

Press coverage of Jackson's death was extensive and while not always accurate, there was no gross fabrication such as appeared in the *East Hampton Star*, outraging the art community.

• • •

The front-page photograph was captioned *A Still Life* and described beer cans, a loafer, and wheel cover in a circle as "That is the way they fell."

SECOND NEIGHBOR: We saw this guy putting the shoe and the wheel cover there—wasn't an Olds one anyway—and beer cans are all over the roadside down in Bonac. That picture was faked and most knew it.

Time, calling him a hot seller, was cautious in its handling of Jackson's position, not suggesting that he might be a flash in the pan but not predicting a brilliant future for his work either.

DOROTHY DEHNER: When I read Jackson's obituary on the front page of the *Times,* my reaction was "How stupid and bourgeois; I'm ashamed for him." But when my husband [David Smith] was killed, I noticed they didn't put *his* death on the front page.

The death certificate wasn't accurate either. Lee signed it with her maiden name, Lenore Krassner; Stella's name was misspelled as Stella May McClore; the length of Pollock's Springs residence was given as four rather than eight years; and the "Paul" of his birth record was finally dropped.

Wednesday was not at all what one thinks of as a day for a funeral; instead of rain and black umbrellas, the sun was bright enough to give an additional reason for wearing dark glasses. It was a day for swimming and beach umbrellas.

CONRAD MARCA-RELLI: People from the City came to our house and we sat around outside waiting for the time to go to the chapel. Around two-thirty, I went to Harris's store to get some stuff, there were a few Bonackers, workers, there. It was so quiet—it impressed me like *High Noon,* that and the waiting. They weren't participating but listening, and then one of them said, "What time does it go on?" I told him about three. That's all that was said—no "What a sad thing" or anything. Everybody was respectfully quiet; they knew something tragic had happened to the artists. We were outsiders, but they always tolerated us well.

By midafternoon the Springs Chapel was crowded. Quite a few strangers showed up and celebrity as well as the heat lay heavy in the church. There was a lot of discomfort for a lot of reasons.

Among the pallbearers were Charles Pollock, Frank Pollock, Sande McCoy (Jay did not come due to Alma's invalid condition), James Brooks, Professor Isaacs, and Ben Heller. There was talk of a second

cadre of pallbearers to oblige old friends long excluded as "New York gangsters," and there was talk of some who couldn't come and of some who wouldn't.

LARRY RIVERS: He tried to run my thing down—talked against my work and even though the end was horrible, I'd had so much flak from those people. Every time I met *her* she would give me some shit. I didn't go to the funeral because I thought, "This is bullshit and I don't believe in colleague shit." It took me a long while to get cool about it all. He was just—I mean, that thing with my girlfriend, trying to fuck her!

ARLOIE MCCOY: It was definitely Lee's decision to sit alone at the service and the family accepted it. We sat directly behind her.

ALFONSO OSSORIO: It was a little awkward, Lee's not sitting with them. And there was tension at the house afterward, where Lee sat by herself in the front room.

FRANK POLLOCK: I didn't think the service was very appropriate. And I thought there should have been testimony from his friends.

There was a kind of testimony mid-service: Reuben Kadish—well back in the jammed room, which had spilled over outside with people at the windows—let out a long, low wail. One mourner, at least, thought it came from Lee.

ELEANOR WARD: Do you remember Lee's scream at the funeral? It struck me that here she'd gone to Europe for a divorce and came back to put on this emotional scene. I thought she was very ambivalent.

BEN HELLER: I was in something of a daze. I hardly remember what the man said, except that it didn't seem terribly apt.

PAUL BRACH: I was enraged by the preacher's talking about sin; he didn't know Jackson. I believe we as artists belong to a subculture, that we are each other's tribe. But if you're not careful around birth, sickness, death, by default the rituals of the other tribes will take over.

Matta, as recalled by Constantine Nivola, stayed outside and had come to the funeral because he saw it as an historic event. And out there he was joined by others.

MILTON RESNICK: I tell you, I couldn't stand it inside. I couldn't listen to the preacher and all that crap. What put her up to it?

DOROTHY NORMAN: We were all strangers in that church—not one of us had been in it before—but we were brought together, even those at odds in the art world. We were given a gift we didn't deserve in that we had not supported that church, nor would we afterward. But I felt the service was right in bridging in the traditional way the gap between life and death. We need that, being a nontraditional society that depends on tradition.

This funeral was strangely intimate, many of us feeling close not only to Jackson but to each other; this made it natural simply to go to Green River in our own cars or to walk at our own pace.

JAMES BROOKS: I remember being in back of a car with the other mourners and wearing Jackson's dark suit. I looked out the back window and saw Patsy Southgate in another car. She was looking at us, very kind of sad and beautiful.

CILE DOWNS: Lee asked me to drive her around a while before going to the cemetery. She said, "Drive me to Louse Point."

Then, standing alone at the graveside, Lee was the center of attention.

ALFONSO OSSORIO: She was so very alone, and then she swayed slightly. Mr. Williams, who had been watching her out of his experience, very unobtrusively moved up and took her arm.

GINA KNEE: I keep remembering Lee's face that day, her expression. It was—enigmatic; it made me think I must be feeling worse than she did. I decided she must be holding something back: relief.

As happened in the chapel, several people thought they heard Lee moan; some call it a shriek.

MORTON FELDMAN: I'll never forget the sound of Jackson's dogs there. One of them let out not really a whimper—not a Hound of the Baskervilles howl—more a wanting, as if missing something.

CHARLES POLLOCK: At the end of the service, I recall my brother Sande and Reuben Kadish in hysterical tears.

FRANK POLLOCK: We were standing there with the dogs when Kadish let out a bellow. In fact, I started to cry, then led him away and quieted him down. When we were about to leave for the wake, he thought he was going to have to go back to New York—he didn't think

he'd be welcome over at the house for food and drinks because Lee didn't like him. I said, "Listen, you're coming along with me," and on the way I told him, "You're going to be welcome at Jack's place."

B. H. FRIEDMAN: Like all of us, I was taught that boys don't cry, and here I was crying for the first time since childhood.

PAUL BRACH: When the minister was done, the silence was so much like one of Jackson's silences. We all stood there and I thought Clem or Harold Rosenberg or one of the brothers even would talk—Morty Feldman told me later he almost said something—and that *someone* would say, "We are burying our brother, Jackson, a tormented, difficult man who was a great painter, who embarrassed us but whom we loved, and who made our lives richer by being there."

JULIAN LEVI: I'd been troubled by the antiseptic air over things that day, and a certain separation between Jackson's mother and Lee. I remember Ibram Lassaw saying right after the burial, "I can't understand these Anglo-Saxon people. They have no warmth, they have no heart: Somebody dies and they are unfeeling, acting as if nothing terrible had happened."

MILTON RESNICK: The last mourners remaining were my wife, Pat Paslov, Bill de Kooning, and myself. We watched Lee led away, leaning on somebody, and it was like something on stage. I didn't want to go to the funeral in the first place; people just assumed I did and they took me. But then the funeral people rolled up their sleeves and took off this green plastic they had the mound covered with. You could see the dirt, and they started shoveling it in. We thought, "He's down in there. He's dead." And that made the funeral real.

There seemed two separate worlds at the wake: One was formed by the dignified groups around either Lee or Stella; the other consisted of those who were either outraged by what they saw as poor taste or delighted by the atmosphere of celebration.

JULIAN LEVI: Lee was receiving sympathy as the widow and rightly—as the widow of a personage, very rightly. Jackson's mother—she received as The Mother, and rightly too.

FRANK POLLOCK: Mother sat there like a queen—without a tear. But the rest of the family, we ate and drank.

CHARLES POLLOCK: I was impressed by her calm and dignity, but I don't remember where Lee was. Mother and I didn't talk about the

loss—there are things Pollocks don't discuss much—and as we understood one another, it wasn't necessary to elaborate on it. But I'd be surprised if her reaction wasn't, "Well, if you choose to live that way, this is what happens: You get rewards and punishments."

CLEMENT GREENBERG: When I spoke to the mother with sympathy, she said, "Well, his work is done."

CAROL BRAIDER: Patsy Southgate was worried about Jackson's mother seeming so cut off from Jackson's friends, so she turned on her best manners and went over to make conversation. She said something like, "Jackson must have had a lovely father; he must have been a strong man." Mrs. Pollock drew herself up and said, "*I* was the strong one."

BERTON ROUECHÉ: There were too many people emoting, and people seeming to carry on more than their friendship would have indicated.

DR. RAPHAEL GRIBITZ: I'll never forget that goddam wake with the poor guy still warm. That was an awful, awful evening; it made me sick. And remember those Charles Addams types hanging about?

CHARLOTTE PARK BROOKS: I thought it barbaric to get together after a funeral service. I wanted to be alone, but because we lived in Montauk and Jim wanted to go, there was nothing I could do about it. And then I began to realize how good it was to get together with people. It was helpful.

JAMES BROOKS: It was a time when a great tension was suddenly relieved and replaced by a good feeling about things.

BEN HELLER: I'd never been to anything quite like it, never understood the function of that kind of ceremony, but I do now.

 Drinks went down so fast and spirits up that someone said Jackson had to be spiking the drinks.

DAVID BUDD: A lot of us had had drinks before the service to brace ourselves, but I don't think we'd remember much about that party somehow, even if we'd been sober. My main memories are of Franz Kline very drunk telling people, "Say what you want, he couldn't paint," and of Penny Potter's chili—best chili I ever had in my life, really hot stuff.

MORTON FELDMAN: What stays with me is that baked Virginia ham. I never tasted such ham, never.

NICHOLAS CARONE: Jackson's friends were there for the right reason, friendship, and that gave it a festive air without anything else needed.

PHILIP PAVIA: It was a happy time, would have been for him. What made it a *joyous* occasion was the realization that this man was loved. He wasn't like Rothko, always insulting people.

CLEMENT GREENBERG: That party *chez* Pollock was the first *real* party given there. We all had a good time.

CHARLES POLLOCK: I had too much to drink, but I remember dancing with a black girl—don't know who she was. And on our way back to Ossorio's I was sitting in back with Sande's daughter, Karen, and put my arm around her. "Uncle Charles," she said, "you're drunk." I got mad and said, "Sande, let me out of this goddam car." The next day I told Sande I was about to marry Sylvia [Charles's present wife], a former student and thirty-four years younger. He said, "I hope you know what you're doing." I did.

PAUL BRACH: It was important politically to be at the cultural event called Jackson's Funeral. All of us were aware of that.

BEN HELLER: I knew from my experience that there is still a part of the ceremony after the burial and formal sympathy giving. You have gone through a ritual, life goes on, and everybody leaves you. At this point a different pain begins, so it was absolutely predictable that Lee would have that terrific control.

ELEANOR WARD: Lee and I were on the back steps talking as if nothing had happened except a gay party. The dog Ahab was running around, and it was getting later and later and better and better.

It was at this point that Penny and I thanked Lee for what was, I realized even as I was saying it, a great party. Lee agreed it had been great and added that she would have a rough day tomorrow with a lot of things to deal with. But if I could make it back by nine in the morning she had a couple of questions for me.

I knew what one would be—the circumstances of the accident—and I wasn't sure about the right answers for her. I remarked to Penny as we left that I saw the wake as a lifting of burdens: for Jackson the weight of his art and his agony; for us the powerlessness to help him other than by our presence; for Lee the release from having to take care of him and the anxiety that brought. Penny saw it as a bon voyage party.

CHAPTER TWELVE
GREEN RIVER II

For many of us the day after Jackson's funeral was one of recovery, emotional and physical. For Lee, there was hardly time for either. The Pollock family met for lunch at a restaurant. During it, Lee produced Jackson's will, which was dated March 9, 1951. She was sole heir and executrix. Had she predeceased Jackson, Sande would have been sole heir and had he not survived, the estate would have been divided among the three remaining brothers. Had Sande failed to qualify as an executor, Clem Greenberg was named to serve; failing him, Alfonso Ossorio. A letter, apparently undated, addressed to the executrix and substitute executors accompanied the will and, while not binding as a codicil would have been, it expressed Jackson's wishes:

> Lee—if you are the executrix lend some of the paintings to my brothers then living. Remember those paintings will belong to you alone and you alone can decide which paintings are to be borrowed and for how long . . .
>
> Sande—if you are the executor I want you to lend some of the paintings to our other brothers. If our Mother is then alive and in need you should apply part of your legacy under my will to her support and maintenance. This is a request which I would appreciate your carrying out.
>
> Clement and Alfonso—I would like you to dispose of my paintings rather than distribute them to my brothers. Give them the proceeds of the sale. Try to maintain the paintings as intact as possible.

The idea of maintaining the paintings intact also applied to Lee and Sande if the paintings were to be disposed of by them.

FRANK POLLOCK: Lee read it and there were no copies; I never did get my hands on it. I told the others later that it must be because Jack didn't expect to precede his mother in death that nothing was left to her. But I thought that loan basis was ridiculous. Jack wouldn't have *loaned* us anything—he'd have given it to us, or not at all. Sande took it the hardest.

JAY POLLOCK: Jack told me he had left a picture to each of his brothers. But I never read the will, don't know what's in it.

ALMA POLLOCK: Why would Jack do a thing like that? Lee must have nagged him, gotten another will out of him later on. And loaning a painting wouldn't be Jack; it could very well be Lee getting out of giving paintings to the boys.

ELIZABETH POLLOCK: Lee earned it. If ever a woman was entitled to every penny, living with that man—she didn't get half what was coming to her.

ALFONSO OSSORIO: The will *was* strange, though obviously there was reason for leaving it all to Lee—an overwhelming guilt perhaps. There was in the family a lack of understanding of what Jackson was up against and what his work involved, though they may have been supportive in terms of his human survival.

CLEMENT GREENBERG: I wasn't astounded by the will because Jackson wasn't up to dealing with others' needs. When he died Lee apparently paid no attention to the will, but later when his work began to bring in money, I asked her about it. She was indifferent.

B. H. FRIEDMAN: The thing I'm left with is the total trust in Lee; nobody really has any say but Lee. Sande and Arloie were extremely supportive, patient with him and at great hardship to themselves, being very poor. But when I said to Lee, "How could he not have left some work to Sande, Sande was so good—" she turned to me in a rage and said, "Don't tell me about brothers. I know all about brothers." That's a rather strong emotional thing. Something else Lee said is that "Jackson and I discussed all this long enough so that I know what he wanted. Don't worry, I'll take care of the McCoys." And she did do several things.

ARLOIE MCCOY: We weren't surprised. I have no feeling about it. Mother Pollock had one painting she gave Sande and we had one painting he'd given Sande before the work became popular. Sande was going to stretch it, but it burned up in the fire we had in the shop.

REUBEN KADISH: After Sande's death, Charles called me and said that a bunch of silk screens were disintegrating in Sande's basement. We took them to Bernard Stephens and he did the full edition of all the screens. Jack worked directly on the screen—he didn't work on a piece of paper—and he did each one on each screen. What we did was pull one print, correct it, take a photo of it and make a new screen. Lee paid for all the materials and the proceeds were supposed to go for the education of Sande's kids.

ARLOIE MCCOY: Lee wanted Sande to go ahead with the understanding that it would go for the kids' education. Sande was in the process of doing the screens again when he died, so then Reuben got the things ready. Lee did give me something, but she didn't give me anywhere near all of it. The edition sold for much more than I had any idea they would sell it for when first talked about.

PROFESSOR REGINALD ISAACS: On the day of the will reading we were numb. We went to the beach with Lee, six or seven of us, but didn't swim or play. We just sat in a circle and talked about what she was going to do. Lee was very calm and her decision was to let everything bide its time. She had been very unhappy in June, and I guess I was aware of that Kligman. After the beach I went out to the old barn—studio—for another look. It seemed odd that Jackson wasn't there—just the flies, the sunshine, the usual disorder. I couldn't believe it had happened.

Probate of the will was delayed by the inquest's not being held until January 18, 1957, due to Ruth's slow convalescence. But Lee underwent a rapid convalescence under pretty harsh therapy.

DR. SAUL NEWTON: A few nights after the funeral Lee was carrying on like an old-fashioned paid mourner. Franz Kline was there and she was blubbering "Help, help" at him. About midnight she *had* to visit the cemetery, so I took her and Patsy there. It was a dark night and I told Lee she would have just one minute. Then I told her when her time was up, got them back, and left her in Patsy's hands as a nightwatch. She slept off her grief and in the morning was in okay shape.

Lee refused to be alone at night on Fireplace Road and stayed with others, including us, at the Farm. Friends, soon to be known as "Lee's night ladies," took turns staying with her, often at considerable inconvenience. It was done willingly out of sympathy for Lee; later it was done because expected, and there was something about Lee's expectations one obliged. Those who didn't found themselves on a kind of nonperson list;

some see this now as an extension of the power of the Art Widow, described so well by Harold Rosenberg.

The first of Lee's two big questions to me was about the accident. It was asked on the back steps facing the pile of stones; it felt more like an audience with a grand inquisitor than a talk with a friend. Her follow-ups were numerous and to the point: That Jackson was not alone didn't have to be mentioned, so strong was the feeling emanating from her that the fate of others was unimportant. My findings were combined with those of the master mechanic Harry Cullum and neighbors. Lee listened intently, or seemed to, but kept making notes on a memo pad about other matters. I was amazed by her claim that Dr. Klein had said it was all right for Jackson to drink and drive.

HARRY CULLUM: He had to be moving fast—with that mile of downgrade and straight as you'd want, even if the Olds was on the tired side—85 to 90, anyway. There was one hell of a crown where the town tar road begins at the beginning of the left curve. Jeez, I almost lost my car a couple of times there when I was a kid, but finally you smarten up and ride that crown—the one they fixed *after* Pollock got killed. Now, if you're half bombed and don't catch her when that crown throws her to the right shoulder and into that loose sand in a low berm, with power steering you'll jerk her back too far on the other side. When you try to correct that, you're in a slide for those trees and she's tailing—then you've lost her, and she's onto those saplings too close to the shoulder anyways.

Next, and it had to happen fast, the saplings are laid flat, whip back up, and catapult the Olds end over end onto its rear bumper. That's when they were thrown out, before she dropped over upside down. There was only scratches, outside of the windshield flattened and a piece out of the steering wheel. If they'd had seat belts, wouldn't none of them lived; in stock car racing we never used seat belts if there wasn't a roll bar—suicide if you do.

DR. WAYNE BARKER: There's a line in *Under Milk Wood* in which the narrator says of somebody, "Poor so-and-so died of drink and agriculture." My version of Jackson's death is that he died of drink, young oaks, and the Town of East Hampton Highway Department.

CLEMENT GREENBERG: This is my hypothesis: He'd been out to spoil the girls' time all day. When he started back for the house after turning around, his fast driving terrified Edith. She started to scream and he had it in for Ruth so much, he took it out on this pathetic girl by going even faster. Then he lost control on the curve. The screaming is what did the killing finally.

• • •

Accompanying the effect of the screaming on Jackson, goes one theory, was the image not of the terrified Edith but of a tortured Stella. It is startling, but no more so that Lee's question: What was this she'd been hearing about "some suicide shit"? I quoted one of several remarks Jackson had made to me in which he indicated he didn't go for suicide: "Why give a lot of bastards a chance to say 'I told you so'? And you don't sort of take others with you, scarring them like Gorky did with that note when he hung himself, 'Goodbye, dears' or some shit. The guy always did talk too much."

Lee told me later that Dr. Henderson did not consider Jackson's death a suicide. Others were more outspoken on the issue, however.

DR. WAYNE BARKER: I did not see Jackson as suicidal, and I don't relate to suicide. While I'm willing to listen to the "Sometimes I think I'll kill myself" thing, I'd rather talk about the problems of living. The topic with Jackson never came up.

DR. VIOLET DELASZLO: I was not surprised, no—there were those accidents. This time, I thought, he has succeeded. But because it seemed he had reached a foreseen end does not mean there was no sense of loss for me—with Jackson there was great loss.

PAUL BRACH: He was looking to do it, but I don't think it was *real* suicide. At that point he didn't give a shit, and it's the way you die when you don't give a shit. Jackson was living at the edge and the edge broke.

The psychotherapeutic community summering on "couch hill" in Amagansett was shocked by the death, however predictable. Some saw it as symbolic suicide, others felt Lee's absence was a larger factor than Dr. Klein's. Then there was Ruth: The threat of commitment there frightened Jackson almost as much as the threat of permanent abandonment by Lee.

Winding up my accident analysis for Lee, I mentioned my concern that my building jack in the trunk might have contributed to Jackson's injuries, tactfully saying that he wanted to get working again on *her* studio. I explained that in spite of a dent in the Olds trunk top, presumably caused by a sapling whip as the Olds went end over end, the trunk had remained closed. I added that old Jimmy checked the car on Sunday and found no sign of the jack in the now open trunk nor, for that matter, of the Old's own jack or spare tire. Lee suggested that Jackson may have left it around "my place here"—an example of the rapid adjustment she was making to her loss. She said matter-of-factly that I could now forget any part in Jackson's death. I agreed, knowing that I could not.

Then Lee came to her second big question: Because Jackson was far from regulation in his life and work, she did not want a regulation headstone—maybe not even a headstone, but something with texture and form that would speak of Jackson. What ideas did I have? As we stared at the stone pile before us, I said—so automatically Jackson could have spoken through me—why not use one of these that had been "dowsed" by his magic?

Lee's phone rang and as she went to answer it, she said such a stone would do for now. She hoped it wouldn't be costly to get it there, and I called after her that it sure wouldn't—any charge was on us. By dusk, I had the biggest stone in the pile at the head of the grave. It looked so good, in addition to being heavy enough to make my tractor shovel grunt, I told myself that here was a stone which, along with Jackson, was going to stay put. But it didn't stay put for much longer than Jackson's work in the studio.

CILE DOWNS: When Lee asked us into the studio, everything was in piles. I thought he did all these great paintings here—what tremendous range! Lee was dating everything she thought she could, dating and making sure she had a clear idea of what was really Jackson's. There were things in there she said about, "These are not his." There were some collaborative works and Lee questioned several things, things he did work on with other people; these were put on one side to think about. She would say, "This one here, this is not by Jackson." But I think she was being *extremely* cautious about removing something that might be Jackson's work.

There were some things that Ruth did—Lee was even thinking *them* over, looking at them very carefully. She said, "Well, that may have been. But Jackson may have worked on them too." One was a small abstraction, sort of scrawly, wandering around—I think it was a painting rather than a drawing. There may have been others, but that's the only one I remember. I have no idea where it went and also I don't know where the painting supposedly given Ruth by Jackson went. I had no knowledge of Jackson giving Ruth *any* painting, but if I had I'd probably been in favor of her getting it if there'd been any way to arrange it.

I think Lee's rage might have been great enough to destroy a painting that she fully believed was Ruth's but not *ever* great enough to destroy a painting she believed was Jackson's. My feeling about Lee is that she had great respect and that she was a very responsible curator of Jackson's work. That was one of her roles as she saw it. She may have raged at Jackson the whole time, but that wouldn't have kept her from being responsible. She was very firm and did things in an authoritative way, and to stash work away for estate reasons or anything else would be out of character for her.

• • •

Rumors of work missing from the studio began early.

B. H. FRIEDMAN: Lee and I were going over all these photographs
for the estate, and I was watching specifically for this gift painting [to
Ruth] and it wasn't there. So that's one painting we know somehow
disappeared from the barn, and I know Ruth doesn't have it because she
is still upset on the subject. I think somebody stole it—I think things were
stolen from Jackson's barn, and Lee suspected some things had disap-
peared. But it would be a wonderful plot flourish had it been destroyed;
however, Lee would never have destroyed a thread of canvas if it were by
Jackson. But if ever she did this could be the one.

One of the mysteries surrounding Jackson's studio after his death is
that so many signed works came out of it; he was an artist for whom
signing was a stumbling block, and even with gifts it was never done
easily.

ARLOIE MCCOY: When Sande was dating Jack's work after the
death, he didn't do any signing although Lee may have signed some. The
thing about signing came up when Jackson was at our house; it bothered
him, but he signed one of ours.

NICHOLAS CARONE: I was in the studio with Lee after Jackson
died and we were going through all these rolled canvases, finding a lot of
stuff unsigned. She asked me to sign; she said, "Can you do it?" I said,
"No, I don't think I can." I don't know how to fake a signature, but I said
I knew the perfect guy. He taught lettering, was one of the best in the
business, and I was there when he did it. He did it in charcoal and she
said, "It's okay." He wasn't keen on doing it, but at that time everybody
wanted to be nice to Lee. This is a multi-million-dollar affair and bigger
than she ever dreamed of when she came back from Europe. She didn't
know what a windfall it would be; nobody knew.
 About collaborative works, Jackson was in my studio while I was work-
ing. He would do little gestures, and I could say that I have things that
were collaborative. And there are a lot of fakes around; it's easy to do if
you're in the milieu, know how. A young couple I know did some in
Europe, and over here they did a Franz Kline for a nice bit of change.

The forgery market in Pollocks slowed due in part to an authentica-
tion committee blessed with Lee's eagle eye. Manuel Tolegian ran up
against this barrier when he submitted three unsigned abstractions to
MOMA. He told me, "I saw Jackson do them with my own eyes." There
have been a number of works lost, or that cannot be identified—at least

fifty according to the meticulous catalogue raisonné's accounting. As for canvases being discarded by Jackson, he had too much trouble being sure a work was finished. Besides, art materials come high.

ALFONSO OSSORIO: He might say a canvas didn't work, but usually he'd keep on. It was his total being that was involved in the pursuit of creation, just as he would say, "I have to get into the canvas to relax." As does every artist, he repainted, but I feel he destroyed very few pictures.

A couple of days after I set Jackson's gravestone, Lee told me that it didn't "work," using Jackson's word, and that she was keeping an eye open for what would.

ELEANOR WARD: I remember Lee going all over the place looking for a big rock. We even went to Sag Harbor, looked around at Alexander Brooks's too. She was obsessed by finding a big rock.

JOHN LITTLE: I found what I thought was the right one on the way to the dump. I called Lee, she took one look and said, "That's it."

Harry Cullum and I probed it thoroughly and decided we could handle it with our heavy equipment in half a day. I told Lee that there was nothing to it and that there would be nothing to pay on this one either. It was the least we could do. As it turned out, we wished we could have done a lot less. Our writeoff charges ran the cost of a couple of funerals for Jackson.

HARRY CULLUM: I still don't get it. That boulder was like an iceberg—most of it was underneath, going way down to a point, which is why we didn't feel anything around its sides. We asked her about blowing it with dynamite to get it down to something reasonable for us to handle—it never would have showed on the grave—but nothing doing. That was the rock she wanted and she wanted *all* of it.

It took our 'dozer, tractor shovel and winch truck over two days to excavate that bastard and work it onto our specially reinforced lowbed trailer. That bastard had to weigh not less than forty tons, but we made it to the cemetery driveway. There, though, the sonofabitch near had us. Instead of crawling *up* the grade on that driveway to the knoll where the grave is, tractor and lowbed trailer just went *into* the grade. We had to use a lot of tackle—cables, chains, snatchblocks, deadmen—to winch the rig all the way up. By the time we had it where we wanted it by the grave, there was some crowd collected. Then we had to re-hitch everything to get the damn thing so's it would roll off the trailer to drop in the hole we'd dug next to the coffin without crushing it. There wasn't a concrete

vault to protect it and being only wood, you slam a boulder against it and you got a cracked egg.

When we put a strain on all the gear to start turning it, I warned this old geezer to get clear on account of the strain. "Sonny," he says, "I been around this stuff longer than you been alive." Just then our big snatchblock shattered and a flying piece just missed his head—I never would have thought an old guy could move so fast. Anyway, we were some lucky: That boulder landed just where we wanted it, but it wasn't where *Lee* wanted it. We turned it for her, what we could, then that was it—turned any more the pressure against the coffin would have shot Pollock out of it like a cork out of a pop bottle.

By then it was quitting time and that whole crowd just got in their cars and drove off, leaving us to work till near dark getting all our gear together and taking care of that driveway. But the cemetery came out all right—practically a new road. And Pollock, he sure got a laugh that day.

The plan was for the boulder to serve as a monument for the whole plot, with the stone that didn't work for Lee as Jackson's gravemarker. However, the stone was moved near the bottom of the plot and eventually it was assumed that the boulder was Jackson's headstone. A slate platform was placed in front of it, although Jackson lies behind it.

In the fall of 1972, I was still haunted by my last scene with Jackson, as well as by uneasiness about the building jack danger. Allegations that I was part of a conspiracy responsible for an insurance award of a mere $10,000 to Ruth Kligman due to my testifying at the inquest to Jackson's sobriety and careful driving determined me to examine the proceedings. There began a relationship with the offices of the Suffolk County Clerk and Medical Examiner extending over the next fourteen years and involving lawyers of three different firms. Through what turned out to be a clerical error, I was advised that the inquest was sealed by court order and that a waiver must be obtained by the next of kin. Lee's not unreasonable response to my request to have the proceedings reopened was that Jackson was dead and that's all that mattered.

I settled for this, being certain that I had not testified at the inquest. But Patsy Southgate reminded me that she and I had driven Jackson's physician, Dr. Elizabeth Hubbard, to Riverhead for the proceedings and that I had accompanied the doctor into the courthouse. It seemed possible after all that in my efforts to oblige the bereaved Lee I had testified to Jackson's sober character. This led to further exertions to obtain a copy of the proceedings and soon others were after it too. So energetic were they that the County Clerk's office called to see if I knew its location, since my name was on record as having tried to obtain it. The call ended with a question I was beginning to wonder about myself, "Who was this Pollock, anyway?"

My second lawyer was unable to get anywhere through proper channels, tried an improper one and failed. After many detours, a third lawyer came up with the now clearly marked route to the truth: All along we had been pursuing a different and intestate Pollock. Now the Medical Examiner's Office doubted there was a file for Jackson's inquest, adding that coroners then kept their offices in their hats. The County Clerk's office did a further search and announced that the file was either lost or destroyed. Our further efforts finally produced it, along with hundreds of others, in disintegrated cartons in the old county jail—uncared for, unmissed, and, due to file numbers out of sequence, next to unfindable.

The fact is that neither Dr. Hubbard nor I testified. When Ruth brought the negligence action for $100,000 against Lee as executrix of Jackson's estate, her counsel reminded her that she had "loved this man" and that she must "protect his memory." This Ruth did effectively in her testimony at the inquest, the description of those last minutes being very different from her account in *Love Affair:*

> . . . We were driving quite normally . . . we passed a curve a little fast and I told him to slow down a little bit—take it easy . . . I felt the car a little out of control, and with that we started skidding. I passed out; I became unconscious before the crash—as we were kind of going toward the trees . . . I don't remember anything until I woke up a few minutes later on the ground, and I hadn't remembered how I got there or anything . . .

There is no indication here of negligence or drunken driving, nor mention of alcohol at all. Ruth told me that her action was settled for $10,000, of which $6,000 went for medical expenses, and that the estate of Edith Metzger also received $10,000. That it took still another lawyer to confirm that Ruth's action was brought in the U.S. District Court is consistent with the earlier efforts; so was the fact that we were informed that the file index was missing, then that the box containing the file was empty. Both items were eventually located, but their disappearance never was explained.

The autopsy report discloses that Dr. Cooper did not perform it after all; that the coroner observed it; that Jackson's "liver was tremendously large, extending way over into the left side of the abdomen. There was a diffuse fatty infiltration of the liver throughout, Meckel's diverticulum [residual fetal structure not unlike the appendix]." Also of interest was that there was no mention of blood or organ samples having been taken; and Patrolman Finch's testimony placed the body only nine feet from the car, which he sees now as due to a typing error in the police report. Were it accurate, it would make the neighbors' reports of Jackson's flight being as "straight as an arrow" not quite that straight.

The estate accounting makes for depressing reading: income tax balance due with interest and penalties amounting to almost $800. Offsetting this are the appraisals of the two Fireplace Road parcels at $31,000, personal effects $250 (the Olds zero), and what presumably is a partial inventory of works averaging about $2,500 each with the exception of a few large notable ones such as *Stenographic Figure* at $3,000, *Summertime* at $12,000, *There Were Seven in Eight* at $9,000, *Search for a Symbol* at $5,000, *Moon Woman Cuts the Circle* at $2,000, *Easter and the Totem* at $9,000, and the superb *Autumn Rhythm* at $20,000. Bernard Reis, later a defendant in the Rothko case, was the tax consultant.

B. H. FRIEDMAN: It would be logical for any good accountant to try to raise prices enough so there wouldn't be huge capital gains later, but at the same time keep them low enough so there wouldn't be a gigantic estate tax. Lee offered the Whitney the biggest, most major paintings at $10,000 to $12,000 but was turned down because it was thought such an overwhelming price. That was the range then, about a year or so after Jackson's death, when everything had been photographed.

It has been claimed that Jackson's estate, appraised at $80,000, within twenty years—even allowing for sales—would be in the $50 million class, a capital appreciation for which Lee could claim much of the credit.

SIDNEY JANIS: After the second exhibition following his death, Lee was a little discouraged by our selling quite a few at low prices and decided not to deal here. He died a little too soon, but other artists were immediately affected—began selling and raising their prices after that romantic death—like Van Gogh's.

ELEANOR WARD: Her handling of the estate was the most brilliant thing that's ever been done—without her those price levels never would have happened.

ALFONSO OSSORIO: Although asked to be a pallbearer (a brother was forgotten), for some reason I was never asked to take part in anything to do with the inventory and I remember thinking it was a little odd. But Lee made a very touching remark about it, probably in the mid-1960s. She exploded and said, "Something people never dream of is I might love these things and not want to let them go!" I think there must be truth in that, or else she'd never have been able to hold out, which is what made it work so well.

BEN HELLER: Bob [Friedman] and I were the two people who said to Lee most strongly, "Don't sell the paintings and put them into stocks and bonds. The paintings will do better later, you can control it better!"

JOHN LITTLE: The three great dealers in the U.S.? Pierre Matisse, Leo Castelli, and Lee Krasner.

One convenient tax provision for an art widow of substance is that she can sell a major work to a museum at, say, $1 million and donate several earlier works valued an equal amount, thus resulting in substantial tax deductions. It is a good deal of money saved for her and a good deal for the museum. In a more elaborate 1980 arrangement with MOMA, seven works worth more than $2 million were acquired, three by donation from Lee and four by purchase. Lee called it a great relief.

Wealth meant no more to Lee than it had to Jackson, yet after his death much of her energy was involved with handling wealth and not all of it was pleasant—nor did it enhance Lee's reputation as a pleasant person. Peggy Guggenheim brought an action against Lee charging that she had been defrauded of paintings rightfully hers under her contract with Jackson. After turmoil on both sides, it was settled as amicably as such matters can be. Then there were the much publicized re-sales of Pollocks at huge prices, which—though they increased the value of Lee's remaining Pollocks—did nothing for her except confirm her conviction that artists and their estates should share in the appreciation of their work. She also had to hear complaints from collectors that Pollocks have a way of flaking, cracking, even shrinking. Some have, including *Blue Poles,* and are no longer loaned.

EMILY TREMAINE: We had seen *Lavender Mist* at the Pollock retrospective after his death [at MOMA, instead of the scheduled works-in-progress show] and the whole room was filled with a lavender light—it almost glowed. Even though the $1 million Ossorio was asking was quite a lot of money in those days, we went to his place to see it and never had a more wonderful meal than he put on for us. But it was dimmer—had lost its glow, seemed almost faded. Then when we were told that he had offered it to the Boston Museum of the Fine Arts, which turned it down, we lost interest.

ALFONSO OSSORIO: It was never bright, and aluminum does tone down a bit. The National Gallery of Art paid $2 million in 1976. [Ben Heller insists the price was $2.5 to $2.7 million]. I *asked* Boston to send it back, being tired of the dickering, and it was the wisest thing I ever did.

MAY TABAK: Jackson knew they had used him, plugged him, then when he wasn't selling, dropped him because he wasn't turning out the things they wanted. And Clem Greenberg, when Jackson couldn't do it anymore—that business of Clem walking into a gallery and walking out saying this is good, that isn't—what nonsense! This jackass did a terrible thing to an artist.

PATSY SOUTHGATE: I think when Jackson had nothing he felt fine. When it became evident he didn't have to be a turd in life, and there were all kinds of possibilities for him, he was just frightened to death. It probably had to do with fear of accepting himself as being a valid person, and that he could deserve to have good things, even fame, happen to him—that he deserved to be loved, to be respected, to be paid, to experience others.

PAUL BRACH: There was a former actress who lived at the Albert Hotel and she came up to Jackson at a bar. He was drunk, no more than usual, and she said, "If you'll buy me a drink, I'll read your palm." She seemed very old to us—tiny and shrunken—and he held out one of those big hands. She studied it, then said, "Your creativity line is very, very strong. Are you a creative person?" Jackson slammed his hand on the bar and shouted, "I'm *Jackson Pollock,* you whore!"

REUBEN KADISH: People were going out there in the early years and paying homage. In New York he had been very much carried away by the Surrealists' homage, and even Mondrian extolled him. When you have people that are gods up there talking about you as an equal— America was the lowest rung of the artistic ladder—and these guys are here from Europe looking at what you're doing as something really important . . .

Jack and I celebrated our birthdays together—we were two January days apart—and we would start on his and end on mine. In between this year, we were at Eddie Condon's and so was Max Baer, the heavyweight champion. Baer was with four girls and four men, buying the drinks, and called us over to join him. We explained it was our birthdays and he turned to Jack and asked who he was. Jack told him—now this is part of his ego, like that "Europe can come and see me!" Max Baer said, "Who the hell is Jackson Pollock?" Jack told him, "When you're gone, people aren't going to remember *you.* But Jackson Pollock—they're going to remember Jackson Pollock."

LARRY RIVERS: I think he had the kind of character that once he got that much attention, it so blew his mind that he had no way of recovering from it. For instance, a guy beats the crap out of some woman and then she says, "He loves me." It's the oldest model you have in mind when you paint: Somebody comes along and says "Great!" It's like, what are artists of the past but *famous* artists of the past? These famous men you have admiration for, you want to imitate in some way—possibly not only what they have done as artists but their reputation as men among other men. Pollock was like American—in my background, with everybody European, I didn't have his rollicking, mother-fucking macho.

ISAMU NOGUCHI: In my last meeting with him, he was disapproving about his success and he was very disturbed. Lee wasn't there and he talked freely about trying to break away from the trap of success, the trap of a narcissistic way of working. He wanted to go *beyond*.

CILE DOWNS: I think Jackson felt fame was for the birds. He really hated all that stuff; he wanted to be loved, understood, and appreciated by people who could look at painting. He so hated fame he would do the most vicious things to admiring people; he hated the whole apparatus—critics, dealers, all those schemes. Yet he wanted to be *numero uno* with everybody loving him, only as though he were nobody. He never got over the fact that people don't love you as much when you're big and successful as they did when you were poor and a nonentity. And so he would complain—complain a lot.

JOAN WARD: I can't remember any painters envying Jackson his success; he suffered too much for it. He and Franz Kline were casualties, being spearheads under that tremendous pressure. It was too much, then at the end not painting—just sitting . . .

GEORGE MCNEIL: He suffered the burden of the pioneering role. I think it affected his sense of responsibility, this having to come up with surprises; that's hell. He would have been much better off if he had not achieved all that notoriety, but if fame comes you have to accept it. And nobody can give up that kind of fame.

ALFONSO OSSORIO: Jackson resented his freedom being curtailed. His absolute freedom to paint was affected; it put a demand of a different sort on the free productive flow. But whatever negative was happening in Jackson had nothing to do with success but with his work.

Yet he felt terrible when he wasn't being recognized, or when the black and white show wasn't understood. There was very little understanding of what he was really doing and going through. I don't think the negative things to do with vulgar fame were more than the troubles he would have had as an artist anyhow. Nor do I think there was fear in Jackson of success so long as he was not standing still. Had he lived, it would have been more difficult for him to keep his demons under control. And there would still have been that awful thing of trying to break the cord with Lee. There was a maternal aspect in that relationship, the way she treated him like a child and he hating it.

JIMMY ERNST: He is to American painting what Cubism is to French painting. And how I sympathize with Lee, knowing that it was not very comfortable becoming the warden of another's reputation and being identified with it.

• • •

When Lee was finally unencumbered enough by estate problems to get back to her own work, she had the artist Athos Zacharias scrape down and paint the floor of Jackson's studio. For visitors, though, Jackson's presence remained strong, and in Lee's failure to establish herself as a painter totally separate from Jackson's career there is an injustice she did not deserve in view of her creative force and ability. Nevertheless, due to a combination of gallery access thanks to bringing with her the Pollock estate, the feminist movement and the devotion of art historian Barbara Rose, curator of twentieth-century painting at the Museum of Fine Arts, Houston, Lee is now a major figure. The effect of Lee's first retrospective at MOMA in December of 1984, organized by Rose and installed by the erudite William S. Rubin, is bound to confirm that position.

RONALD STEIN: I believe that never in her heart did it occur to Lee to be jealous of Jackson's work, but she never felt comfortable working in his studio after he died. Most of her work was done in the 79th Street apartment.

ELEANOR WARD: Last Thanksgiving when I was at a bakery, Lee walked in. Guess what they called her—Mrs. Pollock! I was taken aback because she had worked so hard to be Lee Krasner. But there it was: in the art world Krasner, socially Mrs. Pollock.

A lot of people took exception to that *Krasner/Pollock: A Working Relationship* show Barbara Rose curated at Guild Hall in 1981, I think. I didn't like it, didn't think it was at all a good idea, and I don't like the rewriting of history.

SIDNEY JANIS: I was very much disturbed by that exhibition. First of all, Krasner/Pollock, not Pollock/Krasner. Then in looking at the exhibition, it was—*cruel* on Lee. And she was not aware of that. Also, I felt, any debt between them is the other way round.

CAROL BRAIDER: During Lee's last summer when I was sort of her sitter, she was consumed by rage. She was afraid that if she couldn't find a way to take out her hate on the world, she wouldn't be able to go on painting or even exist. Those weeks were a nightmare. It was as if rage were all she had. Of a Bill de Kooning work going for $2 million, Lee said, "If Bill thinks that's something, wait until he hears the latest in Jackson's sales."

B. H. FRIEDMAN: I really feel Jackson had said what he had to say. He'd made his breakthrough and in a comparatively short time made an enormous statement, produced a great deal of work. I don't think an artist has to do more than that.

LARRY RIVERS: I think maybe what finally happened to Pollock was that the mine—a certain idea—went dry. I mean, how many times can you keep doing it?

PATSY SOUTHGATE: Oh, I think Jackson would have disciplined things. He had such a magnificent force and too much creativity still to have gone under. And if he'd had a good shrink, or its equivalent somehow, he'd have gotten his drinking under control.

ALFONSO OSSORIO: Jackson was *not* finished. He had made it impossible for Lee to stay with him, but there is no question that he had every intention of continuing. I don't think he had *any* feeling of being finished. In any artist's career of length there are periods when there is a complete outpouring; other moments are of a more studied rather than inspirational work. Jackson had had an unbelievably productive decade up to, say, 1952, followed by a short four years in which there was thinking about creative projects, even to do with sculpting—that pile of stones behind the house . . . at the end he was still searching.

DR. WAYNE BARKER: There was this two-handed thing with Jackson, a guy with two halves trying to put them together. He was searching for a oneness, a unity and togetherness with himself. He was doing it through others, depending on them for a sense of unity, and that two-handed way of being would have led him to sculpture—it was always there.

BETTY PARSONS: He added a new dimension, the expanding world. Picasso could never have painted that expanding world. Jackson expanded nature, and the Europeans understood that.

SIDNEY JANIS: Jackson Pollock is the most important painter in the history of the American scene. He created a unique image and he belongs at the top—no question about it in the world view.

DOROTHY MILLER: Without meaning to be, he was a great innovator. If I were doing a show of art from 1900 to 1980, I might leave out Clyfford Still; I can imagine leaving out Motherwell, and I don't know about Rothko. But I'd sure have Jackson. His place is very, very high.

PROFESSOR REGINALD ISAACS: Jackson is the preeminent figure in art history and I do not limit him to American art. His influence has been enormous—not only on other painters, but on the thinking and attitude of architects. There is a feeling of comprehensiveness in his painting which is very important to me as a planner and architect.

B. H. FRIEDMAN: I wasn't prepared for the fact that he would be considered the giant he is today. I thought him a figure important enough to consider as a central character in a biography, and I did feel there was a mythic quality to his life, but I had no sense of showing a piece of history. Now I maintain that he is the most important painter; his is a bigger, more evocative kind of imagery.

ROBERT MOTHERWELL: I underestimated him. Now I would rate him very high—higher as a symbol than by actual deed. I would guess that he will remain a permanent legend equivalent to the Van Gogh one but more forcefully as the world looks more and more to America. In the end he did destroy himself and another; looked at in humanistic terms there is something horrifying about it. Still, in that all out-ness there is a terrible beauty—what Europeans expect Americans to be: simple, violent, and direct, also preferably unsophisticated.

LARRY RIVERS: His works embody that whole idea of the automatic, the unconscious and natural choice of color that was just him—they're like the gorgeous remains of some weird culture. He was a perfect product of that time, exemplified it, and he was full of power and contradictions. He opened up the whole idea of images with generous proportions—before that no one would have them so big. He opened up things for me directly.

GEORGE MCNEIL: Pollock is an extraordinary figure, a phenomenal figure, and is one of those artists who are midwives: They change the course of art. The great power in his work helped all of us who were so intellectually dominated by consideration of form—it was really a tonic.

ALFONSO OSSORIO: He both answered and raised a whole series of new questions for us in the art of our times. He touched the truth, as far as one was able to see it.

MURIEL KALLIS NEWMAN: I put Pollock on top of American art, and for more than Bill's saying "He broke the ice." It's that he innovated a way of seeing, and I looked at his work as an ontological experience that goes beyond our understanding of existence into dimensions not in our ken.

PAUL BRACH: He was the end of Expressionism. He grafted Surrealist Autonomism to Expressionism, and he made about a dozen paintings that moved me very deeply—still do. His position is clear: a major, seminal breakthrough figure.

AXEL HORN: Jackson's death was a Pollock way to go. His place in a certain sense is a fabrication, a useful fabrication that has stimulated a lot of new color and direction unconsciously and not by design. A myth grew up around him, and the time was right. He was "Destiny's child."

FRITZ BULTMAN: American painting had gotten itself in a bind with Mondrian. A lot of people see Jackson in relation to Picasso, but I think he broke up that Mondrian image, helped by calligraphy, and showed that painting could go beyond it. I feel a great pantheism, and a tremendous wholeness in his work, and so I think he's very, very important. As someone said, "There was art and then came Pollock." I believe this.

ELIZABETH POLLOCK: As with parallel breaks in traditional writing patterns, at a particular moment in history he did his abstractions. It is all juxtaposed, which is in fact what genius very often is: the right person at the right time doing what we are culturally ready for.

LEO LERMAN: The effect of this prodigious influence is there in the fact that even people who don't know of Jackson Pollock see differently because of him—all sorts of visual things couldn't have happened without his influence. Pollock freed the eye and he freed the imagination, making him of great stature. He really saw the cobwebs in things and cleared them away.

FULLER POTTER: When you're painting with the rational mind and your work pretends to scream, it is nothing. But the great Pollocks *are* screaming; they are rich and wonderful. So he upped and died.

Jackson's death, of course, was not unexpected and neither was Lee's. She died on June 20, 1984, at New York Hospital, where she was taken for a transfusion in the hope of arresting a debility that had reduced her to ninety-four pounds.

PATSY SOUTHGATE: When I saw her three weeks earlier she was still being wheeled to the park, but she was very weak—and very low. She gave me the feeling of wanting to go, so it's good that she did. But she wouldn't have thought the funeral was so great—you can't get the art world to come to Sag Harbor on a Monday.

Lee would not have thought the location of her grave so great, either. Instead of being alongside Jackson, who lies on the west side of the grave boulder, Lee is on the east side near his feet. I don't know what either of them would make of this, nor do I.

But what to make of Jackson, a man who has haunted me for over three decades?

NICHOLAS CARONE: He was *authentic*. Jackson never played a false note, never put on an act creatively. I can't say that about Picasso.

MILTON RESNICK: For a lot of dead ones I don't give a damn, but Pollock made the world interesting. Of all the people I've known I wish most he was alive.

CLEMENT GREENBERG: We were with the truth when he was sober, but even drunk he was a damn wonderful human being. That's why we bothered with him. In my time and need Jackson was great for me, and in the end—I came to prize the man more than the work.

To put the work before the man never occurred to me until I went to Jackson's extraordinary retrospective in the late winter of 1982, curated by M. Daniel Aberdie at the Centre Pompidou in Paris. For the first time I was able to see the work without the impact of the man being in the way. I was astonished that Jackson had found a way to translate his power and sensitivity as a person, together with that unexpected lyric quality, to his work. The effect on me was so strong I was tempted to forget the person, thrusting him aside as merely an agent for the creation of works that had to come from a source near the divine.

But the fact of the *person* returned—in part because of the reverence of those 3,500 viewers who daily crowded that vast space. That so many of the young spent so long on their knees looking at individual works I put down to tourist fatigue, but on one of my last visits—I went each day for over a week—I realized that the occasional wet cheek I saw was not from the Paris drizzle because those transformed faces were coming from the show and not from outdoors. Since then, the artist Pollock and the man Jackson have become one for me.

The genius of *Jackson* lay in the ability to locate and invade another's core, in a sense making himself part of you. The genius of *Pollock* was the magical gift of transferring the human dilemma to a spiritual rather than merely aesthetic level and giving it life. In so doing he didn't create beauty so much as he made us beautiful in our appreciation. Either way, Jackson or Pollock, this is greatness. For it I am grateful, and by it I am made humble.

PERSONAE

Abel, William, M.D. A founder of the East Hampton Medical Group ("The Clinic"), now professor of Surgery at SUNY, Stony Brook.

Ashton, Dore. Critic and art historian, head of the Cooper Union Division of Art, NYC. Her criticism has appeared in over 70 publications; among her books are *Readings in Modern Art, The New York School, About Rothko,* and the recent critical study of her friend Philip Guston, *Yes, But.*

Barker, Wayne, M.D. (d. 1984). Psychiatrist, southern Illinois. Studied at U. of Chicago, William Alanson White Inst., NYC. Did psychosomatic research at Cornell emphasizing epilepsy, taught at New York College. Author of *Brain Storm.*

Barnet, Will. New England-born artist. Did clear-edge abstractions; in the 60s abstraction and figurative work overlapped. Also noted for his prints. Shows at Terry Dintenfass Gallery.

Bell, Leland. Painter, jazz musician, Washington, DC. "Mondrian was my mentor, did abstractions until late 40s. Same predilection for rhythms and forces are in both ways of working." Founder of the New York Studio School in Paris and an intimate of Giacometti and Arp. Shows at Robert Schoelkopf Gallery.

Blake, Peter, FAIA. Chairman, Dept. of Architecture and Planning, Catholic University of America, Washington, DC. Former curator, Dept. of Architecture and Design, MOMA; former editor of *Architectural Forum.*

Borgenicht, Grace. Art dealer, NYC. Opened her gallery with advice of Jimmy Ernst, Milton Avery, Ilya Bolotowsky; her private collection includes work by Matisse, Cézanne, Picasso, and Gottlieb. Married to artist Warren Brandt.

Brach, Paul. Second Generation painter, writer on art, NYC. Studied with Philip Guston, U. of Iowa, taught at numerous art schools. Many shows, including Leo Castelli Gallery; frequent critical essays. Married to artist Miriam Schapiro.

Braider, Carol. In 1954 opened House of Books & Music in East Hampton with

late husband, Donald Braider. "He had a breakdown the day after Jackson's funeral, and wrote *Palace Guard,* an alcoholic's book forecasting his own suicide."

Brooks, James. Painter, St. Louis, Mo. Studied at Art Students League with Boardman Robinson, taught at Pratt, Columbia, U. of Pennsylvania, Cooper Union. On WPA Project did mural at La Guardia Overseas Terminal, recently restored. Numerous awards; solo shows at Borgenicht, Stable, Kootz, Jackson, and Gruenebaum galleries. Married to painter Charlotte Park.

Budd, David. Painter, St. Petersburg, Fla. As circus worker, was married to bareback-rider member of Cristiani family. Most recent show of abstractions at Max Hutchinson Gallery.

Bultman, Fritz. Painter, New Orleans, La. Studied under Morris Graves, New Bauhaus (Chicago), Hofmann School (NYC), and Provincetown. Taught at Pratt, Hunter; awards and fellowships. Solo shows at Hugo, Kootz, Stable, Jackson galleries; also Galerie Stadler, Paris. Work in major collections.

Busa, Peter. Painter, sculptor, Pittsburgh, Pa. Studied under Benton at Art Students League, Hans Hofmann, etc. Taught at Cooper Union, SUNY/Buffalo. Chairman Dept. of Studio Arts, U. of Minnesota. Work in numerous collections.

Carone, Nicholas. Painter, NYC. Studied at National Academy of Design, Art Students League, also with Hans Hofmann and muralist Leon Kroll. An intimate of Matta, Gorky, Duchamp, Alexander Iolas, he teaches at New York Studio School. Shows at Stable, Staempfli, and Frumkin galleries, extensively abroad.

Cavallon, Giorgio. Italy, to U.S. 1920. Studied at National Academy of Design and with Charles W. Hawthorne and Hans Hofmann. Assistant to Arshile Gorky on Federal Art Project, charter member of American Abstract Artists and the "Club." Shown at ACA, Egan, Stable, Kootz, A. M. Sachs and Gruenebaum galleries. He is represented in such collections as the Guggenheim, Whitney, Albright-Knox, MOMA, and Fogg Museum.

Cherry, Herman. Artist, poet, Atlantic City, NJ. Studied under Stanton Mac-Donald-Wright at Otis Art Inst.; at Art Students League with Benton; taught at U. of California/Berkeley, U. of Minnesota. On WPA Project, also Hollywood scene painter. Abstractions in many collections. Recently shown at Luise Ross Gallery.

Cole, John H. Journalist, member of an early "summer people" East Hampton family. Fished commercially there before moving to Maine and founding weekly *Maine Times.* Writes on environmental issues, and led the 1983 "Save the Moose" campaign. Author of *Striper* and *In Maine.*

Collins, Mike. East Hampton landscaper, did much of the extensive plantings at Ossorio's estate, The Creeks. Grandson of Mrs. Nina Federico of Jungle Pete's.

Cook, Edward F. (d. 1984) East Hampton realtor, insurance agent. "To make a dollar here now, you got to grab it."

Darrow, Whitney, Jr. Cartoonist, Princeton, NJ. Noted particularly for his work in *The New Yorker.*

Dayton, Frank. Cabinetmaker, builder, community leader. Senior member of a family old enough to have built East Hampton's "Home, Sweet Home" cottage two centuries before John Howard Payne made it famous.

Dehner, Dorothy. Artist, sculptor, poet, Cleveland, Ohio. Studied UCLA, Art

Students League, Atelier 17. Wrote foreword to John Graham's *Systems and Dialectics of Art.* First wife of sculptor David Smith. Solo shows at Fried, Willard, Sachs galleries; work in numerous collections.

De Kooning, Elaine. Painter, lecturer, NYC. Studied at the Leonardo da Vinci and American Artists schools, privately with Conrad Marca-Relli, Willem de Kooning. Many teaching posts; solo shows at Stable, de Nagy, Wise, Graham, Elaine Benson galleries. Work in the collections of SUNY/Purchase, MOMA, Kennedy and Truman libraries.

De Kooning, Willem. Artist, Holland, to U.S. 1926. Studied abroad while a house painter. Did murals for 1939 World's Fair, French Line pier, Williamsburgh Housing project. Taught at Black Mountain College, Yale. Numerous awards; intimate of Arshile Gorky and John Graham. Solo shows at Egan, Janis, Jackson, Knoedler, Gimpel, Xavier Fourcade galleries. Retrospectives at MOMA and Amsterdam/Stedelijk in 1968, at Whitney in 1984. Work in most major collections.

DeLaszlo, Violet Staub, M.D. Psychoanalyst, Switzerland. Studied in Zurich, Geneva, and Vienna; analyzed by Carl Jung, whose close friend she became. To U.S. 1940; established private practice, edited works of Jung.

DiLiberto, "Sam." Former Cedar Tavern co-owner and bartender in both its locations. His sense of responsibility and forceful authority was much respected by Jackson.

Dodge, Mrs. Mary Louise. Member of venerable Edwards family of East Hampton. Father was justice of the peace, mother used to take Lee for East Hampton shopping trips in the Pollock bike days.

Downs, Cile. Painter, stencil designer, feminist, Waco, Tex. Better known for her stenciling under the name Cile Lord (she was once married to artist Sheridan Lord) than as a painter, she has been represented in numerous shows. Her most recent was with Charlotte Park and Mary Lincoln Bonnell at the Susan Caldwell Gallery presented by Elinor Poindexter. Co-author with Adele Bishop of *The Art of Decorative Stenciling.*

Dragon, Ted. Dancer, Mass. Studied with help of a scholarship promoted by Balanchine; appeared with American, New York City, Marquis de Cuevas, Paris and Metropolitan Opera Ballet companies. Retired 1952, and with Alfonso Ossorio has been developing the East Hampton Herter estate into one of great opulence.

Ernst, Jimmy (d. 1984). Painter, Germany, to U.S. 1938. Son of Max Ernst, he taught at the Museum of Fine Arts in Houston, Brooklyn College, Pratt. Numerous commissions and awards. Solo shows at Carlebach, Fried, Armstrong, Borgenicht galleries. Work in MOMA, Whitney, Guggenheim, Metropolitan, etc. Author of *A Not-So-Still Life;* member American Academy of Arts and Letters.

Federico, Mrs. Nina. Member of the notable Miller family of Springs, well known for her forty-odd-year ownership of Jungle Pete's. "It got so crowded we couldn't make any money—why, there was even a fellow asking about any bar stools Mr. Pollock used. As for *him,* he was just a poor man in jeans and jacket."

Feldman, Morton. Composer, lecturer, NYC. Studied with Stefan Wolpe; intimate of John Cage, Earle Brown, David Tudor. Developed new sound rela-

tionship through interdeterminancy and graphic notation. A prolific composer and author of numerous articles.

Ferber, Herbert, DDS. Sculptor, NYC. Studied at City College. Solo shows André Emmerich, Kootz, Parsons galleries, Whitney Museum. Work in numerous collections.

Finch, Earl. East Hampton town police patrolman at the time of Pollock's accident. "Then it was one radio car, three of us officers, and you didn't bother the chief after four P.M., no matter what." Retired as lieutenant.

Flack, Audrey. Photo realist painter, NYC. Studied at High School of Music and Art, Cooper Union, Yale, NYU (with Josef Albers). Taught at Pratt, NYU, etc. Solo shows at Roko, Louis K. Meisel, French & Co. galleries. Work in collections of MOMA, Oberlin, and many others.

Fortess, Karl. Painter, lithographer, Belgium, to U.S. 1915. Studied Chicago Art Inst., Art Students League, also with Kuniyoshi. Taught at Brooklyn Museum, American Art School, Boston U. (professor emeritus). Work in collections of Brandeis and Cornell universities, MOMA, etc.

Frankenthaler, Helen. Second Generation painter, developer of "stain school," NYC. Studied with Tamayo, Feeley, Hofmann. Taught at NYU, U. of Penna., Hunter, Bennington College. Solo shows at Tibor de Nagy, Emmerich, Esman, and Knoedler galleries, Jewish Museum. Work in private and public collections internationally.

Friedman, B. H. and Abby. He is a writer, NYC. Educated at Cornell. Has written and/or contributed to fifteen books, including short stories and works on art. His 1972 Pollock biography, *Energy Made Visible,* was selected by the American Library Association as one of that year's Notable Books.

Gagney, Jerry. Related by marriage to the venerable Talmage family, he saw so much death in World War II that in East Hampton, he says, "The cops always called my wrecker because they knew arms and legs off were just another thing to me."

Greenberg, Clement: Writer, art critic, lecturer, Bronx. Studied Syracuse U., Art Students League. *The Nation* is among the many publications to which he has been a contributor. Author of *Joan Miró, Matisse, Art and Culture, Hofmann.* Once a consultant to Knoedler & Co.

Hale, Barbara Barnes: Of New York Social Register lineage, she has been a mainstay of environmental causes on Long Island. Formerly the wife of Robert Beverly Hale.

Hale, Robert Beverly. Artist, poet, lecturer, Boston. Studied at Columbia and the Sorbonne, also with George Bridgman and William McNulty. For over forty years a lecturer on drawing and anatomy at the Art Students League, he was formerly Curator of Modern Painting at the Metropolitan Museum of Art. His poetry has appeared in *The New Yorker,* and his art work is in several collections.

Hare, Denise Brown. Photographer, film critic, Paris. Co-author of *Rosa Bonheur* with Dore Ashton. Her photographs also make a major contribution to the latter's *Yes, But,* a critical study of Philip Guston.

Hayter, Stanley William. Artist, printmaker, writer, England. A chemist with the Anglo-Iranian Oil Co. in the Middle East, he moved to Paris in 1927, lived in the

U.S. from 1940 until 1950, then returned to Paris. The founding director of the influential Atelier 17, he is the author of *New Ways of Gravure, About Prints, Nature and the Art of Motion*. Work in major international collections.

Heller, Ben. Private dealer, NYC. Formerly in the textile business, he began collecting art in 1949 and East Hampton land more recently. "That I've made $4 million on my Pollocks is grossly exaggerated. I've been in hock for works of art since I started."

Horn, Axel. Painter, designer, planner, NYC. Studied under Benton at the Art Students League. "Fired from WPA Mural Division day my first son was born. When I first saw the *She-Wolf* I thought it Pollock's attempt to paint a calf."

Howell, Douglass M. Master papermaker, linguist, and chemist. Designed and built his own equipment for hand papermaking without chemicals from damask cloth.

Hults, Edward W. Plumbing partner with Richard Talmage in The Springs after U.S. Army service in WW II. Retired justice of the peace.

Isaacs, Reginald R. City planner, educator, Canada, to U.S. 1922. Educated at Harvard (Norton Professor). Served Chicago City Planning Commission. Author of ten-volume work on Walter Gropius (in progress).

Jackson, Harry. Sculptor, painter, Chicago. Founder of Wyoming Foundry Studios. Solo shows at Smithsonian, Whitney Gallery of Western Art (Cody, Wyo.); numerous commissions and awards. Author of *Lost-Wax Bronze Casting*.

Janis, Sidney. Art dealer, Buffalo. Opened gallery in his name in 1948. Author (with wife, Harriet Grossman) of *Abstract and Surrealist Art in America*. Honorary trustee of MOMA.

Jenkins, Paul. Painter, Kansas City, Mo. Studied at Art Students League. Solo shows at Gimpel & Weitzenhofer, Tate, Musée d'Art Moderne and Centre Georges Pompidou (Paris), MOMA, Whitney, and Corcoran museums.

Johnson, Buffie. Painter, Boston. Studied at Art Students League, Atelier 17, UCLA (M.A.). Solo shows at Wakefield, Parsons, Max Hutchinson, and Bodley galleries in U.S., considerable exposure in Europe.

Jules, Mervin. Social realist painter in 30s, Baltimore. Studied under Benton (played the kazoo at the Bentons' musical evenings), became Art Students League librarian. Founded branch of American Abstract Artists in Baltimore. "I wasn't able to get on WPA because I had a successful exhibition."

Kadish, Reuben. Sculptor, Los Angeles. Studied at Otis Art Inst., Brooklyn Museum, Atelier 17. Taught at Brooklyn Museum, Manhattanville and Queens colleges, New York Studio School, and (currently) Cooper Union. Solo shows at Poindexter, Graham, and Borgenicht galleries.

Kennedy, Donald. Sculptor in wood and metal, active in promoting the Fireplace Road property in The Springs as a memorial to Lee and Jackson.

King, William. Sculptor, a self-defined "redneck." Known for his witty, elongated pieces suggestive of his own physique. Numerous shows and commissions. Represented by Terry Dintenfass Gallery.

Kligman, Ruth. Former fashion model and art student, New Jersey. Author of *Love Affair: A Memoir of Jackson Pollock*.

Knee, Gina (d. 1982). Painter, etcher, Ohio. Educated at Smith College, long a Santa Fe resident. Widow of portraitist Alexander Brook.

Larkin, Lawrence. Collector and portraitist, NYC. Studied with Guy Pène du Bois, and at Amagansett Art School with Hilton Leach. His late wife, potter Rosanne Roudebush, was the daughter of sculptor John Hayward Roudebush.

Lassaw, Ibram. Sculptor, Egypt, to U.S. 1921. Studied at City College, Clay Club, Beaux Arts Inst. of Design and Ozenfant School, NYC. Taught at Duke, UCLA/ Berkeley, Brandeis, Mt. Holyoke, etc. Founding member of American Abstract Artists and the "Club." Solo shows at Duke, Carnegie-Mellon, Vanderbilt University, and Kootz and Zabriskie galleries.

Lerman, Leo. Editor, writer, art historian. Author of works on Da Vinci, Michelangelo, *100 Years of The Metropolitan Museum of Art,* numerous magazine articles. Veteran senior editor for Condé-Nast.

LeSueur, Joseph. Television writer, California. Editor of *Homage to Frank O'Hara* (a close friend), and intimate of poets Ashbery, Schuyler, etc. Long an observer of the New York art scene.

Levi, Julian. Painter, teacher, NYC (d. 1982). Studied with Henry Breckenridge, Arthur B. Carles, and in France. Taught at Art Students League from 1946 to 1982. Director of the New School of the Art Workshop and associated with Philadelphia Academy of Fine Arts. Work in numerous museums and collections, including MOMA.

Liss, Joseph. He is a radio and television writer, was an intimate of Mark Rothko.

Liss, Millie. Wife of Joseph Liss.

Little, John (d. 1984). Painter and fabric designer. Studied with George Grosz at Art Students League, and for eight years with Hans Hofmann. Over fifteen solo shows; exhibited widely and represented in numerous collections. An intimate of Lee Krasner.

Loew, Michael. Artist, NYC. Studied at Art Students League, with Hans Hofmann, and in Paris at Académie Scandinave and Atelier Léger. Professor of art at UCLA/Berkeley. Solo shows at Rose Fried and Stable galleries, UCLA, Philadelphia Museum of Arts; and Hirshhorn Museums.

Marca-Relli, Conrad. Painter, Boston. Studied Cooper-Union; taught at Yale, UCLA/Berkeley. Solo shows at Stable, Perls, Kootz galleries, NYC; extensive exposure abroad. A master of collage.

Matter, Herbert (d. 1984). Photographer, graphic designer, Switzerland, to U.S. early 30s. Studied with Léger, taught at Yale School of Art, designed graphics for Condé-Nast, the Swiss Pavilion for 1939 World's Fair and the Guggenheim Museum. Filmed Alexander Calder. At the time of his death was preparing a book on his friend Giacometti.

Matter, Mercedes. Painter, New York. Daughter of artist Arthur B. Carles and widow of Herbert Matter, she has been a major force in the development of the New York School. Active in the AAA, founder and long-term director of The Studio School. Says Leland Bell: "She has a passion for art."

McCoy, Arloie. Widow of Sande McCoy, born Conaway at Riverside, California. She was dedicated to Sande from high school days on.

McCoy, Jason. Art dealer, son of Sande and Arloie.

McCoy, Sande (d. 1963). Painter, silkscreener, Cody, Wyo. Jackson's next oldest brother, husband of Arloie, father of Jason McCoy.

McCray, Porter. Retired director of MOMA International Programs. Educated at Yale (M.A. in architecture), he was a friend of Léger, José Sert.

McNeil, George. Painter, NYC. Studied at Pratt, Art Students League, Columbia Teachers College, and with Hans Hofmann. Solo shows at Egan, Poindexter, Howard Wise, Dintenfass, Gruenebaum galleries. Work in collections of MOMA, Whitney. Professor emeritus at Pratt and UCLA/Berkeley, McNeil says that "Art is going in a PR direction but honesty will prevail."

Meert, Joseph. Painter, Belgium, to U.S. 1910. Apprentice railroad car painter, won a scholarship at Kansas City, Mo., Art Institute and School of Design. Also studied at Art Students League under John Sloan, Boardman Robinson, Thomas Hart Benton, and later on the West Coast with Stanton MacDonald-Wright. Benton called him his "most promising student"; became latter's assistant at Kansas City Art Inst. Was Jackson's close friend during the 40s.

Miller, Dorothy. Consultant, retired senior curator of painting and sculpture, MOMA; member Acquisitions Committee, did many breakthrough group shows, worked closely with director Alfred Barr, Jr. Her late husband, Holger Cahill, directed the New York WPA Art Project.

Miller, George Sid. Senior member of The Springs' oldest family, brother of the late Dan Miller of General Store fame. Former supervisor of East Hampton Town, member of numerous town committees, retired as oldest highway equipment salesman in New York State. Currently runs lively boarding stable.

Motherwell, Robert. Painter, Washington. The most widely educated member of the New York School, he attended Otis Art Inst., San Francisco Institute of Fine Arts, Stanford, Columbia (under Meyer Schapiro). European oriented, friend of Matta and many Surrealists. A founder of and taught at New York's Subject of the Artist School, Black Mountain and Hunter colleges, Yale and Harvard. Helen Frankenthaler is his former wife; he is now married to photographer Renate Ponsold. Work in major international collections; major shows at MOMA, Albright-Knox Gallery (1965), Guggenheim Museum (1984).

Namuth, Hans. Photographer, filmmaker, Germany. Studied with Alexander Brodovitch at New School. Has photographed over two hundred artists; made films on Albers, Brancusi, de Kooning, Matisse, Pollock. Recently photographed Francis Bacon, filmed Balthus exhibit.

Newman, Mrs. Muriel Kallis Steinberg. Art collector, Chicago. Honorary life trustee of Metropolitan Museum of Art, major benefactor of Art Inst. of Chicago. Her pioneer collection of Abstract Expressionism (estimated worth $15 million) is to go to the Met.

Nivola, Constantine. Sculptor, Sardinia, to U.S. 1939. Studied in Italy. Former art director for Olivetti Company, *Interiors* magazine. Taught at Harvard, Columbia, UCLA/Berkeley. Public and private commissions and international awards. Solo shows in Italy and at Parsons, Tibor de Nagy, Peridot, Bertha Schaeffer, Willard galleries. Work in major collections, including MOMA, Hirshhorn.

Noguchi, Isamu. Sculptor, Los Angeles. Studied at Columbia, Leonardo da Vinci

Art School, East Side Art School, NYC. Apprenticed to Brancusi; designed stage
sets for Martha Graham. Solo shows at Mellon (Phila.), Marie Harriman, Egan,
Cordier & Ekstrom, Walker, Gimpel & Fils galleries. Recipient of major interna-
tional commissions; represented in numerous collections worldwide.

Norman, Dorothy. Writer, editor, photographer, Philadelphia. An intimate of
Alfred Stieglitz, John Marin, and Jawaharlal Nehru, she was the late Indira
Gandhi's closest friend in this country. Once a *New York Post* columnist, she
founded and edited *Twice a Year*. Among her published works are a two-volume
biography of Nehru and *Alfred Stieglitz: An American Seer*.

Ossorio, Alfonso. Painter, sculptor, Manila, to U.S. 1929. Studied at Harvard,
Rhode Island School of Design. Solo shows at Wakefield, Brandt, Parsons, Cor-
dier & Ekstrom galleries, NYC; studio Paul Facchetti and Galerie Stadler in Paris.
Work in collections of Brandeis, NYU, Yale.

Park, Charlotte. Painter, Concord, Mass. Studied at Yale Art School and with
Wallace Harrison. Taught MOMA children's classes. Her work has appeared at
Tanager, Stable, and Benson galleries, Whitney Annuals, most recently pre-
sented by Elinor Poindexter at Susan Caldwell. Pioneer New York School
painter, wife of James Brooks.

Parsons, Betty (d. 1982). Art dealer and artist, NYC. Studied with Giacometti in
the Bourdelle studio in Paris. Over the forty years of her gallery operation, she
showed most of the major New York School figures, many for their first solo
show. Her artistic judgment and courage extended to and beyond the Second
Generation.

Pavia, Philip. Sculptor, Conn. Studied at Art Students League, Beaux-Arts Inst.,
Accademia Art School (Florence), Paul Bonnet Atelier (Paris). Founder of the
"Club," publisher and editor of *It Is*. Shows at Kootz, Martha Jackson, Max
Protech galleries. Numerous collections and commissions.

Peters, Paul. Television writer. He shared a summer house with the well-known
literary agent Ivan Von Auw, and in retirement they live in Portugal.

Phillips, Helen. Long a sculptor in Paris before moving her studio to New York,
she was a close friend of Peggy Guggenheim and was married to S. W. Hayter.

Pollock, Alma Brown. Wife of Jay Pollock, sister of Jackson's early boyhood
friend, Donald Brown.

Pollock, Charles. Painter, Denver, Colo. Jackson's oldest brother, he studied at
the Otis Art Institute and in New York at the Art Students League under
Thomas Hart Benton. Worked in the art department of the *Los Angeles Times*,
later on display layouts and as a political cartoonist. Supervised WPA art project
in Detroit, taught lettering and calligraphy at Michigan State Univ. Moved to
Paris in 1971 with his wife Sylvia. Has shown in France, England and Belgium
and (in 1984) at the Jason McCoy Gallery in New York.

Pollock, Elizabeth Feinberg. Writer, editor and teacher, first wife of Charles
Pollock, Little Rock, Ark. Studied at University of Arkansas, worked for *New York
World* and as a free lancer, wrote political articles and plays. She was active in the
labor movement. Taught at Michigan State University and for 30 years at
Brooklyn Polytechnic Institute.

Pollock, Frank. Retired horticulturist, third of Roy Pollock's sons, Cody, Wyo.

Moved to New York in 1928, studied journalism, worked at night in Columbia University Library and days for a restaurant peeling potatoes. Married to Marie Levitt Pollock.

Pollock, Jay. Retired rotogravure etcher, Cody, Wyo. Roy Pollock's second son, he worked for the *Los Angeles Times* and Cuneo Press, NY. Married to Alma Brown Pollock.

Pollock, Marie Levitt. Wife of Frank Pollock, she was a surgical nurse.

Pollock, Sylvia Wolf. A book designer, she is also a poet and lives with her husband Charles and daughter Francesca in Paris.

Potter, Fuller. Painter, NYC. Studied in Paris, in NYC with Walt Kuhn. Noted for still lifes shown at the Marie Harriman Gallery. The impact of meeting Pollock in 1949 was such that he painted only abstractions from then on.

Potter, Penny (d. 1984). Actress, NYC. Studied under Michael Chekhov, a founder and director of Theatre Incorporated which sponsored first U.S. tour of the Old Vic, end of the Phoenix Theatre. Former wife of author.

Resnick, Milton. Painter, Russia, to U.S. 1922. Studied at Pratt and American Artists School. Taught at UCLA/Berkeley. Solo shows at Poindexter, Howard Wise, Max Hutchinson, Gruenebaum galleries.

Rivers, Larry. Artist and jazz musician, Bronx, NY. Studied at Juilliard School of Music, with Hans Hofmann, William Baziotes. Solo shows at Tibor de Nagy, Stable, Jackson, ACA, Marlborough, Miller galleries. Work in many major collections.

Rosset, Barney. Publisher, editor, Chicago. Founder/editor of Grove Press, *Evergreen Review.* Bought the Robert Motherwell house that had shocked East Hampton's old guard.

Rosset, Loly. Photographer, Germany, to U.S. 1950. Grove Press editor.

Roueché, Berton. Writer, Kansas City, Mo. Noted for his "Annals of Medicine" pieces in *The New Yorker,* he is the recipient of numerous awards and the author of travel articles and novels, including *Feral.*

Schardt, Nene. Artist and longtime Cape Cod resident. She and her late husband, painter Bernard Schardt, were both Village and summer intimates of Jackson.

Seixas, Frank, M.D. Formerly a specialist in internal medicine, now in alcoholism, NYC. Studied at Cornell, Columbia, and Rutgers. Fellow in psychiatry at Mt. Sinai Hospital, medical director of National Council on Alcoholism. Editor of several journals.

Seixas, Judy. Wife of Frank Seixas, she works for the Boston center for Alcoholism, specializing in children of alcoholics.

Southgate, Patsy. Writer and translator, Washington, DC. Toast of postwar *Paris Review* group, including her then husband Peter Matthiessen, George Plimpton, and William Styron. She was a close friend of Frank O'Hara.

Spaeth, Mrs. Eloise. With her late husband, Otto, a prominent art collector and patron, long a mainstay of East Hampton's Guild Hall. Honorary chairman of the Archives of American Art.

Stein, Ronald. Artist, aviator, NYC. Studied at Cooper Union with Will Barnet,

at Yale with Josef Albers, also at Rutgers. Numerous commissions and awards, solo shows at Tibor de Nagy, Marlborough galleries. Nephew of Lee Krasner.

Sterne, Hedda. Painter, Bucharest, to U.S. 1941. Studied in Europe. Solo shows at Wakefield, Brandt, Parsons, Saidenberg, Rizzoli galleries. Work in many major collections, including MOMA.

Stubbing, Haydn (Tony) (d. 1983). Painter, naturalist, London. An *aide de camp* to Montgomery in WW II, he was a founder with Joan Miró and others of the School of Altamira. Work is in many collections internationally.

Symonds, Edith (Mrs. John H. P. Moore). Artist, Flushing, NY. "A nice cozy little town then. When we moved to West 8th Street it was genteel, not a human sewer." Childe Hassam was a family friend. Studied at Arts Students League with Benton, showed frequently but not in New York.

Tabak, May. A prolific writer now at work on a book about the Depression years in New York, she is a shrewd observer of the art scene and widow of critic Harold Rosenberg.

Talmage, Richard. Of old East Hampton lineage, he was the plumbing partner of Edward Hults. He is busy restoring a near-twin to Jackson's Model A Ford, made famous by Namuth's photographs.

Tolegian, Manuel Jerair (d. 1983). Artist, inventor, Fresno, CA. Classmate of Jackson and Philip Guston at Los Angeles Manual Arts High School. Known in the 30s for social protest paintings, he turned to still lifes on his return to California from New York. His friend and fellow Armenian, William Saroyan, called the latter "an irresistible experience for the eye because of their jewel-like color." Among his inventions is the POWREASEL, an electrically powered easel.

Tremaine, Mrs. Emily. A collection of over 400 works formed in part with her husband, Burton, is as unusual in its balanced modernity as for having the aura of "old" New York money. Says Ben Heller: "As fine a pair of collectors as you can find in every sense."

Ward, Eleanor (d. 1984). Art dealer, NYC. Her twenty years of operating the Stable Gallery gave a start to a large number of now-famous names, including Pop Art stars. She did not enjoy either the commercial side of the gallery operation or the more bizarre behavior at her openings. Nevertheless, "The Gallery became like a salon, filled every Saturday with artists communicating, and this meant more to me than its success."

Ward, Joan. One of the famous "Cedar Bar Twins," she has long been a year-round East Hampton neighbor of Willem de Kooning. Is a noted illustrator for the East Hampton *Star*.

Whipple, Enez. Executive Director of the Guild Hall, East Hampton, recently retired. In her valiant struggle to bring good art and good theater to East Hampton, she was pressured to close down both gallery and theater because it was claimed they attracted the "wrong people" to the area.

Wilcox, Roger. Industrial designer. He and his late wife, artist Lucia, were close to the Pollocks in the early years. "Those winters were pretty solitary, so we needed each other."

Williams, Frederick. The dignified East Hampton funeral director revered by his town and profession.

Wilson, Reginald. Painter, Ohio. Studied under Benton, Harry Wickey, John Steuart Curry. Worked in the easel division of the WPA Art Project. Shows at Feragil, Walker, Perls galleries.

Wood, Jarvis. Bayman by trade, he is Superintendent of Green River Cemetery and a senior elder of the Presbyterian Church in Springs.

Zogbaum, Rufus. Painter, son of the late Wilfred Zogbaum.

Zogbaum, Wilfred (d. 1965). Painter and sculptor. He studied under Hans Hofmann, who called him one of his most brilliant students, and taught at UCLA. He was a combat photographer in WW II, having had a fashion studio with his first wife, Betsy Ross. The late Marta Vivas, filmmaker and feminist, was his widow.

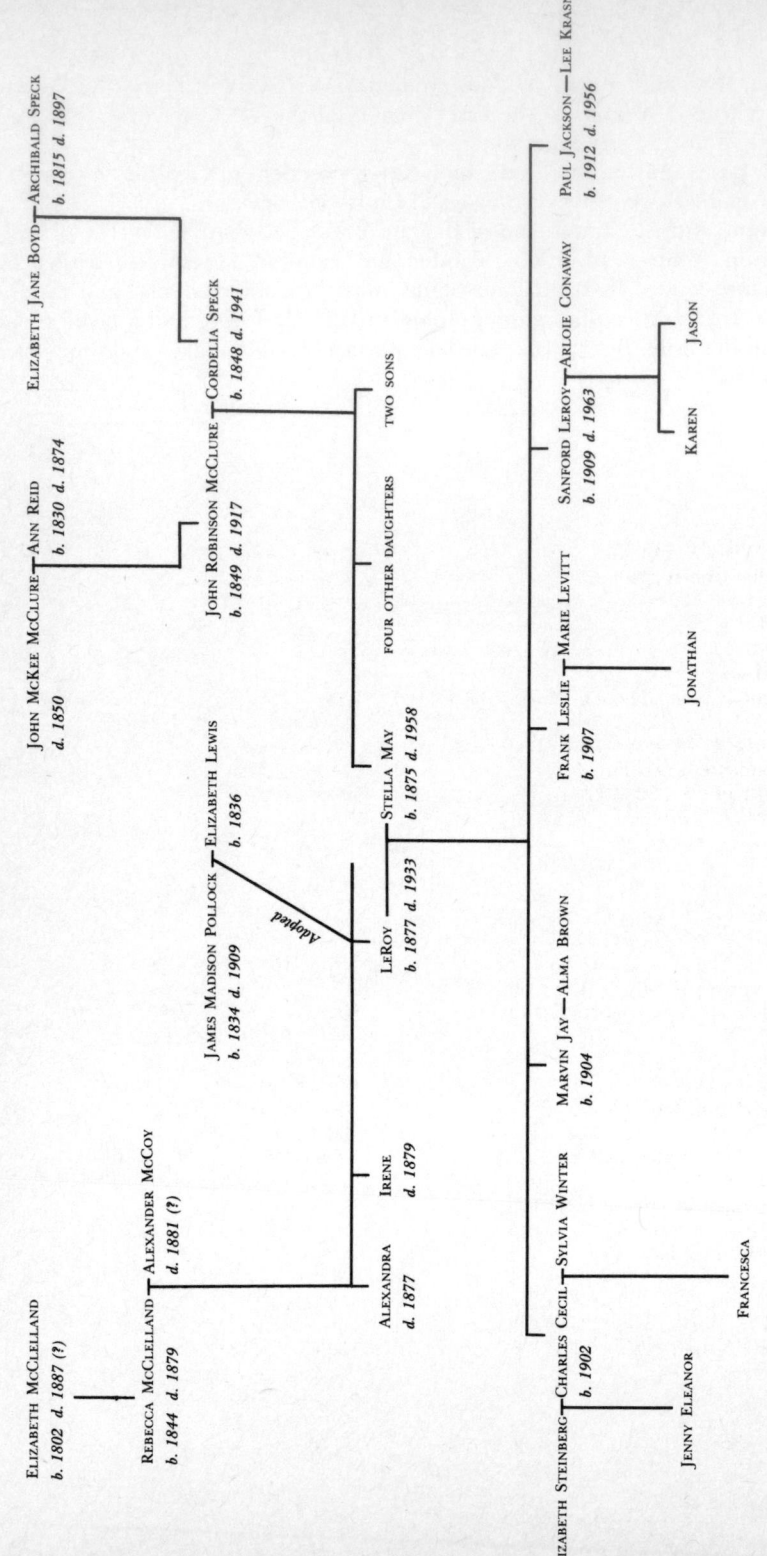

INDEX